OCEANIC ART

MYTH, MAN, AND IMAGE
IN THE SOUTH SEAS

OCEANIC

MYTH, MA

CARL A. SCHMITZ

ART
AND IMAGE IN THE SOUTH SEAS

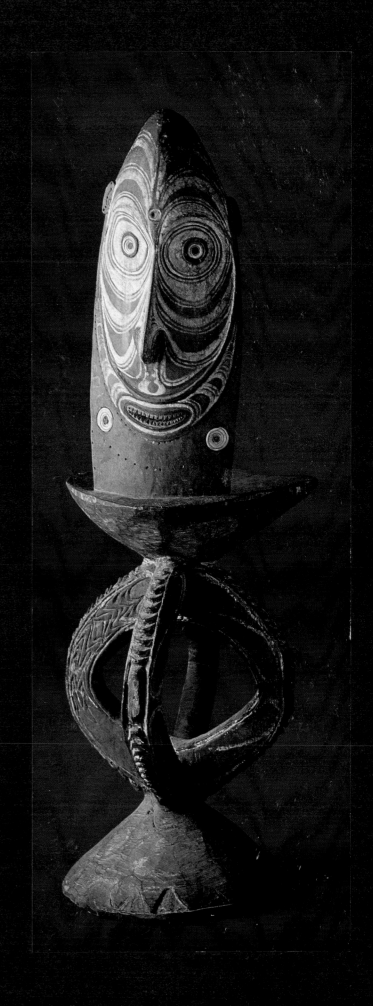

HARRY N. ABRAMS, INC., PUBLISHERS, NEW YORK

CONSULTING EDITOR

DOUGLAS NEWTON

CURATOR, THE MUSEUM OF PRIMITIVE ART, NEW YORK

TRANSLATED FROM GERMAN BY NORBERT GUTERMAN

MILTON S. FOX / EDITOR-IN-CHIEF

STANDARD BOOK NUMBER: 8109–0351–2

LIBRARY OF CONGRESS CATALOGUE CARD NUMBER: 69–12797 → 1969

PREFACE

CARL A. SCHMITZ, the author of this book, was born on August 4, 1920 in Cologne. He was educated there, studying ethnology, sociology, and drama. This culminated in his first book, *Balam: Tanz- und Kultplatz in Melanesien* (1955), a study of Melanesian ceremonial grounds and platforms considered as religious and theatrical settings. In 1955–56, Schmitz carried out field work in the Huon Peninsula area of northeast New Guinea which, apart from a coastal strip, had hitherto been largely neglected by anthropologists. His research resulted in a number of publications in which he went far beyond the conventional techniques of anthropology and ethnography; in them, Schmitz developed a theory of Melanesian culture-history which became one of the main preoccupations of his future work. The most important of these endeavors was his book *Historische Probleme in Nordost-Neuguinea* (1960), in which he proposed systematic methods by which the rough ethnographic data could be analyzed and ordered. Drawing on the principles of Graebner in regard to culture-history, on G.P. Murdock for social structure, and on Eliade, van der Leeuw, Pettazoni, and Jensen for the history of religion, he pursued his aim: "to outline the basic homogeneous cultures in [the Huon Peninsula] from which the cultural situation of today [was] built up." As a result, he was able to deduce "how the culture of the Huon Peninsula was built up from three basic component cultures" which he defined and described, putting them in a hypothetical historical sequence. The religions and the religious art of the area were described in a further book, *Wantoat* (1963), which is remarkable for the profundity of its analysis of myths and their relationship to the often spectacular objects created for the cults. A more general work was *Oceanic Sculpture* (1962), in which certain basic myths he had already isolated in *Historische Probleme* are related to Oceanic art in general.

During this period Schmitz was appointed first curator, then director, of the Museum für Völkerkunde at Basel, with its unrivaled collections of Melanesian art and material culture. He organized for the museum a number of exhibitions on material culture for which he wrote catalogues—themselves sometimes original contributions. In 1962 he was appointed professor of anthropology at the Basel University and in 1965 he became pro-

fessor of anthropology at the University of Frankfort where he died suddenly on November 17, 1966.

The present book was completed shortly before his death, after nearly three years of work. It is his last important statement on the area which as a scholar and a man he cared for most—Oceania—and unites the most constant themes of his work—its history, its religions, and, above all, its art. The death of Carl A. Schmitz was a grave loss to ethnography and anthropology. These he enriched, even in his short working life, with the stimulus of hypotheses and methods which, often controversial, were based on great scholarship. As a man he will not be forgotten for his personal charm and intellectual generosity, even by those who met him only seldom.

DOUGLAS NEWTON

CONTENTS

NEW GUINEA

LIST OF PLATES

All objects depicted are made of wood unless otherwise stated in the plate captions.

POLYNESIA

MICRONESIA

INTRODUCTION

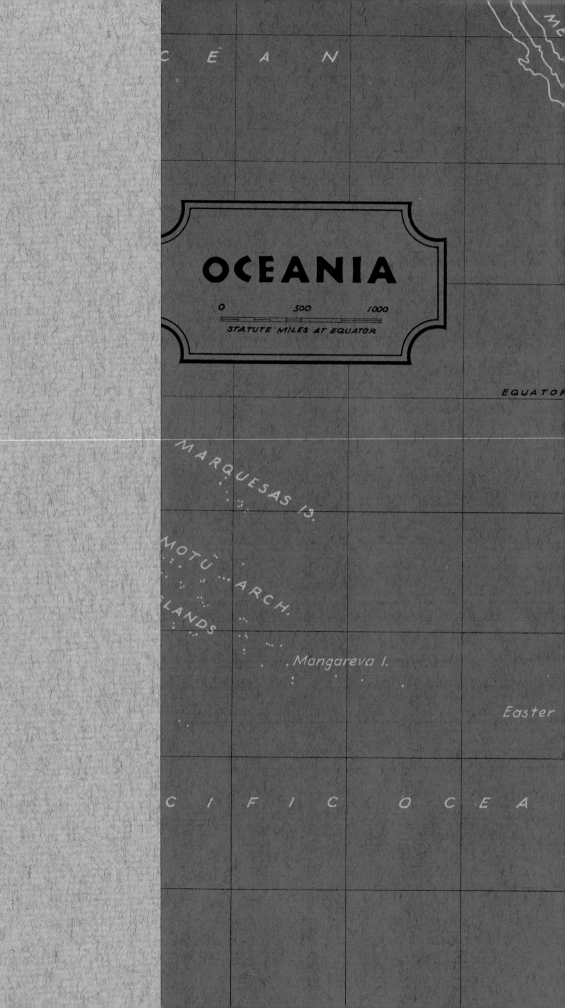

THE geographers of the eighteenth century were the first to divide Oceania into three areas with the names by which they are still known today: Melanesia, Micronesia, and Polynesia. The first of these is the westernmost, lying off northeastern Australia—a belt of islands stretching from New Guinea through the Bismarck Archipelago (which includes the Admiralty Islands, New Britain, and New Ireland), southward through the Solomon Islands to the New Hebrides, New Caledonia, and the Loyalty Islands. The name of Melanesia (from the Greek *melas*, black, and *nesos*, island) was attached to these islands because their population is predominantly dark-skinned. Farther north, beginning well east of the Philippines and extending into the central Pacific, are the tiny islands grouped as Micronesia (*mikros*, small): they include the Carolines, the Marianas, the Marshalls, and the Gilbert Islands. The third grouping, Polynesia (*polys*, many), includes a great many islands of the central Pacific proper, from the Hawaiian Islands in the north to New Zealand in the southwest.

The terms which were promptly adopted to describe the inhabitants of these areas—Melanesians, Micronesians, and Polynesians—are purely geographical: they give no clue to the historical composition and ethnic make-up of the populations. Over the nearly four thousand years of their history, extremely varied human groups with diverse cultural traditions migrated into Oceania. The present-day cultures found in these three areas are the result of a long and complex process of the mingling of those traditions.

Under the circumstances it is impossible to describe the art of the Oceanic peoples in a few words. A perfunctory glance at the reproductions in this book will, at first, produce contradictory impressions, owing to their overwhelming diversity of forms and motifs, in which Baroque exuberance and fantastic combinations, elegant abstraction, and candid realism are found side by side. On further consideration, however, it will be seen that certain forms and motifs do recur, and frequently. In fact, recognition of a few fundamental stylistic forms and a limited catalogue of motifs will enable us to give at least a rough outline of the historical development of Oceanic art. It must be said at the outset that, until very recently, this art has been shaped by Neolithic and Bronze Age impulses.

At this point we must give a word of caution. It was not until the mid-nineteenth century that art objects from Oceania were acquired in any consider-

able number by American and European museums and private collections. Inevitably, these are the sources from which the historian works. Thus, when we try to gain insight into the probable course of development of styles and motifs, we lack works that actually date from the early centuries. All we can do—from our knowledge of how styles and motifs were diffused in relatively recent times and how they tie up with such other cultural developments as the prehistory of southeastern Asia and Indonesia—is draw inferences concerning their place in the relative chronology of the basic cultural traditions.

However, apart from the matter of fundamental styles and motifs (both of which will be discussed in detail), Oceanic art is distinguished from the art of other cultures by its compositional principles. Assuming that works of art are always intended to represent something, we single out two characteristic features of Oceanic art: the prevalence of the principle of simultaneous representation and a marked absence of scenic representations.

Take a simple human figure carved in wood. The motif as such is neutral, but, depending on the cultural group that made it, such a figure is intended to represent an ancestral spirit, a wood spirit, or some other divinity. Thus, further characterization is required. This is supplied in the form of accessories. Bones of departed ones, or objects they owned, make such a carving an ancestral figure; coloring, feathers, or leaf ornaments—all of which must be interpreted as vehicles of hidden powers—turn such a carving into a particular spirit or divinity. At their simplest, such accessories are provided *in natura*, i.e., they are not part of the carving. Their meaning is determined by the socio-religious system of the group for which the works were made. Frequently we observe that some accessories are added in an inconspicuous, as it were, secret manner, and these may be the most significant. In other words, the arrangement of the accessories not only is not artistic, but it is not even logical, for it is not determined by their symbolic significance or their degree of importance. At its most rudimentary, simultaneous figuration of this type is purely additive.

These considerations lead us to a further crucial observation. Most of the sculptures reproduced in this book derive their meaning and function from the religion of the social group. We must accustom ourselves to the idea that the stone or wood carving is not the work as the artist conceived it. In its definitive form, when it fully expressed its content and function, it included a

number of accessories arranged in a specific manner. The reproductions do not include these indispensable features that the work originally possessed; indeed, only rarely have Oceanic works reached museums or private collections as the artists conceived them, for usually only the basic carvings have been transported to Europe or America. That this is true of most illustrations in this book is an important fact which must be borne in mind by the reader. Fortunately, even in this reduced form, many of these works are of great beauty and sublimity, and do not altogether preclude analysis of the Oceanic styles. This is the main reason why only stone, wood, and ivory sculptures are shown in this book: one aspect of Oceanic art is singled out as the most satisfactory object and illustration of historical analysis.

The persistence of additive figuration—there are even many recent examples—is easily explained. The added accessories are not treated primarily as formal problems but as indispensable vehicles of hidden powers. In this respect, nothing can replace them, nor can the artist resort to artistic substitution. Nevertheless, religious accessories and profane ornaments alike can, of course, be treated with formal aesthetic feeling. Unfortunately, this important aspect of Oceanic art has so far been little investigated. For instance, in a given social group the feathers of a certain bird are looked upon as vehicles of hidden powers. The spirit to be represented may have a human shape or the shape of this bird. From the religious point of view, a single feather would suffice to achieve the intended magical effect; when many such feathers are arranged to make a wreath or crown, we know we are in the presence of formal artistic intentions.

In all Oceanic art, and especially wood carving, there is a tendency towards more highly developed artistic creations which can be understood only by taking into consideration the relationships just outlined. In some centers of wood carving (for instance, the Maprik district in New Guinea), works exist which may in a sense be described as copies of genuinely sacred sculptures. They are complete—that is, they include the carved figure, the sacred accessories, and the profane ornaments. But in these works everything is carved in wood. Hence, the accessories are not in this case genuine vehicles of powers, but merely images of them. The same is true of carvings of this kind representing dancers with all their adornments. Almost inevitably, some elements are here omitted or reduced, and since it is often impossible

21

to carve everything in detail, many of the parts are formally merged. Although the compositional principle of simultaneous figuration is still observed, it is no longer of the additive type; it has developed into a higher form.

The fundamental stylistic forms and motifs often strike the unprepared viewer as archaic. But no one can fail to see that Oceanic artists brought an extraordinary mastery to their exploitation of the principle of simultaneous figuration. The combinations—man-animal, bird-fish, and bird-snake, to mention only a few—disclose not only incredible richness of ideas but also an extraordinarily sure sense of form and highly disciplined creative talent. The best examples of this type are found in the central Sepik district of New Guinea, in the *malanggan* carvings of northern New Ireland, and among the Maoris of New Zealand. The uninformed viewer may be tempted to recognize a Dionysian exuberance in the strangeness of the motifs and the unusual character of the forms. But closer scrutiny will soon show that the creative intention and accomplishments of these artists deserve to be called Apollonian. Nothing is left to chance; nowhere does feeling disrupt the form—such an attitude would be contrary to the nature of all the Oceanic peoples. To them, all things are linked and merged into one another. But since the goal of these artists is not noble simplicity but multiplicity of visions, they brilliantly combine formal discipline with diversity of motifs.

Many works reproduced in this book strike European and American viewers as masterpieces. But, since the total effect intended by the artist was different, this impression is often fortuitous. Only in the best examples of the merging type of simultaneous figuration do the works, as we have them, correspond to a great degree, or perhaps completely, to the creative intention of the artists. With these we are actually in the presence of the finest achievements of the art of wood carving. These are rare and cannot be looked upon as products of a standardized popular craft: they are the works of truly great artists. The mass of the wood carvers must be regarded, however, as simply talented artisans.

BASIC
CULTURAL
TRADITIONS

The islands of the Pacific constitute a vast area which stretches eastward from the South China Sea to Easter Island, two thousand miles off the coast of South America. Throughout this area the cultural bloodstream runs from

west to east, from the Asiatic continent to the most far-flung of the islands. Our present knowledge of the course of human history in this region as a whole is still patchy and uncertain in some respects, but voluminous in others.

The starting point of all investigation into the cultural history of these peoples is the descriptions written by Western ethnographers, beginning in the second half of the nineteenth century. During that period, the peoples of southeastern Asia, Indonesia, and Oceania presented a variegated cultural picture. In southeastern Asia and the western parts of present day Indonesia are remnants of high cultures which developed, under Indian and Chinese influences, on the basis of an earlier cultural stratum already in possession of the arts of metalworking. In eastern Indonesia, ethnographic reports give us the picture of an essentially Metal Age tradition. In New Guinea and the rest of Melanesia, however, the Neolithic tradition is often still dominant. As a result, it is very difficult to give a coherent over-all sketch of the history of Oceania, as will be apparent from the following remarks.

Early Man The data now available for prehistoric times suggest that during the Middle Pleistocene (c. 400,000(?)–120,000 B.C.) southeastern Asia and Indonesia were inhabited by a relatively homogeneous population, but that by the Mesolithic period (c. 10,000–2000 B.C.), the population of southeastern Asia and Indonesia practiced three different stone and bone tool-making industries, and consisted of at least two racial varieties (Melanid and Veddoid). It must have been this population that settled the Australian continent in this epoch. Southeastern Australia was inhabited as early as 8000 B.C. The prehistoric finds in Australia show clearly that the technological principles of its stone industries were related to those of Mesolithic southeastern Asia and Indonesia; and, in fact, the traditions of these industries have been preserved to this day in the implements of Australian aborigines. Melanid features, characteristic of the Mesolithic population of southeastern Asia and Indonesia, were particularly conspicuous among the Tasmanians (now extinct). The Australian aborigines of today must be traced back to the proto-Australians of Indonesia, and everything suggests they were related to the Veddoids.

These groups were able to migrate to Australia toward the close of the Pleistocene because at that epoch the level of the sea was more than three hundred feet lower than it is today. Large parts of the continental shelf were above water, leaving relatively short passages of sea to be crossed. It must also be assumed that these people first reached the southern coast of New Guinea, though conclusive evidence on this score awaits further archaeological investigation. During the post-Pleistocene period, the level of the sea rose and today's islands and shore lines were formed. From that time on, the Australian continent was isolated as a historical entity. Subsequent development of Australian cultures built upon this Mesolithic foundation. There are a few traces of trade with New Guinea to the north and with Indonesia to the northwest (dating from a much more recent period), but Australia remained essentially unaffected by the subsequent historical developments that shaped the South Sea cultures.

The Neolithic (c. 2000–200 B.C.) The transition from Mesolithic game hunting to Neolithic agriculture—which was to be crucial for Oceania—was most likely effected on the continent, in southeastern Asia. Considerations based on botanical geography have led to the hypothesis that the tropical rain forests of southeastern Asia proved an important center for the domestication of plants: yams, taro roots, bananas, sugar cane, bamboo, breadfruit, and the mulberry tree.

Unfortunately, archaeological evidence for this transitional phase is still very scanty. The source of Neolithic influence, which at first brought about a sub-Neolithic phase in southeastern Asia, must be looked for in northern China (Yangshao and Lungshao). We know today that methods of cultivating cereals and other plants were brought from northern China to the south by Mongoloid migrants. More recent excavations in southern China have shown that Mongoloid skeletons are invariably found above an older Mesolithic layer containing Melanid skeletons.

The Mongoloid settlers from northern China cultivated millet before anything else. As this Neolithic development moved southward, it inevitably encountered a new environment with different ecological conditions. Wild rice is found throughout the monsoon belt of southeastern Asia, and it is

very probable that here rice became the dominant cultivated crop. Naturally, such Mongoloid settlers would have experimented with other wild plants in this lush region. Unfortunately, tropical plants and fruits leave practically no trace: although we are able to follow the expansion of cereal cultivation, we are reduced to conjecture in the case of tropical plants and fruits. Consequently, it is as yet impossible to say whether the Melanid Mesolithic population in southeastern Asia began to domesticate wild plants on their own or borrowed the idea from the Mongoloid settlers. The second alternative is the more plausible. It has also been established with certainty that by this time pigs and dogs had been domesticated.

It is thus clear that by the Neolithic epoch two great racial types (Melanid and Mongoloid) had made their appearance and eventually spread in varying proportions not only over southeastern Asia and Indonesia but also over Oceania. But since the Melanids were present already in Mesolithic southeastern Asia and Indonesia, whereas the Mongoloids did not reach the southern regions before the Neolithic epoch, we may assume that the Mongoloids not only mixed with the Melanids but also partly drove them out. In the early phase these Neolithic cultures had no ships or navigational techniques, such as would be needed to cross the immense stretches of the northern Pacific from Micronesia to Polynesia. The goal of the early Neolithic migrants was the southwestern Pacific, where the islands are grouped fairly closely together, the route, via the long coastline of New Guinea, into Melanesia proper.

While the first push of the immigrant Mongoloids seems to have been primarily into Indonesia, the Melanids spread into the westernmost islands of Micronesia, as well as southward into New Guinea. In the complete absence of archaeological investigation, it is not possible to say whether the Melanids reached New Guinea at the sub-Neolithic stage of development or only after they were in full possession of Neolithic culture. Excavations at Saipan (in the Marianas) have shown that Neolithic Melanids were there as early as 1500 B.C.

Principal evidence for the spread of these two racial groups is the particular types of stone axes that are still found among their descendants, with the same interesting variations in the shape of the cutting edge. Here archaeological and ethnographic findings suggest that the ax with round or lenticu-

lar cross section should be attributed primarily to the Melanids; the ax with rectangular cross section to the Mongoloids. Both in prehistoric times and more recently, diffusion of the round ax tends to be concentrated in eastern Indonesia, western Micronesia, New Guinea, and the Melanesian islands. Also today, as in the past, the rectangular ax turns up most frequently in western Indonesia, in parts of Micronesia, and most of all in Polynesia.

There can no longer be any doubt that both the Melanids and Mongoloids reached New Guinea and Melanesia in the Neolithic epoch. We may also assume that the Melanids came to New Guinea a little earlier than the Mongoloids. But whether the Melanids settled the Melanesian islands, too, before the Mongoloids got there, is still in question. Most likely the islands of Melanesia were settled by a Neolithic people representing a mixture of Melanids and Mongoloids which had already occurred in eastern Indonesia and on the northern coast of New Guinea. Among these settlers, the Melanid physical type predominated, although for the most part they must have spoken the Mongoloid dialects we find within the Austronesian linguistic family. Such dialects are found only along the northern and northeastern coasts of New Guinea and on the smaller Melanesian islands, not in the interior of New Guinea. The Swiss ethnologist Felix Speiser proposed calling this basic Melanesian culture "Austro-Melanid." The term was intended to denote a Neolithic developmental phase in Oceania during which Melanids and Mongoloids mixed to give rise to a homogeneous population. Excavations have shown that this cultural type was present on the island of New Caledonia as early as 800 B.C.

We must further assume that this Austro-Melanid population, with a Neolithic culture, migrated from Melanesia to the Fiji Islands and into central Polynesia, which at that time must have been still uninhabited. As the Neolithic people coming from Indonesia gradually adjusted to the maritime environment of Melanesia, they developed shipbuilding and navigational techniques, and eventually they were able to undertake long sea voyages into the trackless water wastes of Polynesia. Excavations have revealed the presence of the Austro-Melanid cultural type as far east as the Marquesas (on Nuku Hiva) as early as 120 B.C. The Austro-Melanid Neolithic tradition among peoples of Oceania, in modern times, remains strongest in New Guinea and the islands of Melanesia. However, the culture of these regions under-

went important changes subsequently, as a result of the Indonesian drift (see below, p. 37).

The Neolithic settlers of New Guinea, Melanesia, and Polynesia faced problems of adaptation to the conditions of different zones of vegetation. The typical formation in this part of the world is a zone of coastal vegetation, a zone of tropical rain forest, a lowlands steppe zone, a highland steppe zone, a swamp zone along the larger rivers, and finally the coral atolls. The cultural forms resulting from such adaptations were locally determined.

In general, we may say that the backbone of the economic order was the practice of burning forests to obtain arable land. Each family or cooperative group owned three gardens. The location of the gardens had to be changed each year. In this way the gardens rotated within the group lands, and it usually took about fifteen or twenty years before they returned to the first site. By that time, primary forests had grown again and the soil had completely recovered. The main crops were (and still are) taro roots, yams, bananas, sugar cane, and sweet potatoes. Along the coast, of course, there was fishing. Pigs and dogs were domesticated. Such conditions of life permit only egalitarian social orders; however, these may have been structured individually (patrilineal, matrilineal, or ambilineal). All the members of an economic unit were obliged to cooperate. Nowhere was a sufficient surplus ever laid by to make possible the development of a social hierarchy based on a true division of labor. The chieftain was merely first among equals, and such riches as he might himself acquire—there can be no doubt about this—did not serve to strengthen his personal economic and political power, but had to be expended. His prestige was measured by the skill with which he put his own possessions back into circulation, so that they were distributed all over again.

Wood carving, pottery, the working of stone and sea shell are the crafts in which the Neolithic inhabitants of Oceania must have achieved magnificent results. It is in connection with these crafts that we find the beginnings of a division of labor based on specialization. Some villages devoted themselves primarily to pottery, while talented wood carvers hired out for payment to different villages. However, the life of the individual artisan and that of his family in Neolithic times very much followed the regular pattern of life in his community. In addition to his specialized labor, he also had to help with the collective work of food production.

Although we may assume, in theory, that originally there were basic differences between the Melanid and the Mongoloid Neolithic cultures, most of these differences were obliterated in the course of the nearly three thousand years the Austro-Melanids inhabited New Guinea and Melanesia. Still, in the case of a number of implements, geographical distribution permits the inference that the technological principles underlying them originated in the one or the other component of the Austro-Melanid population. Whether such differences had any bearing on social organization can only be answered by future investigation. Some anthropologists have advanced the view that the kinship structure of Melanid society was originally matrilineal. This hypothesis is supported by a number of arguments, but none of them has so far proved conclusive.

The matter of religion presents us with even greater difficulties. On the face of it, the religion of the present-day New Guineans and Melanesians is very complex: it seems as though fertility rites and the cult of ancestors preside with respect to horticulture, individual crops, the breeding of pigs, various handicrafts, hunting, and fishing. Numerous accounts suggest that in the past, ritual cannibalism was practiced and that head-hunting was current down to quite recent times. Finally, there are clear indications of continuing religious activity which takes the form of secret societies or clubs. Members of these are recruited on a regional basis, and as a rule these religious groups have nothing in common with the kinship structure.

These cults and rituals are associated with certain fundamental religious ideas about the nature of the world, mankind, and culture. We can hardly expect the faithful themselves to give us a scientific account of these, but the ideas expressed in ritual generally also provide the most important themes of myth and the oral literature. Many things that could never have been learned by direct questioning can be inferred from analysis of these themes.

Thus it has been possible to make out a few coherent mythical cycles from the confusing diversity of existing oral accounts. In these cycles we find gods and culture heroes to whom is attributed the creation of the world as it is today. There is no creation *ex nihilo*. Before the present order of things, gods, spirits, and even prototypes of man himself lived together in close proximity. All the essential elements of present-day human culture and its physical environment were created by these divinities at the close of the primeval epoch.

What exists and prevails today was created then. These creative acts not only shaped the present order of things but also sanctioned it, for the original creators are looked upon as sacred beings.

Studies of these problems, though still far from complete, indicate that we may hope one day to gain insight into the religion of the Neolithic populations of New Guinea and Melanesia. A number of the ideas dealing with the origins of the world, mankind, and the most important elements of culture follow a pattern that cannot be denied a certain coherence: it is disclosed not in the names, qualities, or accessories of the mythical heroes, but in the nature of their creative acts. By this criterion, the mythical personages fall into two or more groups, and these apparently can be subsumed under two central heads: Sky Father and Earth Mother. Other key conceptions may be discovered at a later date. What is characteristic of the Neolithic religious tradition is that the key conceptions are so vaguely formulated—none of the divinities is so clearly drawn as to represent unequivocally a Sky Father or Earth Mother; rather, there are two groups of divinities and culture heroes, each with features that in more developed religions are ascribed collectively to a Sky Father or an Earth Mother. On this assumption, it is possible to distinguish in contemporary oral traditions of the New Guineans and Melanesians two groups of ideas, one of which may be ascribed with the highest probability to the original Melanid culture, and the other to the original Mongoloid culture.

The view that all that exists—the world and mankind—had to be wrested in a life-and-death struggle from the Sky Father group by the Earth Mother group apparently belongs to the Melanid tradition. In this view, the world was created when heaven and earth were separated. The Earth Mother group took the initiative in cutting the bonds that formerly held heaven and earth together. Cosmogonic ideas play a very subordinate part in the Neolithic tradition of these tropical settlers: only a few cosmogonic accounts turn up, whereas mythical accounts of the origin of man and of his crops are extraordinarily numerous and varied.

The origin of mankind is told in a story current in almost all the islands of Melanesia. A man-eating giant threatens the inhabitants of earth; he is sometimes in human shape, sometimes a boar or an eagle, while other characteristics show clearly that he belongs to the Sky Father group. One of the

earthlings, an old woman, magically gives birth to twin boys. They grow up with extraordinary rapidity and slay the giant after a long battle. Only then is the earth liberated to be repeopled. The twins take wives, and some variants of the tale suggest clearly that their children are looked upon as the founders of the existing several tribes.

The origin of crops, too, goes back to a slaying. The divinities are killed, dismembered, and buried; and their bodies supply the first seeds of the most important crops cultivated by these Neolithic settlers. In many stories, the dead divinities clearly belong to the Sky Father group, whereas their slayers belong to the Earth Mother group.

Many details in the ritual observances of the present-day peoples become intelligible when they are related to corresponding details in these stories. The original purpose of ritual cannibalism (as well as head-hunting) seems to be accounted for by these religious ideas. The situation is different where the tradition of the Austronesian-speaking Mongoloids comes to the fore. Cannibalism was alien to them, and their religious traditions do not contain anything that could justify such a ritual practice.

One of the traditional religious views of the Mongoloids is that the world originated as a cooperative effort of the Earth Mother group and the Sky Father group. The world was created when a bird or culture hero belonging to the former group raised the earth from the bottom of the sea and set it afloat. This primordial island was then enlarged in various ways until it became the world we know today.

Here, too, cosmogonic ideas play a subordinate part, and there are only a few stories with such a content. In these stories, people come into being either when a Sky hero shapes them from earth and breathes life into them, or uses for this purpose the sinews and veins of a woman who belongs to the Earth Mother group. Characteristically, the most important woman of this group frequently turns into a turtle and goes off to live at the bottom of the sea. The prototypes of the crops, too, are created by both groups. A Sky hero has sexual intercourse with a woman from the Earth Mother group. As a result the seeds of the crops penetrate her body or under her skin, changing a young girl into a shapeless old woman. By pulling or cutting them out of her body, the old woman gives mankind the crops necessary for its sustenance. In the process, she becomes a young girl again.

Motifs and fragments from both groups of stories were amalgamated, so that today there are as many mixed as pure versions of them. But the foregoing seems to be a fair outline of the two most important strains of the Neolithic religious tradition. Numerous features of the art and ritual of the present-day peoples of Oceania can be accounted for only with reference to these traditional stories.

Late Neolithic Developments

Toward the close of the Neolithic epoch, both in Indonesia and among the Austro-Melanid peoples, who had now spread as far as central Polynesia, a development set in which may be described as an intensification of certain Neolithic institutions and ideas. This historical phase is roughly characterized by a trend to individualization. The various social units left the confines of the kinship order and began to form political groups. While technology remained fundamentally unchanged, new channels for arriving at social distinctions were formed, most important of which were the so-called Feasts of Merit. These consisted of successive, increasingly lavish feasts organized by individuals or groups. The giving of each feast was rewarded by the granting of a higher status, and a higher status secured better economic and political opportunities. But the economic structure underlying the system of the Feasts of Merit is organically related to Neolithic economic patterns, such as could be observed until very recently, above all in New Guinea. The feasts were not an absolutely new departure, but a logical outgrowth of the previously existing economic order.

This development was accompanied by a distinct intensification of ancestor worship. Veneration of the dead and utilization of their powers had always been a magical and ritual means which could be manipulated by individuals and families for their own purposes. This aspect of religious life contrasted with the religious celebrations that could be held only by larger groups. The shift of religious life to the less ritualized ancestor worship also reflected the trend to individualization in this phase of Oceania's cultural history.

A further characteristic of this period was the custom of erecting more or less enduring memorials to important persons or events (war, peace, abundant harvests, eminent individuals, Feasts of Merit). Stone memorials include

menhirs (usually unsculptured), altars, dolmens, dissoliths, and honorific chairs, distinguished from ordinary seats by having backs. But the same purpose was often served by the erection of wooden posts or platforms, and by the setting aside of flower beds and certain trees. Over the centuries only parts of the stone memorials have been preserved, and as a result the megalithic aspect of this phase has been stressed. It must, however, be remembered that these stone works in southeastern Asia and Oceania have nothing in common with the megaliths of Europe and Asia Minor. At best there are typological similarities. The large stone monuments, which account for the term "megalith," are absent. The common feature of the New Guinean and Melanesian memorials just mentioned is not so much the stone material itself, but that all of them serve to commemorate important events or individuals.

The Age of Metals and Developed Stone Work (c. 200 B.C. on)

The next great epoch of Oceania's cultural history also began on the continent of southeastern Asia. The crucial development was at first not so much the spread of metalworking techniques as that of artificial irrigation in rice cultivation. Chronologically, this development coincided with the appearance of bronze casting and bronze art. Agriculture now became definitively an occupation of sedentary peoples: the same arable land could now be kept fertile for generations. Even though the setting up of irrigation systems requires extensive organization of labor, the systems themselves are easy to operate. Now each economic unit could produce, with relatively less labor power, a greater food supply than had ever been possible with the Neolithic system of farming. More labor power and more leisure time made possible further social differentiations, including the appearance of social groups that took no part in the production of food. Villages could now be set up permanently at a greater distance from the fields. More people could be integrated within a given economic unit, as enough man power was available to administer the enlarged community and to meet adequately its spiritual, artistic, and festival needs. This is the stage of stratified village societies.

The oldest extant account of artificial irrigation is in Chinese annals compiled in the first century B.C. Excavations carried out in northwestern Yunnan in the 1930s showed unmistakably the successive stages of transition from

the Neolithic settlements to the Metal Age and artificial irrigation. The best known sites with finds dating from this southeastern Asian Bronze Age include Dong s'on in Annam, after which the culture has been named. There are evidences of a highly developed culture with tribal organization, intensive social stratification, great artistic development, and strikingly warlike disposition. Numerous crops were cultivated, including rice and millet, and the water buffalo was the most important domesticated animal. Bronze and iron were worked, and not only utensils and ornaments but also tools and weapons were made of these metals. The finds at Dong s'on, however, are but a part of the material that has in the meantime become available.

From this cultural complex, then, which existed in South China and in the southeastern part of the Asian continent, essential features made their way to Indonesia. Since bronze and iron implements are always found together there, Van Heekeren has suggested that we should recognize an Indonesian Bronze-and-Iron Age. From the outset, in Indonesia, bronze had been a rare and highly valued metal, most of which had to be imported. For this reason we may assume that possession of metal implements and ornaments was a privilege of the ruling strata, while the rest of the population kept its Neolithic tools and utensils. Because of the scantiness of the raw material, broken or damaged pieces were melted and recast. Seen as a whole, however, the influence of decorative work with metals in Indonesia was considerably greater than the spread of metalworking techniques themselves. Bronze Age motifs and ornamental forms appear more frequently on stone and wood sculptures, in engravings on bamboo, coconut shells, and bones, as well as in paintings, than in metal objects. However, need for the costly metal gave rise to trade contacts that reached as far as China, so that not only did Bronze Age ornamentation become current and typical at this time but also formal motifs dating back to China's Chou dynasty were introduced.

This period of Indonesian cultural history was destined to be crucial for later developments. Investigation of this matter, however, is uncommonly difficult, because both Indonesian and Pacific cultural forms underwent further changes before European science began to study them around the middle of the nineteenth century. Moreover, these subsequent changes were of a very different character in Indonesia and in Oceania.

Around A.D. 500, the earliest states made their appearance in Indonesia

(under Hindu and Buddhist influences); in the middle of the sixteenth century, the energetic spread of Islam began; and in the middle of the seventeenth century, Europeans made their appearance. Traces of the Bronze Age phase of Indonesian history survived only in a few islands (e.g., on Nias, off Sumatra). Bronze Age Indonesia in the first half of the first millennium of our era played a central part in influencing the subsequent development of the Pacific cultures, but with important changes and shifts of emphasis. This time the main thrust of the expansion was not in the direction of the southeastern Pacific but followed the northern route through Micronesia toward Polynesia (for the Indonesian drift to New Guinea, see below, p. 37).

But the most important elements of Indonesian Bronze Age culture—metalwork, artificial irrigation of rice, the water buffalo—could not be exported to the Pacific islands and never went beyond Indonesia. Adaptation to living conditions on coral atolls and volcanic islands required an entirely different material equipment. In the middle of the nineteenth century, when Europeans came into contact with the Polynesian and Micronesian culture, its material equipment and methods of food production still resembled those of the original Neolithic settlers. But all observers noticed at once that the religions, the social order, and features of the representational art did not fit the usual Neolithic picture. In such connections, Polynesians and Micronesians showed a decidedly higher stage of development. And these were the very aspects of their culture that could have been conveyed from Indonesia to Oceania.

The classical division of society into nobles, commoners, and priests, which so clearly distinguishes the social structure of Micronesia and Polynesia from that prevalent in New Guinea and Melanesia, can be traced back to the Indonesian Bronze Age. For the sake of completeness, we must mention also a so-called fourth class of "outlaws," made up essentially of prisoners of war and debtors. In Indonesia, this new stratification of society had developed organically out of a more advanced economic organization. But in Micronesia and Polynesia, to which this new social structure was transplanted, we find a certain discrepancy between the simple material equipment and methods of food production on the one hand, and the highly developed social structure on the other. Needless to say, this complex stratification includes new socio-religious ranks, among which the most striking are the

34

master of the ground, the village founder, and occasionally the chieftain's speaker.

In this situation important chieftains inevitably began to hold court and build up a real system of patron-client relationships. Eventually, noble families cultivated the consciousness of their lineage and attempted to legitimate their claims to political power with lengthy pedigrees. Such genealogical lists are a particularly notable feature of Polynesian oral literature, and repeated attempts have been made to use them as frameworks for Polynesian history. Taking a generation as twenty-five years, some of these genealogies would seem to extend into the second half of the first millennium. Such a dating would be consistent with the hypothesis that the second phase of Micronesian-Polynesian history originated in the Indonesian Bronze Age. Nevertheless, it must be kept in mind that these lists refer only to the class of nobles, and do not cover Polynesian history as a whole; and they have no bearing at all upon the earlier Austro-Melanid phase.

Needless to say, the expanded village structure of Bronze Age Indonesia was not reproduced in Micronesia, nor in Polynesia. But the socio-religious nucleus of these villages—communal worship around a meeting place with honorific stone chairs closely associated with the village founder—occurs throughout Micronesia. In Polynesia, it is no longer the central part of the village, but a separate structure outside. In this connection it should be mentioned that terraced structures for worship dating from the late Neolithic epoch are found in central Java; they are strikingly similar to Polynesian religious areas, the *marae*. But the Polynesian structures are more complex, because they also preserve the tradition of altars, which goes back to the old Austro-Melanid phase. These old altars were in themselves sacred zones, whereas, in the later cultural phase, they always had to be erected anew on each occasion of communal celebration in the meeting places.

The religious aspect of this phase also reveals an origin in Bronze Age Indonesia. However, this matter has only begun to be investigated, and all we can give is a short outline of the problem it presents. In contrast to the Neolithic religion, now cosmogonic ideas come to the fore. Above the earth there are several skies, and beneath it there are many underworlds. Usually the number of the skies is equal to that of the underworlds; the number may be three, five, seven, or nine. The whole structure is held together by a world

axis, conceived of as a world mountain, a tree of life, or a heavenly tree. The principle of the world axis can also be personified, usually taking the form of a bisexual divinity. Indeed, the male-female dualism is extended far into secular reaches of the culture, so that whole classes of implements and modes of conduct are distinguished as "male" and "female."

The various elements of human culture, such as tools, crafts, agriculture, hunting, fishing, social structure, land ownership, spirits, birth, death, and so on, are correlated with divinities or groups of divinities, to some extent hierarchized and assigned to dominion over the various skies and underworlds. Preservation and continuing elaboration of these complex religious conceptions require a separate priestly class. The idea that important elements of human culture were stolen from the gods by a culture hero, or came into human possession through marriages with the gods, finds its most meaningful expression against such a background.

Ancestor worship, including solemn burial ceremonies and the idea of a realm of the dead, plays a prominent role. Characteristically, the burial ceremonies comprise several stages. The dead are buried at once, but within the individual tribal groups secondary burials take place on a more public scale at varying intervals. At a later stage, the dead of the preceding period are exhumed, their bones cleaned, and their souls solemnly and definitively bidden farewell. As a rule the bones are not reburied after the second ritual. Also associated with ancestor worship are the notion of the soul's perilous voyage to the realm of the dead on a boat, the role of the steersman and of the various messengers from the realm of the dead who come to fetch the newly departed, and the various tests the souls are put through before they are admitted to the realm of the dead. The older ancestor worship, which in the late Neolithic age developed a method whereby the individual might attain redemption, now has developed into a comprehensive ritual system encompassing entire groups. But whereas in the Neolithic epoch the ritual was primarily performed by kinship groups, this function is now taken over by political groups.

These fundamental religious ideas, which did not make their appearance in Indonesia until the Bronze Age, are combined by the various tribal groups into distinct, codified, more or less self-contained religious systems. Needless to say, these were not the fundamental ideas that were transferred as such to

Micronesia and Polynesia; only scattered remnants of long-past tribal religions reached the Pacific islands. In Micronesia, and above all in Polynesia, these mingled with the religious ideas of the earliest inhabitants, and it was only from this mingling that the peoples of the various archipelagoes developed religious systems of their own in the subsequent centuries. In this context, the isolation of the islands becomes apparent. There is no such thing as a common Polynesian or Micronesian religion. Whatever common features the present-day religious systems of these groups of islands disclose go back either to the Austro-Melanid center of influence in Melanesia or the Bronze Age center of influence in Indonesia.

The Bronze Age influences on Polynesia and Micronesia were due to the migration of large numbers of people in seaworthy craft (double boats) following the northern route. Whether their progress to, and among, the islands of Polynesia was planned or accidental is a question that will perhaps never be completely answered. But the fact that this Bronze Age immigration reached its peak early in the second millennium of our era is crucial. Subsequently, no great upheavals involving all Oceania took place prior to the coming of the Europeans. What we find, rather, is endogenous developments within the various island groups. Time and again sovereignties were formed which stretched over a whole archipelago and which sometimes even extended to neighboring archipelagoes. This last of the historical phases prior to the coming of the Europeans can still be traced in Polynesia and Micronesia.

Influences of Bronze Age Indonesia are also found in the southwestern Pacific, though the racial and linguistic groupings of the modern population of this region clearly show that these influences were not associated with any considerable new immigrations. Naturally, migrants repeatedly trickled in from Indonesia to the southwestern Pacific, but, as a whole, the Bronze Age influences here have the character of a sporadic stimulus diffusion. For this reason, the process is designated as the Indonesian drift. It lasted long after the Bronze Age proper in Indonesia.

The most marked evidences for this Indonesian drift are distributed heterogeneously: from the northwestern coast of New Guinea to Humboldt Bay and Lake Sentani; para-Micronesia and the Admiralty Islands; the central Sepik region of New Guinea; Matthew Island, northern New Ireland,

and the Hibernian Islands; southeastern New Guinea (the Massim region); southeastern Solomons, and the eastern part of southern Melanesia. The features of the Indonesian drift are certain traits of political organization, particularly the appearance of a nobility, certain mythical themes, and above all, certain art styles and a number of iconographic motifs. In the realm of technological equipment, the earmarks of the Indonesian drift include the heterogeneous diffusion of the loom as well as composite carpentry works in wood technique.

More recent investigations have shown that eastern Micronesia must probably be regarded as a secondary center, which has, in recent times, had a special influence along the eastern fringe of Melanesia to New Caledonia, and on the Fiji Islands of western Polynesia. In any event, it seems possible that, before the coming of the Europeans, southern Melanesia and western Polynesia were for a time closely associated politically.

BASIC
ART
TRADITIONS

Though this book deals primarily with stone and wood sculpture, not with the whole range of Oceanic art, we must mention a few problems that bear upon the art aspect of human culture. Our introductory remarks will attempt, following the outline of the basic cultural traditions, to explain or at least to mention the historically ascertainable stylistic and iconographic traditions.

Within these traditions, both superior and inferior works occur. From the aesthetic point of view, there are in all cultures masterpieces whose formal qualities can be compared with one another. Such a comparison would contribute to an aesthetic of forms and make use of phenomenological arguments. At the risk of being too factual, we shall describe formal qualities only when the uninitiated viewer's attention must be directed to particularly subtle details. Where appropriate, this will be done in discussing individual works reproduced in this book.

Turning now to purely art-historical considerations, we must carefully distinguish three aspects of any work of art: style, iconographic motif, and function. In Oceania, these three aspects did not spread uniformly in space and time, but at different developmental tempos.

Style is the totality of the formal means employed to represent a given

motif. A given motif can be executed in very different styles, and conversely, genuine stylistic differences can be discerned most readily in treatments of the same motif. The difference between style and motif is perhaps most strikingly illustrated by the native artist at a mission station who carves a crucifix for his church. The motif he treats is an element of the youngest historical tradition in Oceania, the European. But the figure of Jesus on the Cross will show facial features, and occasionally even a bodily attitude, for the portrayal of which autochthonous formal means were employed. This example also illustrates the fact that stylistic means and motifs do not always change concurrently. The stylistic means are the aspect of art least integrated with the rest of a given culture; they are, so to speak, the independent essential core of art as a phenomenon. But they must not be looked upon as comprising the whole of the phenomenon.

In the history of European art we can determine the style of an artist, of an artistic group, or even of a whole epoch, because the majority of works are reliably dated. The art historian is confronted with an entirely different situation in Oceania. Almost all the works are of practically the same period, having been produced within the last two, or at most three, generations. Only a very few can be shown to have been produced early in the nineteenth century; archaeological excavations have so far yielded a few stone sculptures, but no wood carving, of earlier times. However, the sculptures we possess certainly show stylistic traditions and iconographic motifs dating from different periods. The historian of Oceanic art has only one path open to him. He must try to assign stylistic traditions and iconographic motifs to basic cultural traditions or to particular cultural domains.

To this end, several aspects of what we call style must be carefully distinguished in each motif treated. We shall briefly discuss three of these aspects: number and arrangement of representational essentials, their formal execution, and interplay between front and profile views. Naturally there are also other aspects, such as the relative size of the rendering, degree of distortion in the proportions, and so on.

The simplest example is the motif of the human face. Its complete portrayal includes a number of representational essentials—nose, mouth, eyes, forehead, chin, ears, facial contour, facial surface. To begin with, number and arrangement of representational essentials may vary. A face can be drawn

without ears or nose. The eyes may be set on the forehead or the nose moved to the position of the ears. In fact, the representational essentials of a motif may be rearranged in any manner, and "communication" between them restored, so that the result is a kind of artistic secret code. This kind of treatment is not unknown in Oceania. In addition, the formal execution of the representational essentials may vary independently of the variations in number and arrangement. For instance, the eyes can be made circular, oval, or rhomboid; the nose can be carved straight or curved; and the mouth can be a horizontal line or a "smiling" semicircle.

The interplay between frontal and profile views is an extraordinarily important stylistic device in Oceanic art. A motif executed in frontal view in one cultural domain frequently reappears in another domain, but this time in profile. Famous examples are certain carvings of the Maoris in New Zealand and the natives of the upper Korewori River in the Sepik district of New Guinea. Recognition of this stylistic device often reveals relationships that would otherwise remain obscure.

The term "iconographic motif" denotes more or less figurative combinations: for instance, kneeling women, nudes, male figures in various postures, animals in characteristic poses, and so on. Most of these iconographic motifs are, or were originally, related to the socio-religious systems of the basic cultural traditions or of individual societies. However, the possibility cannot be excluded that motifs exist without any special religious meaning, above all, in the decoration of surfaces. Moreover, it may be assumed that when first created, the meaning of such motifs and their social function were identical, though in the course of their historical existence, form and function have taken divergent paths. In fact, form has a life of its own, so that it may eventually not only lose its original meaning but assume an entirely new function.

Art-historical studies often deal exclusively with the diffusion of motifs, without going into their original or present significance, let alone their function. This approach is based on a methodologically correct axiom, yet its limitations should be kept in mind. A formal comparison between iconographic motifs is meaningful only within well-defined cultural traditions. To take an example, the Gorgon motif (human face with protruding tongue) certainly derives from quite different sources in three areas where it occurs: Africa,

Oceania, and America. It would be erroneous on the basis of this motif alone to infer the existence of contacts between these three parts of the world.

An additional difficulty confronts the historian in Oceania. On the basis of purely formal analysis, it is frequently impossible to decide if we are dealing with human or animal features. The artists of Oceania display extraordinary imagination and sure taste in combining several motifs in a single work representing, for instance, a bird-man or a pig-man, or a fish-man or some other amalgam. Even when they portray an animal, it is often impossible to decide if it is a dog, a marsupial, or a praying mantis, to name only a few of the possibilities. In such cases it is indispensable to refer to the content; formal analysis alone is not enough.

Another example drawn from the mission station will serve to illustrate the difference between the iconographic motif and its function. In New Guinea, especially, we often find Christian churches with wood carvings of two life-size human figures on the main portal. In stylistic treatment, they recall the old culture. Formerly, such figures usually represented key divinities who were worshiped and had sacrifices offered them; in the Christian churches their function is purely decorative.

No inventory of the most important iconographic motifs in Oceanic art has as yet been drawn up, and we know very little about the changes in function they have undergone. Such changes take place within the various tribes and villages and show an incredible range of variation, so that in a book intended merely as a survey of Oceanic art, this subject cannot be discussed at all, even if the sources made it possible to do so. But what can be carried out is the assignment of the most important stylistic features and iconographic motifs to the basic cultural traditions.

STYLE TRADITIONS As we have said, genuine stylistic differences can and should be traced only with reference to the same motif. In Oceanic art we can avail ourselves of a particularly promising one: the portrayal of the human body (even though face and body may to some extent be treated separately). Apart from the fact that this motif is found everywhere in Oceania, it has two other advantages. First, every viewer is familiar with the naturalistic model. Second, in this stylistic analysis, we may omit references to content. A human figure may,

first of all, be looked upon as a purely representational motif. Naturally, it is also an iconographic motif, but this will be discussed in the next section, where certain postures and accessories which can be disregarded in stylistic analysis will be dealt with.

In determining the fundamental style characteristics assignable to any one basic cultural tradition, we must take into account the two aspects of style: first, the number and arrangement of representational essentials, and second, their formal execution. The artistic traditions we note in recent works of art in Oceania go back at least three thousand years. This being the case, features pertaining to full treatment of the human figure can be given only for the newest traditions. For the older traditions, only individual features can be indicated, which taken in themselves would never make up the complete human figure. We must resign ourselves to this limitation, for the available sources permit no fuller account.

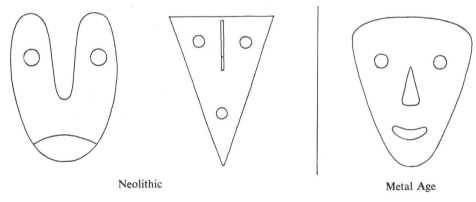

Neolithic Metal Age

FIGURE 1.

BASIC FACE TYPES

We can first indicate one essential difference which, I believe, separates the Neolithic portrayal of the human face from the Bronze Age one. The Oceanic Neolithic face in its pure form always shows the nose firmly connected with the lower edge of the forehead. For this reason the surface of the face proper extends only from the edge of the forehead downward. In contrast, in the Bronze Age faces, the connection between the nose and the lower edge of the forehead disappears. Nose and forehead are now alike parts of the rest of the face (figure 1). Moreover, the tendency appears to treat the individual parts of the face more realistically. Naturally, transitions of every kind are to be found in recent works. However, as will be shown later, we are dealing here with fundamentally different compositional principles.

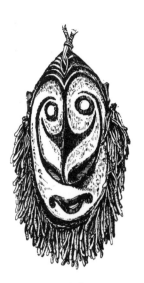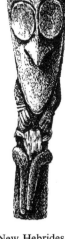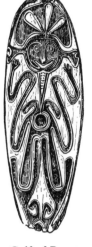

FIGURE 2.

BASIC STYLE OF THE MELANID

NEOLITHIC TRADITION

Sepik River New Hebrides Gulf of Papua

Any attempt to define the basic style of the Neolithic Melanid meets with the greatest difficulties, of course, for we are dealing with the oldest tradition in Oceania. In a general sense, the term "curved style," introduced by Felix Speiser,* may be applied to this tradition. It is primarily described by a negative feature: straight lines are almost entirely absent. Moreover, we get the impression that the artists were painters rather than sculptors. In fact, the curved style achieves its best results in such two-dimensional works as painted surfaces, and in carvings in relief.

A few facial features can readily be used for characterization (figure 2). The nose and lower edge of the forehead form a coherent unit: this line swings up from the bridge of the nose to the left and the right above the eyes, and is extended to form a complete outline of the face, so that the nose, the lower edge of the forehead, and the shape of the face constitute one uninterrupted, beautiful curve. The eyes are usually circular in shape, and the mouth is set very low, so that it is possible to speak of a chinless face.

No reliable indications can be given concerning the formal execution of the body. It seems that in carving wood, the artists began with a round piece and worked it as though in relief. This stylistic tradition has been particularly well preserved in recent art from the Gulf of Papua in southeastern New Guinea.

* "Über Kunststile in Melanesien," *Zeitschrift für Ethnologie*, LXVIII (1936), pp. 304–69.

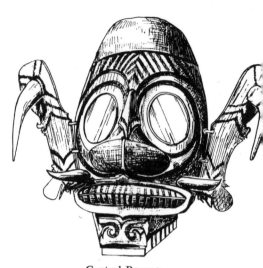

Central Borneo

It is possible to be somewhat more specific about the basic style of the Neolithic Mongoloids (speakers of southern Austronesian tongues). The artists obviously worked with more square-cut balks of wood. The whole human figure is represented standing. The strong stress on the vertical is interrupted by three strongly indicated horizontal divisions—at the feet, at the hips, and at the shoulders. These divisions extend laterally beyond the rest of the figure. The arms hang straight down from the shoulders, so that the hands just reach the lateral extension of the hips and are frequently represented in relief on them. At the elbows, the arms are bent slightly backward; the legs begin at the hips and are distinctly bent forward at the knees. The feet are usually in relief on the block which forms a pedestal.

The treatment of the head is very characteristic. It is usually massive and set directly on the shoulders, without any neck, while the face hangs down, straight and boardlike, over the chest. The point of the chin is thus situated at the collar bone; viewed frontally, this type of face gives the impression that shoulders are on a level with the ears. No less typical is the treatment of the facial features. The nose and the lower edge of the forehead form a unit, at right angles to each other; the shape of the face is an emphatic inverted triangle, with its apex at the chin, and the eyes and mouth are circular. The facial plane recedes sharply right under the forehead, so that the nose, the eyes, and the mouth form ridges with perpendicular surfaces. Viewed from the side, the result of this treatment is an unmistakable silhouette, which the various cultural domains developed in their own ways as a leitmotif (figure 3).

This style can be observed in a relatively pure form in works of recent date originating on the northeastern coast of New Guinea (Astrolabe Bay, Tami Island) and on some of the easternmost islands of Melanesia. As the

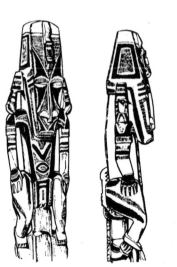
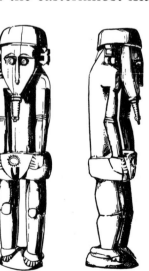
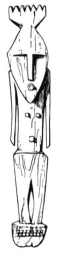

Huon Gulf Astrolabe Bay Mortlock Islands

FIGURE 3.

BASIC STYLE OF THE MONGOLOID

NEOLITHIC TRADITION

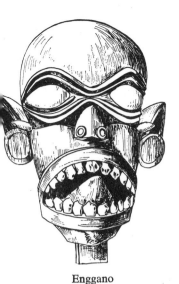
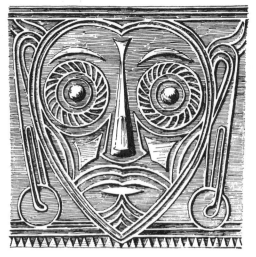
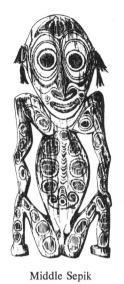
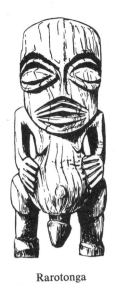
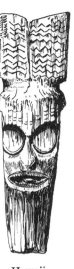
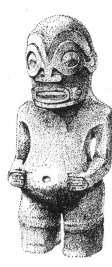

| Enggano | Bali | Middle Sepik | Rarotonga | Hawaii | Marquesas |

FIGURE 4.

FACE TYPE OF

BRONZE AGE TRADITION

basic style of the early Austronesian-speaking immigrants, this version of the human figure is of extraordinary importance in Oceanic art; few Oceanic representations of the human figure have not been influenced by it. Paul Wingert was clearly correct in placing particular emphasis on it.* Essential characteristics of this basic style are also found in northern Asia: even the briefest glance at certain wood *ongon* figures made by Siberian tribes confirms this. The cultural-historical importance of this observation cannot be discussed here in greater detail, but it deserves separate treatment.**

The basic style of the Bronze Age tradition similarly breaks down into two aspects. I shall deal first with one type of treatment of the face that belongs to this earlier historical phase. Nose, eyes, mouth, forehead, and chin are all kept within a clearly recognizable facial contour. Characteristic are the oversized saucer-shaped eyes (figure 4). Such faces appear on bronze implements from Indonesia (ceremonial axes, drums), and the influence of this stylistic feature is found on Enggano (off Sumatra), in central Borneo, and in Polynesia, from the Marquesas to Hawaii—in other words, along the northern migration route. But it also occurs in the region of the Indonesian drift: in the climax area of the central Sepik River district and on some islands of the New Hebrides.

* "Human Forms in the Art of Melanesia," *Records of the Auckland Institute and Museum*, IV, 3 (1952), pp. 145–52.

** Credit goes to Hans Damm for having first pointed out the extra-Oceanic parallels with this stylistic form. See H. Damm, "Sakrale Holzfiguren von den Nordwestpolynesischen Randinseln," *Jahrbuch des Museums für Völkerkunde zu Leipzig*, X (1952), pp. 74–87.

45

Another group of stylistic features, also dating from the Bronze Age, pertains to the portrayal of the whole figure. The formal execution clearly discloses the most important features of the basic Neolithic Mongoloid style. The legs are fully rendered, knees protruding forward, and the arms hang straight down .But the head is set on a clearly indicated neck. The bottom of the lower jaw is emphatically horizontal, the facial area recedes at an angle, and frequently the whole head has an oval shape above the point of the chin (figure 5). It seems as though less importance is attached to the portrayal of the face: in most cases, the representational essentials are merely engraved on the facial surface. The influence of this style is found in Micronesia and in Polynesia as far as Mangareva (in the Gambier Islands) and Easter Island. It is also found in the region influenced by the Indonesian drift—at several points in New Guinea (e.g., the *korwar* figures of Geelvink Bay, the sculpture from Lake Sentani, the central Sepik River, and the southeastern tip of the island). It also occurs in the Admiralty Islands, northern New Ireland, and the Hibernian Islands, in the Solomon Islands down to New Caledonia, and quite recognizably in the Fijis.*

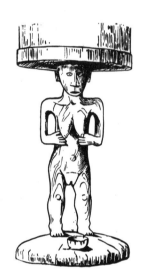

Tanimbar

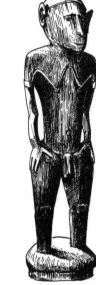

Lake Sentani

ICONOGRAPHIC MOTIFS

The content of iconographic motifs is determined by the socio-religious system. Ideally, it should be possible to distinguish between the motifs reflecting basic cultural traditions and those reflecting individual societies. The former would be characterized by the great breadth of their diffusion, whereas the latter would scarcely be encountered beyond the zone of influence of the society in which they originated. Art-historical investigation in Oceania still has a long way to go before we can be so definite. Studies of the interrelations of religion, society, and art in Oceania not only have barely begun, but considering the nature of the available sources it is doubtful if it will ever be possible to carry them out in every cultural domain. The problems have only begun to be attacked, and here I must confine myself to a few summary remarks.

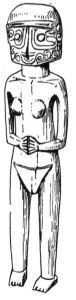

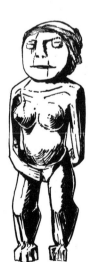

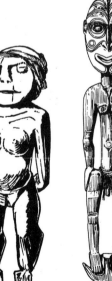

Massim Area Fiji Middle S

* Once more, it was Hans Damm who first pointed out these stylistic features; he associated their occurrence in eastern Melanesia with an influence originating in Micronesia. But they are obviously far more widespread and date from the Bronze Age phase of Oceanic art. See H. Damm, *ibid.*

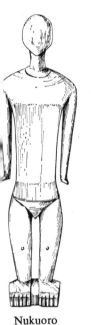

Nukuoro

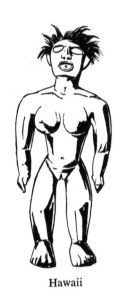

Hawaii

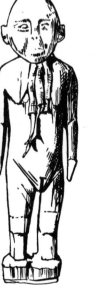

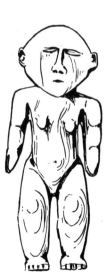

lortlock Islands

Tonga

If iconographic motifs are interpreted as pictorial compositions intended to portray an idea that is part of the socio-religious system, their execution presupposes a relatively high development of carving techniques. In my opinion, this stage was not reached until the late Neolithic era and Bronze Age. The majority of iconographic motifs in recent Oceanic art originated at that time, while great skill in treating such iconographic motifs developed only long after their invention.

Let us for a moment keep to the example of the human figure. The formal execution as such is a pure, so to speak, neutral representational motif. However, once it is intended to convey details of the socio-religious system—and only with this does it become an iconographic motif—it is done through assigning particular postures to the body, and by adding various accessories. In the early Neolithic age such compositions were produced by attaching the accessories more or less as natural objects to the neutral human figure.

The technique is clearly recognizable, for example, in the costume of a *Dema*-spirit actor among the Marind-Anim tribe of southwestern New Guinea. The culture of these groups was barely affected by later historical traditions. Wood carving was poorly developed. The dancer hung on his body the accessories characterizing the type of spirit he wanted to represent. These usually were palm leaves, painted or studded with various fruit seeds. In this way, a costume was produced, with parts which were not logically co-ordinated; it must be interpreted as an additive representation of all the desired characteristics. In the early Neolithic period neutral human figures, carved in wood, were characterized in a similar way. They became iconographic motifs purely through being decked out with accessories. In my opinion, fully carved treatment of such compositions, involving a certain necessary artistic abridgment, is a late development in the art of Oceania.

Finally, I must once again point out that stylistic features and iconographic motifs do not have a parallel historical development. We must keep in mind that newer iconographic motifs may be represented with the aid of older stylistic features; conversely, older motifs may be represented with the aid of newer stylistic features. The magnificent figures from the Yuat River area in the Sepik district of New Guinea (plate 94) represent a divinity belonging to the socio-religious system of the Neolithic Melanid tradition, but their essential stylistic features belong to the Neolithic Mongoloid tradition.

The *korwar* figures produced in the Geelvink Bay area in northwestern New Guinea belong to the socio-religious system of the Indonesian drift. Similarly, with respect to formal execution, the posture of the bodies is a Bronze Age stylistic feature—but the faces belong recognizably to the older Neolithic Mongoloid tradition (figures 3, 4). Such observations are intended merely to show that it would be false to base cultural-historical investigations in Oceania on the morphological description of individual works of art. Recent works are traceable to the most various traditions. The foremost task of art-historical investigation is not to present the exotically fascinating and absolutely beautiful, but soberly to analyze the many lines of development combined in recent works of art, which have frequently given rise to outstanding, unique achievements.

If, all these reservations notwithstanding, I venture to place a few iconographic motifs historically, I do so only with motifs related to the socio-religious system of the basic cultural traditions. Now, socio-religious institutions are subject to change. We cannot expect all older cultural institutions to have been preserved intact over more than three thousand years of history. Just as both old and new traditions are recognizable in recent works of art, so both old and new institutions recur in latter-day socio-religious systems.

A central feature of the Melanid socio-religious system showed remarkable powers of survival: ritual cannibalism and head-hunting. These practices were justified and sanctioned by the basic religious ideas of the Melanids concerning the origin of man (see above, pp. 29–30). It will be remembered that the primordial man-eating giant who played a crucial part in this was killed by twins and eaten. This was, in a sense, the first cannibalistic communal feast in this world, the model for all later ones. Now, it seems that this primeval giant is far more frequently represented in art than any other figure from the creation myths of the Neolithic Melanids, either in his primary aspect or his secondary aspects as god of war and of hunting. His appearance is described in great detail in numerous myths. A number of iconographic motifs in portrayals of the human figure must go back to this early context, because they correspond exactly with descriptions in the myths.

The most important of these motifs is that of the protruding tongue (or Gorgon motif), another the position of hands lying across the belly. The

myths always mention that the giant inserted boars' tusks in his jaws, the better to tear his victims. The Oceanic iconographic motif of tusks sticking out of the corners of the mouth goes back to this, and has nothing to do, as might be surmised, with a faintly remembered representation of a feline.

With the present state of our knowledge one is unable to list the motifs that can safely be assigned to the socio-religious system of the Neolithic Mongoloids. It seems possible that, in the course of the long process that produced the Austro-Melanid peoples and culture, certain Melanid iconographic motifs remained dominant, while at the same time the Mongoloid style asserted itself. Future research may clarify further details. Apart from this, we find in individual cultural domains a limited number of secondary motifs which are incontestably related to the Mongoloid socio-religious system. Thus, in the Astrolabe Bay region of northeastern New Guinea, some female figures in the typical Mongoloid style have a diamond motif incised above the *mons Veneris*. This motif goes back to an important phase of the central creation myths of this tradition. One of the two culture heroes discovers his wife's adultery by finding a new tattoo on her *mons Veneris*. Along the northern coast of New Guinea at least one of the two culture heroes is always portrayed in the classical style of the Mongoloid tradition. The ornament that dangles out of the mouth of dancing figures (not to be confused with the protruding tongue) must also belong to this tradition. In addition, I would include the comb, set across the head, which occurs occasionally.

However, the majority of the iconographic motifs in recent Oceanic art belong, as might be expected, to the context of Bronze Age influences. As the most important of these, I would first mention the squatting posture, with arms or elbows resting on the knees. The hands are placed under the chin or against the sides of the head. One of the oldest examples of this motif in Oceania occurs on the famous disc-shaped bronze ceremonial axes from Roti, in eastern Indonesia. Other motifs which belong to this newer tradition are female figures kneeling; female figures with a child in the lap, on the head, or on the shoulders; with one or both hands touching the breasts; with one or both hands touching the vulva; and with legs grotesquely spread apart. In the present state of our knowledge, the content of these motifs cannot be reliably established, but it is striking that all involve female figures.

In conclusion I wish once again to recall that in the history of Oceanic art the ability to carve large compositions could have developed only under Bronze Age influences. It is in Melanesia, where other Bronze Age influences are felt, that the high points of wood carving are always found—on the northwestern coast of New Guinea, in the Sepik district, in the *malanggan* carvings of northern New Ireland, in southeastern New Guinea, and in the Solomons, as well as in Hawaii, on Easter Island, and, of course, also among the New Zealand Maoris. Pictorial compositions related to the socio-religious background are not only of high artistic quality but at the same time achieve unsurpassed clarity and plasticity.

In this late phase of Oceanic art we also find secular genre scenes. Individual figures from the Admiralty Islands, like some of the spatulas from the Massim region in southeastern New Guinea, achieve astonishing realism (not naturalism). To this phase also belong the relief-like carved house beams on which lengthy stories are represented. Traces of this form of expression are found from Celebes Island to the Palau group and the Admiralty Islands, but it does not seem to extend farther into the Pacific.

With this we conclude our introduction. We have tried to give a survey of how one part of the world's art history became what it is. No one will suppose that we have adequately covered the subject in this brief summary, but such a summary provides the background necessary for an adequate viewing of these works of art. Contemplation and enjoyment of art are not always fed from the same rational and emotional sources. And if we have to choose between the beautiful and the exotic, Europeans and Americans only too often succumb to the temptation to find the exotic beautiful as such. If these remarks have succeeded in discouraging this charming error of the enthusiasts, we shall have achieved an important goal.

NEW GUINEA

THE NORTHWEST COAST

IN the fifteenth century, the coastal regions and islands of northwest New Guinea fell under the rule of the sultan of Tidore, a small island west of Halmahera, in the Moluccas. Meantime, the inhabitants of Biak, an island in New Guinea's Geelvink Bay, made repeated raids upon the Moluccas. Not surprisingly, then, the population of northwest New Guinea must be considered as falling within the sphere of Indonesian influence (the Moluccas being the easternmost part of the far-flung Indonesian culture, which, as we have seen, had a metalworking tradition combined with Islamic features).

Agriculture in the inland regions, fishing, and highly specialized handicrafts characterized the culture of this part of New Guinea. The people were not only outstanding wood carvers and boat builders, but also capable navigators. Their social order shows clearly that a nobility and a priestly class were in the process of formation. These traits do not occur, or at least are not so clearly defined, in any other area of New Guinea.

This culture area is characterized by the so-called *korwar* figures which are found only here. Consequently, the art of the northwest coast of New Guinea has sometimes been generically designated as the "*korwar* style." The typical objects are wooden figures, with oversized heads and small bodies, shown either standing or crouching. They were supposed to be the dwelling places of the souls of distinguished ancestors. In some, the head was hollowed and the ancestor's skull placed inside (plates 3, 4).

The relation of the head's proportions to the torso, the horizontally jutting chin, and the crouching position with arms on knees, all belong to the Metal Age stylistic tradition. The flat treatment of the face, however, points to an older tradition. The dominant facial element is the nose which hangs perpendicularly, a relief band, from the edge of the forehead; the flared nostrils, turned slightly upward, form an anchor-shaped nose. As a rule, the eyes are small and circular. The face is a trapezoid, and the mouth extends the entire width of the chin. Many *korwar* figures hold a shield, and occasionally the chin rests on it (plate 3). The shield is executed in openwork technique with scroll motifs and double spirals. The contrast between the stiff, angular face and the elegant curves of the openwork carving accounts for the special charm of this style. This art is a local development, though attempts have been made to show that a "*korwar* style" extended throughout the Oceanic region. This has merely confused the art-historical problem,

which is rather one of noting instances where individual features of this local style appear in other areas.

Among the finest achievements of the style are the openwork carvings used as canoe prows (plate 1); the double spiral, here reduced to a simple S form, fills the ornamental surface in endless repetitions. These magnificent pieces decorated the war boats which penetrated into the Moluccas.

The same technique was used on some headrests; the example reproduced here (plate 5) is particularly elegant. In addition to the technical skill involved, one must admire the taste with which the motifs were adapted to the surface to be decorated. On this score, the Geelvink Bay artists are surpassed only by the Maori artists of New Zealand.

A rare example of the art of this stylistic area is the figure from Manokwari (plate 2). Such standing human figures with outspread arms occur in eastern Indonesia; here, however, the sculpture is topped with a head the face of which might be called the epitome of the *korwar* style. Cassowary feathers, stuck in the wood, form a radially protruding spray of hair. But the most noteworthy feature of this work is the turtle which is held by the figure. This, no doubt, is a religious iconographic motif, though of obscure significance.

The rare headrest (plate 6), apparently showing a dog, may actually be one of the representations of animals often found in the possession of priests and sorcerers, for whom they are vehicles of magical power.

THE
NORTH
COAST:

Lake Sentani
and Humboldt Bay

Evidences of Indonesian cultural influence dating from the metalworking period are perceptible along the northern coast of New Guinea to Lake Sentani and Humboldt Bay: farther east, they become scantier. Ancient bronze axes that belong unmistakably to the technical and stylistic tradition of the southern Asian Bronze Age have been found around Lake Sentani.

However, the culture of the inhabitants of this region does not differ, as far as its economic aspects are concerned, from the other cultures of the northern coast of New Guinea. The people cultivated the forests or the grassland and gathered sago. Their settlements, for the most part, consisted of pile houses built in the shallow waters of the lakes and the bay. The houses were linked to one another by footbridges which, at the end of the village overlooking

open water, formed a sort of communal veranda. A conspicuous feature was the high, conical roofs of the round or polygonal temples—surely elements of more recent cultural influences. They are to be found as far inland as the eastern shore of Lake Sentani. Inside these temples, directly under the opening in the roof, were fixed round discs with incised curvilinear ornamentation; these have been interpreted as solar symbols (colorplate 1).

The inhabitants of villages on the eastern shore of Lake Sentani, to whom most of the works reproduced here once belonged, believe that they descended from the sky to earth in a mythical prehistoric age. As they came down, they either landed on aerial roots of the *waringhi* tree, or jumped through a hole in the sky directly down to the earth. For a long time they lived among flowers and shrubs and fed on clay or earth. Subsequently, birds brought them the seeds of many fruit trees, and an old woman finally taught them the cultivation of sago and the coconut palm, and the art of house building.

In social order, the strongly developed institution of the chief class (*ondoforo*) is noteworthy. The office is patrilineal; thus important chieftains have their positions buttressed by their ability to prove that they come from a long line of chieftains. Their prominent position was formerly matched by the splendor of their houses; their verandas served as village meeting places for both political and ceremonial occasions. The most important of the large wood carvings from this area, now in museums, were taken from these *ondoforo* houses. The pillars are particularly impressive. They were made by uprooting whole trees, trimming off the upper branches, and then placing the trunks in the ground upside down, roots in the air. Between every two such upended trees, hewn beams or planks were placed; spaces in the walls thus formed were decorated with incised ornamentation and openwork carving. Such incised decoration usually consists of variations on the double spiral; the carvings often reproduce lizards, disposed one next to the other in profile.

Human figures in the round were only rarely carved out of the trunk itself (plate 8); the stylistic features of this figure are like those of freestanding human sculptures (plates 9, 10). These were either placed inside the houses against the house posts or served to decorate bridges and piers in the village. Such figures should not, any more than the figures carved on the house posts,

be regarded as ancestor images; their function was purely ornamental.

One of the most noteworthy sculptures of this series is the female figure holding a child (plate 10). Nothing definite is known about the significance of this iconographic motif, which occurs frequently on the northern coast. In this case, the figure is reproduced in profile view, since in this way the fine balance of the lines is better appreciated; but there can be no doubt that originally the artists conceived all such figures frontally. Only when we confront them, so to speak, do we grasp the heraldic rigidity of their nature.

Among the larger wood carvings are a few decorated roof ornaments; the specimen illustrated here shows a cassowary pulling a man (plate 12). We presume that such carvings projected at the corners of the houses reserved for young men. If so, their artistic quality is all the more admirable; frontal rigidity, such as characterizes the vertical house carvings, would have been possible here, but would have appeared clumsy in the different architectural context. With sure taste, the artists matched their conceptions to the horizontal rhythm of this part of the architecture. Profile drawing demands concentration on essentials. The creative process in this case was surely very different from that in the case of the vertical figures with their robust expression.

In the incised ornamentation, variants of the double spiral recur as the most frequent pattern, a particularly impressive example being the bowl (plate 11). Here we discover faint echoes of still another element in the Metal Age stylistic tradition. The whole surface is divided into regular ornamental fields—in this case, horizontal bands. The design is executed quite clumsily, in contrast to similar objects from other archipelagoes in Oceania.*

THE NORTH COAST: *From Humboldt Bay to Astrolabe Bay*

The population of the north Coast of New Guinea exhibits a uniform cultural pattern. Small farming on the slopes of the coastal mountains and deep-sea fishing are the most important methods of procuring food. There is usually intensive trade between the coastal villages and those of the jungle interior. The products of the two natural environments supplement each oth-

* But see the reproductions from the Admiralty Islands, plate 160, and from the Marquesas, plate 252.

er well, so that the natives have a stimulus to produce a surplus over and above their own needs for trading. Certain coastal villages gradually came to specialize in the production of specific objects—pottery, boats, ceremonial houses, utensils made of wood or shell.

While most trade with the interior was channeled through a few centers conveniently located for the purpose, a brisk trade was also carried on up and down the coast in splendid big outrigger canoes. This maritime traffic attained surprising volume, and had the effect of blurring to a considerable extent the original differences in cultural equipment peculiar to each locality. This is particularly apparent in the linguistic composition of the population. Groups of villages speaking Austronesian dialects alternate with others speaking non-Austronesian dialects, in no regular pattern. Certain dialects reach far inland, while others are confined to a narrow coastal strip. It is interesting that the many small, and mostly volcanic, islands off this coast show a particular susceptibility to the more recent cultural influences. These tiny islands must always have served as bases where products of the various localities were accumulated and from which they were redistributed.

The intensity of artistic activity in this area is astonishing. Very few objects were not affected by it. In some villages the wood carver's art attained a mastery that can arouse nothing but admiration. It is represented in every village, moreover, and even inferior works belong to the same stylistic tradition. The most noteworthy decorated objects include parts of the ceremonial houses (ridge poles and ladders), prow ornaments and other carved parts of the big canoes, figures of various sizes, slit gongs and hourglass-shaped hand drums, masks, headrests, mortars and pestles, spoons, small bowls for grinding betel nuts, and spear shafts and ax handles. Unlike those of the two cultural areas discussed above, the stylistic features indicate a predominance of the Neolithic-Austronesian tradition; the features of the Metal Age tradition are somewhat less marked. There is no doubt that more recent tradition was diffused evenly along the northern coast, but in mingling with the older tradition it proved less vigorous than it did to the west.

Some of the masks served as house ornaments (plates 14, 15); others were worn by dancers on ceremonial occasions (plates 16–19). The latter are often recognizable by the perforations along the edge by which the mask was fastened to the fiber costumes. Such a mask covered the dancer's face only,

while a cloak made of fibers concealed his body. Three stylistic types are roughly distinguishable. In some masks (plates 14, 15), we note the heart-shaped and figure-eight-shaped eye area, pointing upward and outward. The nose, starting just between the eyeholes, does not lie flat on the face but flares out in front of it. The mouth is small and much less emphatically stressed than the eyes and nose. In a second type (plates 17–19), the Neolithic-Austronesian features are more distinct. The lower edge of the forehead is usually a straight line, and directly below it the face recedes sharply. The eyes are set either upon the facial surface or upon the slope of the brow itself (plate 19). In the former case, the eyes look straight ahead; in the latter, downward. The nose traces a downward curve in front of the facial surface. Only in one example (plate 17), does the tip of the nose touch the facial surface. Another (plate 19) shows that the artist modeled the nose on a bird's beak (usually that of the cassowary). The mouth is tiny. The inhabitants of this area classified their masks, which as a rule represented bush spirits, according to the form of the nose. A notable feature is the carved nasal ornament, a naturalistic reproduction of the shell rings that the inhabitants of these villages wore in their noses, which were pierced for the purpose.

Three examples of the many large figures are reproduced here. A relatively rare iconographic motif (plate 21) shows a kneeling woman and child. Both figures are vertical and viewed frontally. The intention was not naturalistic; the kneeling positions of mother and child might rather be called unnatural. Two other figures (plates 20, 22) belong to the Neolithic-Austronesian stylistic tradition, as is clearly shown by the attitude of the body and the position of the head. Though both belong to the same stylistic tradition, the figure from the Murik Lagoon (plate 20) is incontestably superior artistically. The face is framed by a beard of woven human hair. The sharply accentuated shoulders are covered with engravings, which give the figure a heraldic appearance.

Among the most attractive creations are countless amulet figurines, rarely more than a few inches high. Men either carried them in net bags or wore them fastened to their belts (plates 23–25). The nose is elongated and often gives the impression that its tip is connected with the penis. But on closer inspection it appears that this is not the case; the penis is separate from the tip of the nose, which curls back toward the body. The nose and penis are linked in a very few cases only (though in the majority of those

shown here), and it would be mistaken to assume a sexual symbolism that does not, in fact, exist.

The numerous wooden pounders from the northern coast have handles shaped as faces, and frequently also as human figures. The facial type in all these implements, not only the three reproduced here (plates 28–30), belongs to the Neolithic-Austronesian tradition. Most noteworthy is the pounder from Seleo showing a four-legged animal with a human face.

The headrests were household objects, and a theme on which the artists of Oceania played innumerable variations. Their original significance is still obscure. It is surely mistaken to think them due only to the elaborate coiffures of the people. Some of them, at least, must have been thought to possess magical powers; men slept on them—particularly on nights before major communal undertakings—to endow themselves with unusual potency and thus increase their chances of success. There are two forms: those carved from a single block of wood (plate 31), and those in which the rest itself was carved wood but had rattan supports (plates 32, 33). The latter type (in specimens from the northern coast) often shows a human figure at either end, usually male and female, facing each other. The example of the first type (plate 31), has two crocodile heads that point in opposite directions and a fish on the base. This combination must certainly have originated in a place where the river empties into the sea.

Villages situated in inlets along the lower Sepik and the Ramu rivers produced the finest works of this particular area (plates 37–40). Here the stylistic features of the recent traditions assert themselves most strongly. Both the slit gong (plate 37) and the large hand drum (plate 38) are noteworthy for the carefully balanced distribution of their incised ornamentation, elegantly adjusted to the sculptural forms. The design areas are divided into fields in which double spirals and wavy lines suggesting clouds predominate; the handles of the slit gong once again show the same type of male and female human figures facing each other.

Two rare objects include a very old ceremonial adze with numerous interlocking iconographic motifs (plate 40) and a mythological group (plate 39). The adze shows a lizard biting a human face, while on the angle of the handle is a crouching human figure whose mouth is in the form of a bird's beak. The mythological group is one of only two specimens known. (This

example shown is in Basel; the other is in the Field Museum, Chicago.) It is of special interest. The arrangement and execution of the figures exemplify the more recent stylistic influences. The sea eagle, pig, and "twins" are, however, prominent figures in the myths of the oldest known cultural tradition in this area. Therefore, this carving demonstrates graphically that in studying the art of Oceania we must carefully separate stylistic features from iconographic motifs, since each may well be due to entirely different historical influences.

THE MAPRIK AREA If, starting from Aitape on the northern coast of New Guinea, we cross the mountains to the south, we reach a hilly grassland which descends slowly to the Sepik River valley. All the rivers here have their sources on the inland side of the coastal mountains and flow down to the Sepik, which continues almost due east to the sea. The region is generally called "Maprik," its administrative designation.

In this culture area, only non-Austronesian dialects are spoken. It seems, however, that for all their local differences they belong to a larger common group which, starting from the northern coast, reaches the Sepik near the Washkuk Hills, and even extends farther eastward. These dialects differ fundamentally from the dialects (also non-Austronesian) spoken within the famous central Sepik culture area.

The people of the Maprik area are typical Melanesian grassland cultivators. The rows of houses which form their small villages are hidden in tall grass; the men's ceremonial house alone soars above them, often to as much as sixty feet high, with its mighty, richly painted, sharp-peaked gable. The yam thrives excellently in the dry soil of this region, and much ritual is connected with its cultivation. This includes competitions for the biggest and finest tubers, displays of the whole harvest, decoration of the longest tubers with woven masks, and decoration of "yam altars" with carved figures.

The early explorers of the larger Sepik area—within which the Maprik sub-area falls—arrived at the conclusion that a specific cultural tradition, different from the culture of the middle Sepik, had spread from the coast southeastward as far as the upper middle Sepik valley. The surmise was based not on linguistic evidence alone, but even more on the distribution of

house forms and on the forms of a number of everyday tools. Further study of the fundamental stylistic features of the Maprik area serves to confirm this early conclusion. Almost all representations of the face in this area have in common a placing of the nose perpendicular to the horizontal lower edge of the forehead. This feature is also found in the south, in representations of faces among the Washkuk group (plate 110; colorplate 19). Similarly, in a large number of the carved human figures, the verticals are stressed in the positions of the arms and legs. Even though the population speaks non-Austronesian dialects, the above-mentioned features clearly disclose the influence of the Neolithic-Austronesian tradition. But though basically influenced by this tradition, the artists of the Maprik area have developed an unmistakable local style.

From a functional point of view, the types of carvings may be subsumed in three large groups: ceremonial-house decorations (plates 41, 42, 44; colorplate 6), figures employed in the secret yam cult (plates 43, 46, 47; colorplate 5), and head ornaments for dancers also used as decorations for the yams at the harvest displays (plate 48). The secret cult usually comprises a series of six to eight feasts, celebrated in irregular succession: participation in all of these feasts is required for a man to achieve full status as an adult. The names of the individual rituals and the paraphernalia employed in them vary locally.

Figures with non-vertical arms and legs are less important ritually than figures with vertical arms and legs. This observation is a very interesting one to the art historian. The crouching or squatting position of the legs and the ritual-devotion attitude of the arms (plate 43; colorplate 5) belongs, most probably—as an iconographic motif—to the more recent stylistic tradition. This tradition was thus at some point adopted into the artistic repertory, but given a subordinate place within the ceremonial scale of values.

Only a few figures are sculptured in the round (plates 45, 46), and even then the works are conceived in frontal view. Most works, however, have a semicircular cross section, i.e., the back of such carvings is flat. The head is oval, and the face is invariably convex. The lower edge of the forehead is indicated by a horizontal line, either incised or painted. The perpendicular nose lies exactly in the middle of the face. In many faces the convex surface next to the nose rises slightly to form a distinct visible ridge. As a rule, the

nose is very long, so that the mouth, shaped as a small circle or oval, is scarcely visible underneath it.

The body as a whole also has the form of a convex oval. The arms do not hang vertically, but adhere closely to the oval outline of the body. The sexual parts, male or female, are always represented clearly, but are not exaggerated. Relatively little care has been spent on the legs.

Painting plays an essential part in the art of the Maprik area. The predominant color is yellow, which may be combined with red, black, or white. The painting of the figures is remarkable for exhibiting a life of its own. First, specific surfaces of the carving are enhanced by vigorous colors. The surfaces so treated often give the figures an appearance out of key with their carved shapes. This is especially true of faces. But the Maprik artists also employ painting to supply details that have not been carved: by this means they add ornaments to chest and head, and bracelets to arms and legs. The overall impression of these Maprik polychromed sculptures is that dancers with painted faces and special ornaments are represented. This peculiarity is what distinguishes Maprik art from the art of the other stylistic areas of northern New Guinea. Though carved and painted figures were elsewhere modeled occasionally on living dancers, only in the Maprik area does this type of representation predominate.

Many human figures have a figure representing a bird on their heads, most often a hornbill or a cockatoo. These animal carvings refer to the "totemic" symbols of the clans and tribes, identifying them as such. The man-animal combination was with these peoples a social and religious necessity. Only rarely do we find brilliant fusions of the two, such as those for which the artists of the middle Sepik are justly praised.

The *maira-nyan* figure (plate 46) must be a very old example; it was probably made prior to the introduction of European iron tools. This ceremonial figure represents a secret ceremonial object of secondary importance. The decoration of the head reproduces a feather ornament, and the many hooks must be interpreted as birds' beaks or as *yina*, daggers made of cassowary bones.*

* All the objects from the Maprik area reproduced in this book that are in the Museum für Völkerkunde, Basel, were collected during the last fifteen years by A. Bühler and A. Forge. Since the results of Forge's research were not in print at the time of this writing, it must be mentioned that the brief observations are based on Forge's collection data.

THE SEPIK AREA The Sepik area is undoubtedly the most famous single art-producing region in all Melanesia. Hardly a museum or an important private collection today lacks a few treasured examples from it. Ever since the early twentieth century, there has been a steady flow of art objects from the Sepik area which have made their way into European and American collections. Only in our own day does the productive energy of these carvers seem to have gone into decline. It is all the more astonishing, then, that our knowledge of this art should be so scanty: the greater our regret that in spite of the contributions of a number of scholars,* ethnology has missed an opportunity. By comparison with the brilliant studies we have of, say, the art of the American Pacific Northwest, Sepik art is still an unexplored subject. Unless a concerted effort is made within the next few years to collect all the data still available concerning the older generation of Sepik artists, one of the most important art-producing regions in the whole of human history will remain no more than a very incomplete chapter in ethnographic archaeology.

The Sepik River has its source in the northern watershed of the central mountains of New Guinea. After making its way leisurely in broad meanders through the lowlands of the interior, it breaks through the coastal mountains to the sea, forming a swampy delta. It is the people who live along the middle course of the river in the interior lowlands who consider themselves the "real" Sepik people. Their culture is a genuine river culture: with its changing water levels, its economic resources, and its navigability, the Sepik determines every material feature of their lives. Because a portion of the interior lowlands is below sea level, the river has itself built up dykes. During the seasons of high water, vast areas are flooded; even during low water, countless canals serve as the main arteries of communication through the grassland and the sago swamps. Only in the chains of hills, scattered like islands between the right-bank tributaries, does one find grassland or rain-forest cultivation of the general Melanesian type. The center of the Sepik culture is concentrated along the middle reaches of the river, but the influence of this fascinating culture has spread to every village along its vast course. In the first phase of contact with Europeans, this process of acculturation was

* For instance, Thurnwald, Reche, Behrmann, Schlaginhaufen, Schultze-Jena, Bateson, Mead, Whiting, Bühler, Wirz, Forge, Haberland, and Newton. See Bibliography.

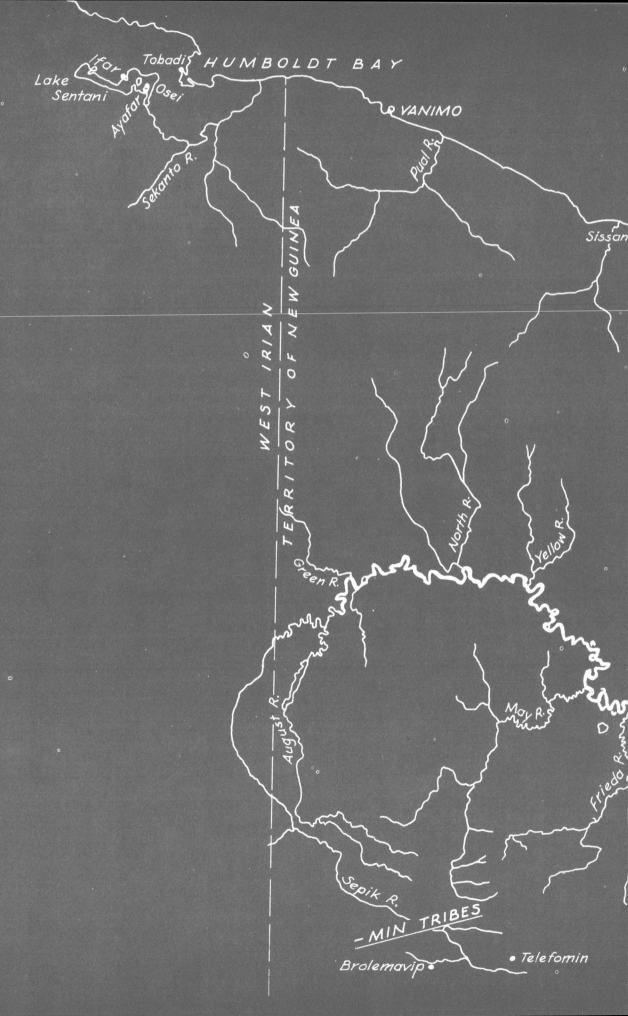

SEPIK AREA

0 10 20 30 40
STATUTE MILES

HUMBOLDT BAY

Lake
Sentani
Ifar
Tobadi
Osei
Ayafar
VANIMO
Pual R.
Sekanto R.
Sissan

WEST IRIAN
TERRITORY OF NEW GUINEA

North R.
Yellow R.
Green R.
August R.
May R.
Friedo R.
Sepik R.
MIN TRIBES
Brolemavip
Telefomin

actually intensified. At that time, as they have often done since, people left their remote villages in the central mountains and moved closer to the river, where they have been obliged to adapt to the new environment. And in this process they have been guided by the culture of the Sepik people.

The Sepik villages consist of long rows of houses built near the riverbanks. The large ceremonial houses are built somewhat apart from the other dwellings on a parklike stretch of grass, bounded on the long sides by embankments planted with palm trees and colorful bushes. At one end of it rises the gabled front of the mighty temple, its peak towering high above the treetops. The oblong structure is raised above the ground on sturdy pillars decorated with carvings (plates 54–56). In many such buildings, the gables are, in addition, decorated with finials, typically showing a male figure, eagles with spread wings perched on their shoulders (plate 57). This iconographic motif also occurs in smaller carvings, and is supposed to symbolize the warlike strength of the male villagers (colorplate 17). The triangular space above the entrance, formed by the steeply pitched roof, is often decorated with a painting of a face, or a mask which may be made of a variety of materials—carved wood, woven rattan and bamboo strips, or large leaves sewn together (plates 61–63).

Only males are allowed in the ceremonial houses. Here important visitors are received, and the sacred portions of the great festivals are performed. Naturally, the ritual implements and musical instruments are stored here also. Long rows of large slit gongs either stand upon specially carved bases or are hung by ropes from the ceiling (plates 51, 83, 84). No less striking are the ceremonial stools, used not so much for seats as for pulpits (plate 70; colorplate 12). From the ceiling, net bags and woven baskets hang on wooden hooks which serve to keep whatever has to be stored off the ground. Usually the hooks are provided with discs on the top to prevent the rats, which nest in the ceiling, from getting at the contents of the baskets. Such suspension hooks are found in many Melanesian islands, but no other area, surely, has developed such richness of forms as we find here (plates 71–76). And in this connection we must also mention the long racks (plate 77) on which enemy skulls, the trophies of successful head-hunting raids, were hung in the old days. (Plate 78 shows a recent miniature version of this iconographic motif.)

Among the sacred instruments are the ceremonial bamboo flutes, some of

which are as much as ten feet long. They invariably exist in pairs. The upper ends are decorated with wood carvings stuck into the hollow tube as stoppers; and these flute stoppers, too, display incredible variety of form (plates 88–90). Generally, their sound was interpreted as the singing of birds. Less sacred, but no less artistic, are the small hand drums shaped like hourglasses, used to accompany singing and dancing (plates 85, 86). A special form is the water drum whose body does not terminate in the usual tympanum (plate 87). Many of the other musical instruments of this region are not reproduced here, but we may mention the wooden trumpets which were formerly blown during head-hunting raids, including two particularly fine examples from the Korewori River area (plates 106, 107).

Each of the ceremonial houses belongs to a group of clans and each clan has its own particular sacred fetishes which are stored there. These are objects which the people believe hold an effective amount of creative power; for this reason, they can only be approached with proper ritual precautions. The rites are intended to obtain a share of the power through an act of communion, or, by sacrifices, to influence its positive—or negative—action. In their outward forms, the fetishes have scarcely anything in common. As a rule they are small objects—stones, bones, teeth, or simulacra of these in clay. They might also be called "relics," since many are said to have been inherited from a mythical hero who endowed them with their magical powers.

The population of northern New Guinea, particularly of the Sepik area, exhibits a marked tendency to represent individual culture heroes or creative divinities, either in the form of complete human figures, carvings, or, more simply, masks, and it has been repeatedly observed that fetishes are either hung on such figures or placed in front of masks or images. In some cases the figures represent ancestors, and are used in ancestor worship.

Such figures from the Sepik area are among the most important works of art produced anywhere in Oceania (plates 49, 52, 58, 95, 101, 102; colorplate 17). Although they all have similar functions within the religious context, each has its individual name and is recognized only by the group to which it belongs. We are best informed about the significance of certain figures from the Yuat River area, including that representing Ambossangmakan, a god of war and hunting (plate 95). The figure was furnished with a bundle of spears, a bag of netting containing various fetishes, and had a bone dagger stuck

through the loop formed by the left fist. Of particular interest are the small faces on the belly and shoulders. This motif is clearly discernible on the magnificent small figure (plate 94), also from the Yuat River area. These faces illustrate a specific passage in the corresponding myth, where the god and several of his companions are described as being constantly pursued. In the course of the flight, the god changed into a tree trunk, and his companions sat on him, particularly on his stomach, shoulders, and knees. The figures from the upper Korewori River (plates 101–104) most probably also have something to do with hunting rites.

Some figurative carvings belong to a different type; they are usually made for display inside the temple, on the back wall. Especially famous are the openwork boards from the region between the middle and upper Sepik (plate 80; colorplate 9), which also must bear some relationship to the hooks from which head-hunting trophies were suspended. A hitherto unreproduced example is the carving from the Washkuk area (plate 109); so far, nothing is known about its function. To still another type belong the masklike images, such as those from the Keram River area (plate 92) or the upper Sepik village of Swagup (plate 111). However, such divinities are also represented in animal form; probably the best known examples are the huge crocodiles from the Korewori River area (plate 100).

The fetish in dog form (plate 91) from the swamplands of the lower Sepik is a particularly instructive example. The crude carving received its intended shape only with the addition of strings of sea shells. The figure has the personal name of Adjaud, and was the property of the males of the village of Adjera. Nothing is reported as to its actual origin which was a matter of secondary importance. But the relevant myth explains and confirms the figure's religious significance. A woman "found" it during a great natural disaster—that is, at a moment of great numinous upheaval. The disaster is described as an eruption of the volcano on Manam Island, during which the earth was covered with volcanic dust and ashes, large parts of the riverbank gave way and were carried off, the ground shook, and finally the ceremonial house collapsed. While all this was going on, a grassy island floated down the river, and the woman saw the figure on this island. In fear, she took it to the men of her clan, who decorated it and named it Adjaud. As soon as they slaughtered a pig and offered it in sacrifice to Adjaud, the "earthquake"

ceased. The figure had thus proved its efficacy and became an object of worship. From then on one of its most important functions was to help the men track down pigs in the bush. But like the powers of every other fetish, those of this figure were ambivalent; among other things, it could cause illness in the village, curable only by offering sacrifices to it. In the course of time it became a burden. When a Christian mission was set up, the men took the figure to the missionary who clearly was better equipped, both ritually and economically, to cope with this dangerous, costly object. This example shows the religious-psychological mechanism which operated in all such figures.

The elegant carving of a marsupial (plate 64) must surely be interpreted as a similar fetish, but unfortunately nothing is known about its significance. Other such objects are the headrests mentioned earlier, which the Sepik artists decorated with truly baroque fantasy (plates 53, 81, 82, 98, 99). Concerning two sculptures (plates 59, 60) their collector, Paul Wirz, tells us that they refer to the myth of the culture hero Betman-Gambi, who plays an important part in Iatmul mythology. His body shows several round holes of different sizes. The figure was placed in front of the ceremonial house when the mythological episodes it refers to were re-enacted. A wood carving about three feet long showing a woman and a crocodile's head with a bird perched on its snout, was pushed through the round opening, and moved back and forth a few times. This symbolized the revivification of Betman-Gambi by the woman and her children, the crocodile and the bird. Thus many details of the carvings were accounted for in the myths of the clans to whom the figures belonged.

A separate category is constituted by the impressive dance costumes with their carved wooden masks (plates 65–69, 96, 97, 105, 110). Such costumes are generally used in representations of the clan spirits, in which the dancers perform on the big dancing ground by the flickering light of torches, to the accompaniment of drums. Whether modeled in clay or carved in wood, the masks are attached to conical frames placed over the dancers' heads, while long fiber skirts conceal their bodies. Especially characteristic of the art of the middle Sepik area are the narrow masks (plates 67–69); they are either made of wood or modeled in clay over a real human skull. Such costumes with masks also appear in the tributaries of the Sepik; the individual masks are, of course, of different styles.

The art objects from the Sepik area do not represent a uniform style. It is possible to distinguish the styles of the lower Sepik (plates 49–53), the middle Sepik (plates 54–90; colorplates 9–13), the Keram River (plates 91, 92), the Yuat River (plates 93–99; colorplates 14, 15), the Korewori River (plates 100–107), the Washkuk area (plates 108–110; colorplates 16–19), and finally the upper and middle Sepik (plates 111–114; colorplates 20–24). Historically speaking, Sepik art has resulted from an intermingling of many traditions in which the stylistic tradition of the Metal Age is especially prominent. The large, saucer-shaped eyes; the curvilinear motifs in openwork carvings; the use of the double spiral in relief bands and ornamental engravings; regular division of the ornamental surface—all these traits confirm this hypothesis. Moreover, the Sepik artists use a large number of iconographic motifs common to this more recent cultural tradition. While such aspects indicate that the Metal Age acted as a particularly keen stimulus, evidences of the older Neolithic-Austronesian stylistic tradition are also unmistakable. The stressed verticals in many figures and the straight-line edge of the forehead at the bottom, beneath which the face recedes, cannot be ignored. "On the whole, we can repeat about Sepik art the statement already made about the art of the northwest coast: its special charm results from the contrast between rigid, vertically composed figures and faces in the Neolithic-Austronesian stylistic tradition and the rich interplay of elegant, almost baroque curves deriving from the tradition of the Metal Age." Typical examples here, perhaps, are the two ceremonial boards (plate 80; colorplate 9).

"The Sepik artists developed a vitality which has rarely been equaled in the Pacific region." This is reflected not only by the fact that nearly everything they made, utilitarian as well as sacred, was decorated artistically but, above all, by the extraordinary richness of their invention. They employed almost all the artist's devices, with the exception of perspective.

"The sheer pleasure of playing with ornamental lines was certainly an important element in this art." Time and again we meet with representations of faces in which the actual contours are duplicated by parallel lines, starting from the nostrils and surrounding the eyes. A typical example is the suspension hook (plate 72; other examples are plates 52, 61, 80, 105). It has even been suggested—correctly or not cannot be determined—that in these cases the peg indicating the nose was elongated to become an ornamental line.

The drop-shaped additions placed under the eyes or diagonally above (cf. plates 54–56, 68–70, 73, 74, 105) are noteworthy details. Nothing definite is known about their significance, though they lend a very special expression to the face. Elsewhere in Oceania, these additions are found primarily in two other areas of New Guinea, the Huon Gulf, and the Gulf of Papua.

The farther upstream we move along the Sepik River, the more distinct become certain echoes of the curvilinear style of the Gulf of Papua. The center of Sepik art proper is in the middle reaches of the river, the area inhabited by the Iatmul. From this area the local style spread widely and particularly influenced the lowland regions adjacent to the southern tributaries. The local style of the Washkuk area to the south and the adjoining area must be seen in the context of the stylistic features of the large Maprik culture area, which extends almost to the Sepik River. Above the Washkuk area, large carvings are made less and less frequently; art is confined to the ornamentation of implements. Of particular interest in this area are the war shields, some of which are today used as door boards (Kupkein, plate 113; Green River, plate 114; May River, colorplates 21, 22). Naturally, their decoration shows a certain affinity with features of the central Sepik style, but the curvilinear designs also exhibit very special variations which are met with elsewhere only in southern New Guinea.

THE
NORTHEAST
COAST:

Astrolabe Bay
to Siassi Islands

Europeans, especially Miklukho-Maclay, the Russian anthropologist, began to study the inhabitants of Astrolabe Bay as early as 1880. Important collections, now in the Ethnological Museum in Budapest (Fenichel, Biró), in the Field Museum in Chicago (Lewis, Dorsey), as well as in some German museums and in private collections, were assembled during the period of German colonialism. Thus, except for three items, all the reproductions from this region are of objects acquired before 1910.

The culture does not differ from the usual coastal type found throughout Melanesia, the general character of which was outlined in dealing with the northern coast. Religion includes numerous versions of a creation epic whose general features are widespread throughout Oceania but are here given a particularly impressive and detailed local form. This is the story of two brothers, Kilibob and Manub, who separated after a great quarrel and became

the ancestors of all human beings. The story is obviously of central significance in the religion, for it has been preserved to this day, and lies at the heart of several latter-day Cargo cults.

Today, the art of this culture has almost entirely vanished, but a glance at the examples shown here are convincing evidence that this was formerly another high point of Oceanic culture.

All the early visitors to this region were particularly struck by the so-called *telum* figures, found in many village squares, which the early observers all agreed are not to be regarded solely as ancestor figures. Probably they, like the large figures of gods in the Sepik area, represent divinities worshiped as the tribe's mythical ancestors.

About ten years ago, the long lost collection of an early traveler, H. Zöller, was rediscovered by a fortunate accident. In 1889, Zöller set out from Astrolabe Bay into the Finisterre Range and to this expedition we owe what is surely one of the finest works ever found in Melanesia (plate 115). The body and form of the face show the features of the Neolithic-Austronesian tradition; the position of the head with the jutting chin and protruding ears points to the influence of the Metal Age. While we have encountered these stylistic traits before, the special contribution of the artist was the ability to mold and interrelate these elements with particular plasticity, giving the sculpture an expressiveness rarely encountered elsewhere in Oceania.

The limestone figure (plate 117) is another *telum*. Early explorers report that stone, rather than wooden, *telum* figures were worshiped, especially in the inland sections. Very few have found their way into museums, and these are always cylindrical or conical stones with a little clumsily executed carving. This figure is the only extant example of a complete *telum*.

The female figure from Ruk Island, off the west coast of Astrolabe Bay (plate 116), is also unique. The execution of the breasts with their sea-shell ornaments shows a certain tendency to realism. It is not clear whether the representation concerns the birth of a human being, or the legend of a female divinity who gave birth to yams as well as people, and was the founder of mankind.

To another group of sculptures belong the house posts (plates 118–120). The two examples from Astrolabe Bay (plates 118, 119), when scrutinized closely, disclose the same stylistic features. The differences in the execution

of them are so striking, however, that to the casual eye the figures might seem quite unrelated.

Clearly, the villages south of Astrolabe Bay (particularly Bogadjim and Bongu) tend to an emphatically sculptural treatment of the stylistic conventions. The figure from Ragetta Island, off the west coast of Astrolabe Bay, is flatter, less expressive, and the proportions are less surely balanced. The object hanging out of the mouth is not to be mistaken for the tongue—it shows an ornament that performers of the war dance held in their teeth. Another unique work is the large house post from the Siassi Islands, acquired by the Hamburg Expedition to the South Seas in 1908 (plate 120). It exhibits the same essential stylistic features as the two works just mentioned, but again we find striking differences in the execution of the various elements. The ceremonial houses of the area must have contained many such posts; not one, unfortunately, was ever photographed. They must have been enormously impressive.

The three masks shown here (plates 121–123) again exhibit a play of variations on the same fundamental elements. The execution of the mask from Umboi Island is elegant and rhythmical; the two others, from the south coast of Astrolabe Bay, seem crude and archaic by comparison. The tendency to greater sculptural quality is clearly marked here.

Along the northern coast of New Guinea, as well as on some of the smaller islands of Melanesia, small mortars were used for crushing the areca nuts chewed with betel. It has been said that only toothless old men needed them; this may have been the case, but possession of such carefully worked mortars must also have been a status symbol. The specimen from Sio Island (plate 124), surely one of the finest, is typical of the Neolithic-Austronesian style. (Cf. also the example from Huon Gulf, plate 131, and from the Solomons, plate 202.)

THE
EAST
COAST:

Huon Gulf
to Massim Area

Two centers of wood carving, both on the east coast of New Guinea, are celebrated for their achievements. In the north, the people of the Huon Gulf villages developed a characteristic local style. In the south, the inhabitants of the three archipelagoes off the coast (the Trobriand Islands, the D'Entrecasteaux Islands, and the Louisiade Archipelago) and those of the villages at

the easternmost tip of New Guinea, collectively referred to as the Massim, also created a local style. Both centers were influenced by the Metal Age stylistic tradition which, however, was more strongly felt in the Massim area than in the Huon Gulf. Whether the two should consequently be treated as a single greater Massim area is a question only future investigation can settle; it would be premature to assume or even imply that the Massim area was the generative center. For the present it is safer to leave the question open, and to present the two centers separately.

In the Huon Gulf area, the Tami Islanders were regarded as by far the most outstanding wood carvers and boatbuilders: hence European ethnographers' customary use of the phrase "Tami style." The term can certainly serve as a collective designation, but it must be kept in mind that works with the same stylistic features were produced all around the shores of Huon Gulf, particularly by the Jabim and Bukawac linguistic groups.

The categories of art objects produced in these villages scarcely differ from those of the rest of the northern coast. Some types are unusually plentiful. Serving bowls and spatula-like spoons with carefully carved handles are more frequent here; so are the headrests, of which large numbers may be found in European and American collections.

A little way inland, some of the most important so-called prehistoric stone sculptures of New Guinea have been found. A particularly impressive example is the stone head (plate 125) acquired by the missionary Keysser in 1905; its only counterpart is in the Field Museum in Chicago. This is quite obviously the upper end of the handle of a pestle. Unfortunately, we know nothing for sure about these stone sculptures. The present-day inhabitants say they know nothing about the artists who made them, but this is hardly enough to justify a belief that these sculptures are vestiges of an extinct people, as was maintained during the romantic phase of cultural ethnology. They might well have been produced by the immediate ancestors of the present-day population.

The faces on the massive house post (plate 126) and on the white-painted mask (plate 127) show the characteristic features of this area with especial clarity. Eyes and nose are close together, forming the central complex of the face. The straight, lower edge of the forehead does not run clear across the face, but is confined to the area defined by the eyes. These are semicircular,

set directly under the edge of the forehead; above the edge, slight curves are carved or painted, giving the eyes a realistic aspect. The nose is perpendicular, thin and sharp; occasionally the nostrils are flattened out, creating the "anchor shape" discussed above. The proportions of nose and eye are natural, and nowhere does the nose dominate the face, as in much of the work found on the northern coast. The same is true of the mouth, which invariably is in the form of a regular rounded oval. But inside the mouth there is usually a figure-eight design of unknown significance. The triangles at the outer corners of the eyes are found only in the Huon Gulf area, and serve as an identifying feature of work from the area.

Of the three headrests reproduced here (plates 128–130), the last is so typical of the style that no further comment is required. The two others must be considered separately, but they are both significant works of art. One (plate 129) includes the familiar iconographic motif of opposed male and female figures. The little mortar for areca nuts (plate 131) is among the finest products of these gifted and imaginative artists.

The serving bowls from the villages around the Huon Gulf are well known. The usual form is an oval, with the underside decorated at one end with a large-surface Tami face. The outer rim is rich in complex engraved ornamentation. The bowl shown here (plate 132) is not entirely typical, but surely meets the highest standards. The underside, with its engraved ornamentation and carved borders, is in the form of a fish. We have already remarked, in describing the typical face form, on the tendency to realism in the Huon Gulf area; on this score, the bowl speaks for itself.

Our reproductions of work from the Massim area begin with two female figures. The first (plate 133) is a rare specimen, apparently from the region of Roro-speaking villages on the south coast of New Guinea's Papuan tip. The somewhat clumsy work shows distinct features of the Neolithic-Austronesian tradition. By contrast, the smaller figure from the Trobriand Islands (plate 134) shows to what refinements the influence of the Metal Age could lead. In spite of the characteristic, though distracting, facial ornamentation, this work is distinguished by well-balanced proportions, a tendency to realism, and a certain smoothness.

In the art of the Massim area, and above all the Trobriand Islands, the lime spatulas occupy a special place. These are small spatulas with elongated

oval blades and handles consisting of carved figures. They are used in betel-chewing to carry burned and powdered lime to the mouth. In two typical examples (plate 135), the crouching pose, the position of the head on the trunk, the tendency to realism, and the engraved decoration show clearly enough the influence of the metalworking tradition. The peculiar charm of these works is partly derived from the contrast between the polished dark wood and the white, lime-filled incisions.

On the big outrigger canoes from the Massim area, one extremity consists of a plank carved with particular care (plate 136). The individual designs have been variously interpreted as eyes, eggs, rainbows, clouds at dawn, and so on. We are better informed about the little human figure at the center of the top border. In the d'Entrecasteaux Islands, at least, the figure represents Matakapotaiataia, the hero of myths, with many analogies throughout Melanesia, which form part of the doctrine of ritual cannibalism. A version recorded by Géza Róheim offers a glimpse into the world of spirits which underlies the frequently bizarre details:

Matakapotaiataia's village was Kopoa-kapoai (Bubbling water) and his mother was called Kakasiro (Breadfruit). The people of this village were being killed by Tokedukeketai (Cannibal) and Bawe-garagara (Grunting Pig), so that they were afraid and all ran away except one woman who was pregnant; she had had intercourse with many men. She hid in a hole and gave birth to Matakapotaiataia (Eyes springing out), so named because he had four eyes, two in front and two behind. He grew up and said to his mother: "Where are all the people?" She told him they had run away and he asked her where was their enemy. "Down below on Mount Tojaj," she said. "But what will you do, he is a very great man?" Matakapotaiataia cut many spears and hardened them in the smoke. He went to Mount Tojaj and found Tokedukeketai in his garden, but his grandchildren were in the village. The youth hid in the bush behind the village and painted himself black. When he came out, lightning, thunder, and rain heralded his approach. . . . The children in the village cried out: "What manner of man is this! He has two eyes in his face and two at the back." He asked the children to tell their grand-

father that he would come back in three days. Meanwhile he hid the spears at different places one at a time. One he hid at Gujadaru, others at Soisoija, Majaru, Quanaura, Tausipwa, and Dutuna; but he took one with him. Then he met Tokedukeketai and threw the spear at him, but it broke off in his body. Matakapotaiataia ran away past all the places where he had hidden spears, and at each he stopped to throw one. At last he came to Gujadaru where the last spear was hidden, and with this he finally succeeded in killing Tokedukeketai. Then came the two brothers of Matakapotaiataia, the eagle scratched out the eyes of the giant, and the dog bit off his testicles. Matakapotaiataia ordered the dog to drag the body back into their village. They did this and cut off the giant's long hair; but they ate his body.*

The myth, then, reveals what symbolic significance the elegant little figure on the washboard had for the occupants of the boat: the victorious prehistoric hero was sailing with them, leading them into battle and other undertakings.

The last work shown (plate 137) is a shield, on which the designs, instead of being incised as is usual on the wooden objects, are painted. Until recently it was only known that none but the famous, leading warriors had the right so to paint their shields. In a discussion of the designs, two ethnologists proposed two contradictory interpretations at which they had arrived purely theoretically. Later the curator of the South Australian Museum at Adelaide recalled that he had such a shield with a description referring to a legend. The Museum acquired the shield about forty years ago, and it is no longer possible to establish who wrote the description—perhaps it was Bronislaw Malinowski, the foremost authority on the Trobriand Islands. The legend is the more significant because it supplies the native names for the individual ornaments. The shield reproduced here is very much like the one in the Adelaide museum.

The large ornament on the narrow upper edge of the shield has the form of a certain type of lime spatula. In the middle we make out a circle divided into

* G. Roheim, *The Riddle of the Sphinx; or Human Origins,* trans. by R. Money-Kryle (London, 1934), pp. 179–80.

four segments, which is supposed to represent the morning star, or Venus. On both sides are heads of snakes which suggest a particular mythical snake. On the vertical part of the ornament (the shaft of the spatula) the symbol of a little fish is painted—a kind found in shallow water. The two quadripartite circles in the middle of the shield supposedly represent stars which are also visible at dawn but are less important. Inside the lower, broader half of the shield there is a large oval filled with complicated ornaments. The center piece of this oval must be interpreted as a fish with tail pointing downward. This is surrounded by two other ovals; in the upper half of each of them we recognize a frigate bird. The whole figure is once again surrounded by white bands which have been interpreted as rainbows. There can be no doubt that all these designs and their combination on shields originally had symbolic meanings. Unfortunately, we have no idea what these were. However, in this connection we may mention another important circumstance. This ornamental sign language operates purely additively, i.e., it juxtaposes individual symbols and formally subordinates them to the ornamental surface. If we had a better understanding of the sign language involved, this bizarre art would be far more accessible to us. But it is hardly likely that even the most painstaking investigation would tell us all we want to know, for the majority of the designs have long since been drained of their symbolic sense and, by dint of constant repetition, have become merely decorative.

THE SOUTH COAST: Gulf of Papua to Torres Straits

The south coast of New Guinea, from Cape Possession in the east to the mouth of the Fly River in the west, is a flat, swampy area, with extensive deltas at the mouths of the major rivers. The villages are built either right on the seashore or hidden away in the mangrove forests. No organized tribes have been found, though a regional division is discernible. Villages which have been in close contact for some length of time are aware that they have common traits; for instance, the groups called the Elema at the eastern end, the Namau in the delta of the Purari, and the Kerewa farther west. Only non-Austronesian dialects are spoken throughout this area.

Food cultivation, fishing, and sago provide the population with most of its food. In former times the ritual head-hunt played an important role. The

myths include long epics recounting the exploits and journeys of culture heroes, and important episodes from these epics are enacted at spectacular feasts. The numerous costumes with masks for dancing and the multiform effigies made of painted bark which were carried by the dancers are famous. The center of ritual activity is the huge ceremonial house, which only men are permitted to enter and where the fetishes of the individual clans are kept. For many generations the people have carried on trading by way of great rivers, as far inland as the valleys of the Central Highland. There was also a lively maritime trade with the Massim area in the east. The Motu traders, from the region around the modern town of Port Moresby, crossed the Gulf of Papua with outrigger boats. Thus the peoples living around the Gulf of Papua, far from being isolated, were exposed to as many cultural influences as other peoples of New Guinea.

In the art of this area, two-dimensional works predominate; three-dimensional sculpture takes second place. The artists achieved great mastery in painting and relief carving, in which curvilinear forms and the facial type of the Neolithic-Melanid tradition are characteristic. But, along with these stylistic elements, we also find others corresponding to those of the upper central Sepik area and the northeast. For this and other reasons, a link between the cultures of these areas and the Gulf of Papua has repeatedly been conjectured; so far, however, it remains hypothetical.

The rituals practiced in this region are intended on the one hand to communicate magic powers to the whole community and on the other, to introduce adolescent boys to religious life. They include the important *Moguru* and *Mimia* ceremonies, which were observed mainly in the western Gulf of Papua. Wooden figures (plates 138–140, 145; colorplate 28) appear in these ceremonies as visible fetishes. New ones are carved for each ritual and brought solemnly to the ceremonial house to be attached to one of the posts and decorated with leaves and other ornaments. The adult men form a long row in front of the figures, standing with legs wide apart; the boys to be initiated crawl between the men's legs and then press their chests against the wooden figure. By this gesture, the powers contained in the figure are supposed to be transmitted to the boys. The men dance with the figures in the ceremonial house; finally they are either discarded or stored beneath the house. Large quantities of fruit are placed in front of the figures, not as a

sacrifice, but rather as a transfer of power. After an interval of time during which the magic powers are communicated to the fruit, part of it is eaten by old people; another part is thrown into swamps and streams to make the fish multiply; and the rest is burned in the plots under cultivation, the ashes serving to increase their fertility. The leaves decorating the figures are worn by the young men around their necks, as they, too, are supposed to contain a portion of the figure's powers and to bring the young men luck in hunting and fishing.

Three such figures (plates 138–140) are from the region of the Purari and Bamu Rivers. Even though they are sculptures in the round, it cannot be said that the artists intended to produce three-dimensional works of art. Every feature is either painted or incised; they are found only on the front side of the crude carving. This is seen best in the figure of a dancing man (plate 139): the striking pose was not in the first place produced by the carver, but merely adopted from the natural forms of the piece of wood and interpreted by him. This technique is very typical of Papuan Gulf artists. They repeatedly let themselves be inspired by the bizarre, accidental shapes of the roots or branches that serve as their raw material. The artist's contribution here consists less in his ability to create form than in his highly adaptable fantasy—a trait favored by the circumstance that the purpose is to produce a fetish rather than a piece of craftsmanship.

In this culture a certain archaic dynamism has asserted itself with particular strength, and has remained very much alive. Fetishes are not the only indispensable paraphernalia for the ritual; masks, bull-roarers, and stylized crocodile forms also are central to it. Almost every ceremonial house around the Gulf of Papua contains large numbers of oblong oval boards, with one side decorated with painted reliefs. Each of these *gope* or *kwoi* boards is closely linked to a person or a special event. In a sense, they represent the individual particles of creative power which made possible the particular persons or events celebrated. There is always a face on the upper part, clearly exhibiting the features of the Neolithic-Melanid tradition. On many boards the body is not indicated; its place is taken by a series of curvilinear patterns. The example shown came from the Kerewa group, and is notable for the fact that the whole body is represented in stylized form (colorplate 26).

In the west of this area, the hinterland north of the Fly River delta is

inhabited by the Gogodara tribe. In this swampy tract, villages consist for the most part of a single long house in which individual families occupy cubicles opening off a central corridor. Their culture scarcely differs from that of other groups around the Papuan Gulf. But it is noticeable that the artists very often employ soft wood, and for this reason have been able to produce some impressive large-scale sculptures. In the Gogodara art, however, the main feature is not the carving but the painted decoration, and the painted designs betray a link with the tribes farther inland, along the middle and upper reaches of the Fly River.

Plate 141 shows the model of a sacred canoe carved out of soft wood. Technically, such a canoe is built like any other, and goes by the same name, *gi*. But, as ritual objects, such *gi* are regarded as vehicles of magical powers. They are identified with the crocodile, the dangerous beast which, everywhere around the Gulf, is considered the zoomorphic incarnation of important vehicles of power. Among the Gogodara the sacred canoes are built primarily in connection with the ceremonies of initiation, every boy receiving one. They are placed one beside the other on small supports. At the climax of the ceremony the novices are put by their sponsors into their canoes, and must remain standing in them for a time. The aim is the same transfer of magical powers as can be observed in other rituals in this area.

The Marind-anim people's groups of villages are situated far to the west of the Fly River, in the area defined by the mouths of the Maro, Kumbe, and Bian Rivers. They do not belong to the culture of the Papuan Gulf, properly speaking; nevertheless, the two cultures have distinct affinities. The two examples of their art shown (plates 142, 143) are included largely because they are executed in a technique not represented in any of the other New Guinea styles we have already examined. Whereas all the previous objects were carved from a single material, this lizard and pig have been assembled from several. Here again, the carver's degree of modification of the basic material is very modest. The special charm of these two objects derives on the one hand from the clumsiness of the composition and on the other, from the skillful handling of the extraneous additions. The "pig" becomes a pig by virtue of the real pig's bristles and tail attached to it; equally, the "lizard" comes to life as a lizard through the red and white seeds the artist has skillfully applied to the basic material.

81

In the area of the Fly River delta, the Kiwai Island villages obviously constitute the cultural center from which emanated strong influences affecting the whole Papuan Gulf area. Their individual power can be seen in the style, which differs perceptibly from that elsewhere in this area. The male *Moguru* ceremony figure (plate 145), for all its individuality, reminds us of those works from the north coast which show a combination of Neolithic-Austronesian and Metal Age stylistic traditions. The legs are bent slightly forward; the arms hang down perpendicularly; and the hands, pointing slightly inward, rest on the thighs. The position of the head in relation to the body is equally in the Neolithic-Austronesian tradition. The facial outline is pear-shaped with a horizontal chin. The prominent nose, straight and narrow, falls perpendicularly from the straight line, lower edge of the forehead, while the mouth is cut in the form of a semicircle. Two striking features account more than the others for the characteristic appearance of the face: the radially protruding ears with their long, pierced lobes, and the enormously high, steep forehead which takes up almost one-third of the facial area.

All these features, notably the high forehead and the straight, narrow, prominent nose, are also found on the wooden mask from the south coast of the so-called Trans-Fly area, west of the Fly River delta (plate 146). This very rare mask is a masterpiece of great expressive power, which is emphasized by the contrast between the dark wood and the white seashell inserts in the eyes. The perforation at the lower end of the mask served, as we have seen in other examples, to attach a fiber costume. A similar style turns up in islands in the Torres Straits farther to the south. But here masks and dance emblems are made of tortoise shell, individual plates of which are heated and reshaped before being sewn together. This technique naturally modifies the appearance of the works, but when we compare them with those from the lower Fly River reproduced here, it is clear that Torres Straits art belongs to the same tradition.

The presence of such unmistakable features of the Neolithic-Austronesian and Metal Age traditions in the middle of the south coast of New Guinea is the more surprising for the fact that nowhere in this area are Austronesian dialects spoken. The works from the lower Fly River and the Torres Straits belong to another world from those of the Papuan Gulf. Only a definitive

analysis of the art of the south coast of New Guinea will eventually account for this phenomenon.

THE
SOUTHWEST
COAST:

Asmat
Area

The coastal region between the Groot Moeras River in the west and the Eilanden River in the east is inhabited by approximately twenty thousand Asmat, whose name means "the real people." To the west of this coastal strip lies the Mimika area, and to the east, the Casuarinen Coast which adjoins the Marind-anim area. In this swampy flatland, flooded for most of the year, the villages are hidden away in mangrove forests or rise on embankments above the rivers. The essential means of transportation is the dugout canoe, without which human life could not be sustained in this region. Sago crops, fishing, hunting, and modest farming plots provide the inhabitants with their food. Ritual head-hunts and ritual cannibalism played an important role until very recently, and there are also extensive rituals for assuring the success of each of this people's economic activities.

The amazing art of the Asmat has long been known to experts, but only during the past few years has the public at large become aware of its existence. The most striking objects from the area are the ancestor poles (*bijs*), from twenty to twenty-six feet high, which are produced both in the inland Asmat area and along the Casuarinen Coast. The religious significance of these poles (plate 152) is very complex. In a general way, they are fetishes; at the same time, however, the human figures superimposed on one another are believed to represent members of the clan who were killed by enemies. The *bijs* are also related to the idea of the dugout canoe, for they can be interpreted as upended canoes, the body of the boat greatly reduced, its prow enormously exaggerated. The rituals connected with these poles show that on one hand they serve to harbor the souls of the dead, and consequently keep them away from the village, while on the other, they serve as vehicles of magical powers for they are thrown in the sago swamps after the ceremony— supposedly, to fertilize the sago palms.

The poles are cut from trunks of mangrove trees; one flat root projection is left attached. This is then carved in openwork into the flaglike emblem which characterizes the *bijs*. The tree is tracked down in the forest as if

it were an enemy, then ceremonially cut down. When the bark is removed, the red sap of the tree oozes out from the white wood of the trunk, reminding the Asmat of the enemy's blood. Preparing the trunk takes weeks of labor during which the artists must take special care to prevent the pole from coming into contact with the ground, which would profane it. In the Asmat area the finished poles are set up vertically, whereas on the Casuarinen Coast they are leaned diagonally on a scaffolding.

In the interior, actual "soul ships" are made, full-sized, but without floors. Their occupants are carved human figures and animals—crabs and birds—and at the center, there is invariably a tortoise, a creature regarded as a particularly efficacious fertility symbol. The religious significance of these soul ships, too, is complex. They perform the same function as the *bijs* of the coast. The souls of the recently dead are conjured into them so that they can be carried away from the village. For this purpose they are set up in front of the mens' houses, and later carried to the sago swamps. But besides, the soul ships play an important part in initiation ceremonies, performing the same function as the previously described ritual canoes (*gi*) of the Gogodara. The novices must sit on the carved tortoise and are given a ritual scarification; the ceremony apparently endows them with the magical powers these ritual carvings are supposed to contain.

In the southern part of the Casuarinen Coast large carved crocodiles are used for the same purpose (plates 153–155). The whole body is covered with bands of ornamentation carved in relief, as are the four legs. At the end of the snout there is usually a human head with the face looking upward, while on the crocodile's neck is perched a human figure or a bird. Finally, the tail often terminates in a human head. In the whole region of south New Guinea from the Asmat area to the Papuan Gulf, there is thus a religious complex in which crocodilian monsters and boats appear as central fetishes. Further investigation into this complex is needed, and must include traits from other areas, such as the enormous crocodile carvings of the Korewori River in the Sepik area (plate 100). The Asmat relate a myth concerning the origin of man which they say they took over from another people. According to this story, a prehistoric culture hero wandered along the coast from east to west. On his way he built ceremonial houses everywhere he went, carved human figures in soft wood and placed them inside the houses. Then he beat his drum, and the

sound transformed the wooden figures into human beings, the earliest occupants of these houses. Now that ceremonial houses are built by the people, the artists carve numerous figures of this kind, which they install in new houses. A dance is then performed to the beat of drums; the dancers begin in a crouching attitude, moving their still "wooden" legs very slowly at first, only at the end moving freely as dancers fully "awakened to life." These figures (plates 148, 149, 156) refer to this religious conception.

No less famous as works of art are the prow carvings of the big dugout canoes in which the men traveled on their head-hunting expeditions (plate 151). Among other things, these expeditions had the purpose of avenging recent deaths among members of the clan. The human figures in such carvings are supposed to represent these dead.

The war shields, which technically speaking are pure parrying shields, were carved in relief over the entire surface (plate 147). The main motif is the human figure with arms and legs both bent sharply. This is either fully or partially executed in a continuously repeated pattern. It may be mentioned that the stylized designs represent not only the human figure, but also, and sometimes simultaneously, the praying mantis.

The art of the southwest coast of New Guinea strikes us as extraordinarily bizarre. Relief ornamentation, openwork sculpture, and sculpture in the round are all executed with great mastery. In addition, these artists were skillful at combining these different techniques in a single work. This fact alone should warn us against regarding this art as evidence of some particularly archaic cultural stage. Closer scrutiny compels us to recognize that the human faces and the poses of the figures bear the hallmarks of the Neolithic-Austronesian stylistic tradition. We find hardly any traces of the Neolithic-Melanid tradition as it is found in the art of the Papuan Gulf even though faces are occasionally executed in a manner which brings to mind the Gogodara style. For the time being, we may limit ourselves to the hypothesis that features of both the Neolithic-Austronesian and Metal Age traditions have become widespread along the southwest coast of New Guinea. In the culture area of the lower Fly River these occur in a very pure form, whereas they have been subject to local modifications along the southwest coast.

THE NORTHWEST COAST

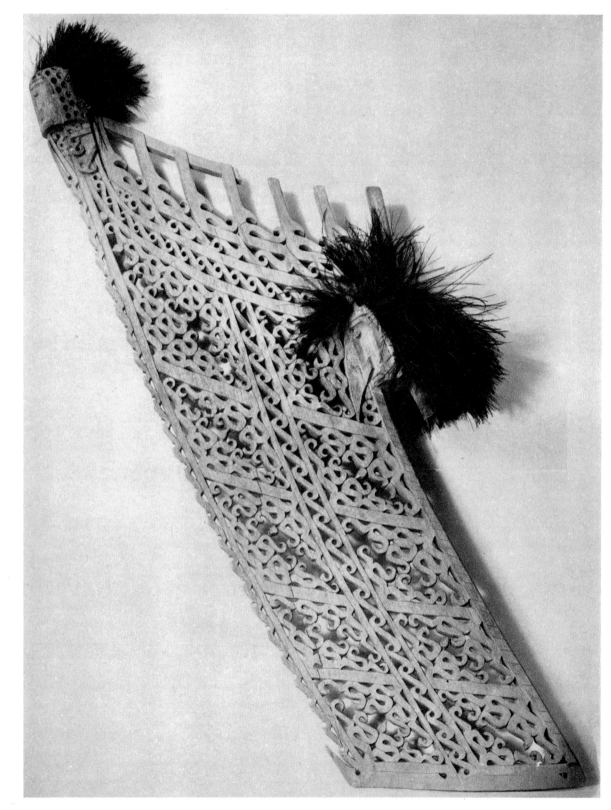

PLATE 1. CANOE PROW
New Guinea, Northwest Coast, Geelvink Bay
Height 37 3/8"
Peabody Museum of Archaeology and Ethnology,
Harvard University, Cambridge, Mass.

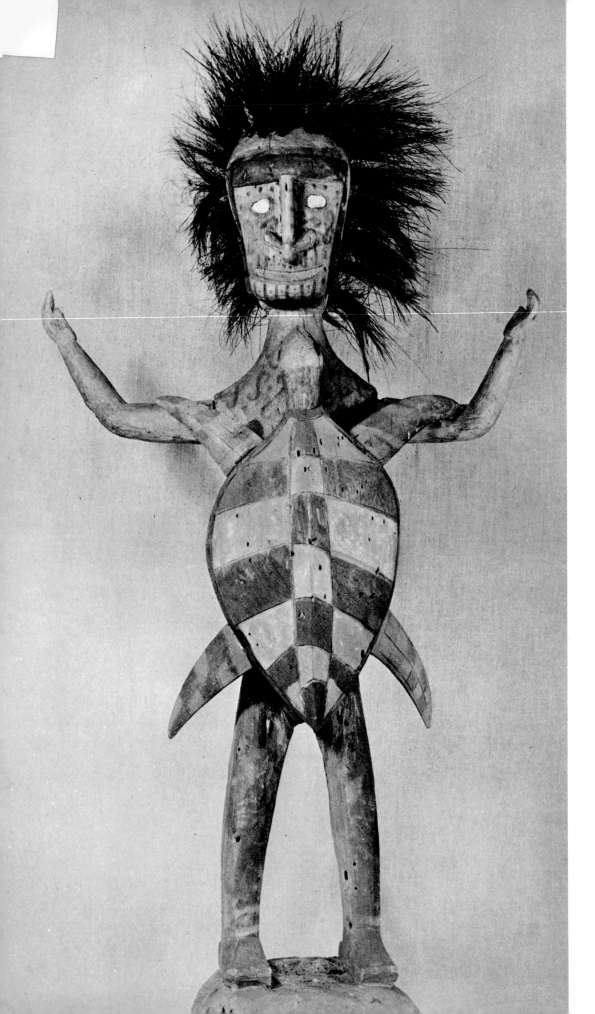

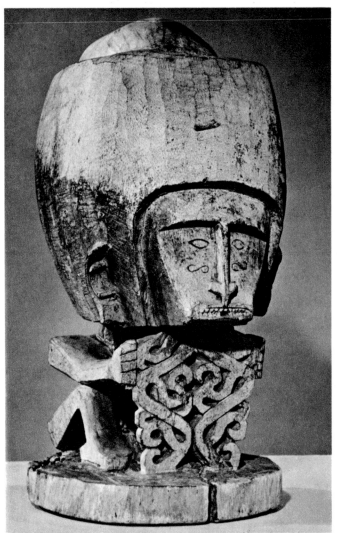

PLATE 2. MALE FIGURE HOLDING TURTLE
New Guinea, Northwest Coast, Geelvink Bay, Manokwari (Kibler, 1930)
Height 41 3/8"
Linden Museum, Stuttgart

PLATE 3. *Korwar*
New Guinea, Northwest Coast, Geelvink Bay, Biak Island
Height 15 3/4"
Rijksmuseum voor Volkenkunde, Leiden

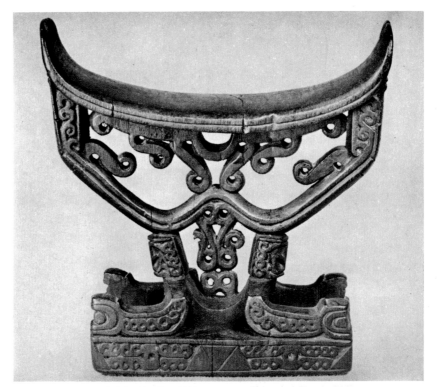

PLATE 5. HEADREST
New Guinea, Northwest Coast,
Geelvink Bay, Waropen (Kibler, 1930)
Height 7 1/8″
Linden Museum, Stuttgart

PLATE 4. *Korwar*
New Guinea, Northwest Coast,
Geelvink Bay, Doreh Bay (de Clerq, 1893)
Height 7 7/8″
Rijksmuseum voor Volkenkunde, Leiden

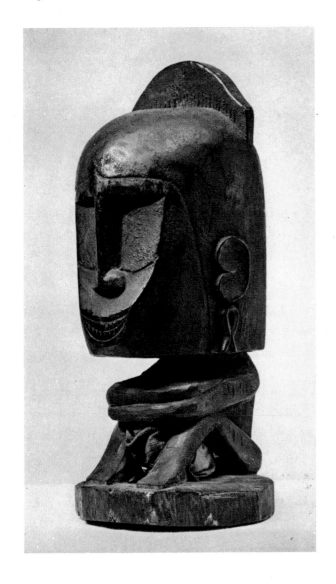

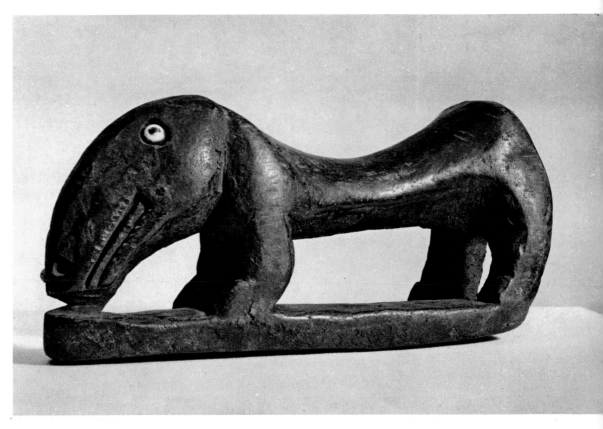

PLATE 6. HEADREST
New Guinea, Northwest Coast, Geelvink Bay, Waropen (Kibler, 1930)
Length 11 3/4″
Linden Museum, Stuttgart

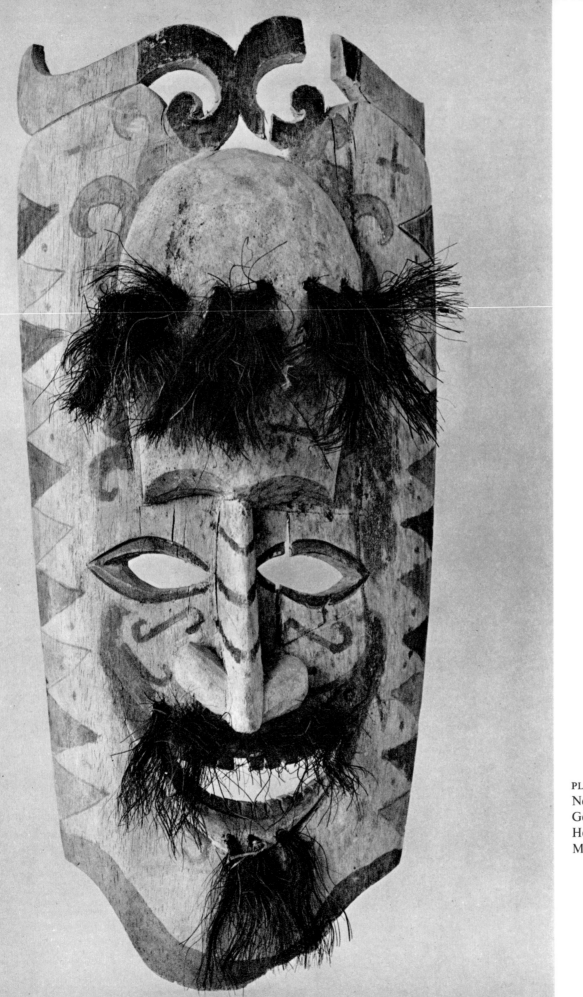

PLATE 7. MASK
New Guinea, Northwest Coast,
Geelvink Bay, Doreh Bay (P. Wirz, 1922)
Height 16 1/8″
Museum für Völkerkunde, Basel

THE NORTH COAST:

Lake Sentani and Humboldt Bay

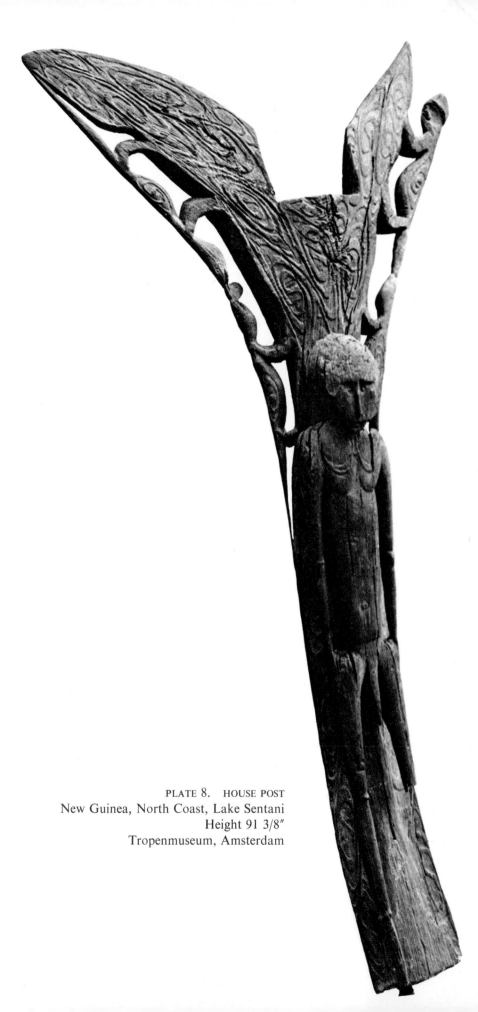

PLATE 8.　HOUSE POST
New Guinea, North Coast, Lake Sentani
Height 91 3/8″
Tropenmuseum, Amsterdam

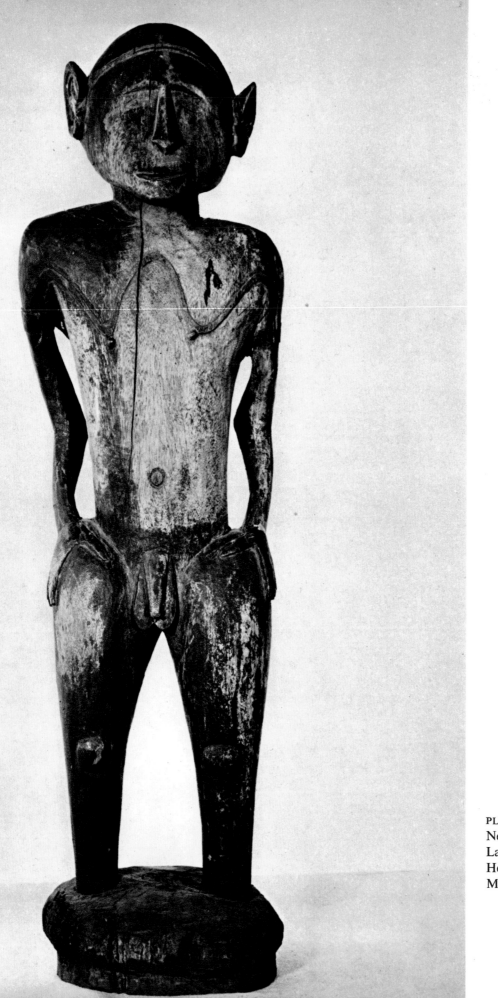

PLATE 9. STANDING MALE FIGURE
New Guinea, North Coast,
Lake Sentani, Ayafo (P. Wirz, 1927)
Height 41 3/8″
Museum für Völkerkunde, Basel

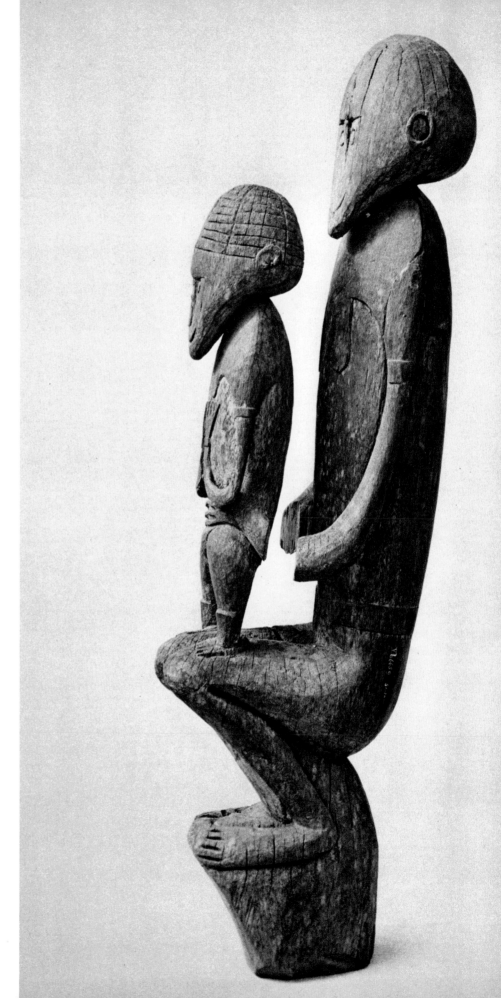

PLATE 10. FEMALE FIGURE WITH CHILD
New Guinea, North Coast,
Lake Sentani, Ifar (P. Wirz, 1927)
Height 36 1/4″
Museum für Völkerkunde, Basel

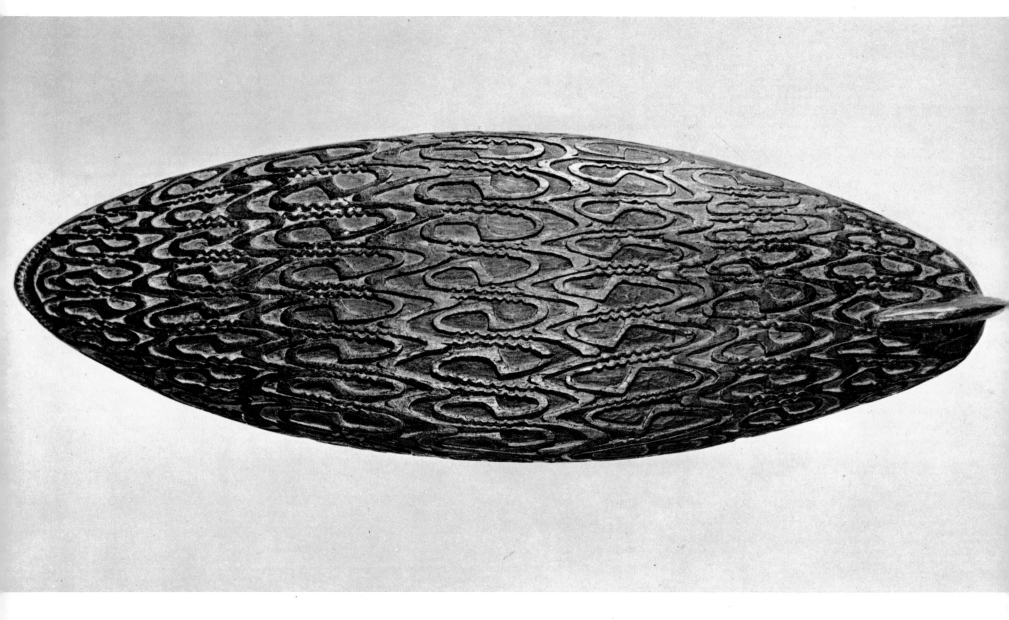

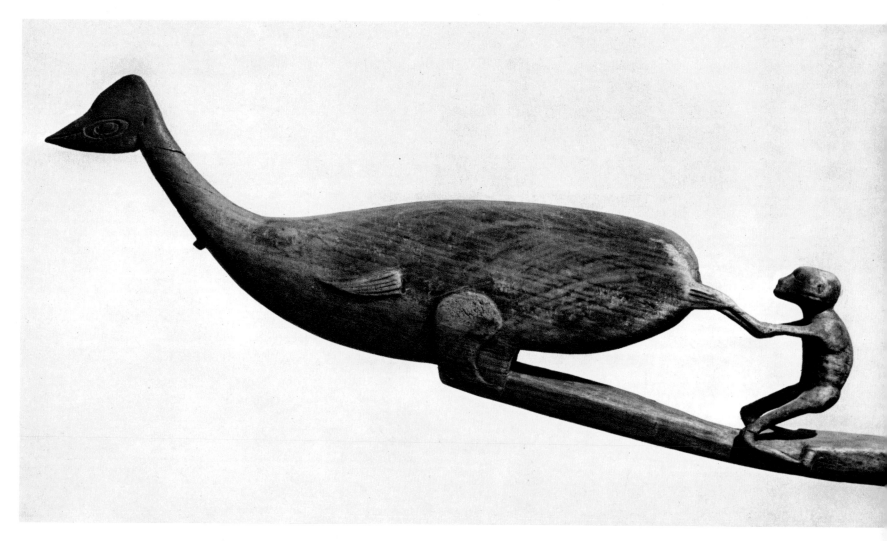

PLATE 12. FINIAL OF HOUSE BEAM: CASSOWARY PULLING A MAN
New Guinea, North Coast, Lake Sentani, Osei (P. Wirz, 1927)
Length 77 5/8″
Museum für Völkerkunde, Basel

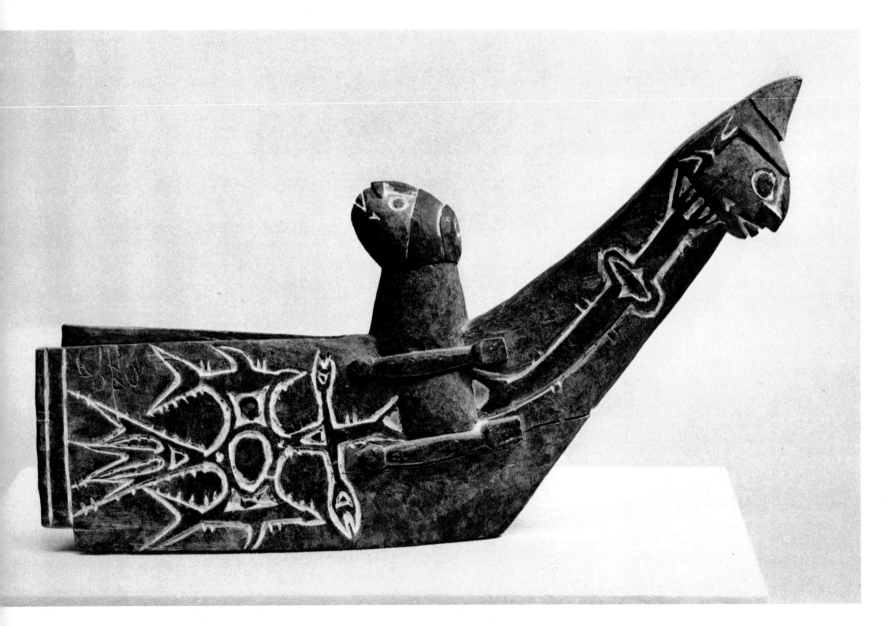

PLATE 13. PROW ORNAMENT
New Guinea, North Coast, Humboldt Bay, Tobadi (v. d. Sande, 1906)
Length 28 3/8″
Rijksmuseum voor Volkenkunde, Leiden

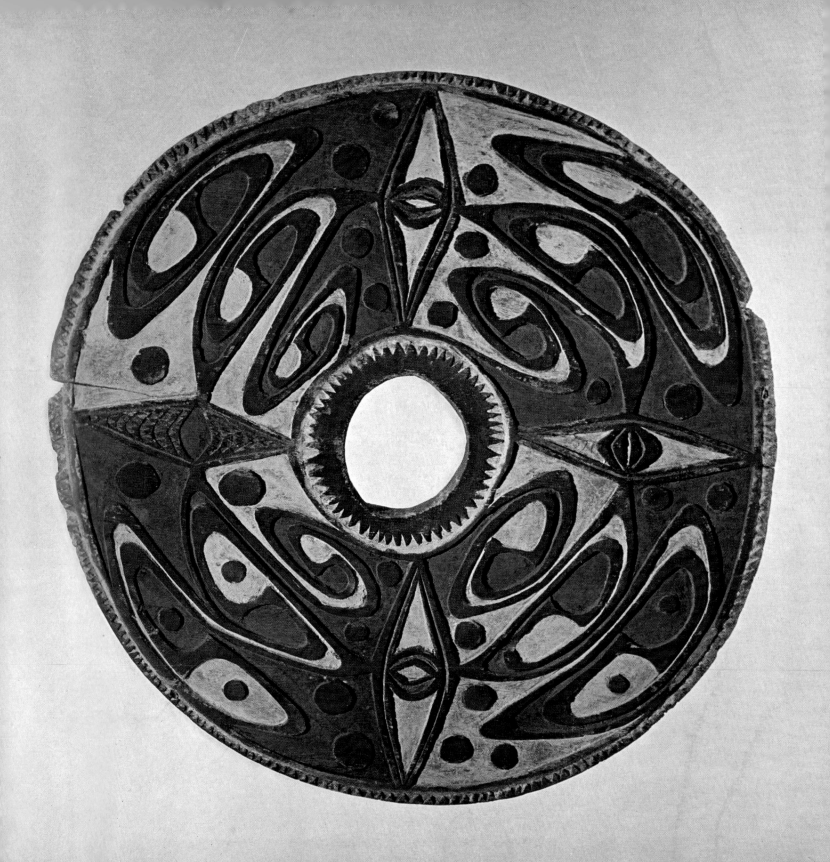

COLORPLATE 2. SHIELD
New Guinea, Sissano
Height 53″
American Museum of Natural History, New York

THE NORTH COAST:

From Humboldt Bay to Astrolabe Bay

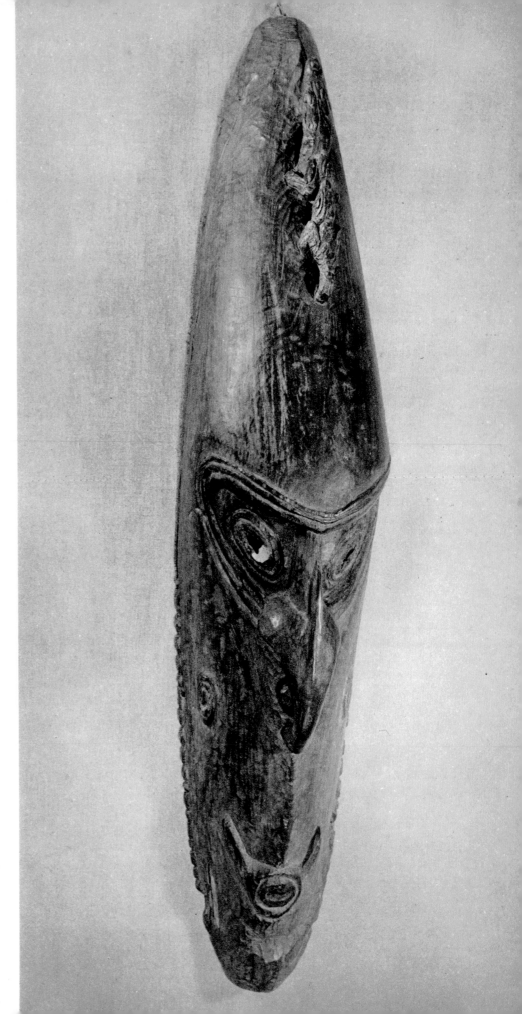

PLATE 14. GABLE MASK
New Guinea, North Coast, Murik Lagoon (Speyer)
Height 40 1/8″
Linden Museum, Stuttgart

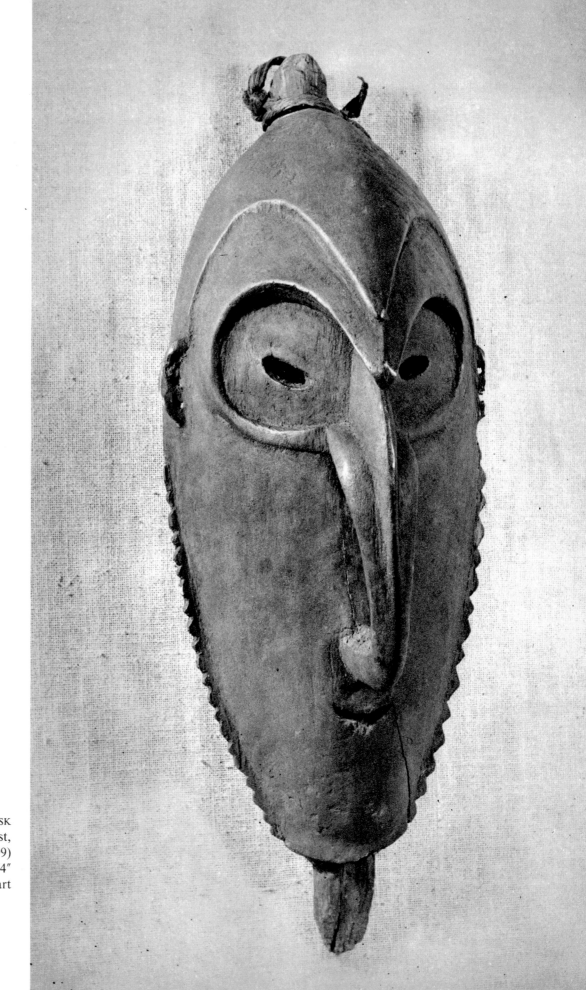

PLATE 15. MASK
New Guinea, North Coast,
Lower Ramu River (Baessler, 1899)
Height 15 3/4″
Linden Museum, Stuttgart

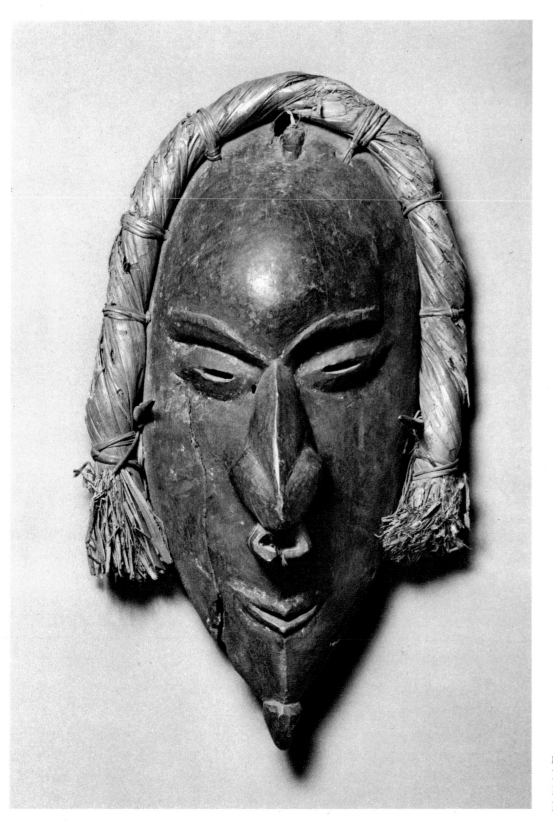

PLATE 16. MASK
New Guinea, North Coast, Sepik Estuary (Bethke, 1905)
Height 16 7/8″
Museum für Völkerkunde, Basel

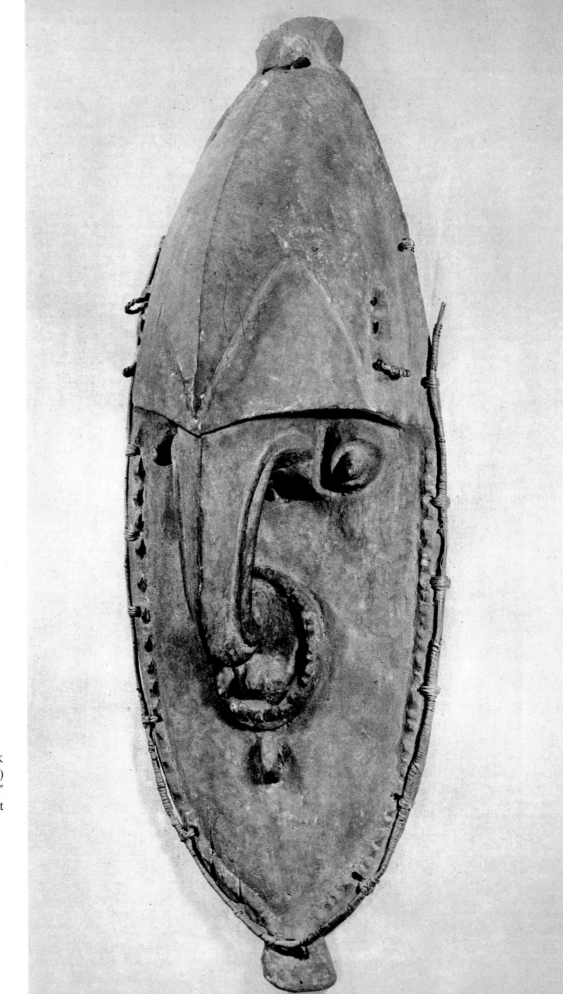

PLATE 17.　MASK
New Guinea, North Coast, Wallis Island (Hahl, 1907)
Height 39 3/8″
Linden Museum, Stuttgart

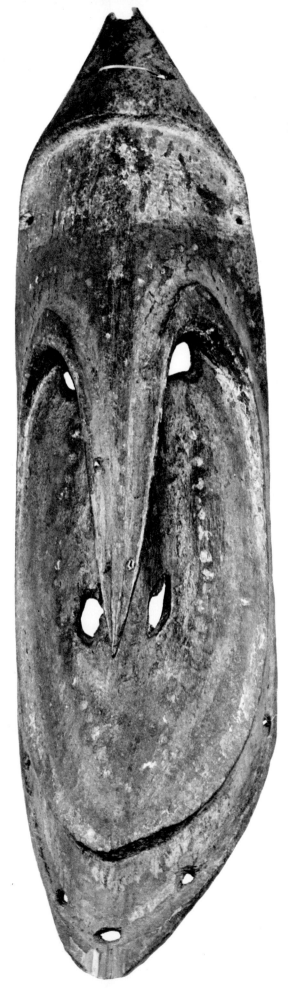

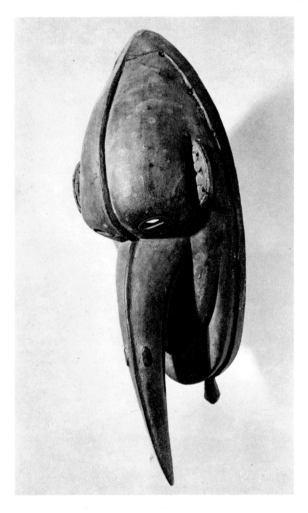

PLATE 18. MASK
New Guinea, North Coast, Wallis Island (Schoede, 1911)
Height 19 5/8″
Linden Museum, Stuttgart

PLATE 19. MASK
New Guinea, North Coast, Bogia (Kohler, 1960)
Height 20 1/8″
Collection P. Kohler, Ascona, Switzerland

PLATE 20. MALE FIGURE
New Guinea, North Coast, Murik Lagoon, Manganum (Behrmann, 1914)
Height 28″
Linden Museum, Stuttgart

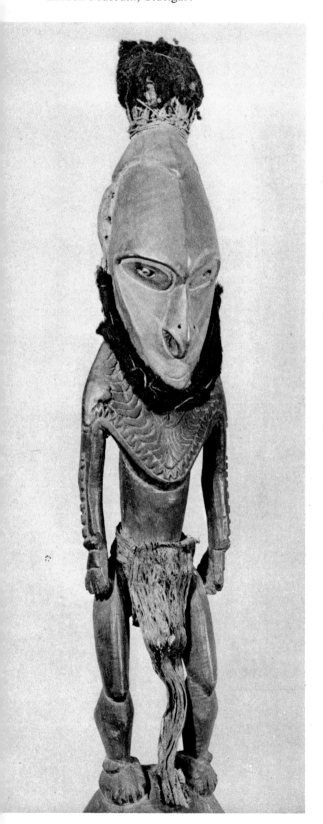

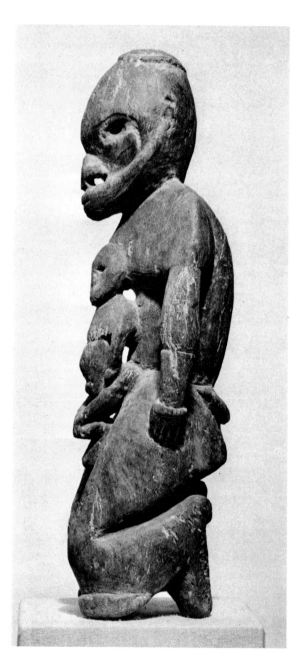

PLATE 21. MATERNITY GROUP
New Guinea, North Coast, Aitape area
Height 20 7/8″
Collection S. Brignoni, Bern

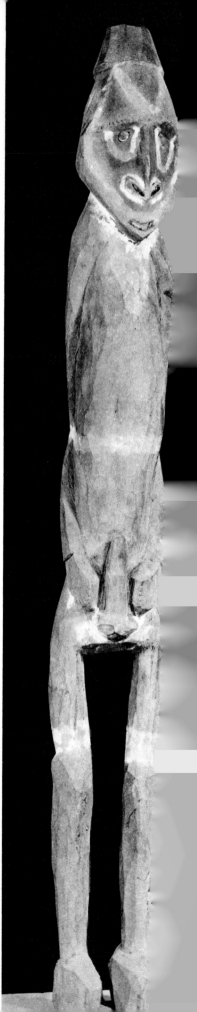

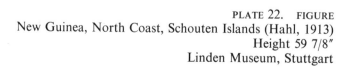

PLATE 22. FIGURE
New Guinea, North Coast, Schouten Islands (Hahl, 1913)
Height 59 7/8″
Linden Museum, Stuttgart

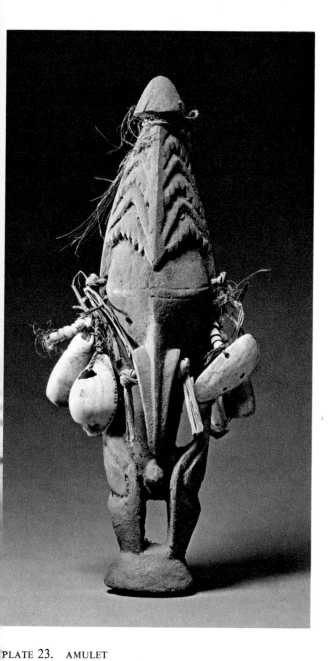

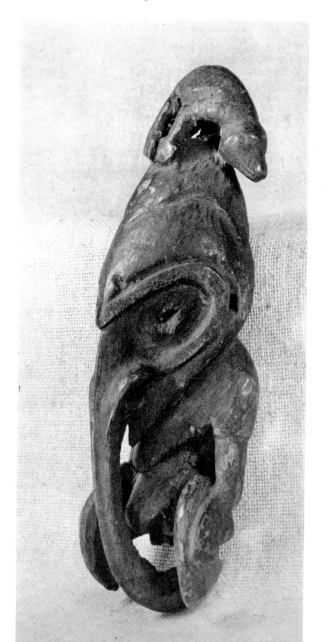

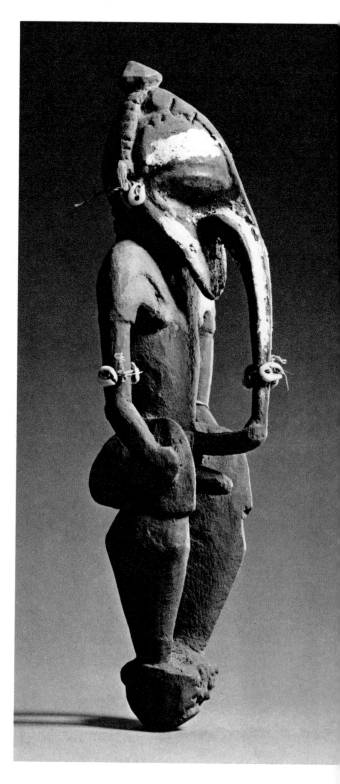

PLATE 25. AMULET
New Guinea, North Coast, Bogia (Wandres, 1896)
Height 10 5/8″
Museum für Völkerkunde, Basel

PLATE 24. AMULET
New Guinea, North Coast, Murik Lagoon (Hahl, 1907)
Height 5 7/8″
Linden Museum, Stuttgart

PLATE 23. AMULET
New Guinea, North Coast,
Lower Ramu River (Wandres, 1896)
Height 6 3/4″
Museum für Völkerkunde, Basel

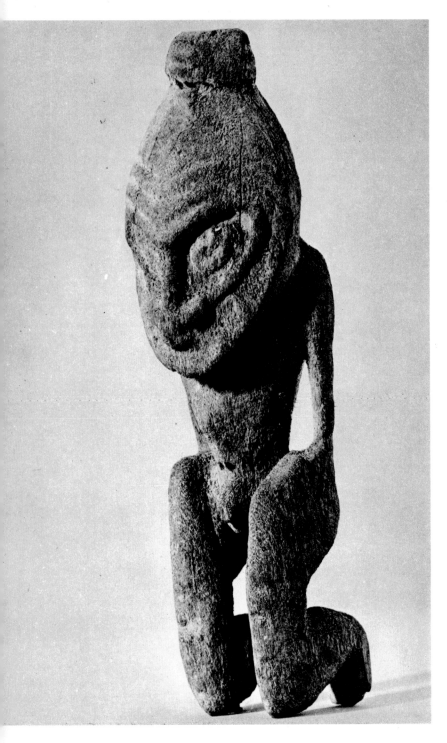

PLATE 26. AMULET
New Guinea, North Coast, Manam Island (Kohler, 1960)
Height 6 3/4″
Collection P. Kohler, Ascona, Switzerland

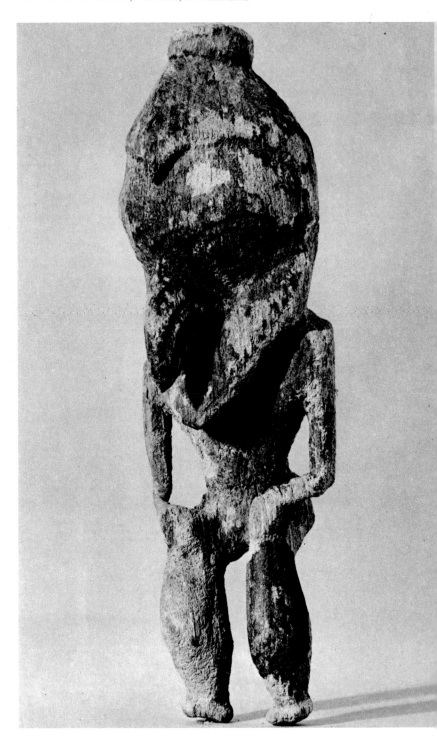

PLATE 27. AMULET
New Guinea, North Coast, Manam Island (Kohler, 1960)
Height 7″
Collection P. Kohler, Ascona, Switzerland

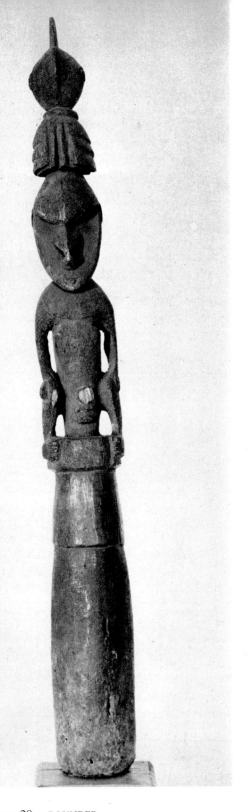

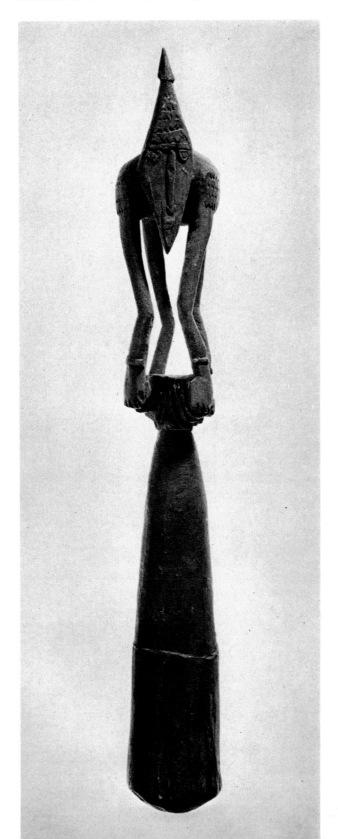

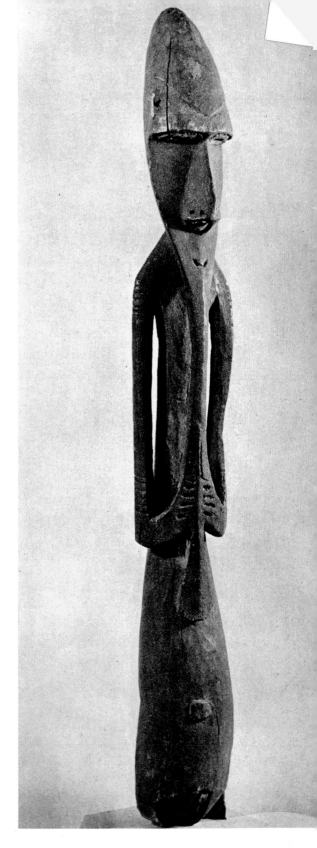

PLATE 29. POUNDER
New Guinea, North Coast, Seleo
Height 27 5/8″
Smithsonian Institution, Washington, D.C.

PLATE 28. POUNDER
New Guinea, North Coast,
Wallis Island (Schoede, 1911)
Height 28 3/8″
Linden Museum, Stuttgart

PLATE 30. POUNDER
New Guinea, North Coast,
Murik Lagoon (Hahl, 1913)
Height 23 5/8″
Linden Museum, Stuttgart

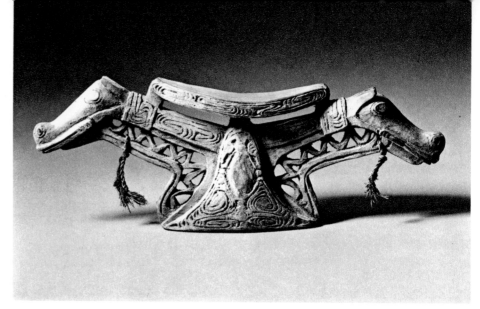

PLATE 31. HEADREST
New Guinea, North Coast, Hansa Bay, Awar (Speiser, 1930)
Length 16 7/8″
Museum für Völkerkunde, Basel

PLATE 32. HEADREST
New Guinea, North Coast, Aitape (Liese, 1899)
Length 16 7/8″
Museum für Völkerkunde, Basel

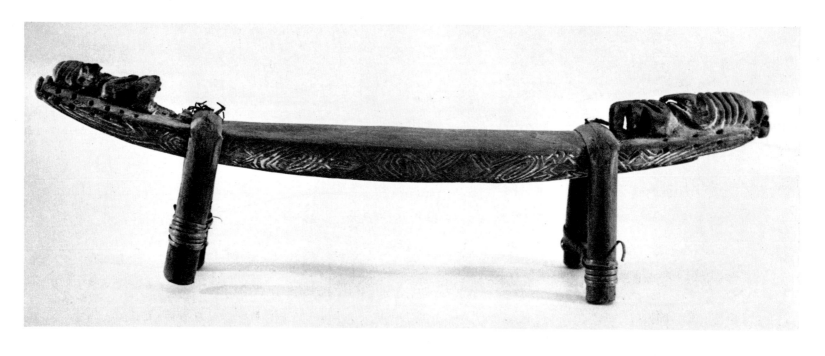

PLATE 33. HEADREST
New Guinea, North Coast, Aitape area
Length 15″
Museum für Völkerkunde, Basel

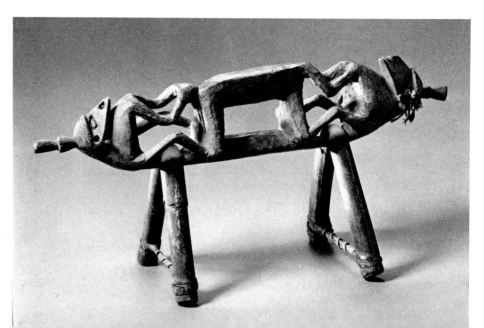

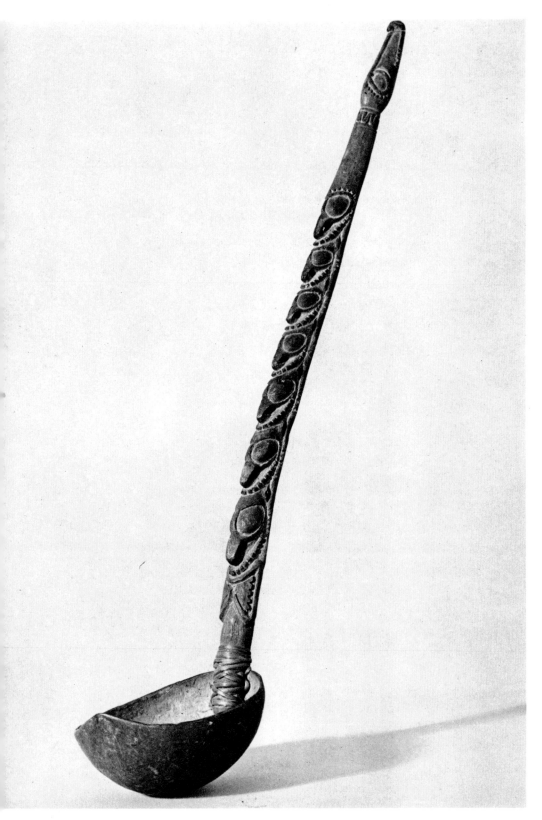

PLATE 34. SPOON HANDLE
New Guinea, North Coast, Manam Island (Kohler, 1960)
Height 20 1/2″
Collection P. Kohler, Ascona, Switzerland

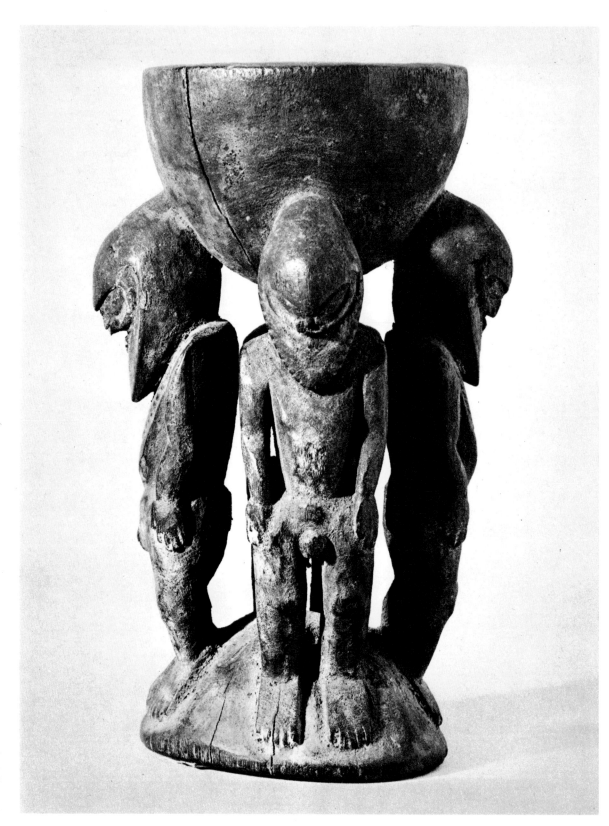

PLATE 35. BETEL MORTAR
New Guinea, North Coast,
Manam Island (Kohler, 1960)
Height 7 5/8″
Collection P. Kohler, Ascona, Switzerland

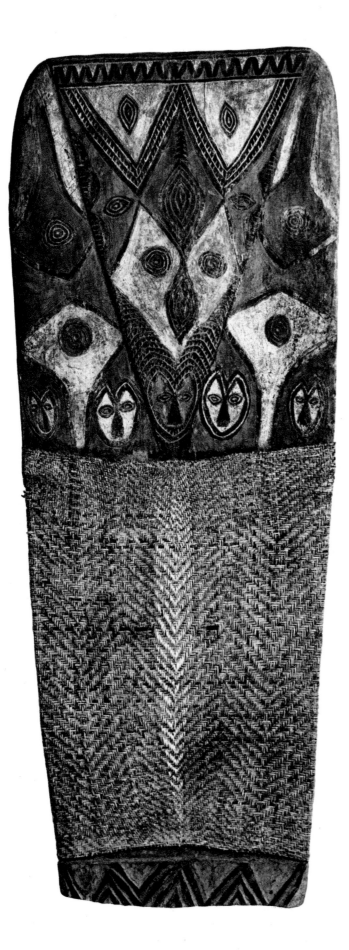

PLATE 36. WAR SHIELD
New Guinea, North Coast, Lower Ramu River (Markert, 1958)
Height 55 7/8″
Collection G. Markert, Munich

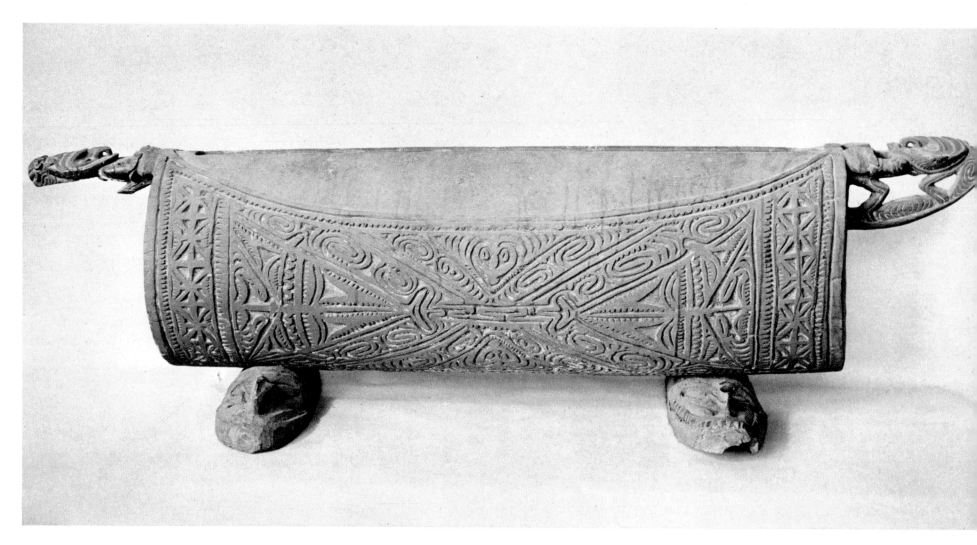

PLATE 37. SLIT GONG
New Guinea, North Coast, Lower Ramu River (Wandres, 1896)
Length 52 3/8″
Museum für Völkerkunde, Basel

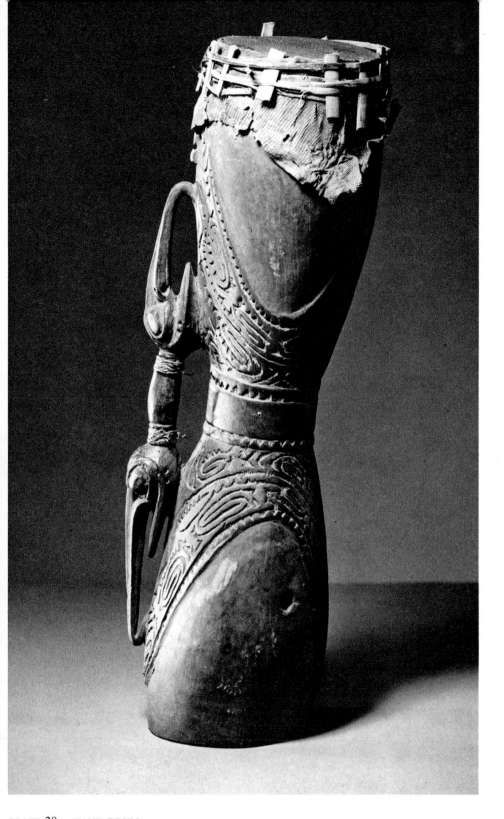

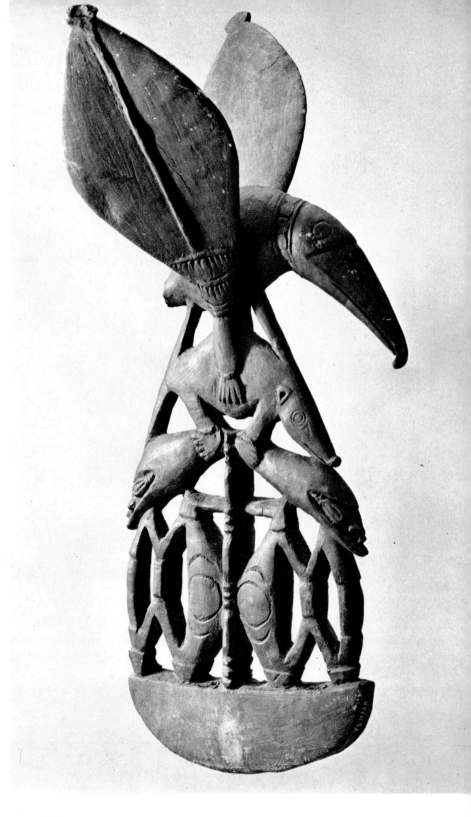

PLATE 38. HAND DRUM
New Guinea, North Coast, Lower Ramu River (Wandres, 1896)
Height 26 1/8″
Museum für Völkerkunde, Basel

PLATE 39. MYTHOLOGICAL GROUP
New Guinea, North Coast, Murik Lagoon (Bühler, 1932)
Height 26 3/8″
Museum für Völkerkunde, Basel

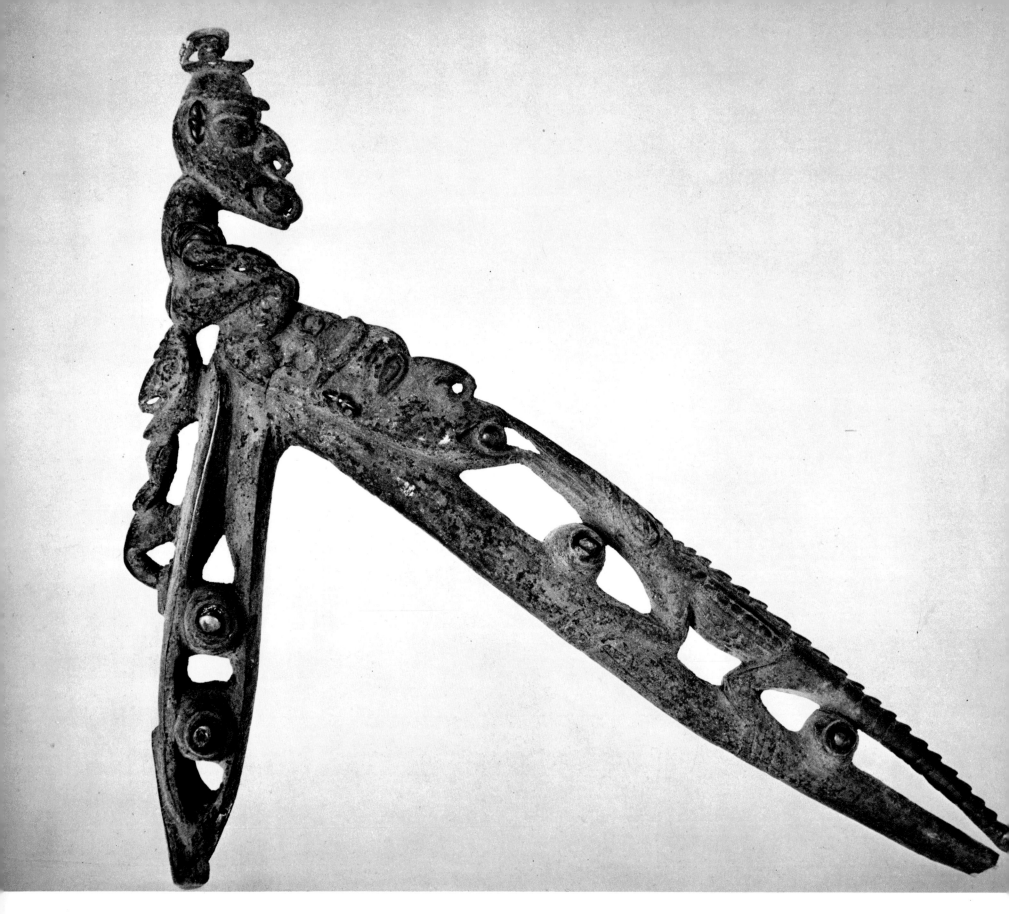

PLATE 40. CEREMONIAL ADZE
New Guinea, North Coast, Lower Ramu River
Height 16 1/2″
Rautenstrauch-Joest Museum für Völkerkunde, Cologne

THE
MAPRIK
AREA

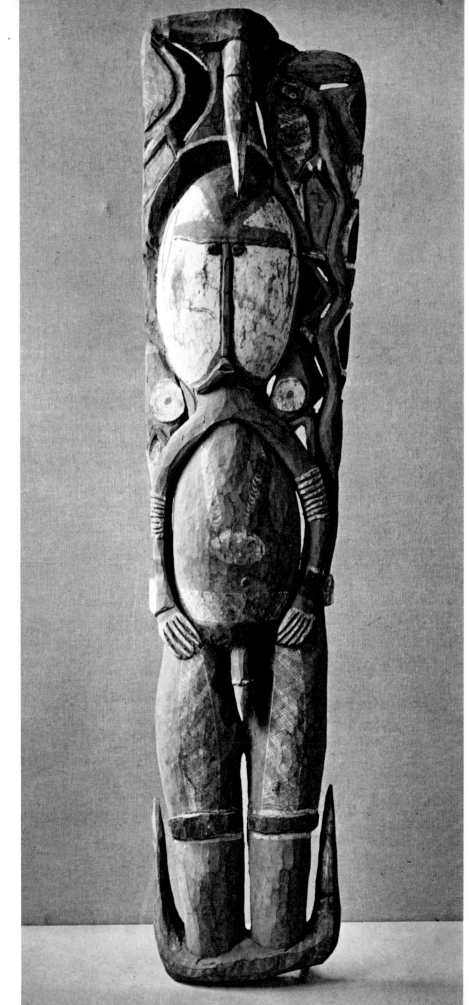

PLATE 41. *Raakama* FIGURE
FROM CEREMONIAL HOUSE
New Guinea, South Maprik, Numbungai (Bühler, 1955–56)
Height 88 5/8″
Museum für Völkerkunde, Basel

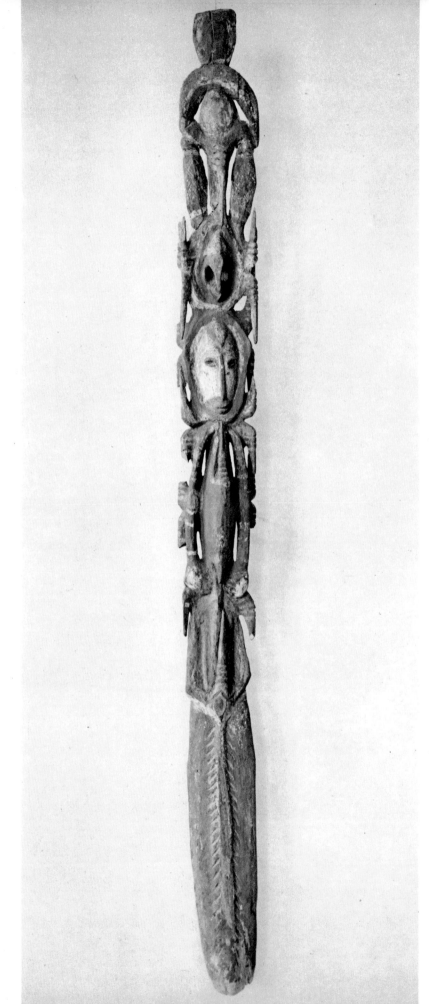

PLATE 42. *Maira* FIGURE FROM CEREMONIAL HOUSE
New Guinea, South Maprik, Numbungai (Bühler, 1955–56)
Height 62 5/8″
Museum für Völkerkunde, Basel

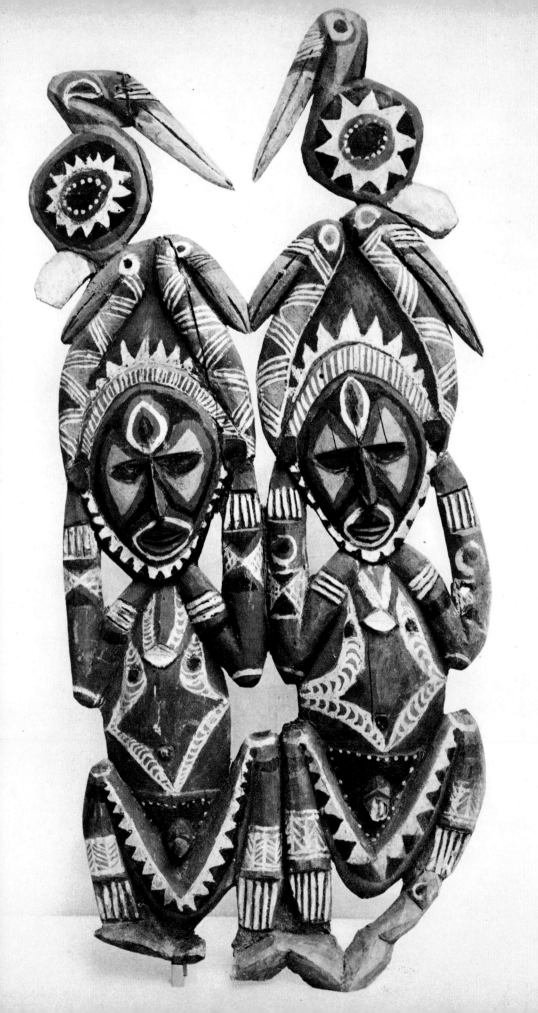

PLATE 43. *Wulge* BOARD
New Guinea, North Maprik, Kalabu (A. Forge, 1959)
Height 45 1/4″
Museum für Völkerkunde, Basel

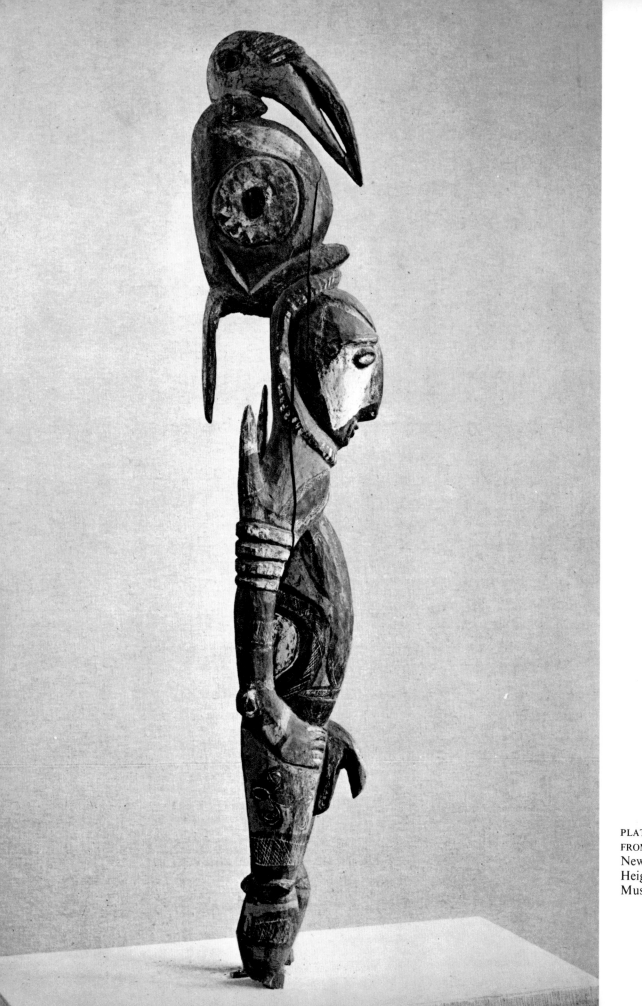

PLATE 44. *Maamba maira* FIGURE
FROM CEREMONIAL HOUSE
New Guinea, South Maprik, Bogmuken (Bühler, 1955–56)
Height 68 1/2″
Museum für Völkerkunde, Basel

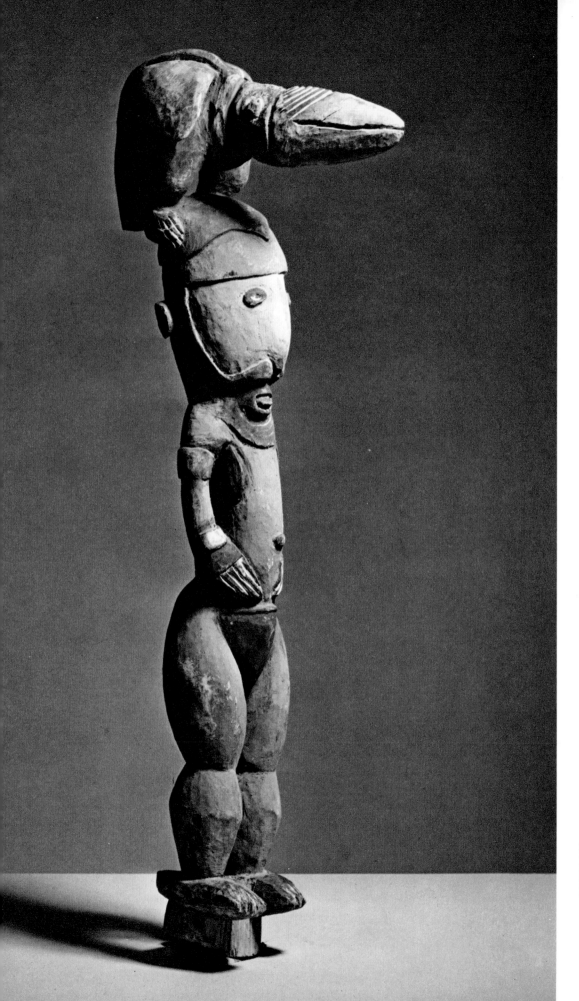

PLATE 45. FIGURE FROM CEREMONIAL HOUSE
New Guinea, South Maprik, Kwotmagum (Bühler, 1955–56)
Height 33 7/8″
Museum für Völkerkunde, Basel

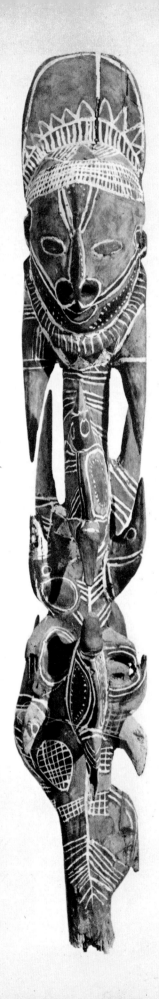

PLATE 46. *Maira-nyan* FIGURE
New Guinea, North Maprik, Wingei (A. Forge, 1959)
Height 53 1/8″
Museum für Völkerkunde, Basel

PLATE 47. *Wabinyan* FIGURE
New Guinea, North Maprik, Wambak (A. Forge, 1959)
Height 37 3/8″
Museum für Völkerkunde, Basel

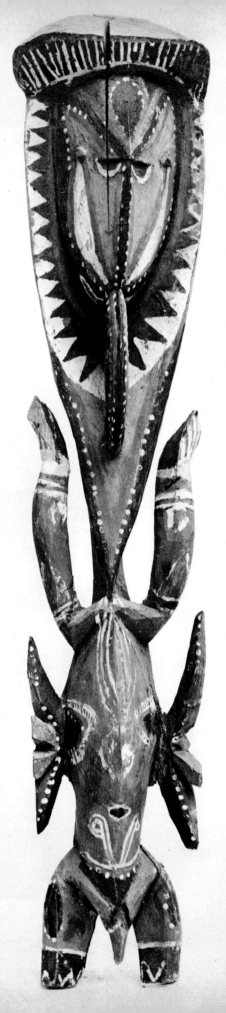

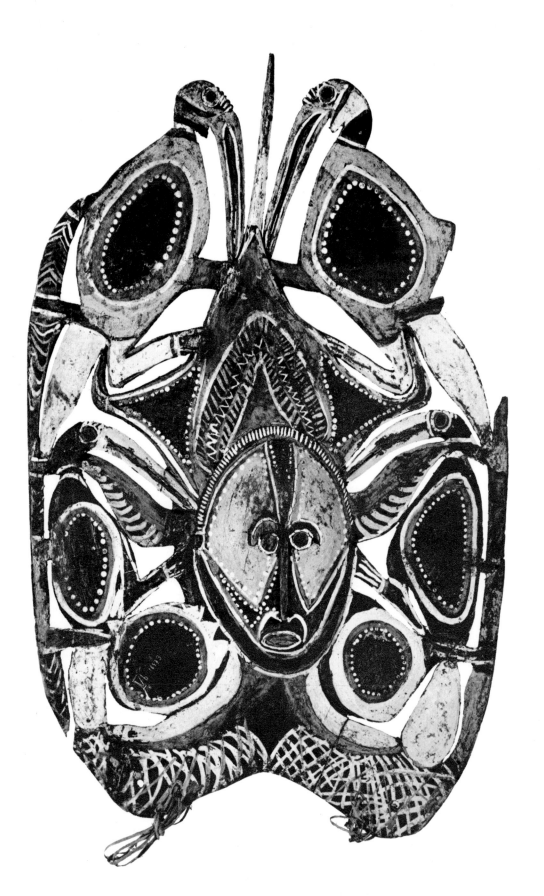

PLATE 48. HORNBILL HEADDRESS
New Guinea, North Maprik, Kwambigum (A. Forge, 1959)
Height 29 1/2″
Museum für Völkerkunde, Basel

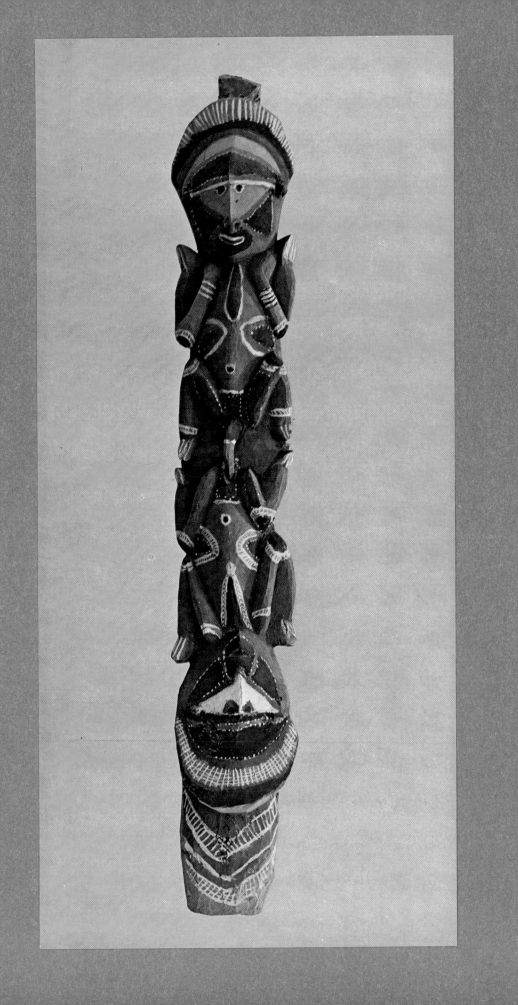

COLORPLATE 4. *Ku-tagwa* BOARD OR PLAQUE
New Guinea, Maprik area (A. Forge, 1959)
Height 59″
Museum für Völkerkunde, Basel

COLORPLATE 5. *Wulge* BOARD
New Guinea, North Maprik,
Kalabu (A. Forge, 1959)
Height 45 1/4″
Museum für Völkerkunde, Basel

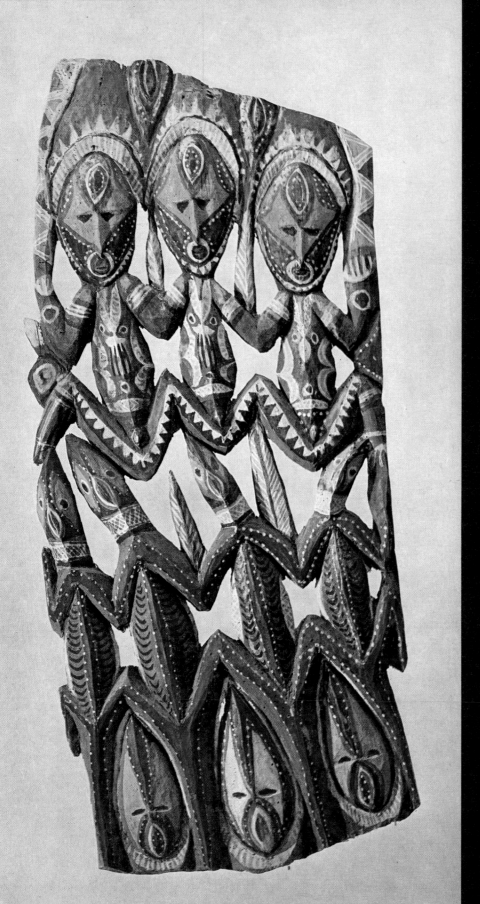

COLORPLATE 6. CEREMONIAL HOUSE
FACADE DECORATION: HORNBILL
New Guinea, Northern Abelam
Height 44 1/4"
Museum of Primitive Art, New York

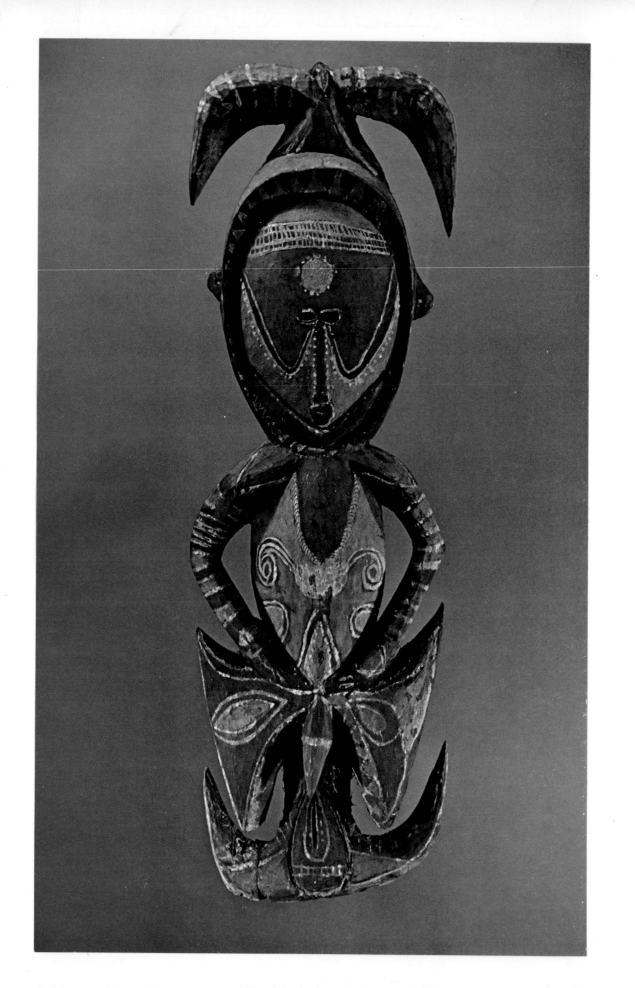

COLORPLATE 7. SUSPENSION HOOK
New Guinea, Abelam
Height 38 1/2″
American Museum of Natural History, New York

COLORPLATE 8. HEADDRESS
New Guinea, Abelam
Height 13 7/8″
American Museum of Natural History, New York

THE SEPIK AREA

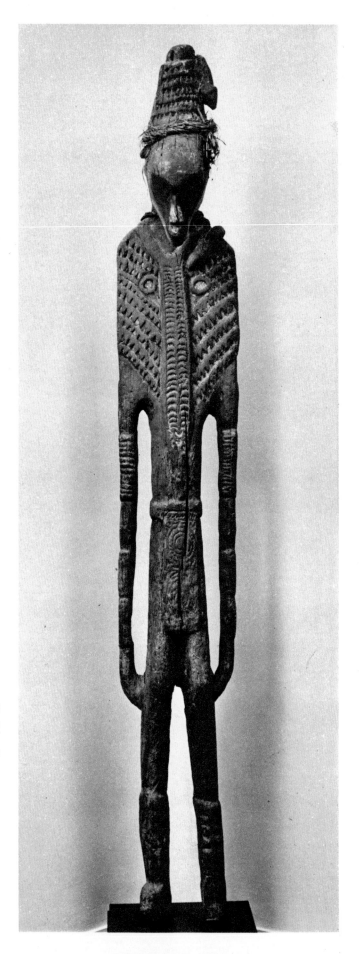

PLATE 49. STANDING MALE FIGURE
New Guinea, Lower Sepik, Singrin (A.B. Lewis, 1909)
Height 80″
Collection Mr. and Mrs. R. Wielgus, Chicago

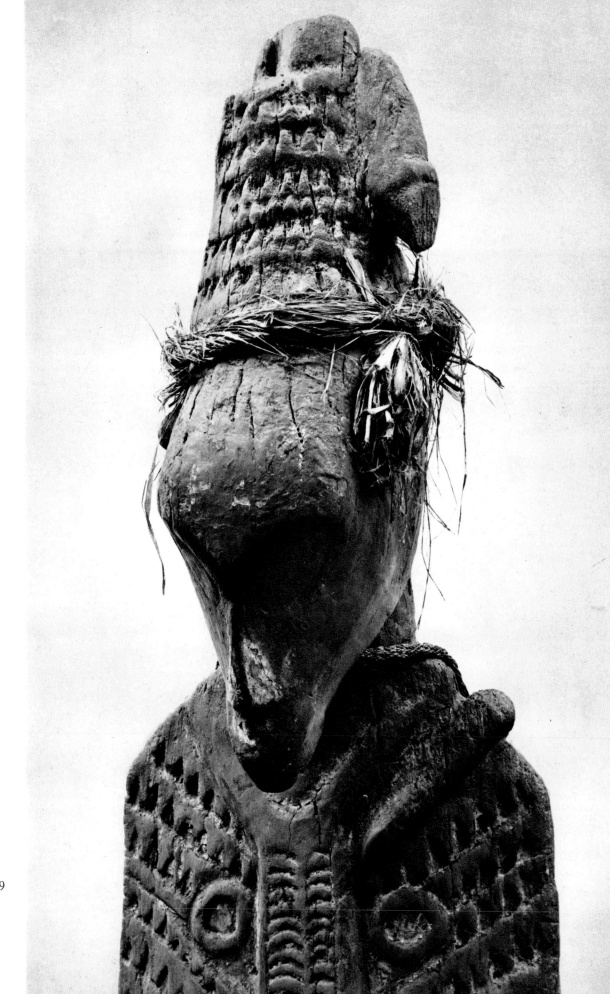

PLATE 50. Detail of Plate 49

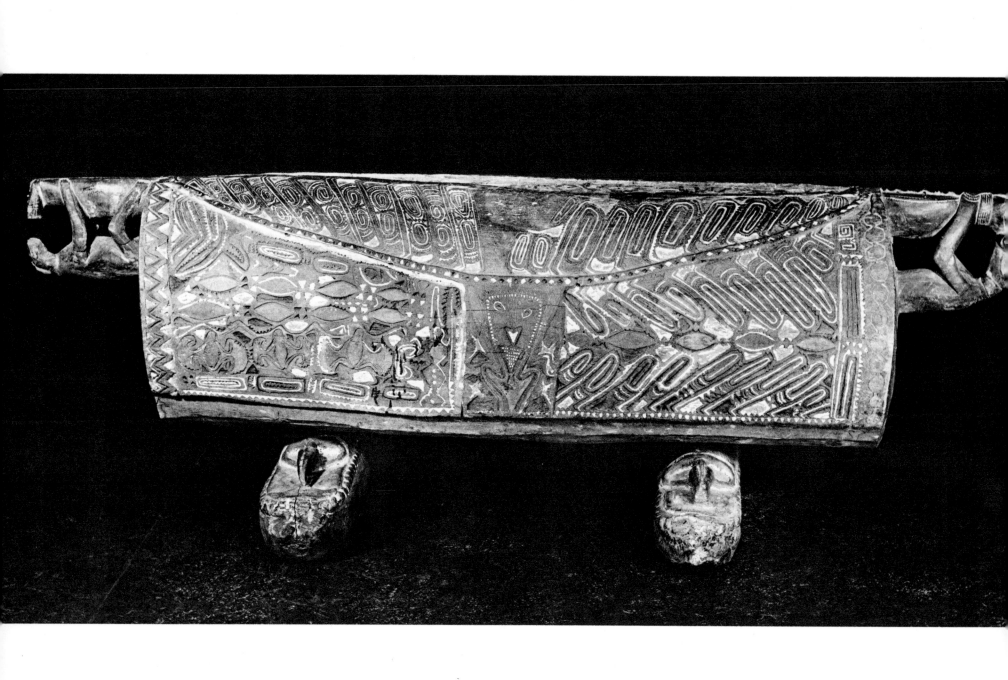

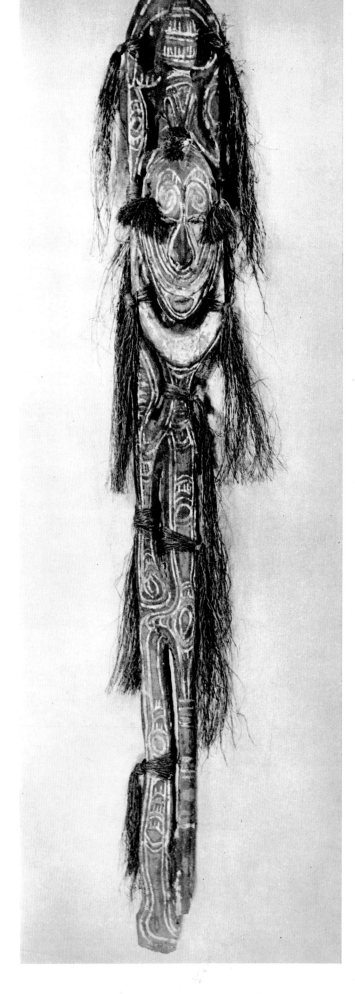

PLATE 51. SLIT GONG
New Guinea, Lower Sepik (Hahl, 1913)
Length 91 3/4″
Linden Museum, Stuttgart

PLATE 52. *Atei* FIGURE
New Guinea, Lower Sepik, Singrin (Behrmann, 1914)
Height 62 1/4″
Linden Museum, Stuttgart

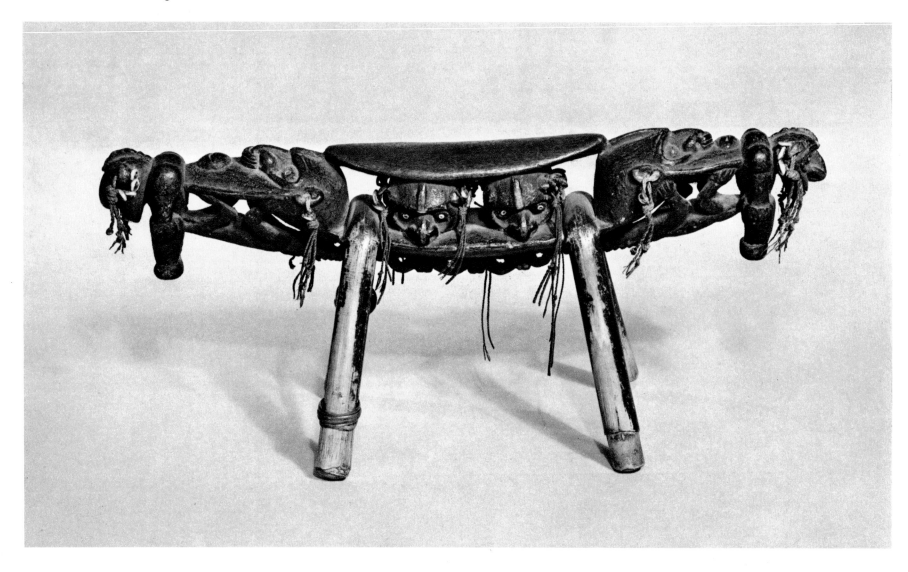

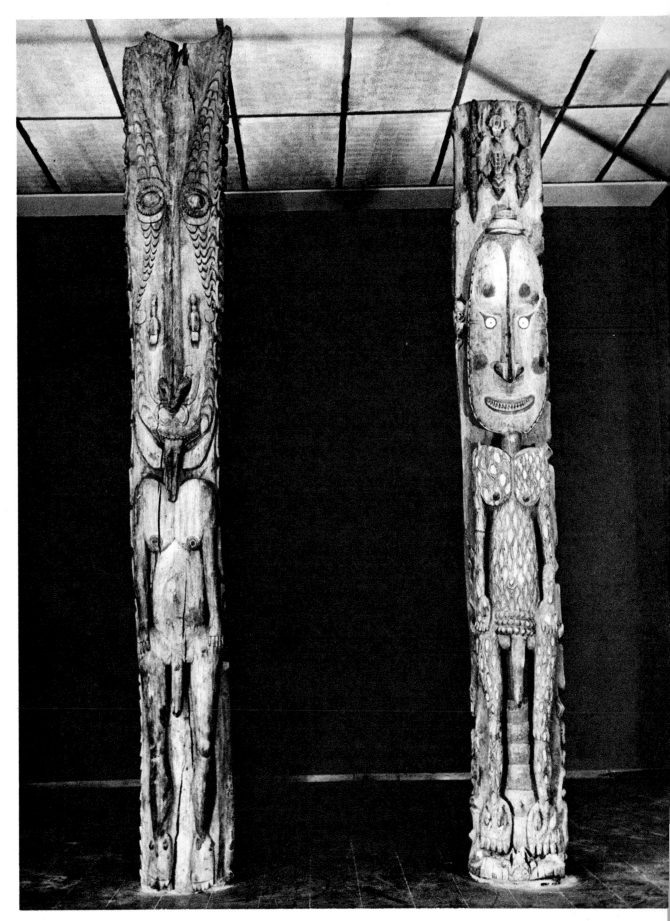

PLATE 54. HOUSE POST (two parts)
New Guinea, Middle Sepik,
Kanganaman (Markert, 1961)
Combined height 28'2"
Linden Museum, Stuttgart

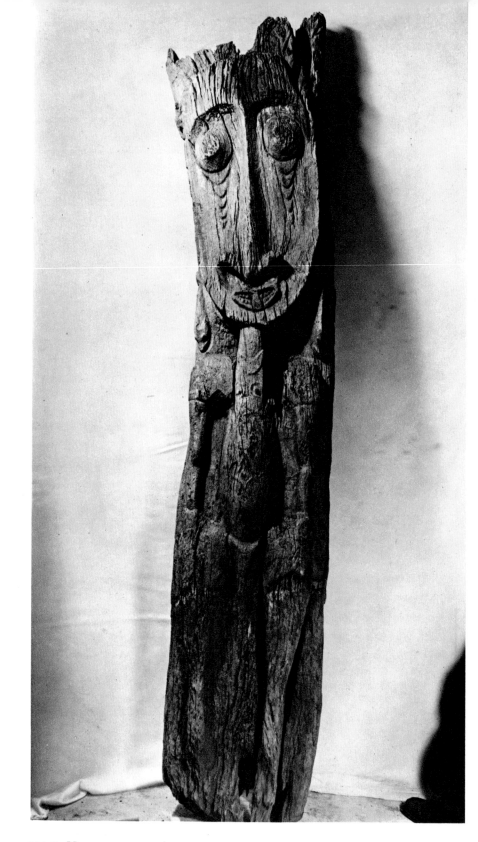

PLATE 55. HOUSE POST
New Guinea, Middle Sepik, Nyauranggei (Forge, 1961)
Height 84″
British Museum, London

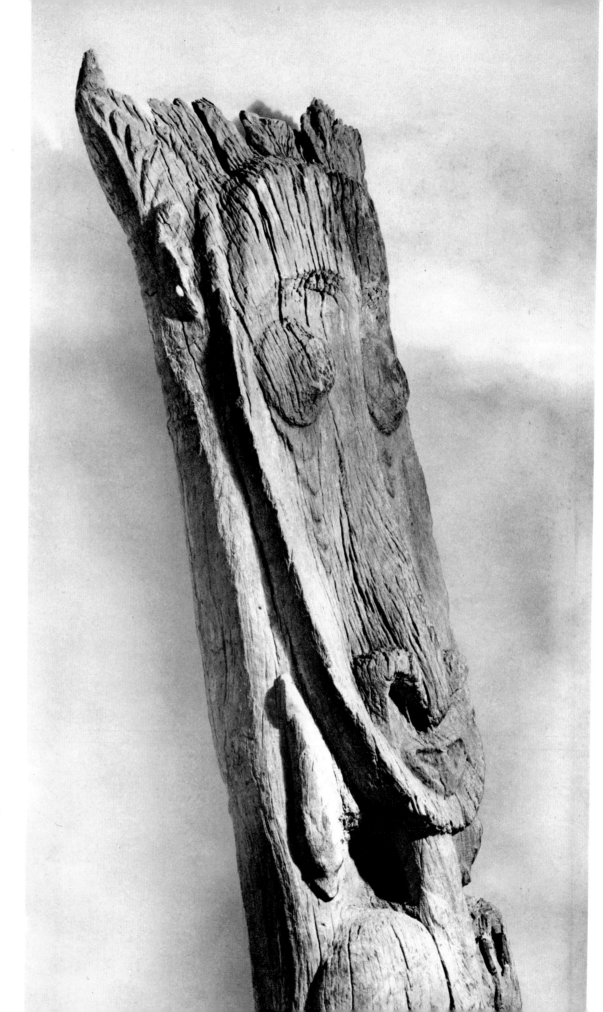

PLATE 56. Detail of Plate 55

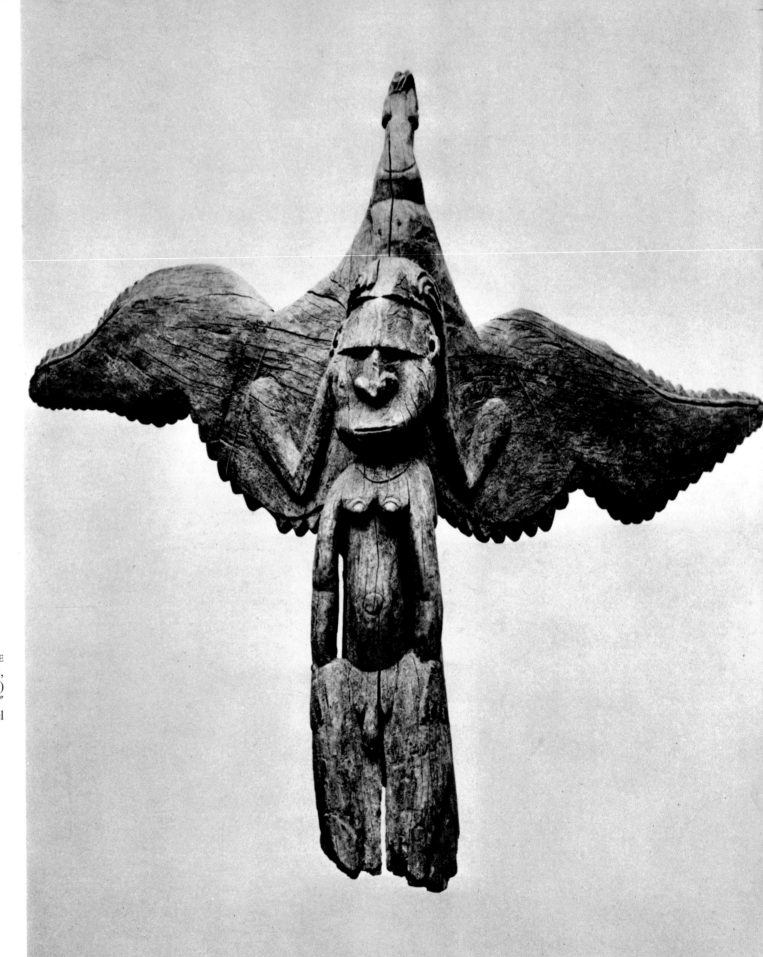

PLATE 57. FINIAL OF CEREMONIAL HOUSE
New Guinea, Middle Sepik,
Korogo (Bühler, 1959)
Height 43 1/4″
Museum für Völkerkunde, Basel

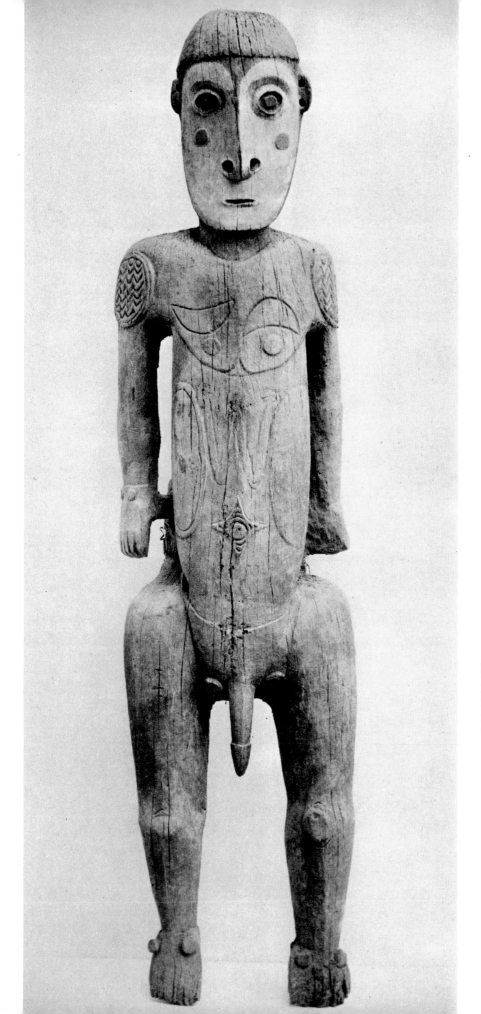

PLATE 58. MALE FIGURE
New Guinea, Middle Sepik,
Sawos area, Yamok (Bühler, 1959)
Height 84 5/8″
Museum für Völkerkunde, Basel

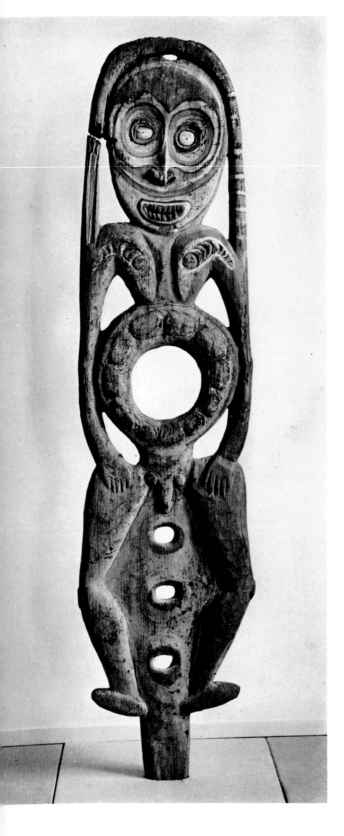

PLATE 59. FIGURE OF BETMAN-GAMBI
New Guinea, Middle Sepik, Mindimbit (P. Wirz)
Height 87 3/4″
Tropenmuseum, Amsterdam

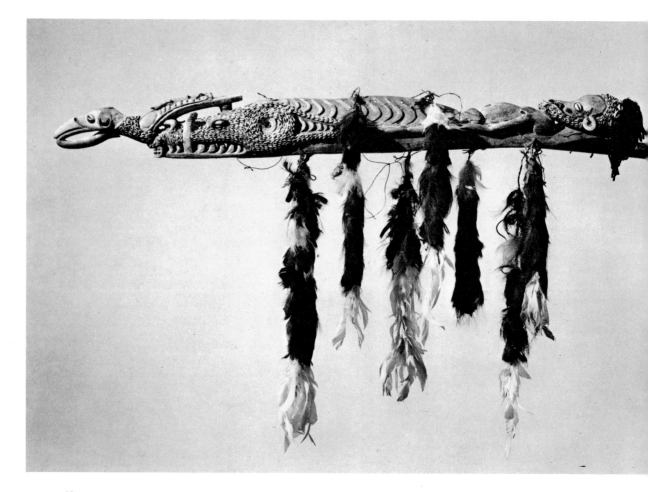

PLATE 60. CROCODILE CARVING FOR MORTUARY RITES,
ASSOCIATED WITH FIGURE OF BETMAN-GAMBI
New Guinea, Middle Sepik, Mindimbit (P. Wirz)
Length 46 1/2″
Tropenmuseum, Amsterdam

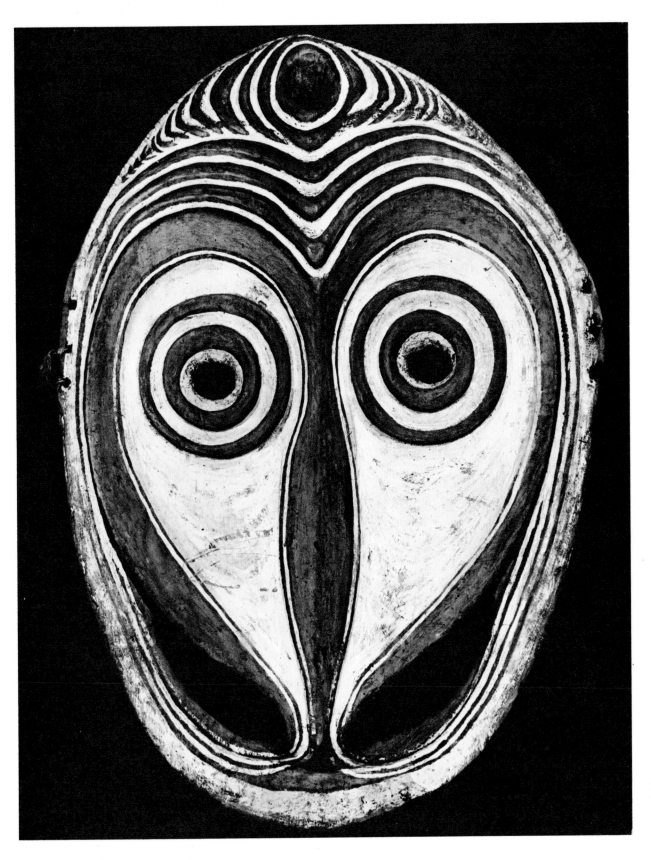

PLATE 61. GABLE MASK
New Guinea, Middle Sepik (Haug)
Height 36 5/8"
Linden Museum, Stuttgart

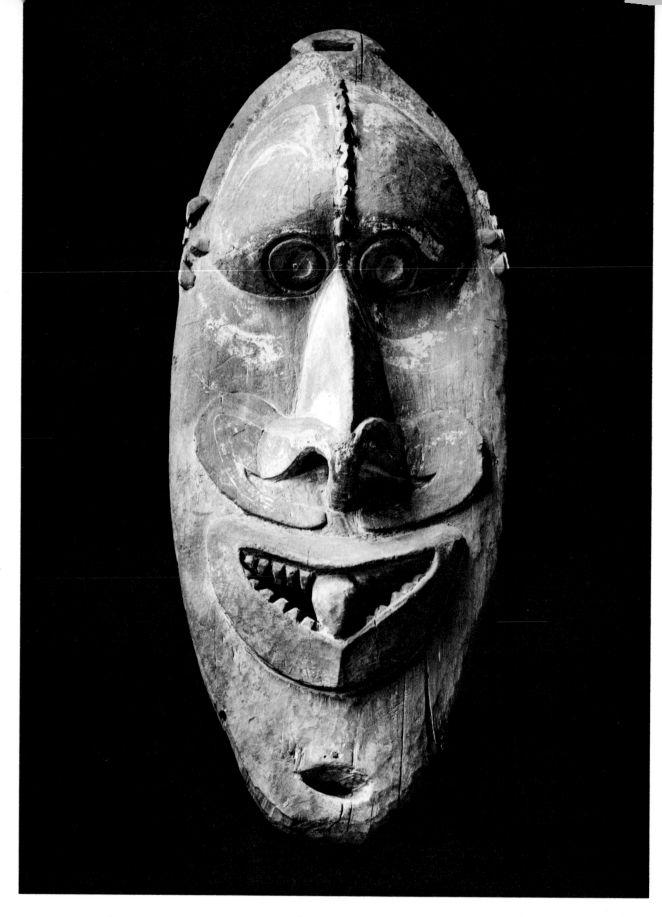

PLATE 62. GABLE MASK
New Guinea, Middle Sepik,
Tambanum (Speiser, 1930)
Height 44 1/8″
Museum für Völkerkunde, Basel

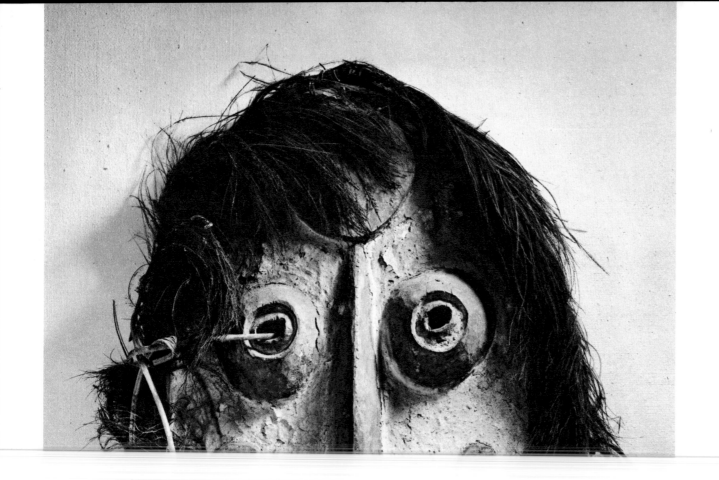

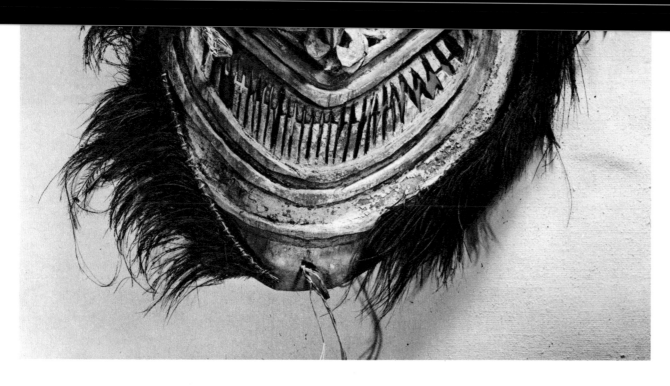

PLATE 63. GABLE MASK
New Guinea, Middle Sepik,
Lake Chambri, Yambi-Yambi (D. Wirz, 1955)
Height 35 3/8″
Museum für Völkerkunde, Basel

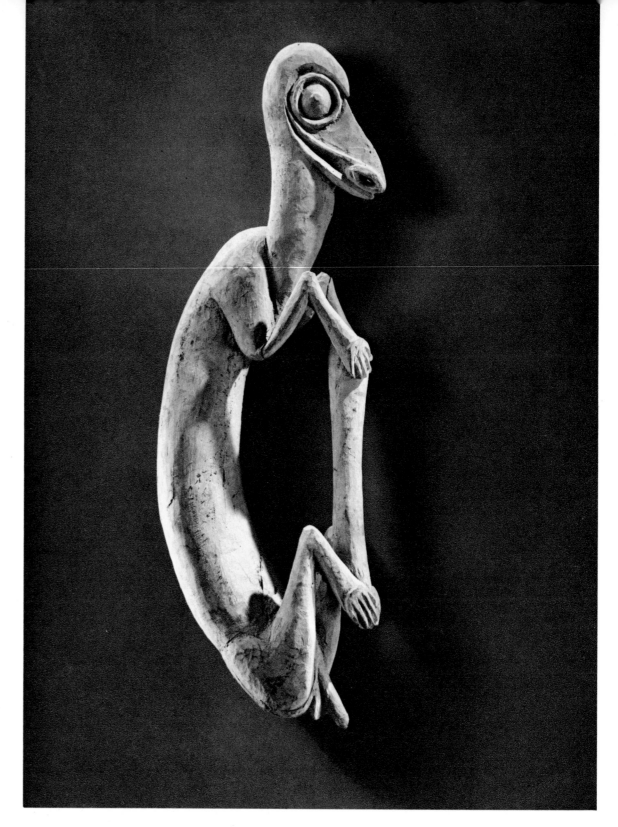

PLATE 64. ANIMAL FIGURE
New Guinea, Middle Sepik, Lake Chambri
Height 22 1/2″
Museum für Völkerkunde, Basel

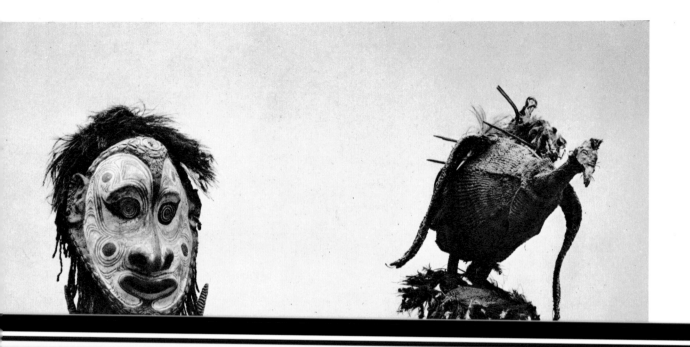

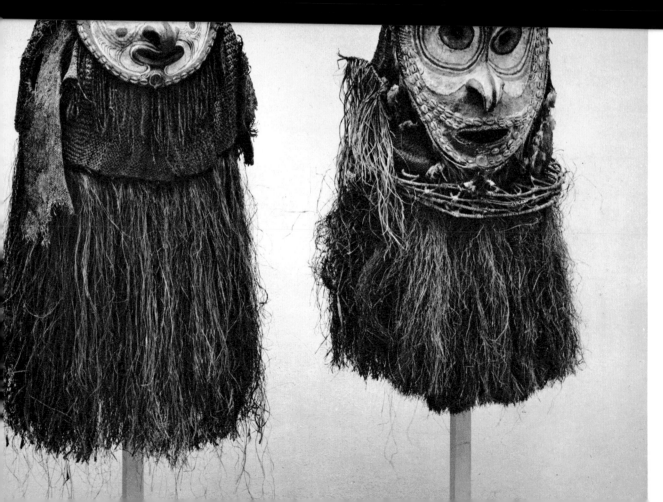

PLATE 65. CLAN MASK COSTUMES
Left: New Guinea, Middle Sepik,
Kararau (Bühler, 1955–56)
Height 68 7/8″
Right: New Guinea, Middle Sepik,
Mindimbit (D. Wirz. 1955)
Height 65″
Museum für Völkerkunde, Basel

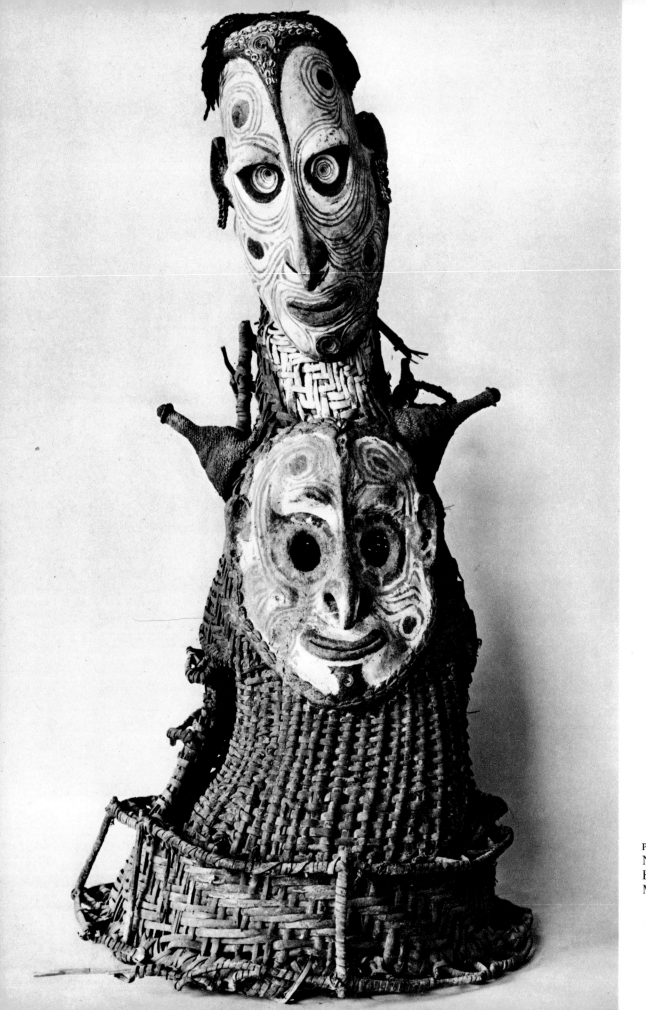

PLATE 66. DANCE COSTUME
New Guinea, Middle Sepik, Kararau (A. Forge, 1963)
Height 40 1/8″
Museum für Völkerkunde, Basel

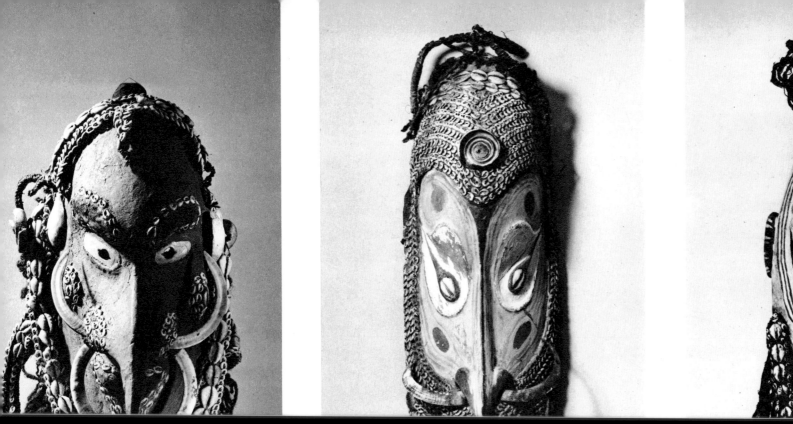

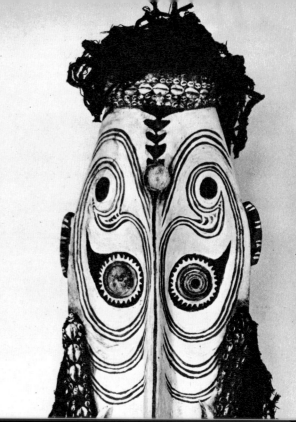

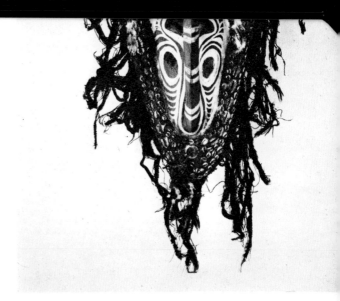

PLATE 67. MASK OF DANCE COSTUME
New Guinea, Middle Sepik,
Kanduanum (Bühler, 1955–56)
Height 25 1/4″
Museum für Völkerkunde, Basel

PLATE 68. *Wolisamban* MASK OF DANCE COSTUME
New Guinea, Middle Sepik,
Kararau (Bühler, 1955–56)
Height 24 3/8″
Museum für Völkerkunde, Basel

PLATE 69. MASK OF DANCE COSTUME
New Guinea, Middle Sepik,
Kamindibit (Bühler, 1959)
Height 32 5/8″
Museum für Völkerkunde, Basel

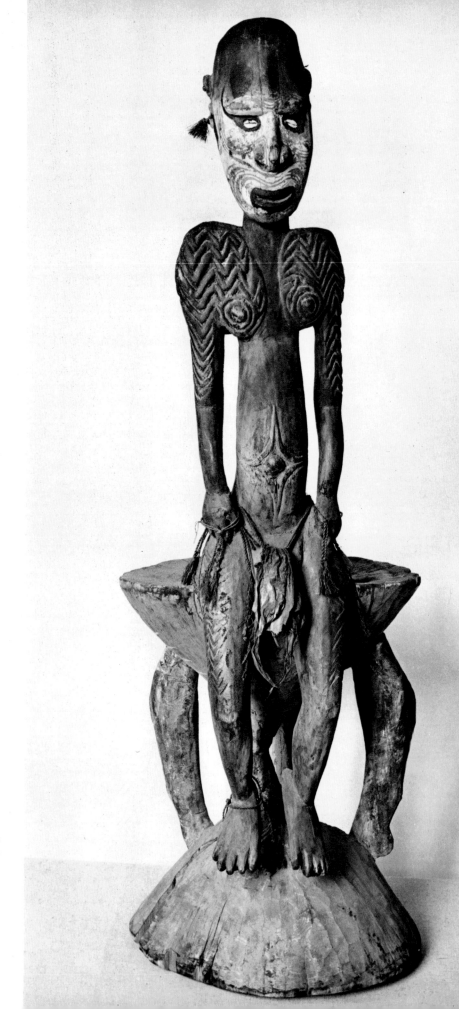

PLATE 70. CEREMONIAL STOOL
New Guinea, Middle Sepik, Kanduanum (Speiser, 1930)
Height 62 1/4″
Museum für Völkerkunde, Basel

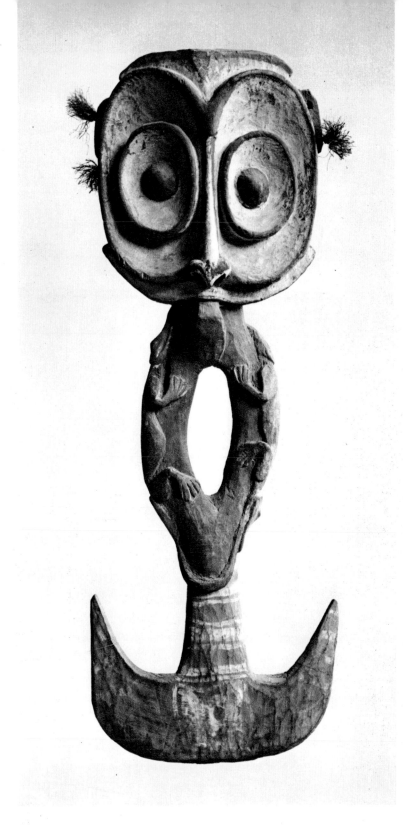

PLATE 71. SUSPENSION HOOK
New Guinea, Middle Sepik (Speiser, 1930)
Height 41″
Museum für Völkerkunde, Basel

PLATE 72. SUSPENSION HOOK
New Guinea, Middle Sepik, Lake Chambri, Sangriman (Bühler, 1959)
Height 18 7/8″
Museum für Völkerkunde, Basel

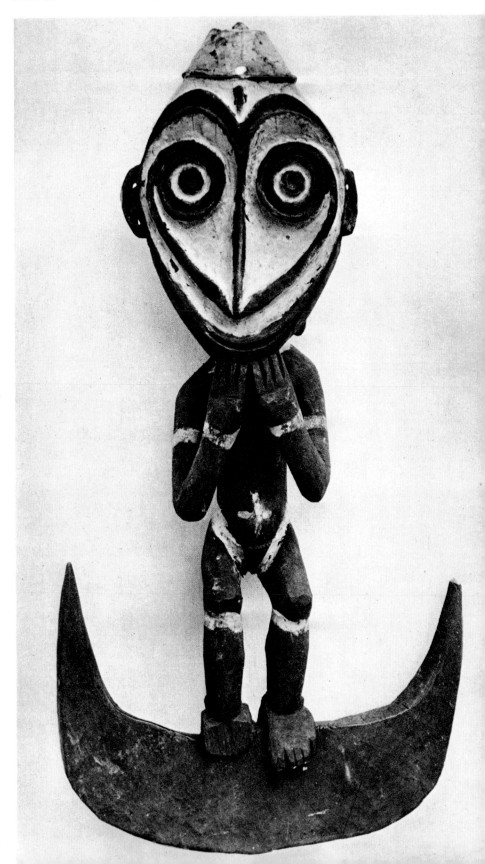

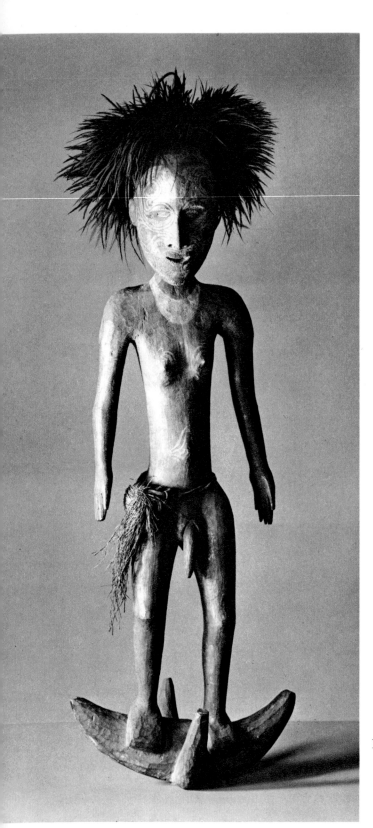

PLATE 73. SUSPENSION HOOK
New Guinea, Middle Sepik,
Kararau (Bühler, 1955–56)
Height 37 3/4"
Museum für Völkerkunde, Basel

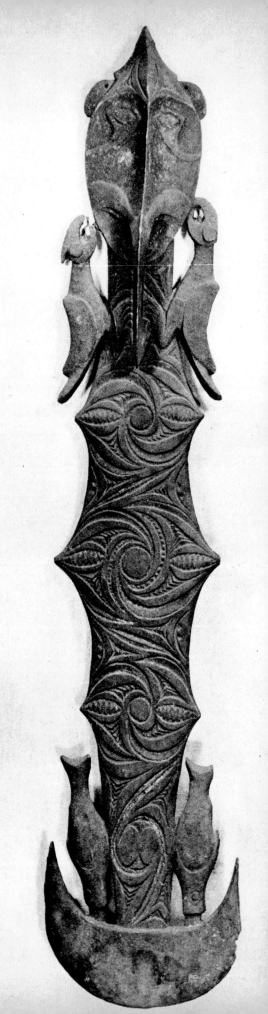

PLATE 74. SUSPENSION HOOK
New Guinea, Middle Sepik, Blackwater River (Häberle)
Height 53 1/8"
Linden Museum, Stuttgart

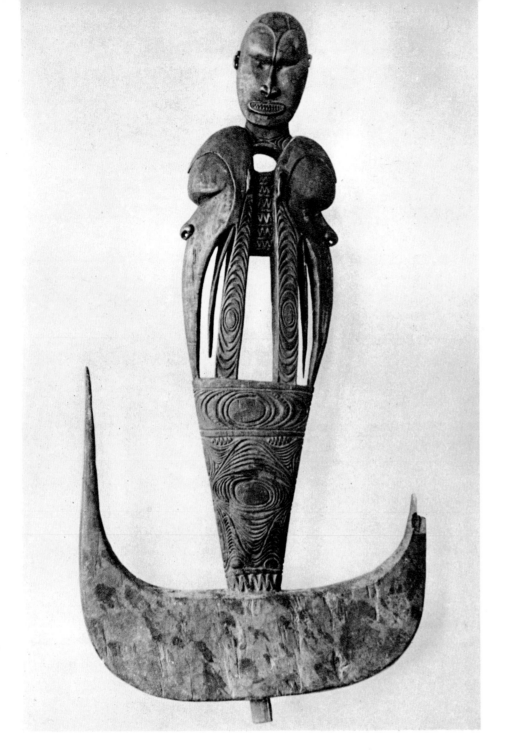

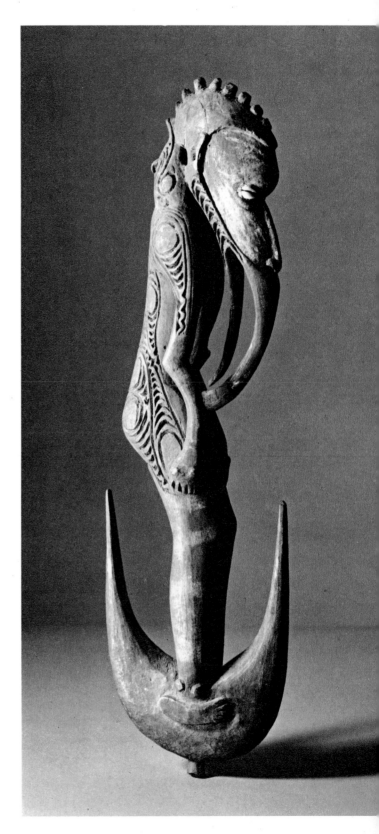

PLATE 75. SUSPENSION HOOK
New Guinea, Middle Sepik, Blackwater River, Kaningra (D. Wirz, 1962)
Height 31 1/2″
Museum für Völkerkunde, Basel

PLATE 76. SUSPENSION HOOK
New Guinea, Middle Sepik, Lake Chambri, Kilimbit (D. Wirz, 1962)
Height 24 3/8″
Museum für Völkerkunde, Basel

PLATE 77. HORIZONTAL SUSPENSION HOOK
New Guinea, Middle Sepik (Haug)
Length 9′1″
Linden Museum, Stuttgart

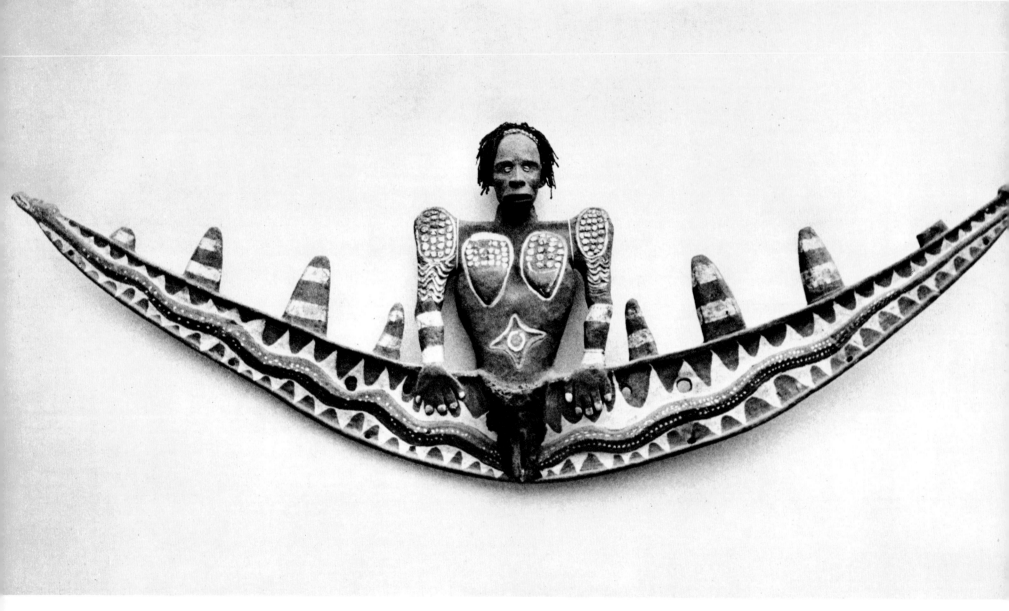

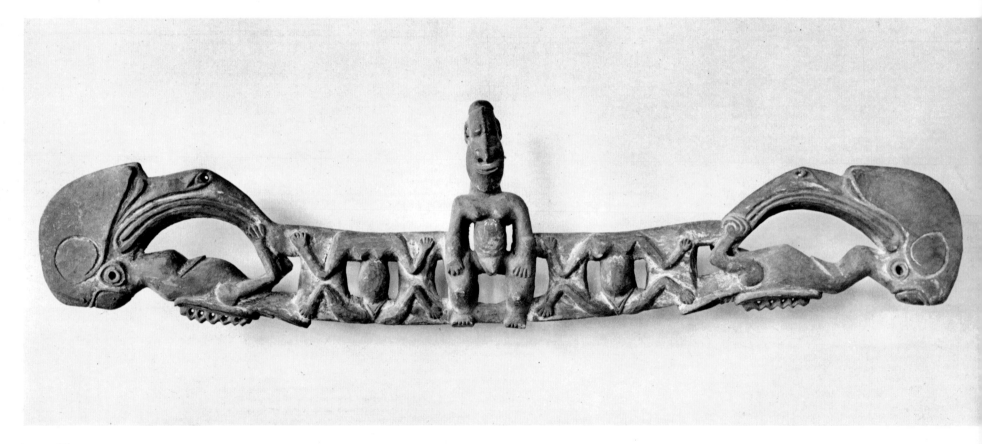

PLATE 78. GABLE ORNAMENT OF CEREMONIAL HOUSE
New Guinea, Middle Sepik, Sawos area (Bühler, 1959)
Length 36 5/8″
Museum für Völkerkunde, Basel

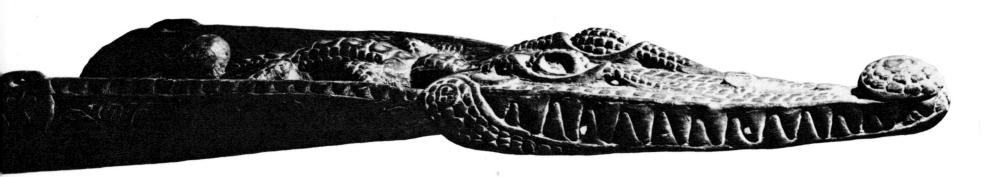

PLATE 79. PROW ORNAMENT
New Guinea, Middle Sepik, Iatmul Tribe
Length 78″
Museum of Primitive Art, New York

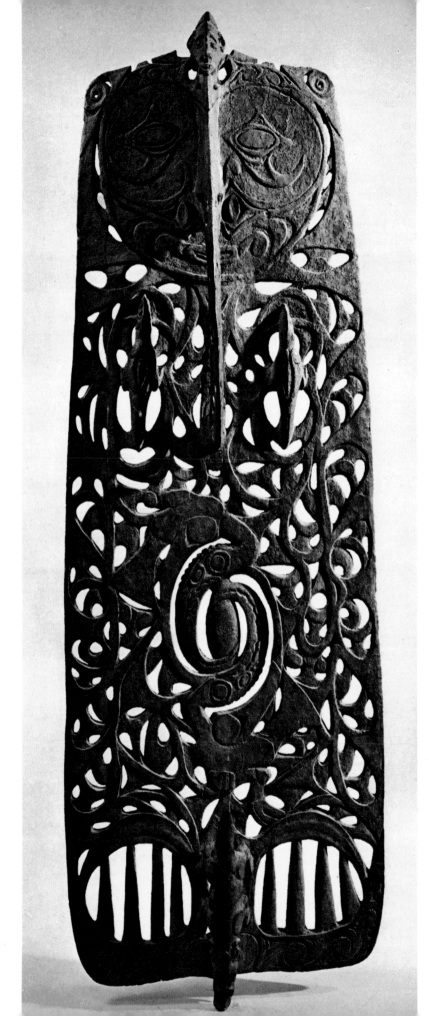

PLATE 80. *Malu* CEREMONIAL BOARD
New Guinea, Middle Sepik, Sawos Tribe
Height 83 1/8″
Museum of Primitive Art, New York

PLATE 81. HEADREST
New Guinea, Middle Sepik, Timbunke (Bohmig, 1924)
Length 42 1/8″
Museum of the University of Pennsylvania, Philadelphia

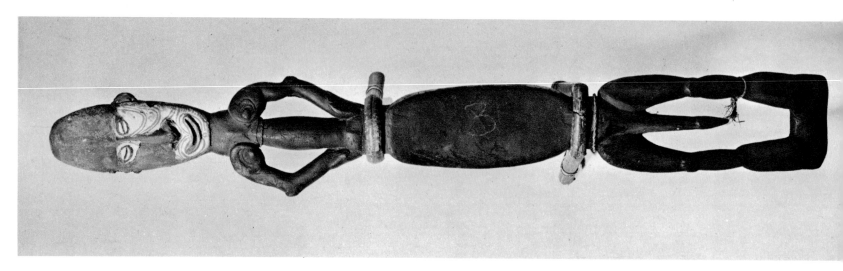

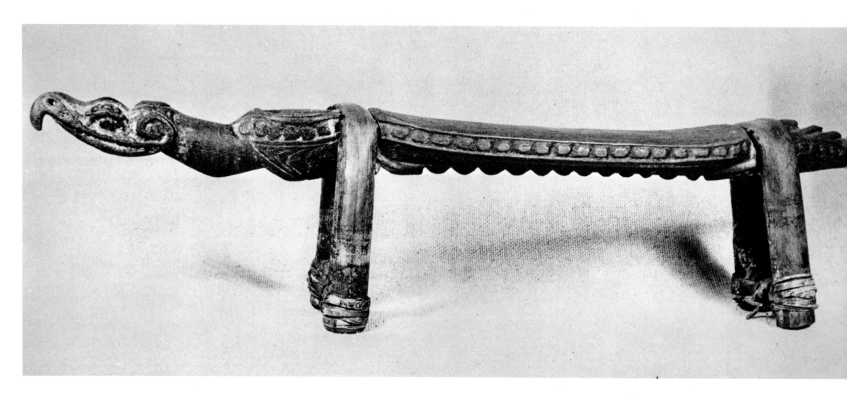

PLATE 82. HEADREST
New Guinea, Middle Sepik
Length 19 5/8″
Linden Museum, Stuttgart

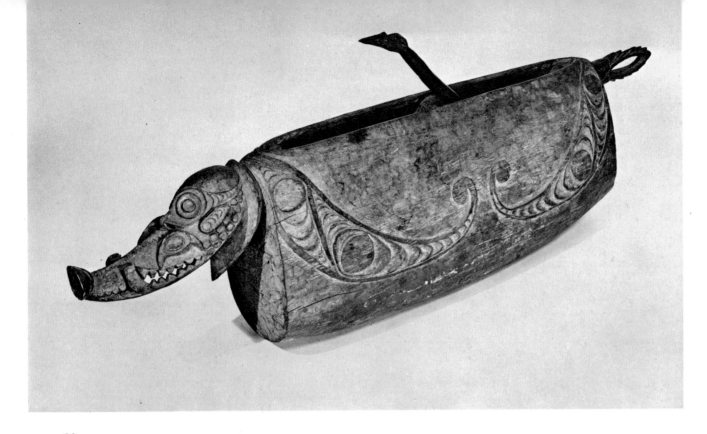

PLATE 83. SLIT GONG
New Guinea, Middle Sepik, Angriman (Chinnery, 1928)
Length 45 1/4″
University Museum of Archaeology and Ethnology, Cambridge, England

PLATE 84. SLIT GONG
New Guinea, Middle Sepik (Class, 1914)
Length 83 1/8″
Linden Museum, Stuttgart.

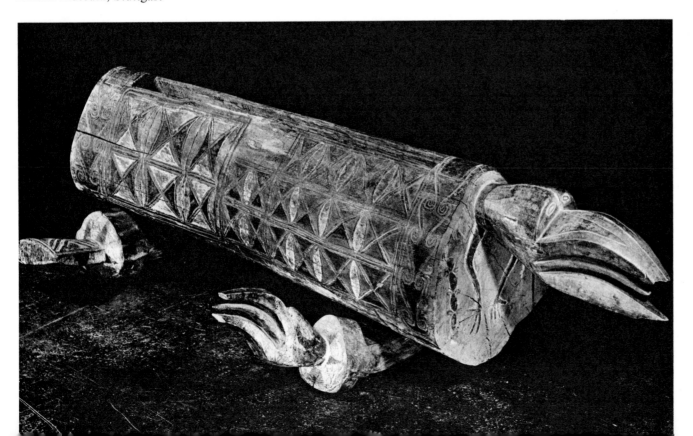

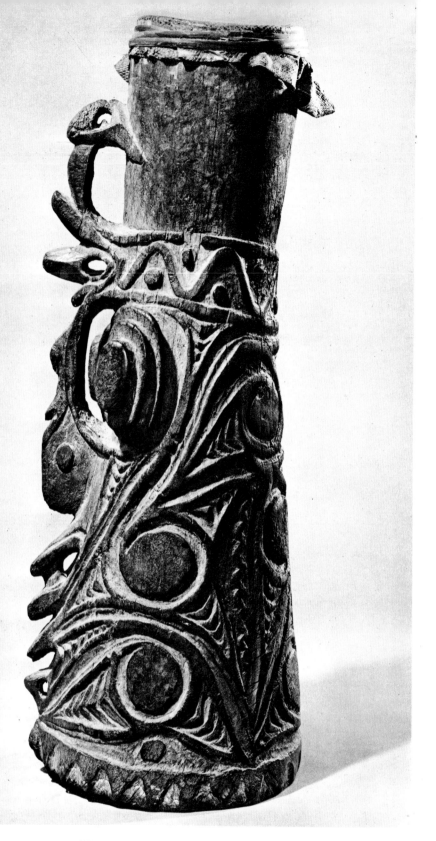

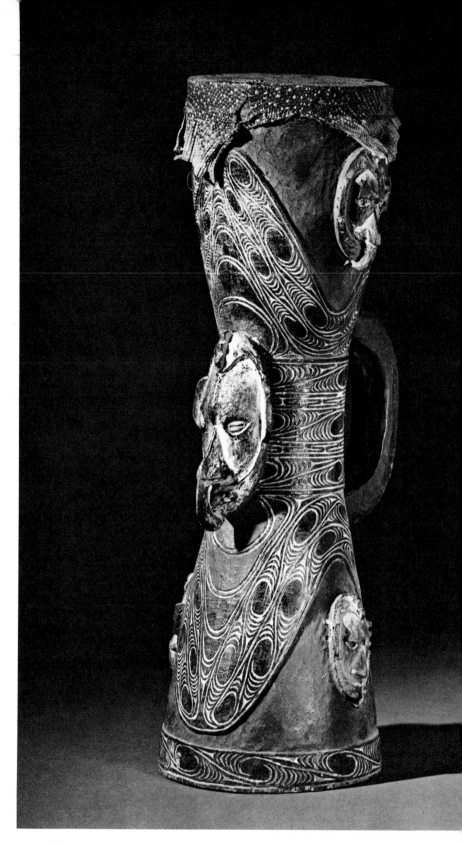

PLATE 85. HAND DRUM
New Guinea, Middle Sepik
Height 25 1/4″
Collection N. Heinrich, Stuttgart

PLATE 86. HAND DRUM
New Guinea, Middle Sepik (Markert, 1963)
Height 22 7/8″
Collection G. Markert, Munich

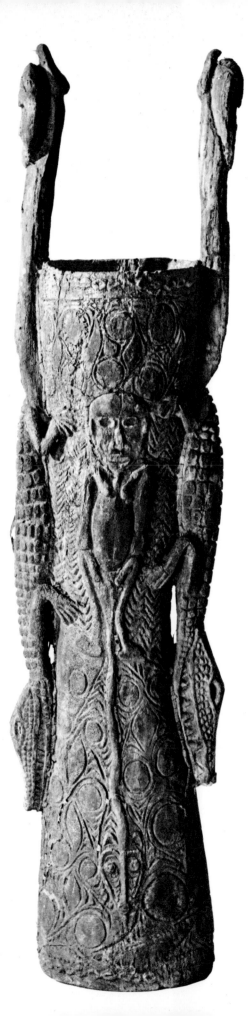

PLATE 87. WATER DRUM
New Guinea, Middle Sepik, Nindugum (Panzenböck, 1963)
Height 33 1/2″
Museum für Völkerkunde, Basel

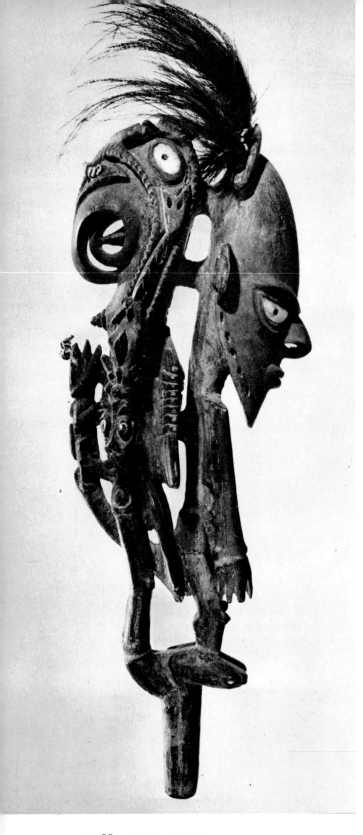

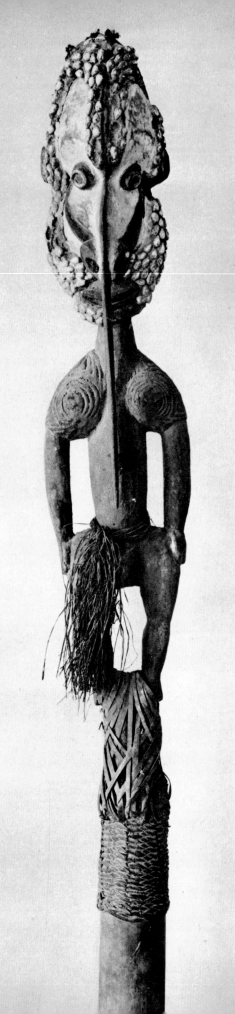

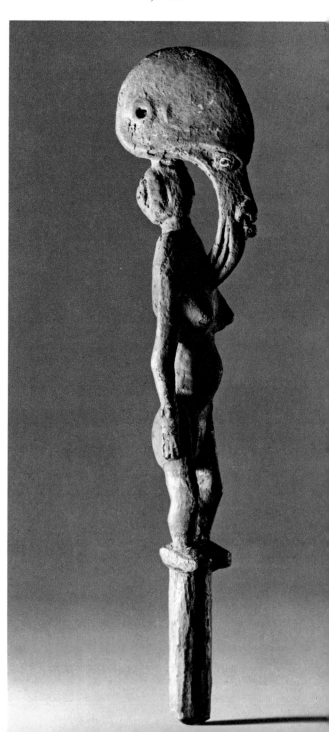

PLATE 89. FLUTE STOPPER
New Guinea, Middle Sepik, Sawos area, Yamok (Bühler)
Height 21 1/4"
Museum für Völkerkunde, Basel

PLATE 90. FLUTE STOPPER
New Guinea, Middle Sepik, Sawos area (Bühler, 1959)
Height 18 1/2"
Museum für Völkerkunde, Basel

PLATE 88. FLUTE STOPPER
New Guinea, Middle Sepik
Height 22"
Peabody Museum, Yale University, New Haven

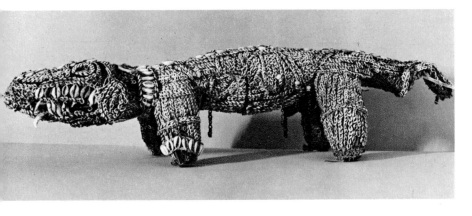

PLATE 91. FETISH IN DOG FORM
New Guinea, Sepik District, Keram River (Kohler, 1960)
Length 31 1/8″
Collection P. Kohler, Ascona, Switzerland

PLATE 92. MASKLIKE CARVING
New Guinea, Sepik District, Keram River
Length 29 1/2″
Missie Museum, Steyl, The Netherlands

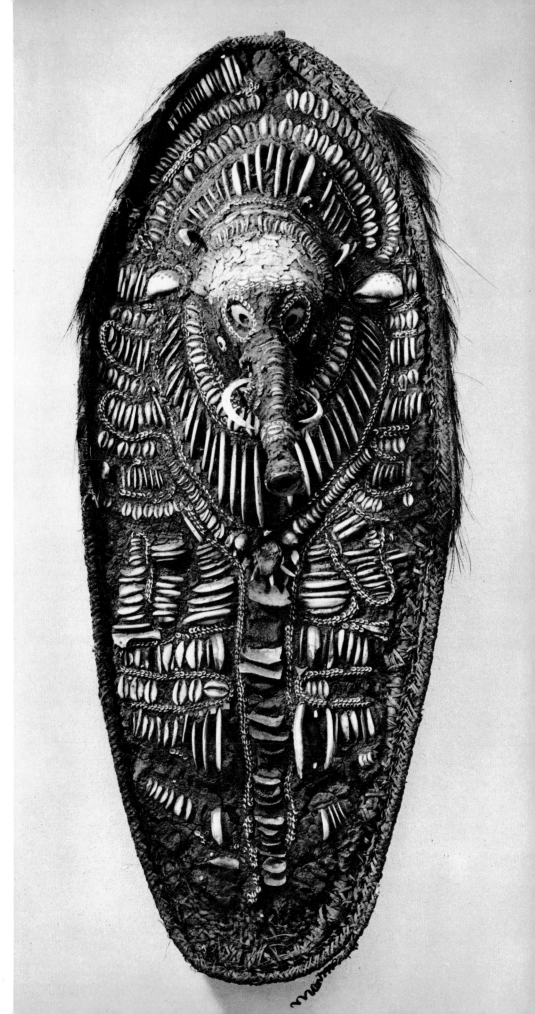

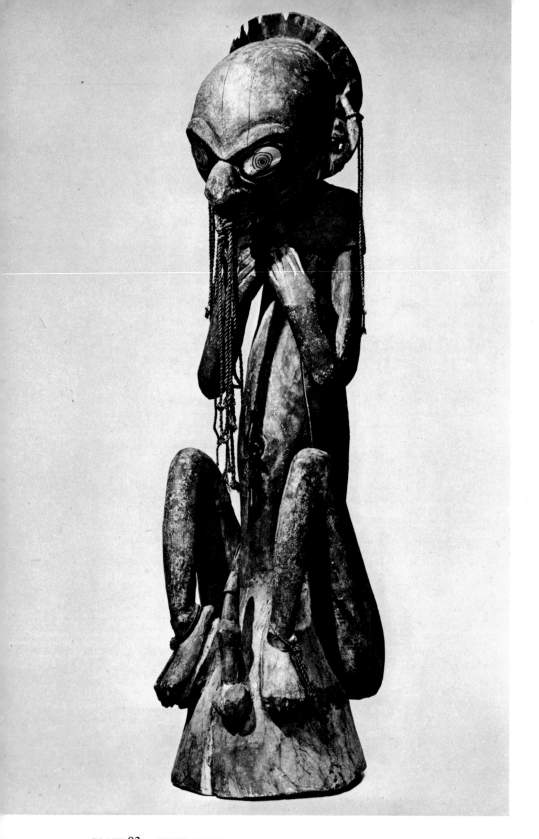

PLATE 93. HOUSE FINIAL
New Guinea, Sepik District, Yuat River (Bateson, 1930)
Height 37″
University Museum of Archaeology and Ethnology, Cambridge, England

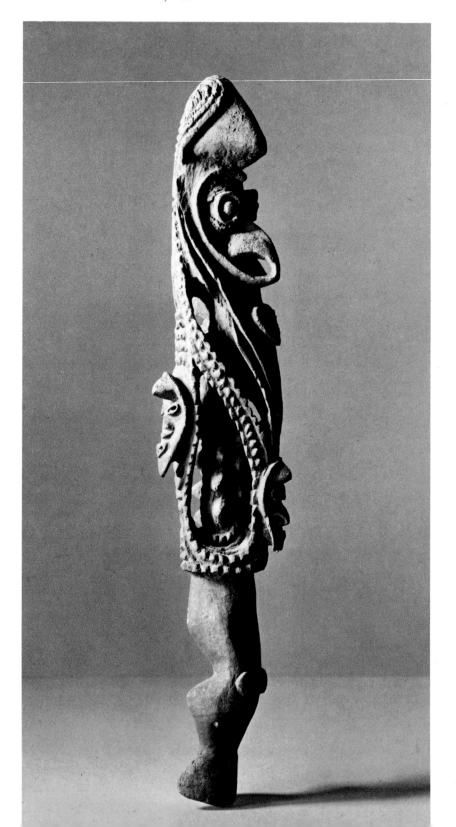

PLATE 94. MALE FIGURE
New Guinea, Sepik District, Yuat River, Bun (D. Wirz, 1962)
Height 24″
Museum für Völkerkunde, Basel

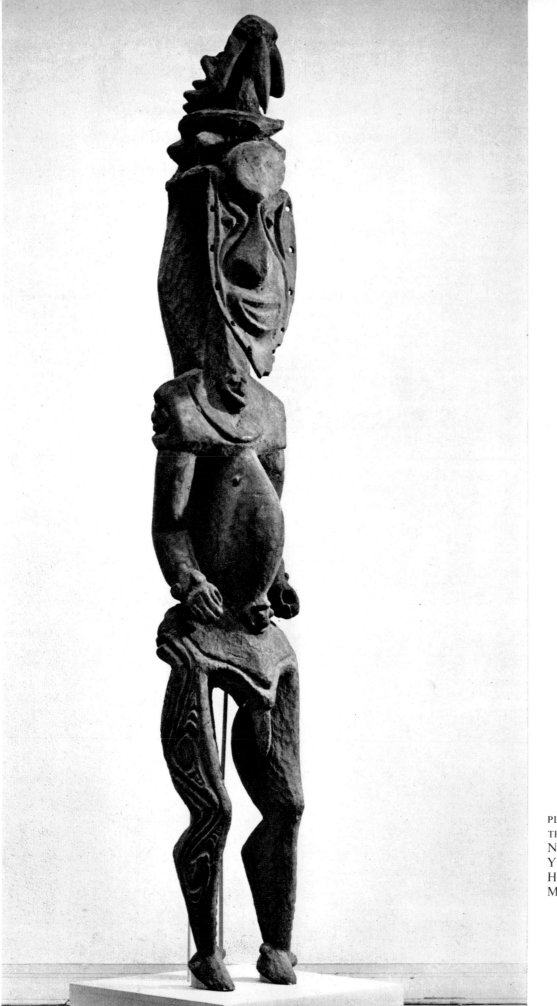

PLATE 95. MALE FIGURE REPRESENTING
THE GOD AMBOSSANGMAKAN
New Guinea, Sepik District,
Yuat River, Mansuat (D. Wirz, 1955)
Height 95 1/4″
Museum für Völkerkunde, Basel

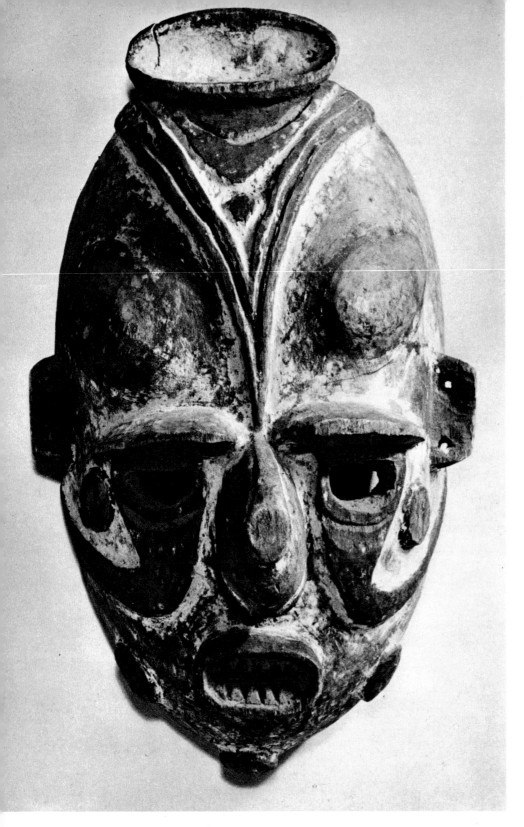

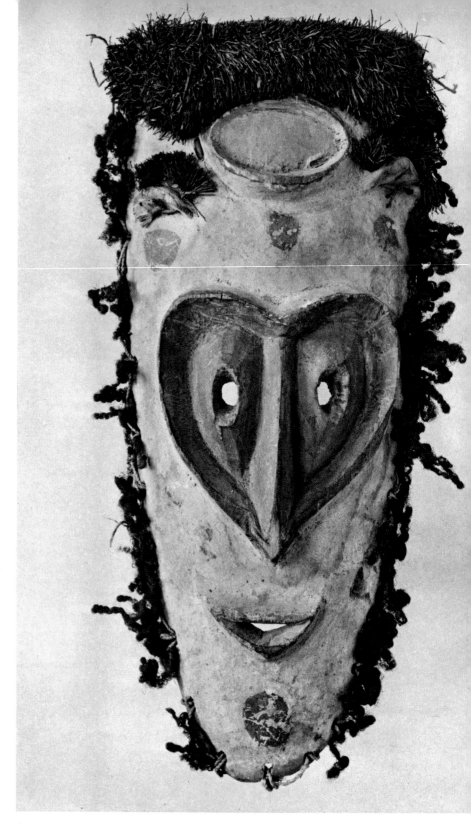

PLATE 96. MASK OF DANCE COSTUME
New Guinea, Sepik District, Yuat River
Height 16 1/8″
Städtisches Museum für Völkerkunde, Frankfort

PLATE 97. MASK OF DANCE COSTUME
New Guinea, Sepik District, Yuat River, Kinakaton (D.Wirz, 1962)
Height 15 3/8″
Museum für Völkerkunde, Basel

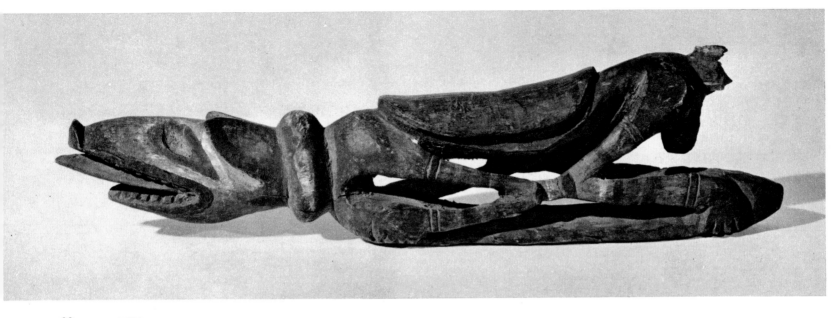

PLATE 98. HEADREST
New Guinea, Sepik District, Yuat River (Mead, 1930)
Length 20 7/8″
American Museum of Natural History, New York

PLATE 99. HEADREST
New Guinea, Sepik District, Yuat River (Mead, 1930)
Length 15 3/8″
American Museum of Natural History, New York

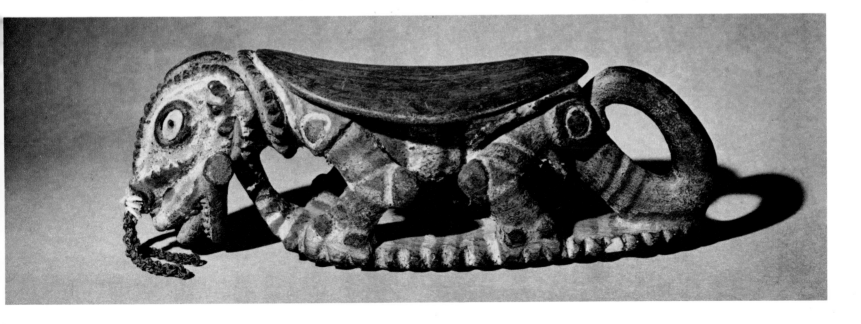

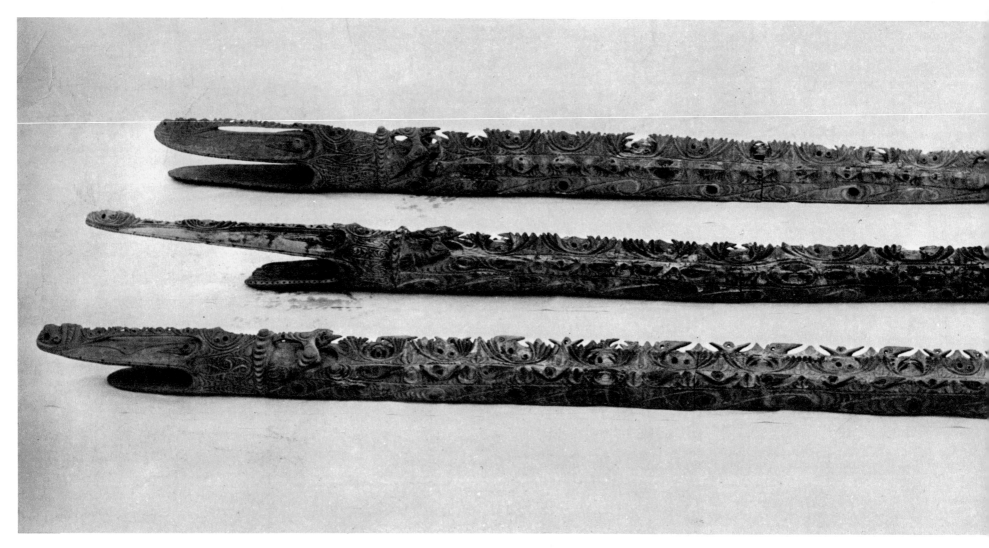

PLATE 100. THREE CROCODILE CARVINGS
New Guinea, Sepik District, Korewori River (Bühler, 1959)
Length 22′
Museum für Völkerkunde, Basel

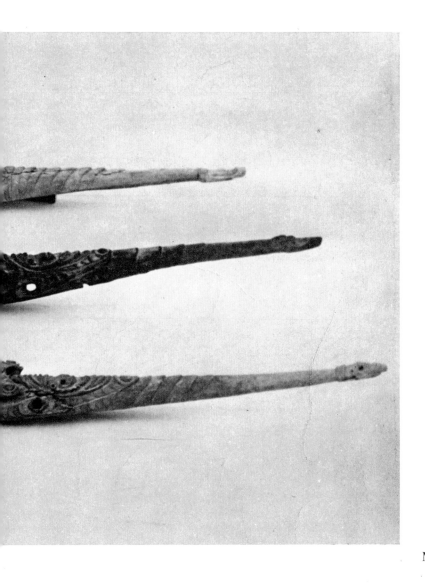

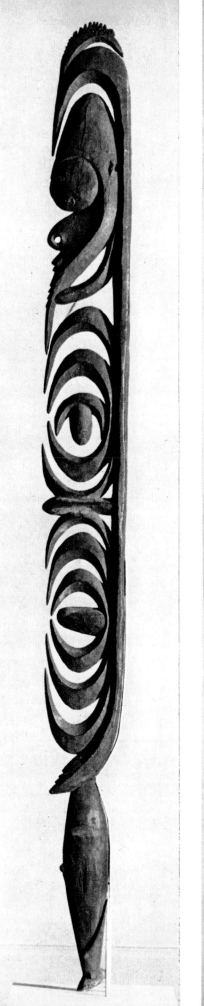

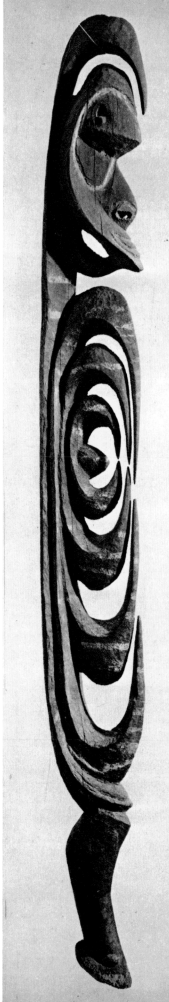

PLATE 101. *Yipwon* FIGURE
New Guinea, Sepik District,
Upper Korewori River,
Tschimbud (Bühler, 1959)
Height 92 1/2″
Museum für Völkerkunde, Basel

PLATE 102. *Yipwon* FIGURE
New Guinea, Sepik District,
Upper Korewori River,
Amanggabi (Bühler, 1959)
Height 71 5/8″
Museum für Völkerkunde, Basel

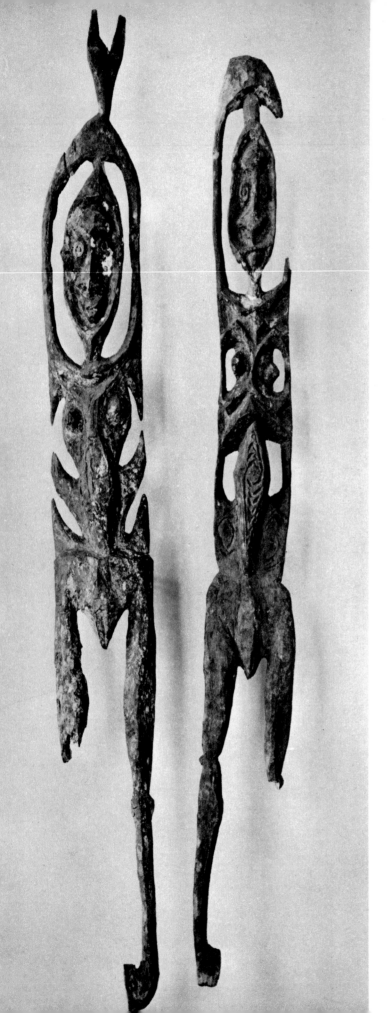

PLATE 103. FEMALE FIGURES
New Guinea, Sepik District,
Upper Korewori River (Panzenböck, 1962)
Left: height 75 1/4″; right: height 74 3/8″
Museum für Völkerkunde, Basel

PLATE 104. FEMALE FIGURE
New Guinea, Sepik District,
Upper Korewori River (Panzenböck, 1962)
Height 32 1/4″
Museum für Völkerkunde, Basel

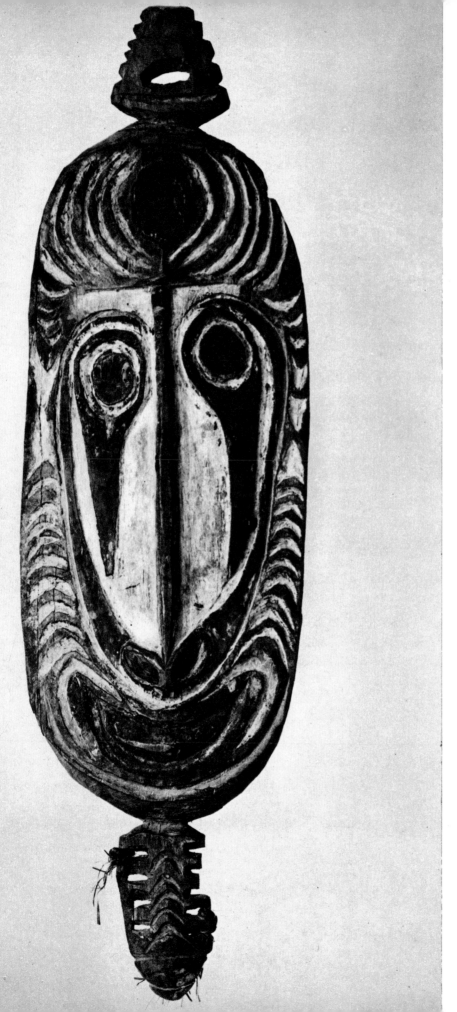

PLATE 105. MASK OF DANCE COSTUME
New Guinea, Sepik District,
Korewori River, Ambanoli (Bühler, 1959)
Height 22″
Museum für Völkerkunde, Basel

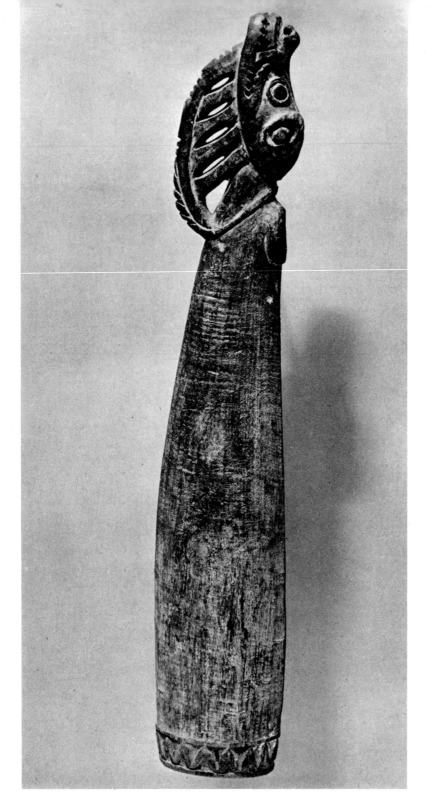

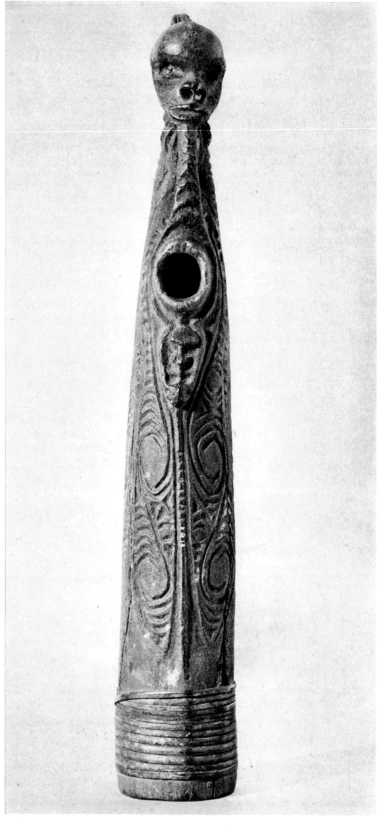

PLATE 107. TRUMPET
New Guinea, Sepik District, Korewori River (Kohler, 1960)
Height 20 1/8″
Collection P. Kohler, Ascona, Switzerland

PLATE 106. TRUMPET WITH CROCODILE HEAD
New Guinea, Sepik District, Korewori River (Kohler, 1960)
Length 22″
Collection P. Kohler, Ascona, Switzerland

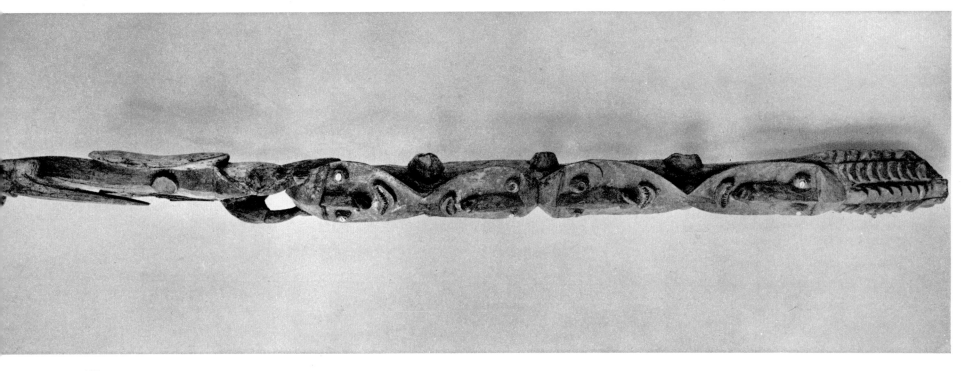

PLATE 108. ORNAMENT OF CEREMONIAL HOUSE
New Guinea, Sepik District, Washkuk area (Bühler, 1959)
Height 45 1/4″
Museum für Völkerkunde, Basel

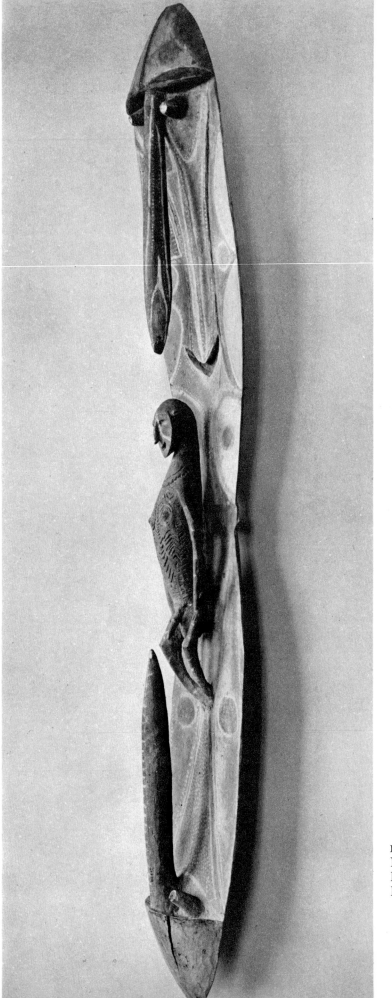

PLATE 109. CARVING FROM CEREMONIAL HOUSE
New Guinea, Sepik District, Washkuk area (Bühler, 1959)
Height 92 1/2″
Museum für Völkerkunde, Basel

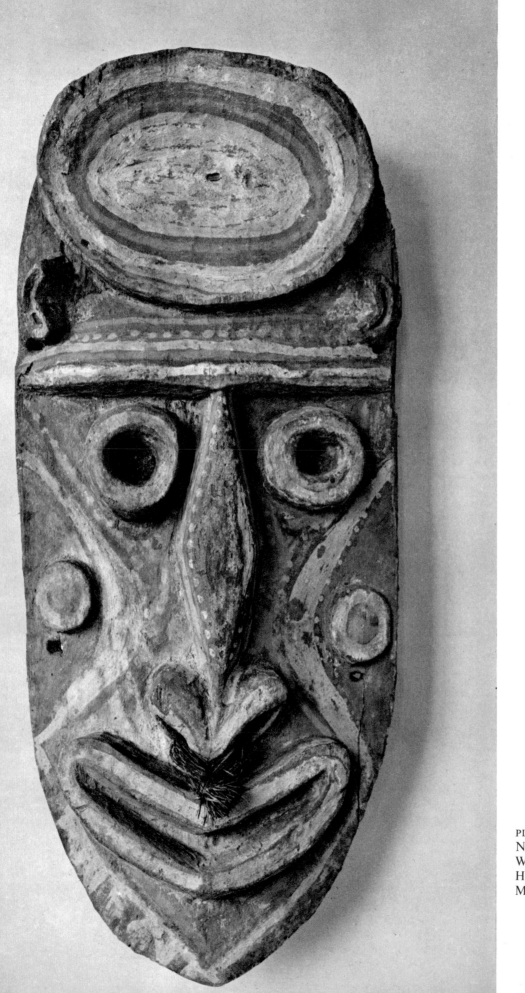

PLATE 110. MASK OF DANCE COSTUME
New Guinea, Sepik District,
Washkuk area, Seserman (D. Wirz, 1962)
Height 27 5/8″
Museum für Völkerkunde, Basel

PLATE 111. MASKLIKE CARVING
New Guinea, Upper Sepik, Swagup (Panzenböck, 1962)
Height 59 7/8″
Museum für Völkerkunde, Basel

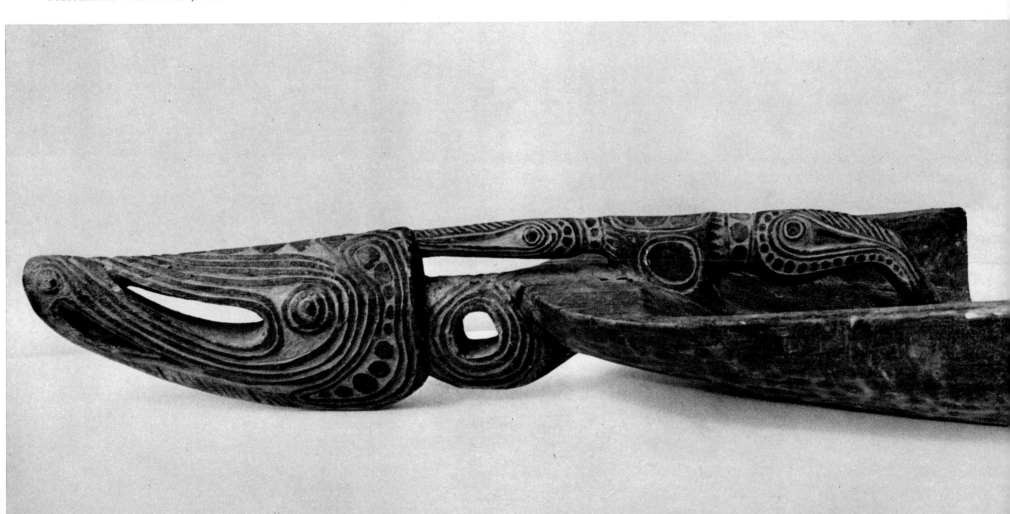

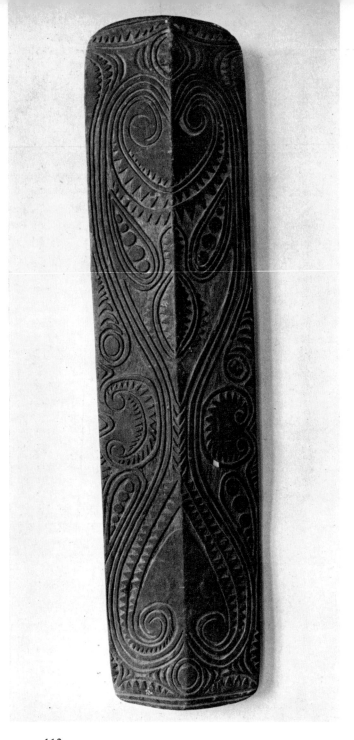

PLATE 113. WAR SHIELD
New Guinea, Upper Middle Sepik, Kupkein (Bühler, 1959)
Height 66 7/8″
Museum für Völkerkunde, Basel

PLATE 114. SHIELD
New Guinea, Upper Sepik, Green River (Panzenböck, 1964)
Length 63″
Museum für Völkerkunde, Basel

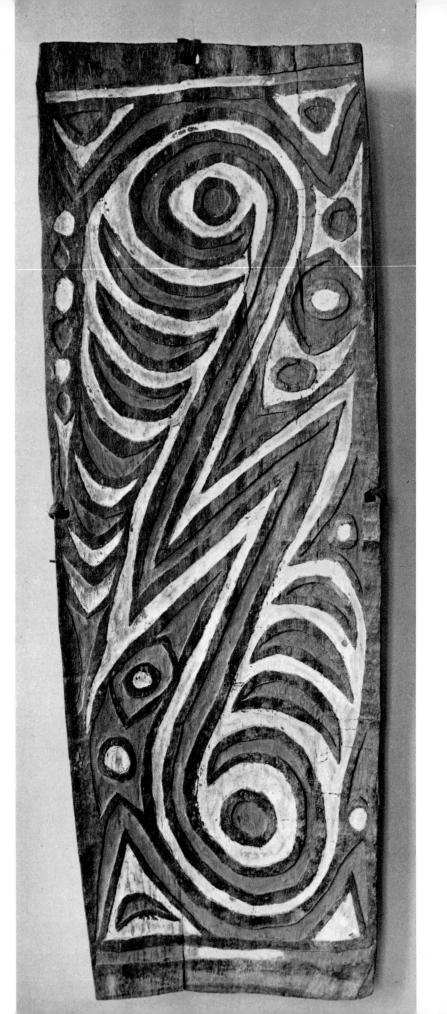

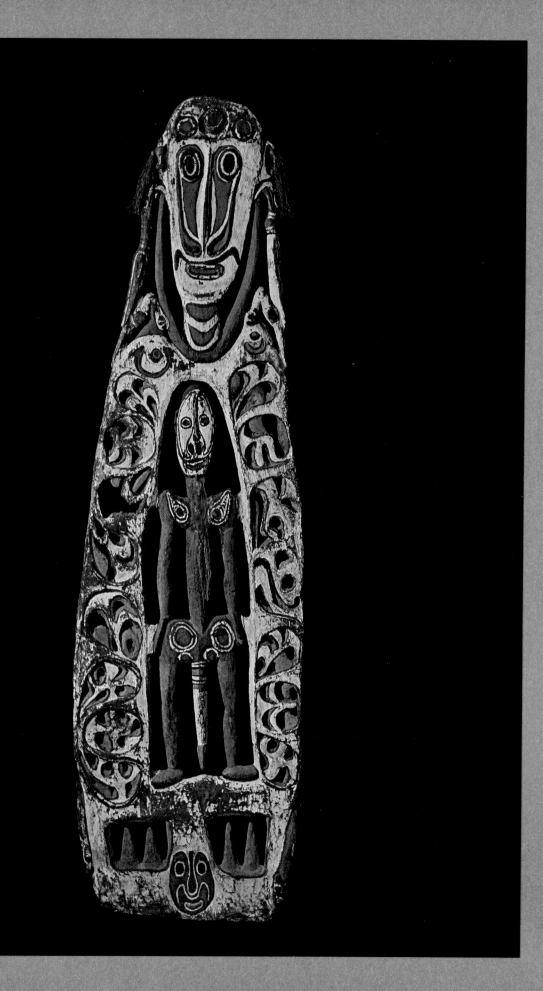

COLORPLATE 9. CEREMONIAL BOARD
New Guinea, Middle Sepik, Kararau
Height 90 1/2″
Collection G. Eckert, Basel

COLORPLATE 10. HORIZONTAL SUSPENSION HOOK
New Guinea, Middle Sepik (Markert, 1960)
Length 36 5/8″
Linden Museum, Stuttgart

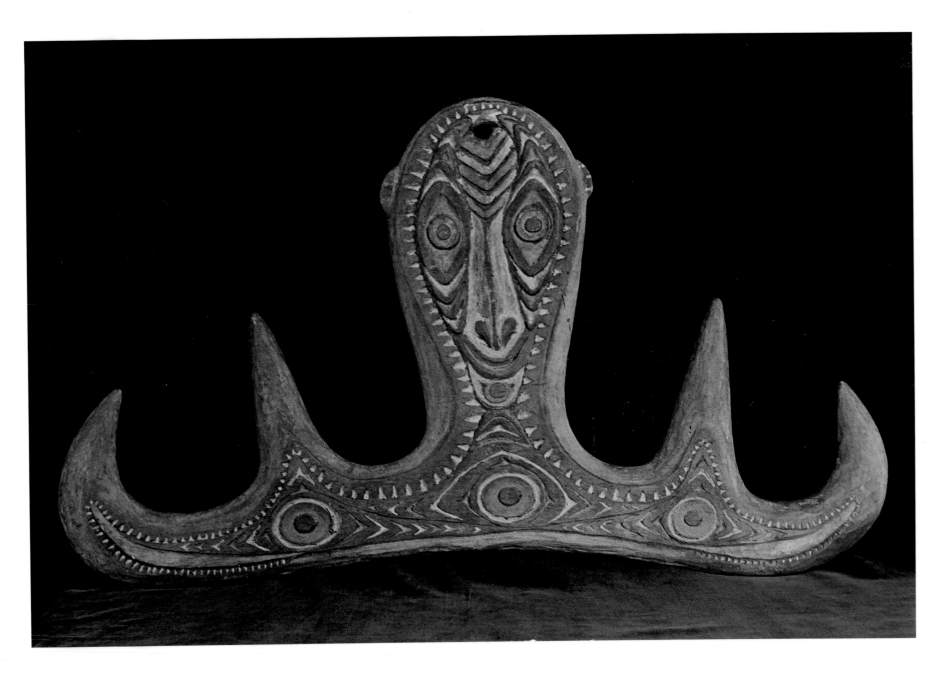

COLORPLATE 11. HORIZONTAL SUSPENSION HOOK (reverse side of hook in Colorplate 10)

COLORPLATE 12. CEREMONIAL STOOL
New Guinea, Middle Sepik,
Blackwater River, Kabriman (Bühler, 1959)
Height 56 1/4″
Museum für Völkerkunde, Basel

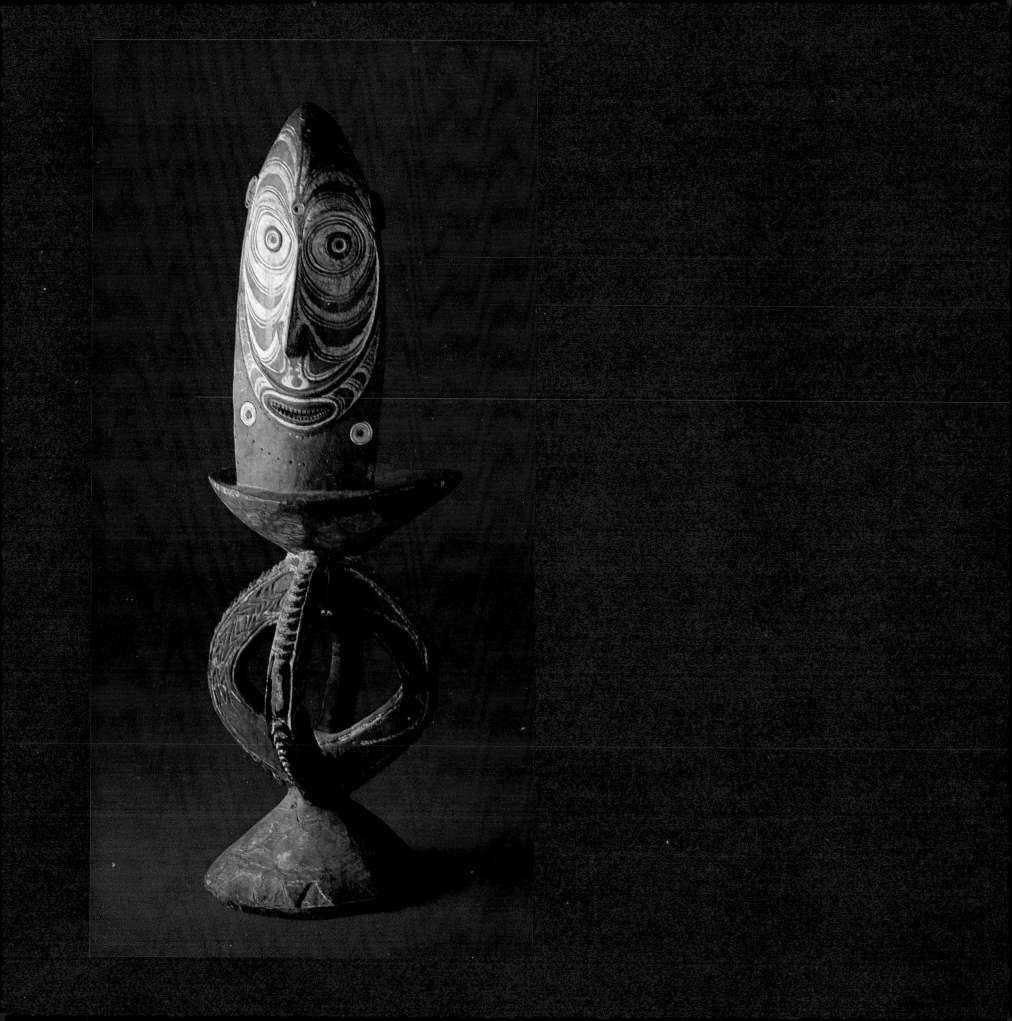

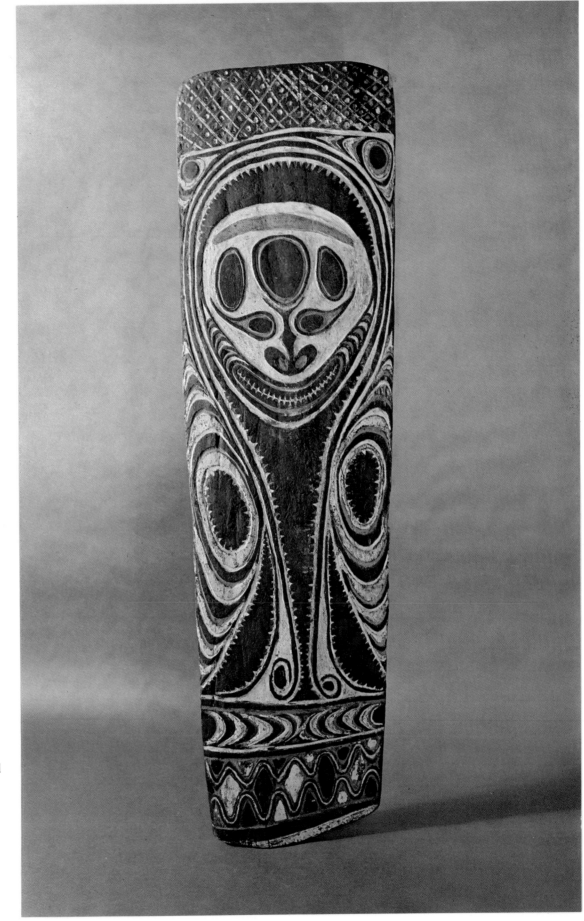

COLORPLATE 13. WAR SHIELD
New Guinea, Middle Sepik,
Lake Chambri (Bateson, 1930)
Height 61 3/8"
University Museum of
Archaeology and Ethnology, Cambridge, England

COLORPLATE 14. MASK
New Guinea, Sepik District, Yuat River
Height 12 1/8″
Museum of Primitive Art, New York

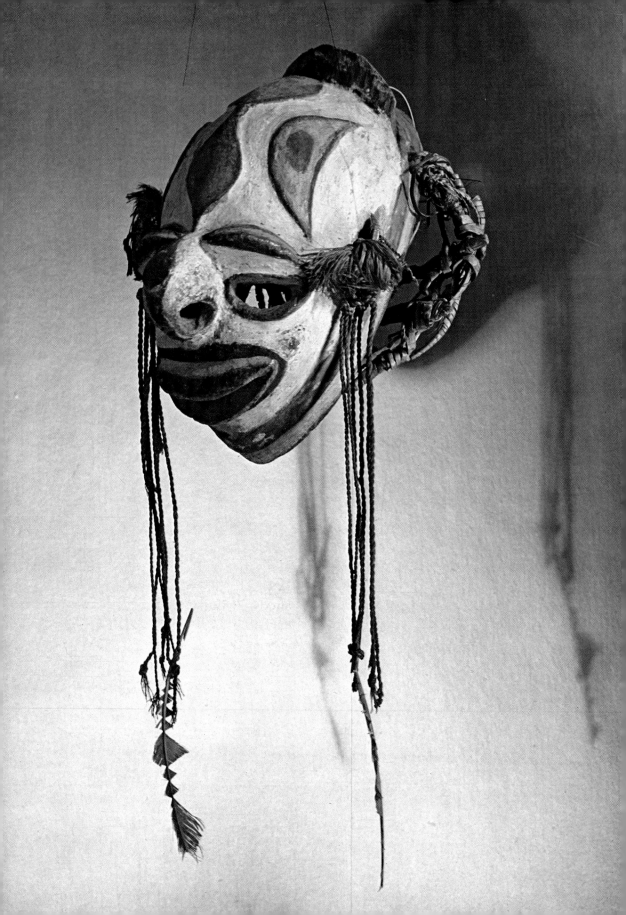

COLORPLATE 15. DECORATED FLUTE FIGURE
New Guinea, Sepik District, Yuat River
Height 27″
American Museum of Natural History, New York

COLORPLATE 16. ORNAMENT OF MEN'S HOUSE
New Guinea, Sepik District, Washkuk area
Height 45 1/4″
Museum für Völkerkunde, Basel

COLORPLATE 17. ORNAMENT OF MEN'S HOUSE:
MALE FIGURE WITH BIRD
New Guinea, Sepik District, Washkuk area
Height 41 3/4″
Museum für Völkerkunde, Basel

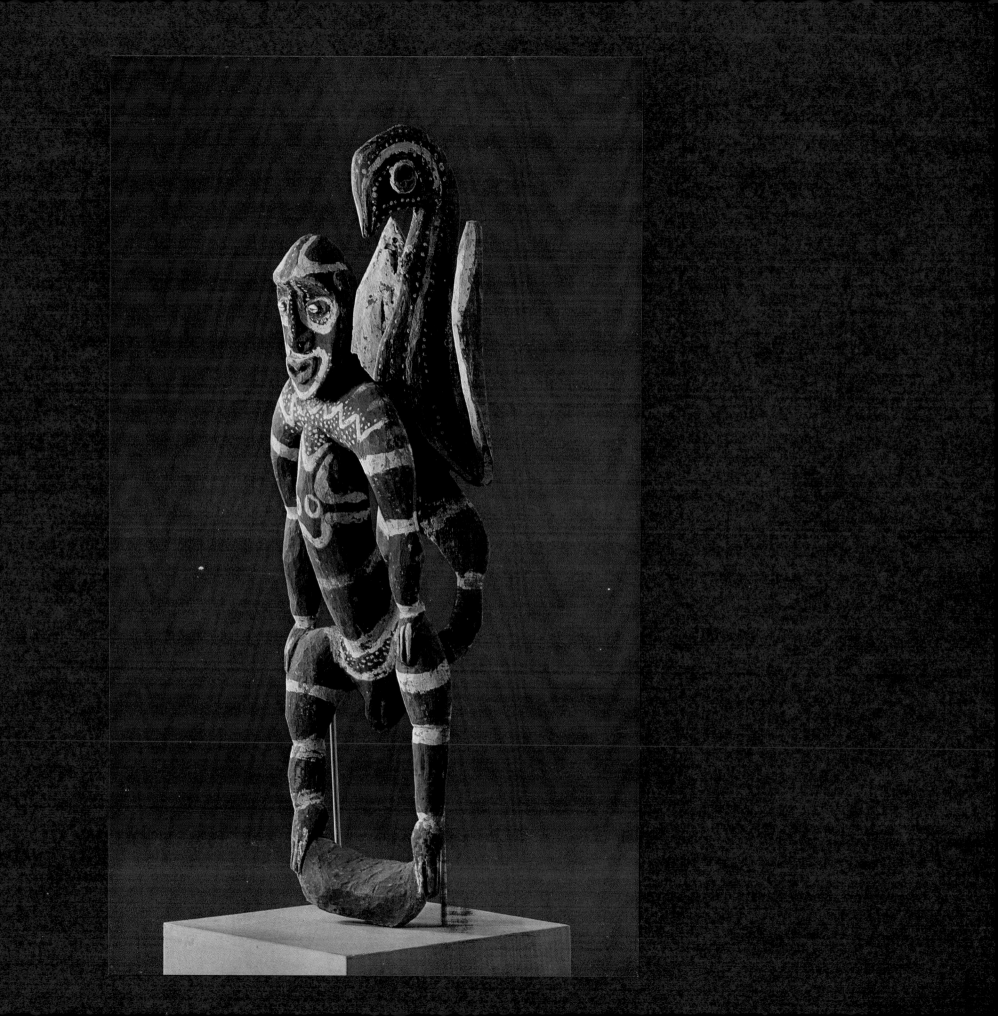

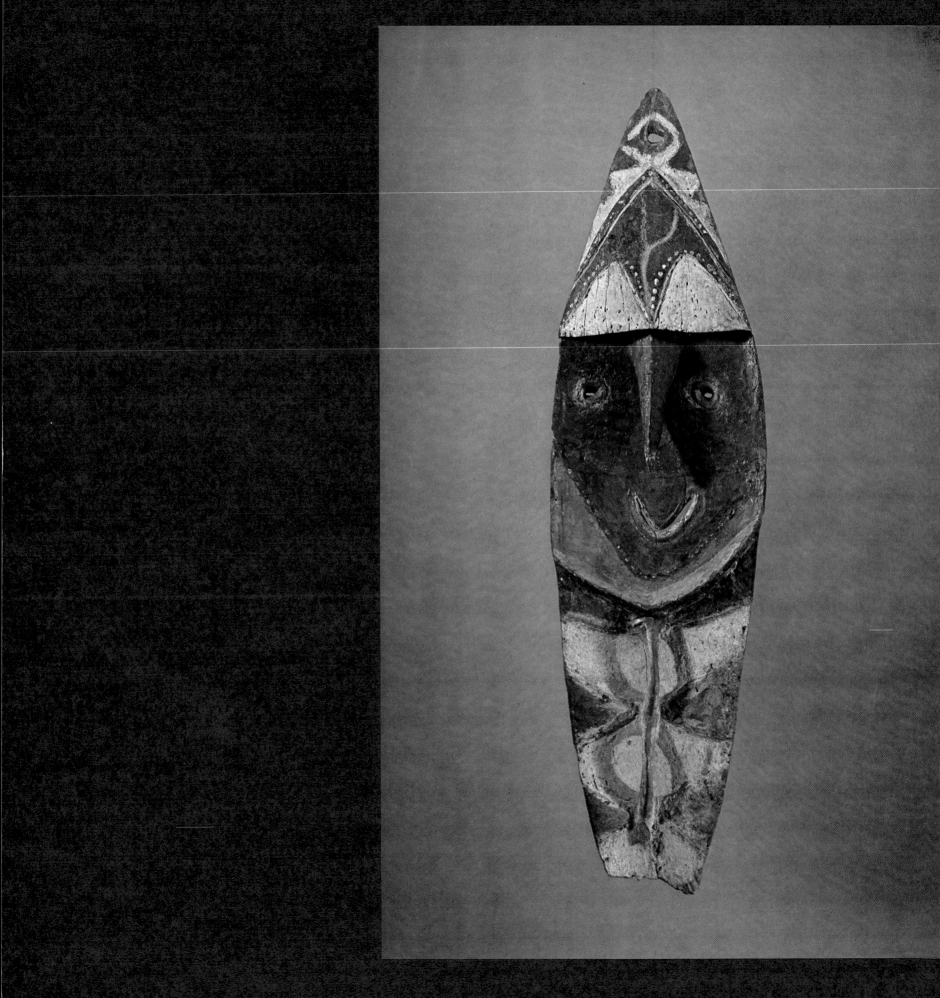

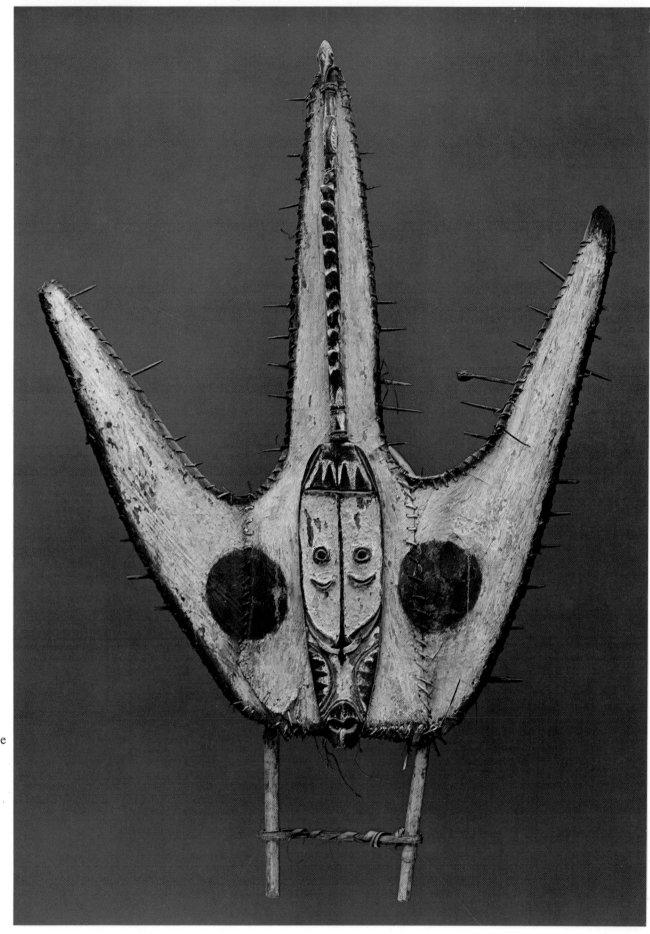

COLORPLATE 19. FIGURE
New Guinea, Sepik District, Washkuk area, Amarke
Height 54"
Museum of Primitive Art, New York

COLORPLATE 20. CANOE SHIELD
New Guinea, Upper Sepik, Swagup (Bühler, 1959)
Height 49 1/4"
Museum für Völkerkunde, Basel

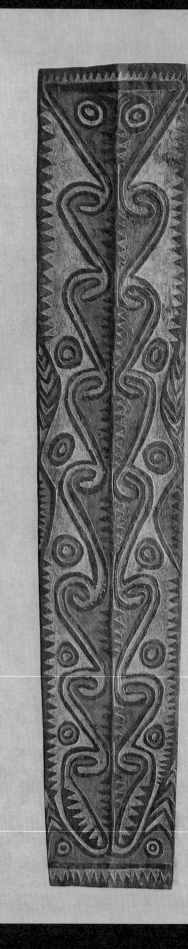

COLORPLATE 21. WAR SHIELD
New Guinea, Upper Sepik,
May River (Bühler, 1959)
Height 79 1/8″
Museum für Völkerkunde, Basel

COLORPLATE 22. SHIELD
New Guinea, Upper Sepik,
May River area, Min tribes (Bühler, 1959)
Height 70 7/8″
Museum für Völkerkunde, Basel

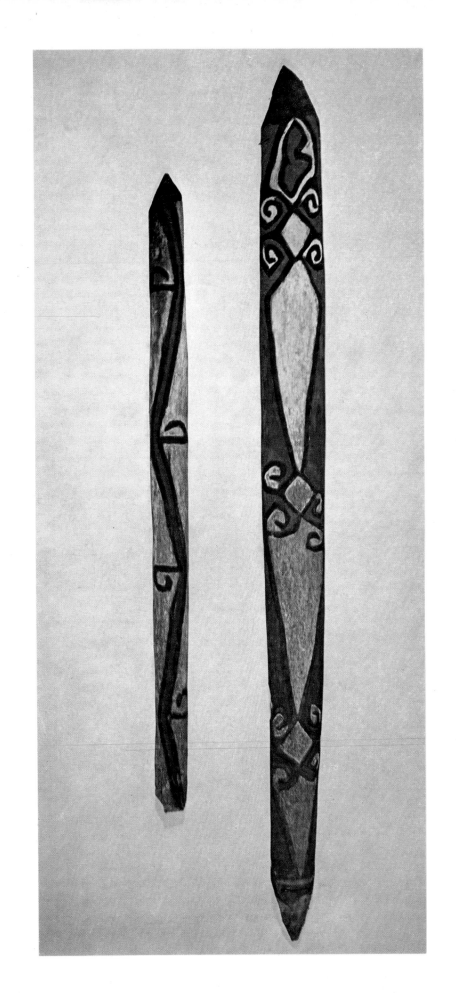

COLORPLATE 23. BOARDS FROM CULT HOUSE
New Guinea, Star Mountains,
Dolemavip (Bal Cranstone, 1964)
Length of longest board 8'4"
British Museum, London

COLORPLATE 24. BOARD (*gerua*)
New Guinea, Central Highlands, Siane
Height 55 1/8″
Museum of Primitive Art, New York

THE NORTHEAST COAST:

Astrolabe Bay to Siassi Islands

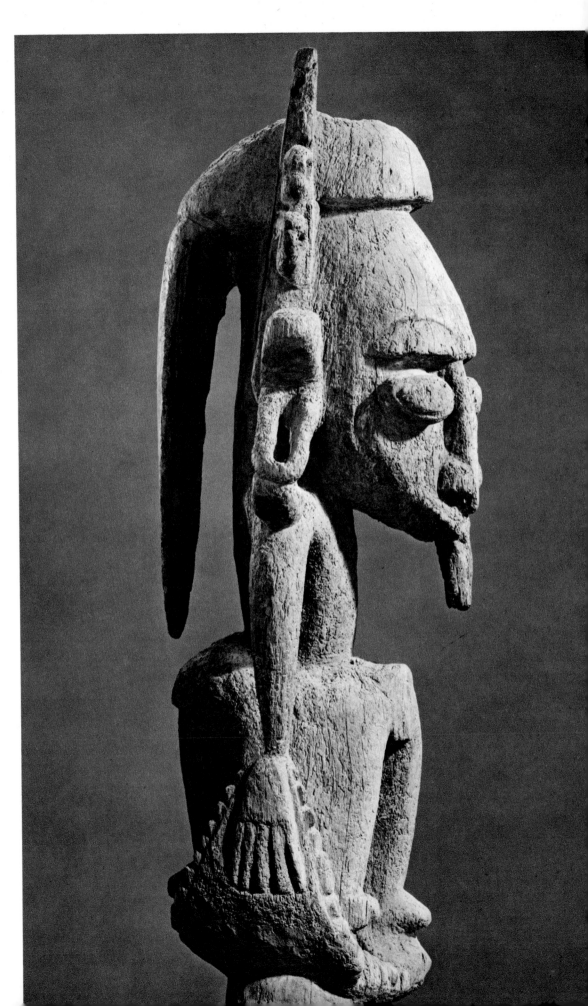

PLATE 115. *Telum* FIGURE
New Guinea, Northeast Coast,
Astrolabe Bay, Bogadjim (Zöller, 1890)
Height 33 7/8″
Collection N. Heinrich, Stuttgart

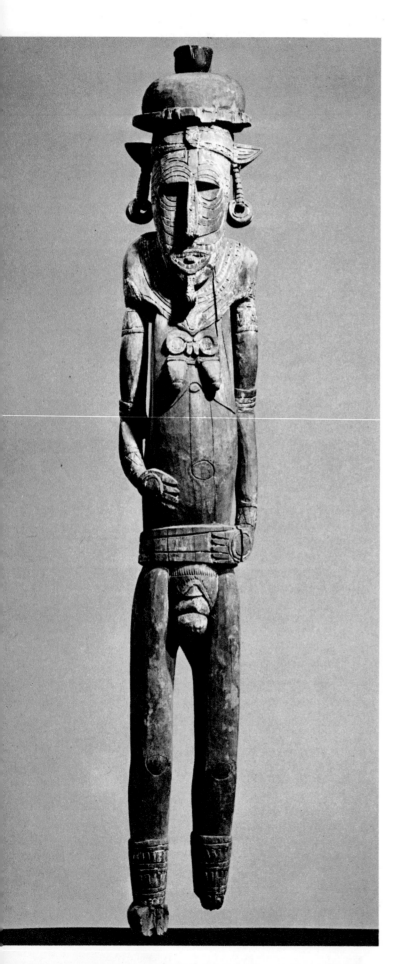

PLATE 116. FEMALE GIVING BIRTH
New Guinea, Northeast Coast, Astrolabe Bay, Ruk Island (Wandres, 1909)
Height 59 7/8″
Collection N. Heinrich, Stuttgart

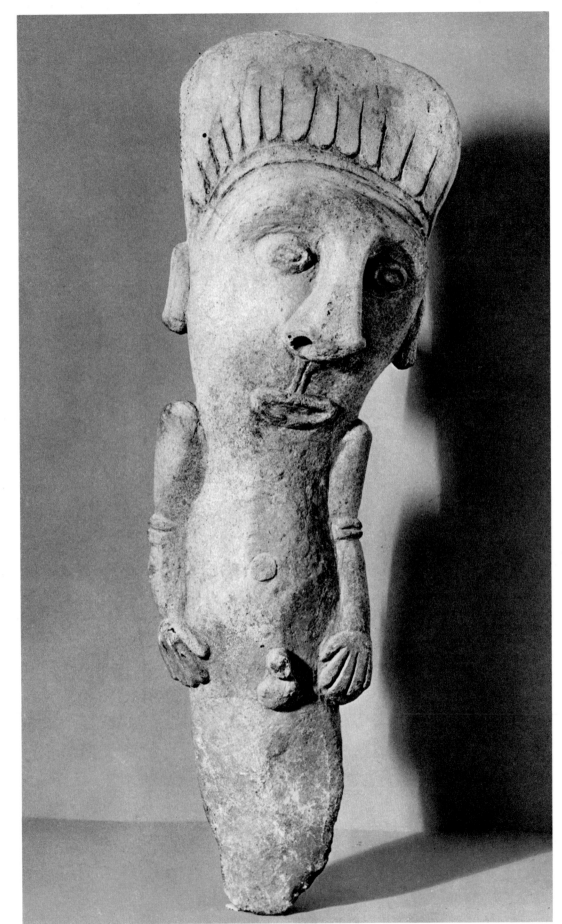

PLATE 117. *Telum* FIGURE
New Guinea, Northeast Coast,
Astrolabe Bay, Bogadjim Hinterland
Limestone, height 24 3/8″
Collection P. Kohler, Ascona, Switzerland

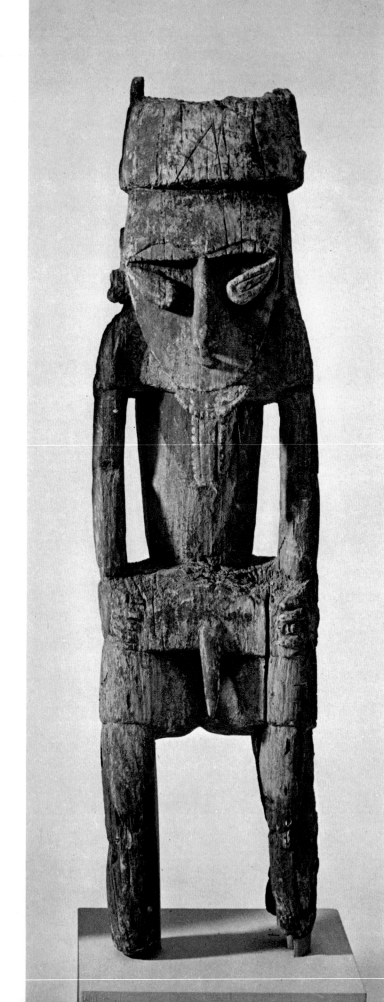

PLATE 118. HOUSE POST
New Guinea, Northeast Coast, Astrolabe Bay, Bongu (Fenichel, 1892)
Height 48 7/8″
Ethnographical Museum, Budapest

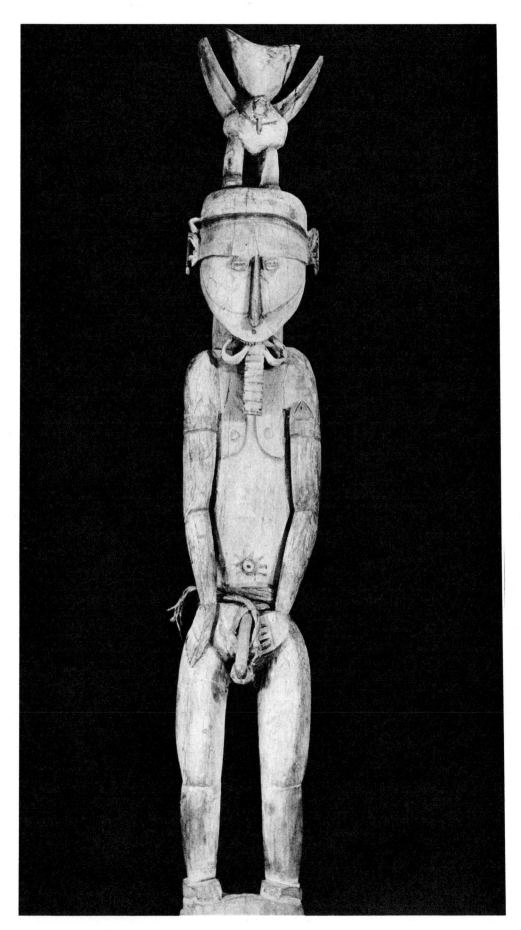

PLATE 119. HOUSE POST
New Guinea, Northeast Coast,
Astrolabe Bay, Ragetta Island (Magnus, 1910)
Height 93 3/4″
Linden Museum, Stuttgart

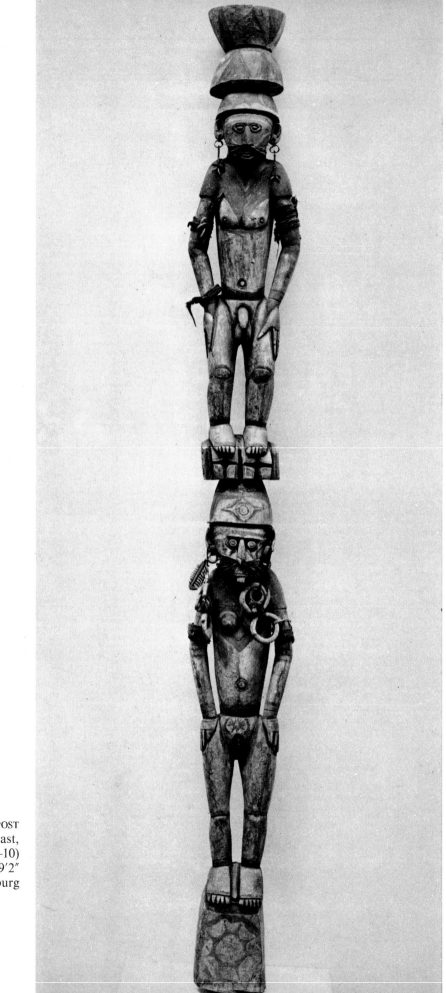

PLATE 120. HOUSE POST
New Guinea, Northeast Coast,
Siassi Islands (Hamburger Südsee Expedition, 1908–10)
Height 9′2″
Museum für Völkerkunde und Vorgeschichte, Hamburg

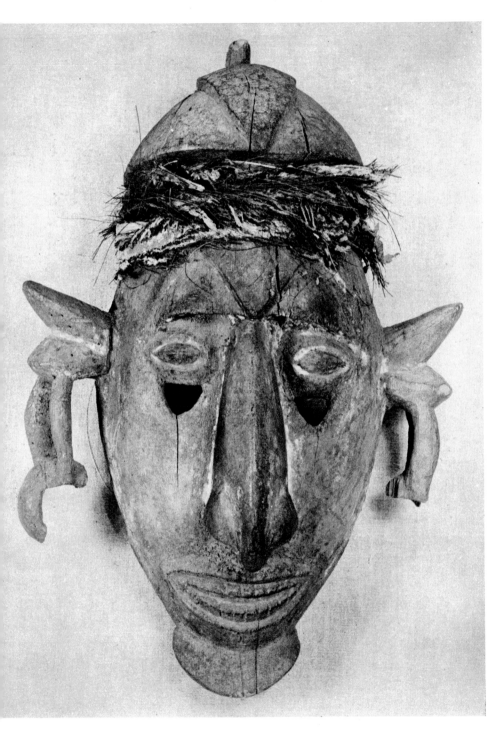

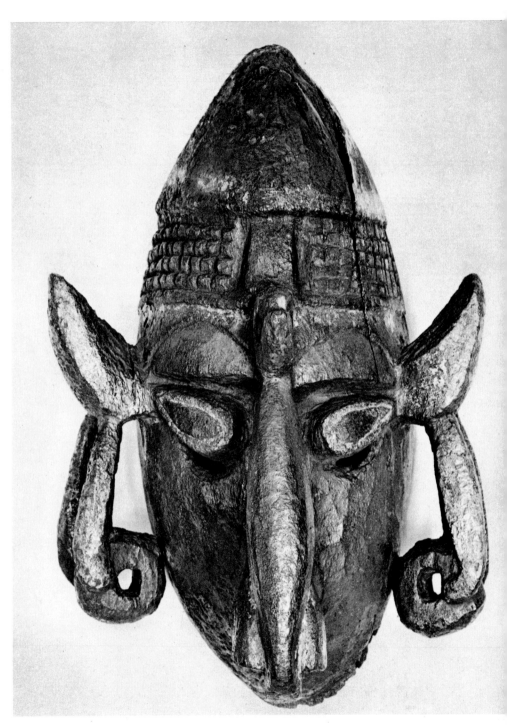

PLATE 121. MASK
New Guinea, Northeast Coast, Astrolabe Bay, Bongu (Hagen, 1902)
Height 17 3/4″
Linden Museum, Stuttgart

PLATE 122. MASK
New Guinea, Northeast Coast, Astrolabe Bay, Bogadjim (Fenichel, 1892)
Height 16 1/2″
Ethnographical Museum, Budapest

PLATE 123. MASK
New Guinea, Northeast Coast, Umboi Island (Speiser, 1930)
Height 16 1/8″
Museum für Völkerkunde, Basel

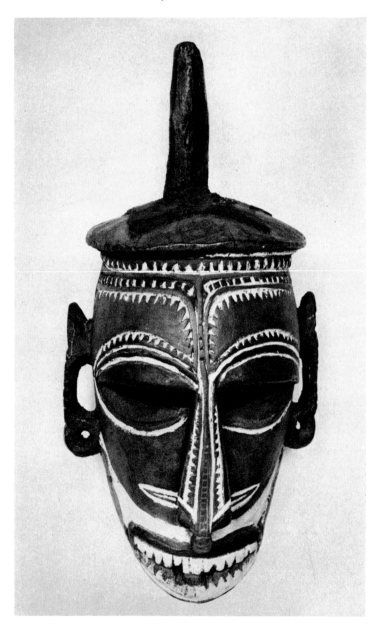

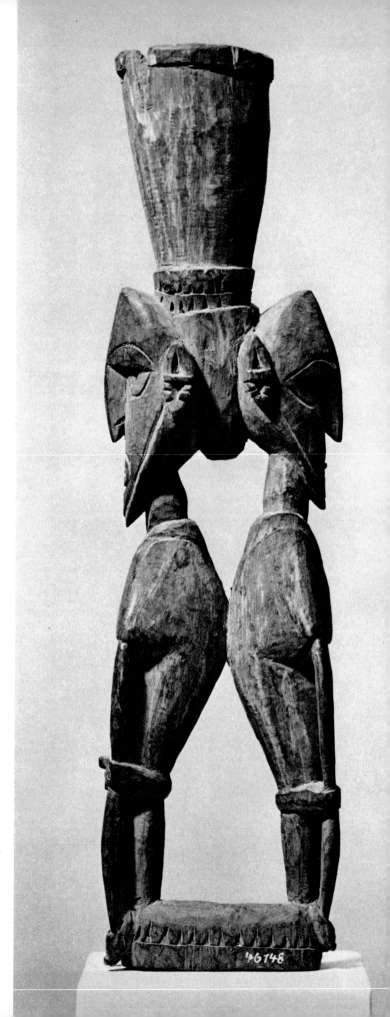

PLATE 124. BETEL MORTAR
New Guinea, Northeast Coast, Sio Island (Schmitz, 1955)
Height 13″
Rautenstrauch-Joest Museum für Völkerkunde, Cologne

THE EAST COAST:

Huon Gulf to Massim Area

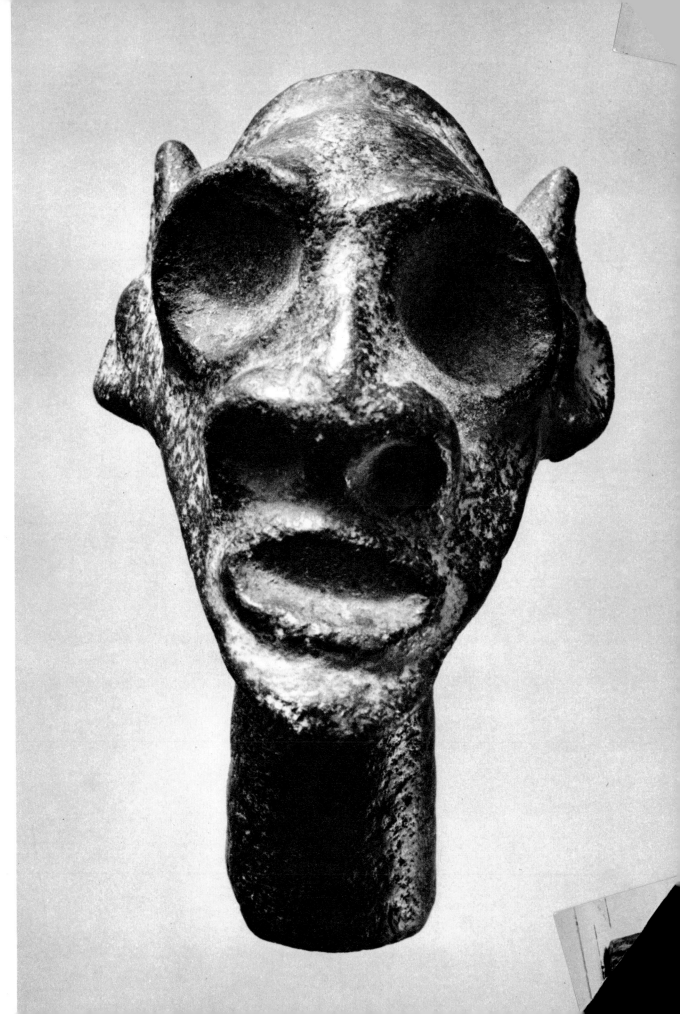

PLATE 125. HEAD OF PESTLE
New Guinea, East Coast,
Huon Gulf, Sialum (Keysser, 1905)
Carved stone, height 3 7/8″
Missions Museum, Neuendettelsau

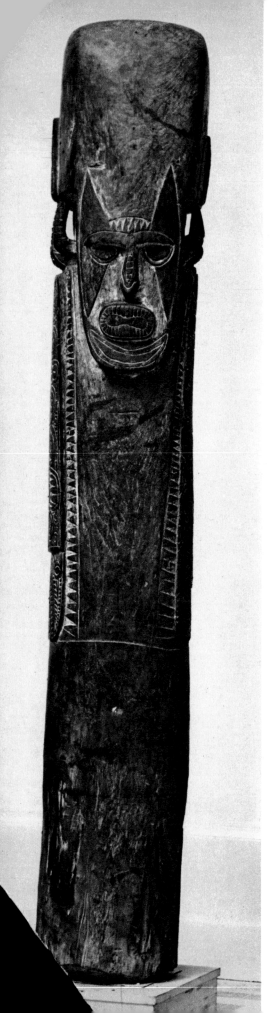

PLATE 126. HOUSE POST
New Guinea, East Coast,
Huon Gulf, Tami Island
Height 84 5/8″
Rautenstrauch-Joest Museum
für Völkerkunde, Cologne

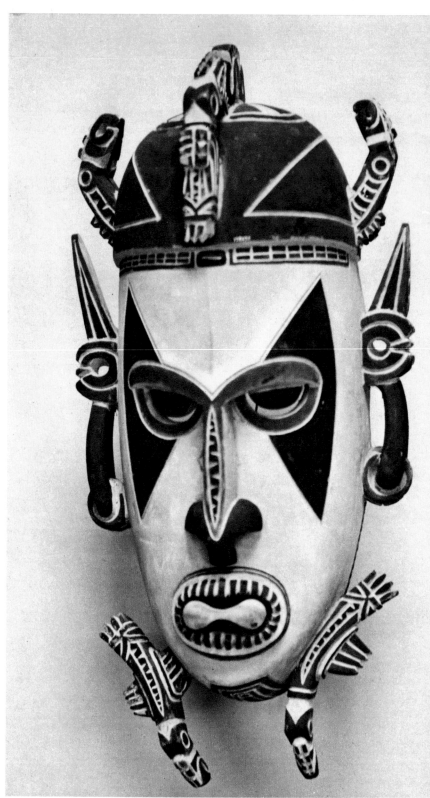

PLATE 127. MASK
New Guinea, East Coast, Huon Gulf, Apo
Height 24″
Field Museum, Chicago

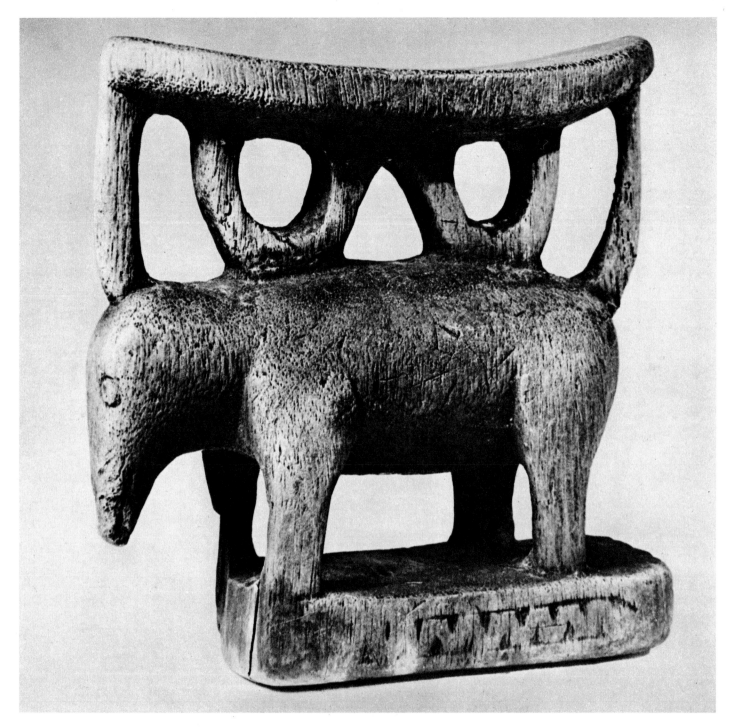

PLATE 128. HEADREST
New Guinea, Northeast Coast, Huon Gulf (Biro, 1901)
Height 5 1/2″
Ethnographical Museum, Budapest

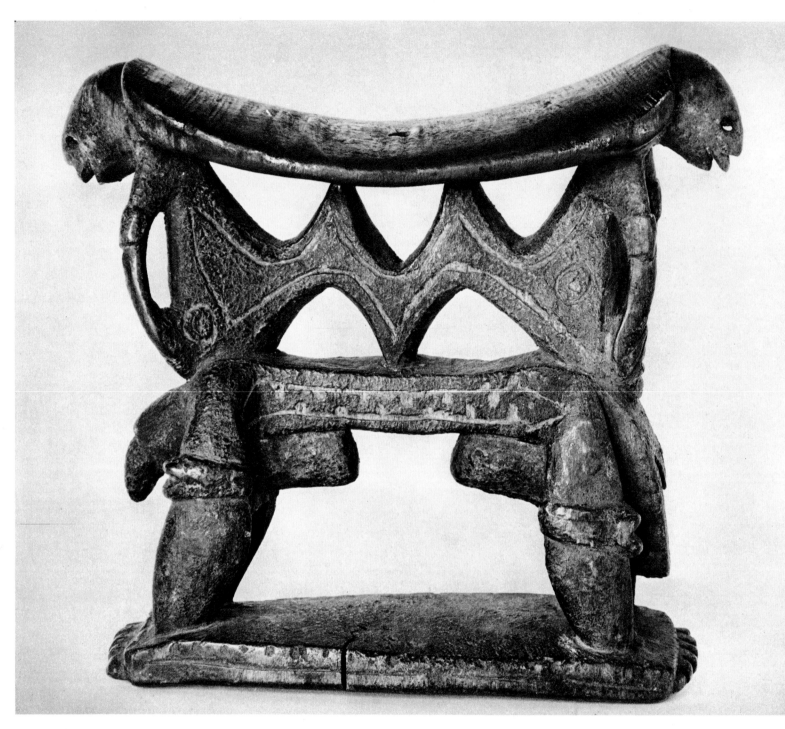

PLATE 129. HEADREST
New Guinea, Northeast Coast, Huon Gulf (Häberle)
Height 6 1/2″
Linden Museum, Stuttgart

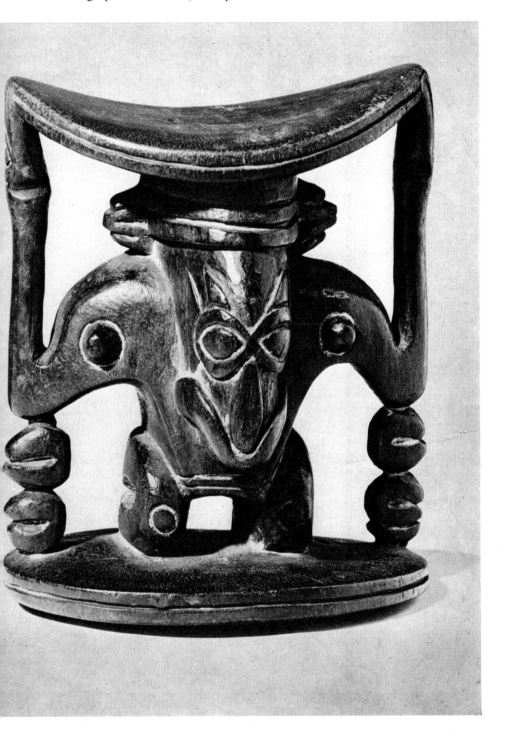

PLATE 130. HEADREST
New Guinea, Northeast Coast, Huon Gulf, Tami Island (Biro, 1901)
Height 4 3/4″
Ethnographical Museum, Budapest

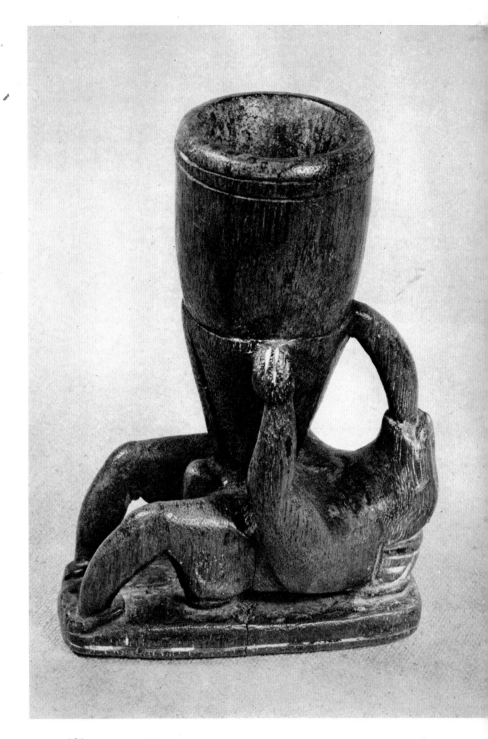

PLATE 131. BETEL MORTAR
New Guinea, Northeast Coast, Huon Gulf
Height 5 1/8″
Linden Museum, Stuttgart

PLATE 132. BOWL IN FISH FORM (underside)
New Guinea, Northeast Coast, Huon Gulf, Tami Island
Length 20 1/2″
Linden Museum, Stuttgart

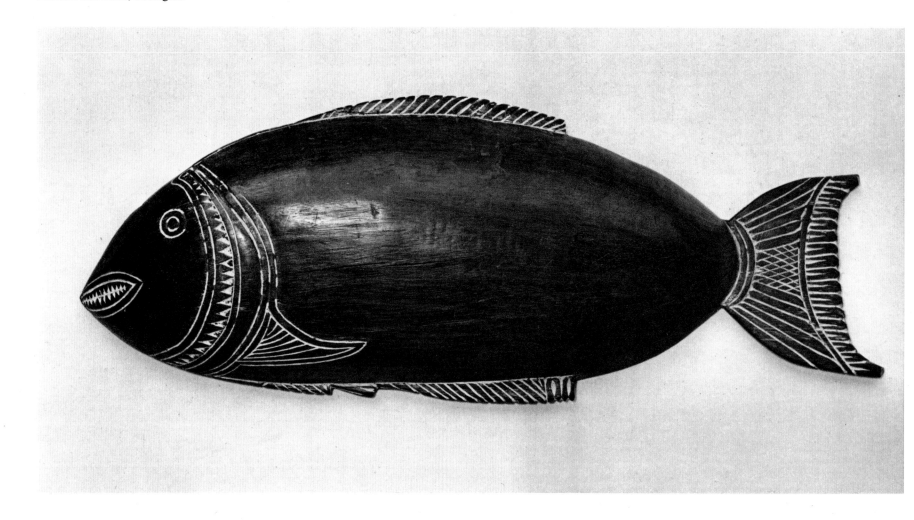

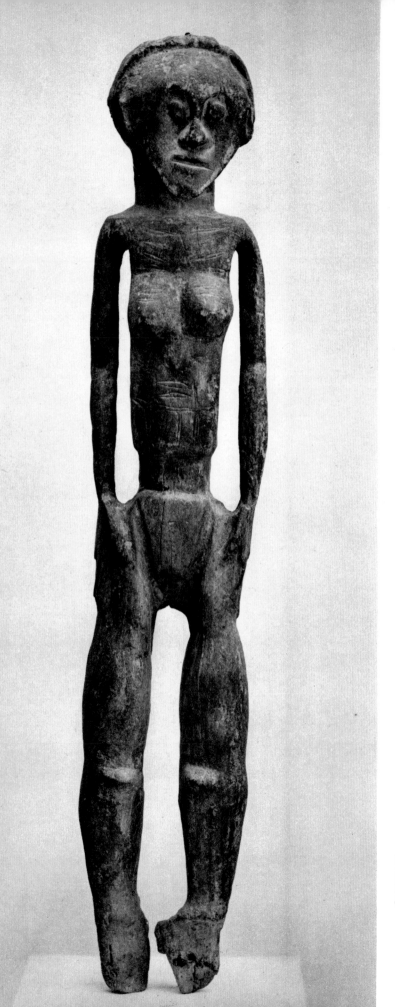

PLATE 133. FEMALE FIGURE
New Guinea, Massim area, Roro Group
Height 38 5/8″
Collection S. Brignoni, Bern

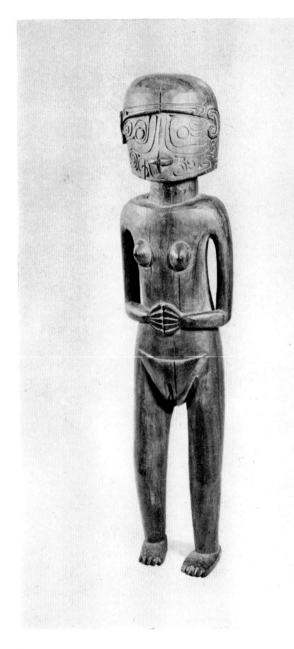

PLATE 134. FEMALE FIGURE
New Guinea, Massim area, Trobriand Islands
Height 17 3/8″
Peabody Museum, Salem, Mass.

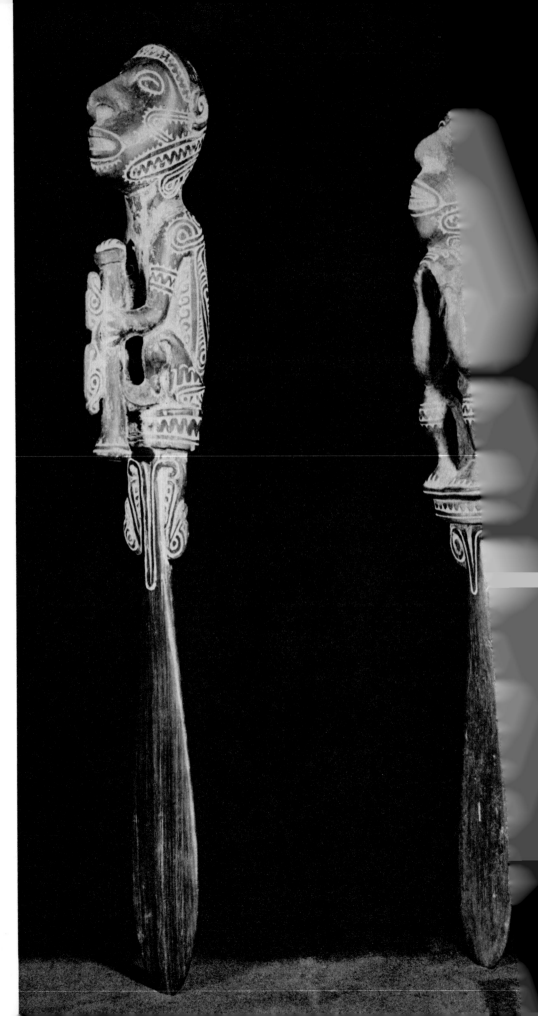

PLATE 135. SPATULAS
New Guinea, Massim area
Lime, left: height 17 3/8″; right: height 16 1/2″
Buffalo Museum of Science

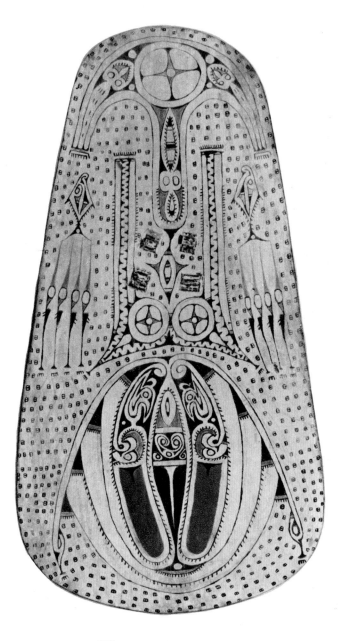

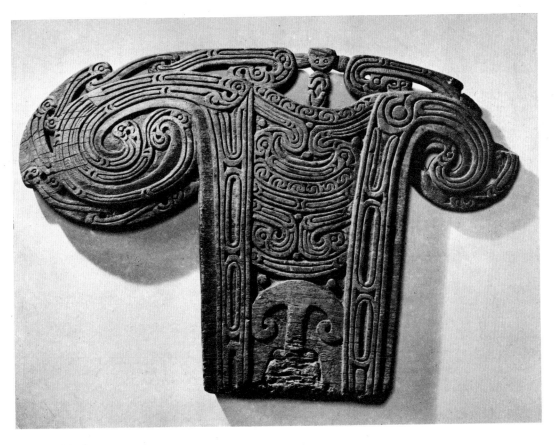

PLATE 136. PROW ORNAMENT
New Guinea, Massim area, Trobriand Islands
Height 17 3/4″
Ethnographical Museum, Budapest

PLATE 137. SHIELD
New Guinea, Massim area, Trobriand Islands
Height 34 1/4″
Buffalo Museum of Science

COLORPLATE 25. SHIELD
New Guinea, Massim area, Trobriand Islands
Length 29 1/4″
American Museum of Natural History, New York

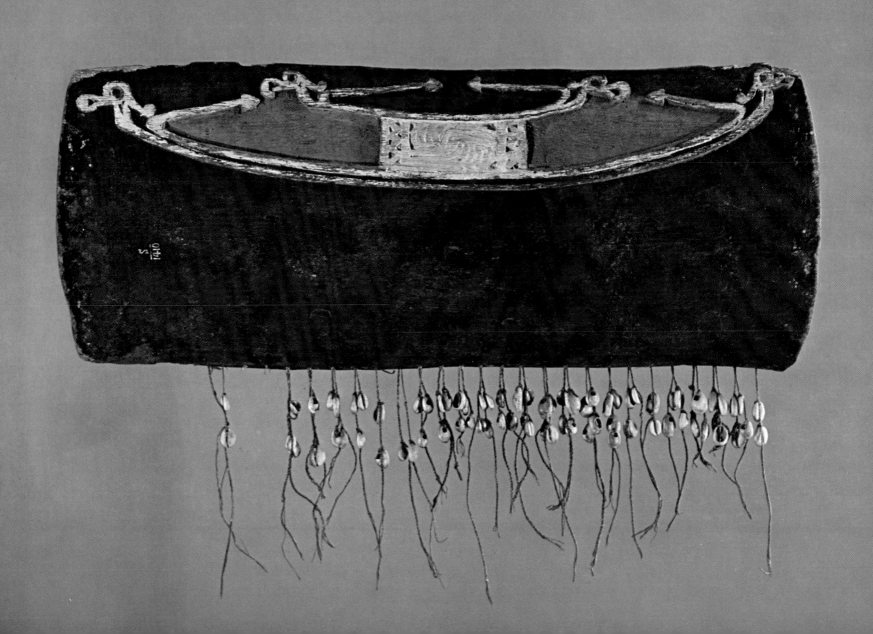

THE SOUTH COAST:

Gulf of Papua to Torres Straits

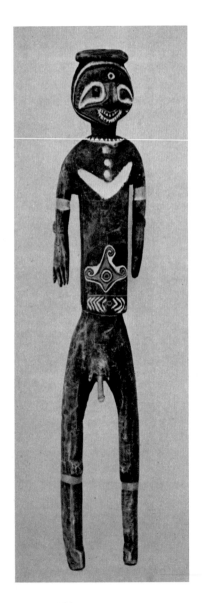

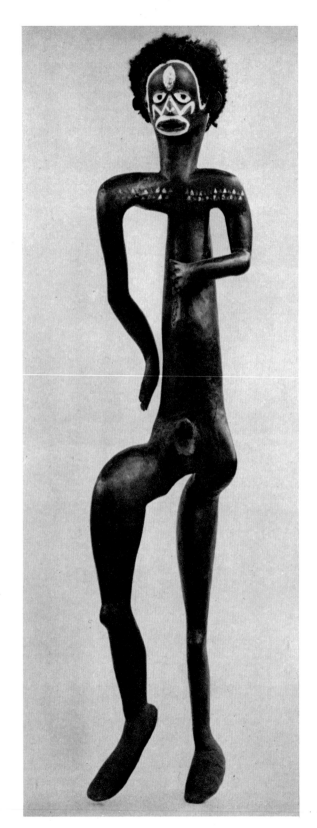

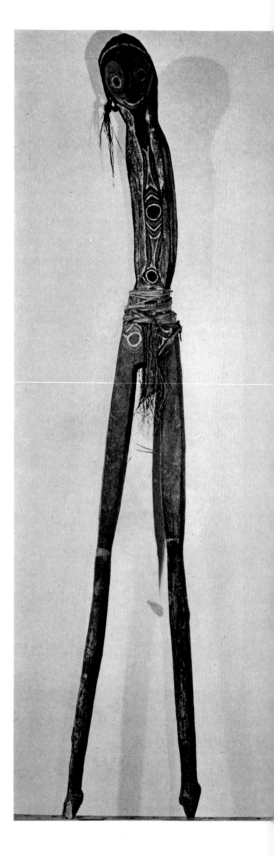

PLATE 138. MALE FIGURE
New Guinea, Gulf of Papua, Purari River (P. Wirz, 1931)
Height 70 7/8″
Museum für Völkerkunde, Basel

PLATE 140. FEMALE FIGURE
New Guinea, Gulf of Papua, Turama River (P. Wirz, 1931)
Height 68 7/8″
Tropenmuseum, Amsterdam

PLATE 141. CANOE MODEL (*gi*)
New Guinea, Gulf of Papua, Gogodara Tribe (P. Wirz, 1930)
Length 45 1/4″
Museum of Primitive Art, New York

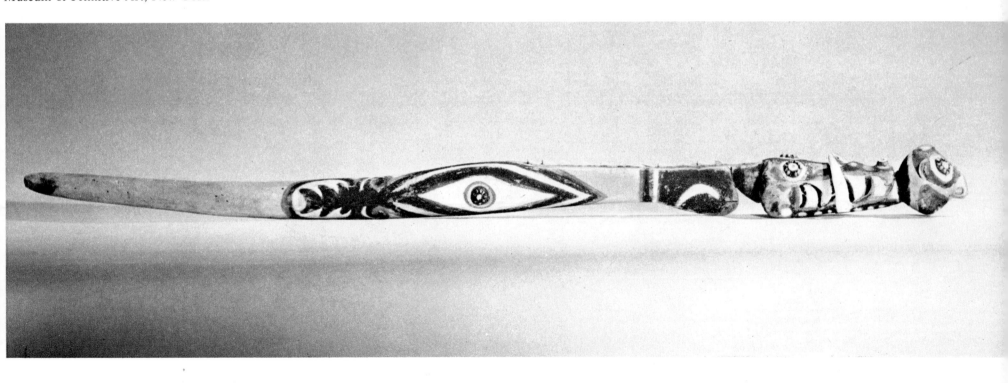

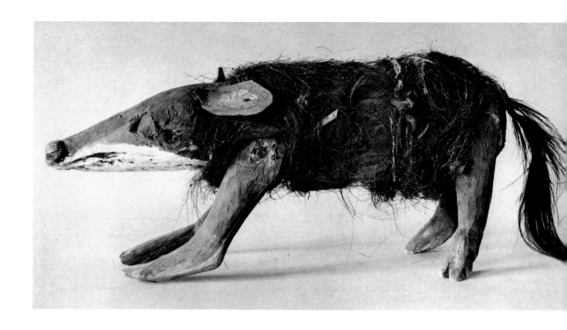

PLATE 142. LIZARD CARVING
New Guinea, South Coast, Marind-anim Tribe (P. Wirz, 1920)
Length 65″
Museum für Völkerkunde, Basel

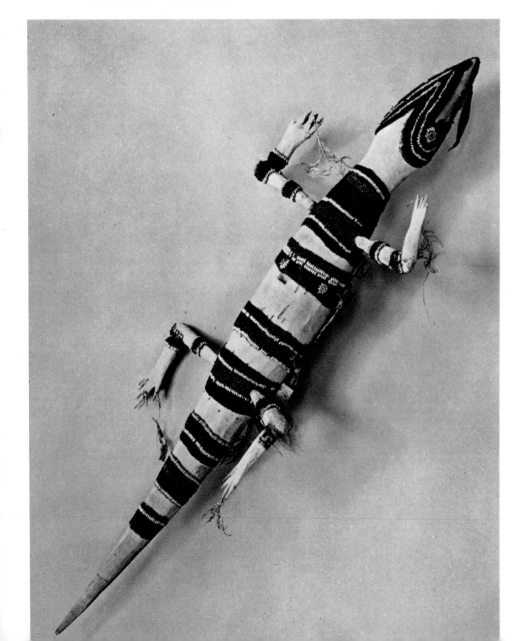

PLATE 143. PIG CARVING
New Guinea, South Coast, Marind-anim Tribe (P. Wirz, 1920)
Length 28 3/4″
Museum für Völkerkunde, Basel

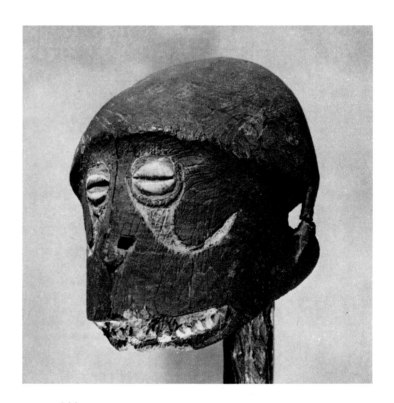

PLATE 144. IMITATION TROPHY HEAD
New Guinea, Gulf of Papua, Wapo
Height 13″
Collection R. J. Sainsbury, London

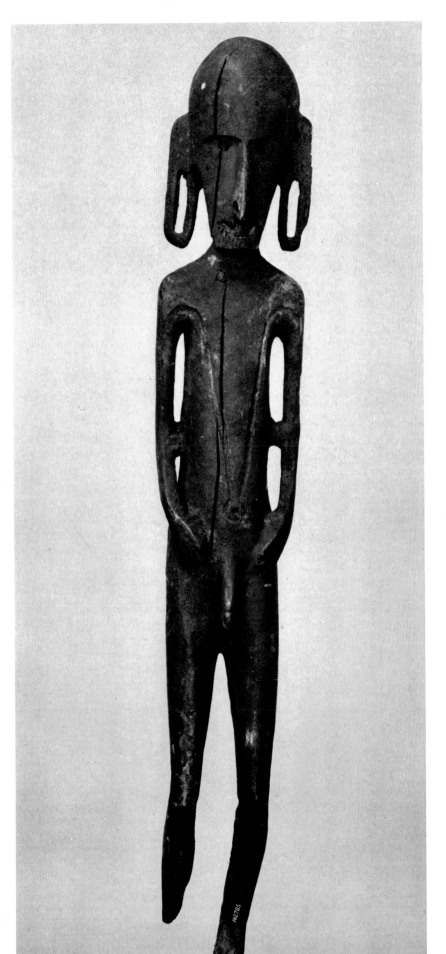

PLATE 145. FIGURE FOR *Moguru* CEREMONY
New Guinea, South Coast, Lower Fly River
Height 39 3/8″
Field Museum, Chicago

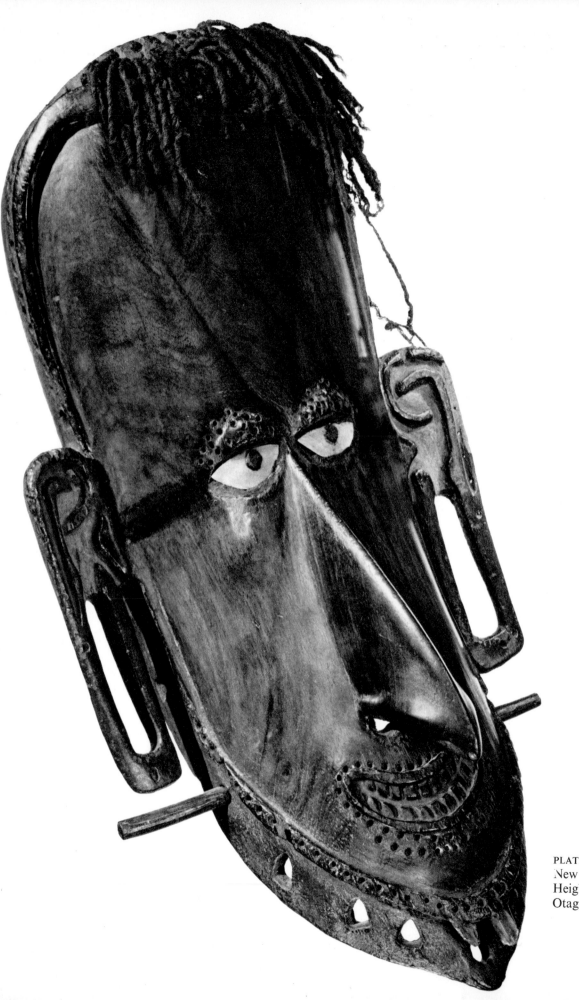

PLATE 146. MASK
New Guinea, South Coast, Trans-Fly area
Height 24"
Otago Museum, Dundein, New Zealand

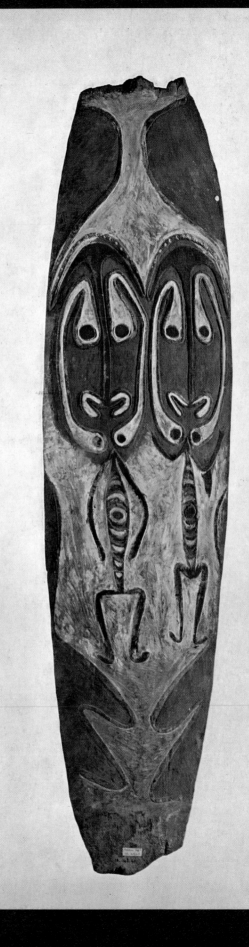

COLORPLATE 26. ANCESTRAL BOARD
New Guinea, Gulf of Papua,
Kerewa (A. C. Haddon, 1916)
Height 46 1/4″
University Museum of
Archaeology and Ethnology, Cambridge, England

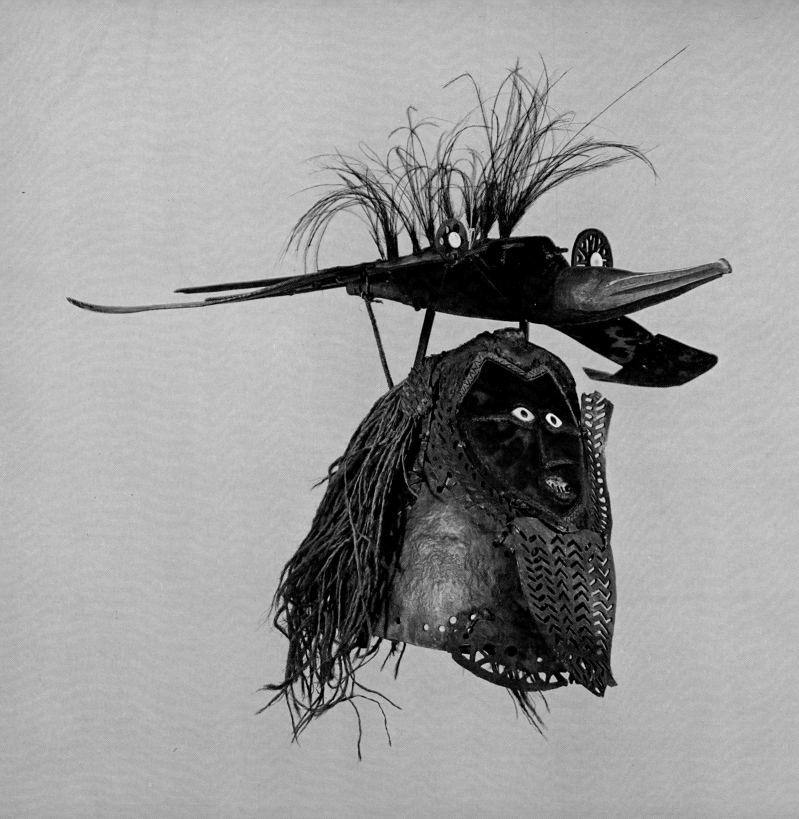

COLORPLATE 27. HELMET MASK
New Guinea, Torres Straits
Height without feathers 13 1/2″
Museum of Primitive Art, New York

COLORPLATE 28. *Kaiamuru* ANCESTOR FIGURE
New Guinea, Gulf of Papua,
Kerewa, Turama River, Gibu
Height 52″
Museum of Primitive Art, New York

THE SOUTHWEST COAST:

Asmat Area

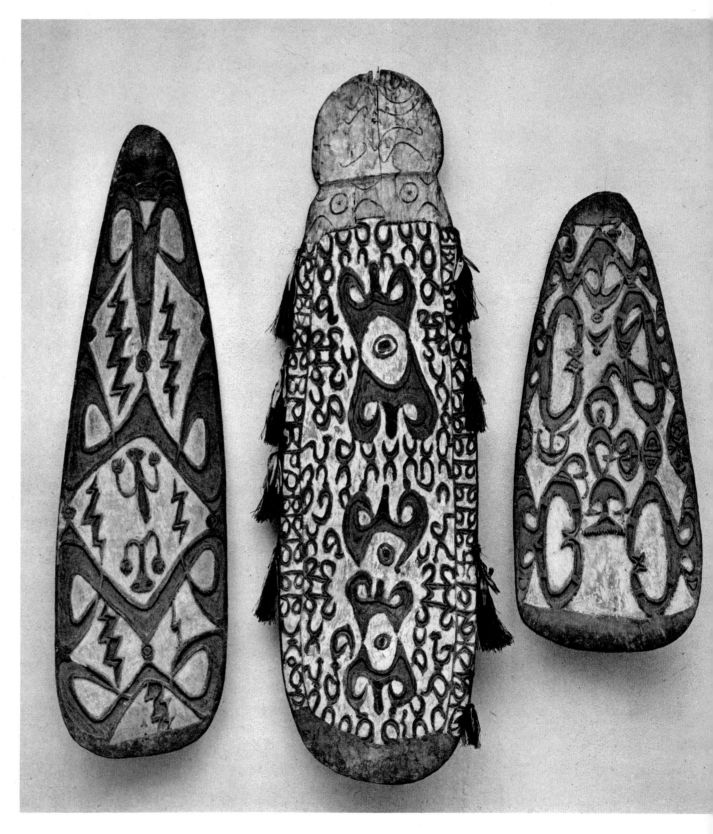

PLATE 147. SHIELDS
Left: New Guinea, Southwest Coast,
Asmat area, Lorentz River (P. Wirz, 1923)
Height 67 3/8″
Museum für Völkerkunde, Basel
Center: New Guinea,
Southwest Coast, Asmat area
Height 76″
Collection S. Brignoni, Bern
Right: New Guinea, Southwest Coast,
Asmat area, Lorentz River (P. Wirz, 1923)
Height 49 1/4″
Museum für Völkerkunde, Basel

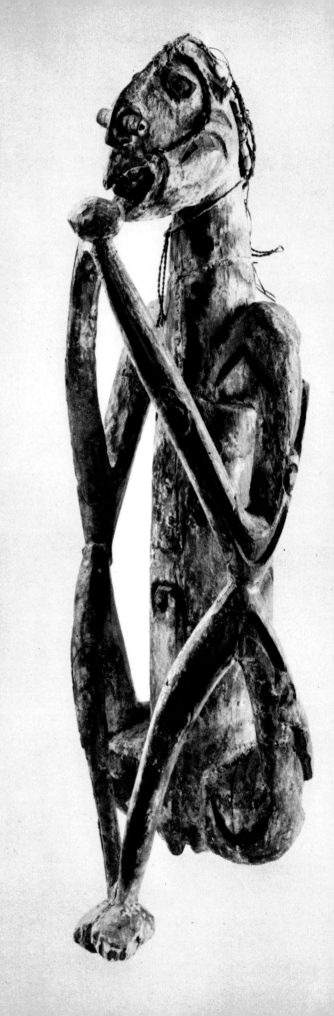

PLATE 148. SEATED FEMALE FIGURE
New Guinea, Southwest Coast,
Asmat area, Noordwest River
Height 15″
Collection Mr. and Mrs. R. Wielgus, Chicago

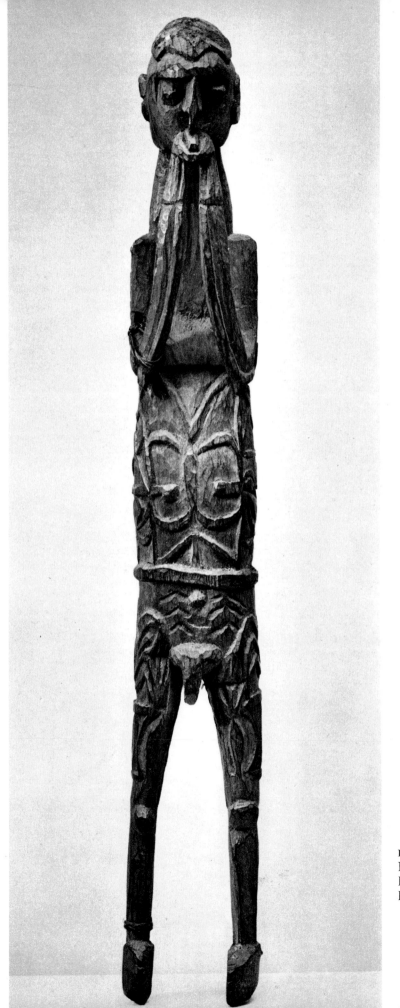

PLATE 149. STANDING MALE FIGURE
New Guinea, Southwest Coast, Casuarinen Coast (Visser, 1959)
Height 38 1/8″
Rijksmuseum voor Volkenkunde, Leiden

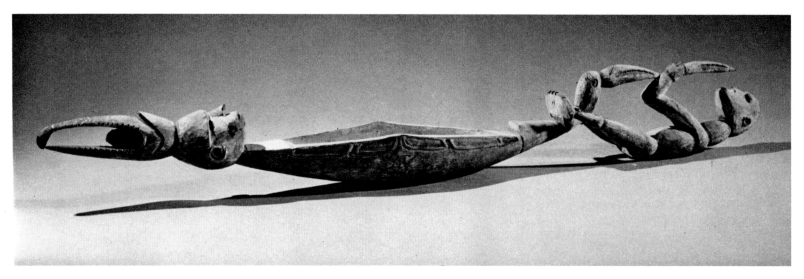

PLATE 150. BOWL FOR SAGO LARVAE
New Guinea, Southwest Coast, Asmat area (Michael C. Rockefeller)
Length 40″
Museum of Primitive Art, New York

PLATE 151. WOODEN CANOE PROW ORNAMENT
New Guinea, Southwest Coast, Asmat area
Length 31 1/2″
Museum of Primitive Art, New York

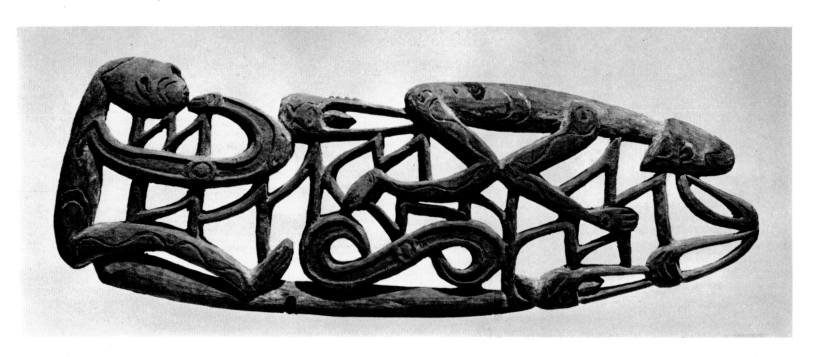

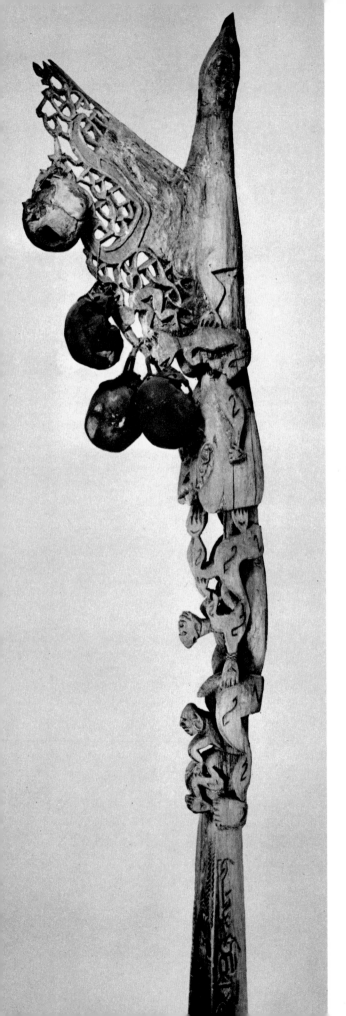

PLATE 152. ANCESTOR POLE (*bijs* POLE)
New Guinea, Eilanden River, Asmat Tribe (P. Wirz)
Height of entire pole 12′3″
Museum für Völkerkunde, Basel

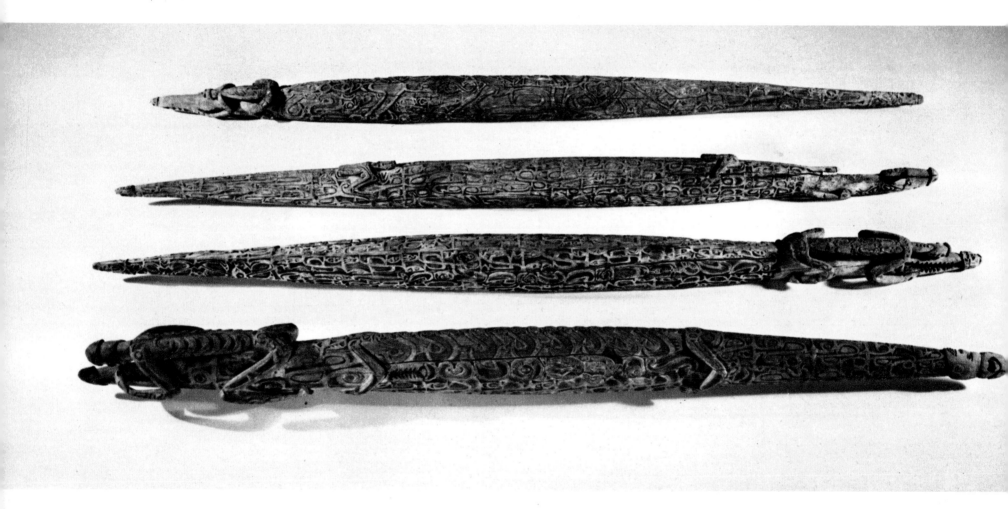

PLATE 153. CEREMONIAL CROCODILES
New Guinea, Southern Casuarinen Coast, Asmat area (Michael C. Rockefeller)
Length of longest crocodile 12′
Museum of Primitive Art, New York

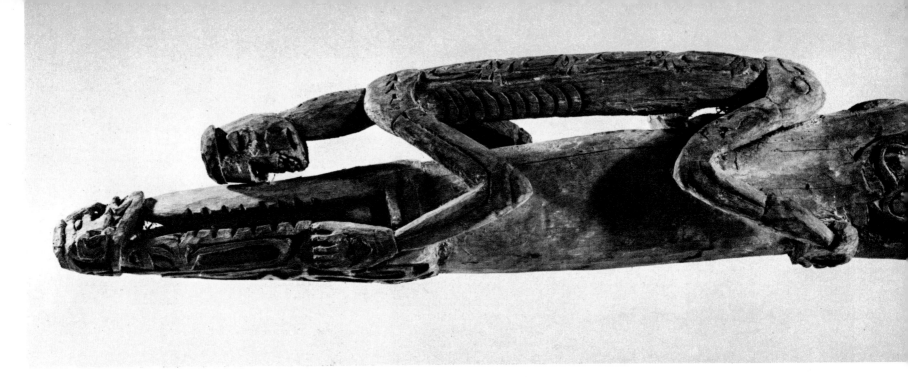

PLATE 154. Detail of Plate 153

PLATE 155. Detail of Plate 153

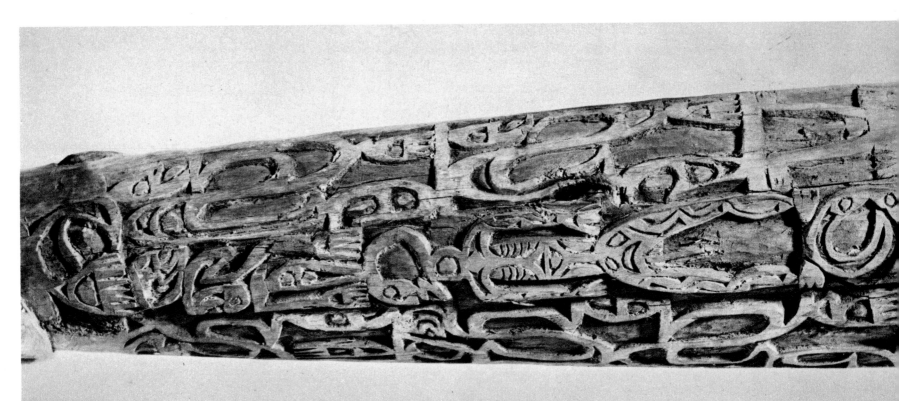

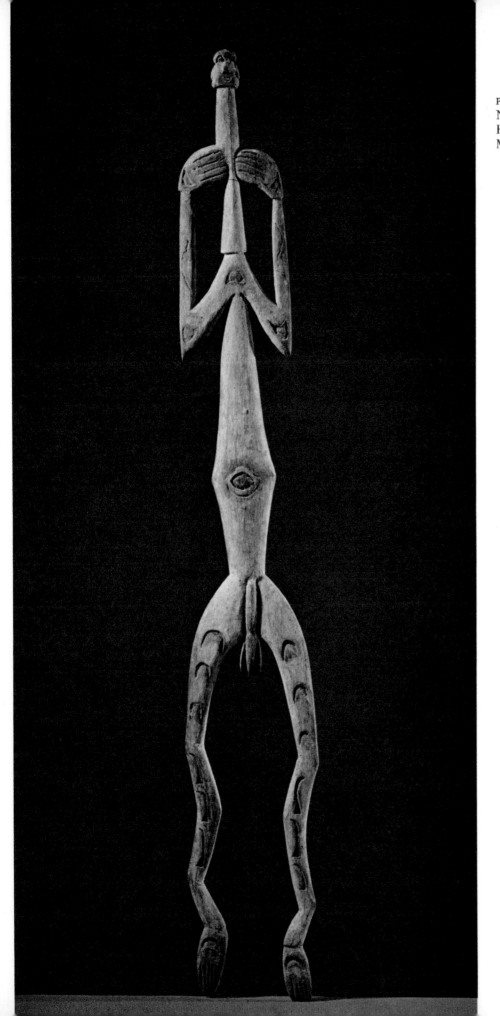

PLATE 156. STANDING FIGURE
New Guinea, Southwest Coast, Asmat area
Height 37 5/8″
Museum of Primitive Art, New York

MELANESIA

ADMIRALTY
ISLANDS

OFF the Pacific coast of New Guinea lie several island groups, among them the Admiralty Islands, with a total land surface of eight hundred square miles. The largest, Manus Island, alone covers six hundred square miles; the remaining area is made up of a number of lesser islands, some extremely small. The peoples of this group are usually divided into the Manus, the Mantankor, and the Usiai. The Manus occupy primarily the south coast of Manus Island and the islands directly south of it. Their villages are situated right on the beaches, built as a rule on piles standing in shallow lagoons. They possess little land, are mainly deep-sea fishermen and traders, and constitute the most active of the peoples in this archipelago. The Mantankor are typical Melanesian tillers of the soil. They have sufficient land both along the coast and inland to grow vegetable crops and practice fishing. It is among them that we find the most talented wood carvers and builders of houses and boats. Finally, the Usiai, who inhabit the interior of the main island, are typical rain-forest cultivators such as are to be found all over Melanesia. The hypothesis advanced by early anthropologists that the Usiai belong to a particularly old population stratum in Melanesia is completely unfounded. Their differences from the Manus, and even more from the Mantankor, are primarily due to their adaptation to a different physical environment. In the 1930s the total population of the Admiralty Islands was about fourteen thousand.

Their supreme god is Kot: he has always existed, is changeless, and occasionally manifests himself in the form of a shooting star or a fireball in the sky. However, in day-to-day religious practices, the spirits of the dead (*belit*) play the most important role. Their activities, like those of all vehicles of magic powers, are ambivalent; generally speaking, however, they are amicably disposed towards their own clan descendants. Their mythology is typically Melanesian. In the legends, the snake (*moat* or *malai*) plays the most important role as a bringer of culture: it taught human beings how to get the seeds needed for the cultivation of crops from its own body and how to make fire and pottery. And the *mbushat* tree grew from the snake's tail bone, when it was planted in the ground. In some versions the *malai* actually created the world and the human race itself. In a few groups the same divinity, under the same name, is said to be a crocodile. In another myth, the snake and the osprey were born from two eggs, which came from a woman's blood.

The osprey and the snake fought; as a result, the snake was cut to pieces which turned into fish and smaller snakes. The coconut and the areca palm are said to have grown from the head of a slain man. All these legends are current throughout Melanesia and New Guinea, and the inhabitants of the Admiralty Islands are true Melanesians in their religious beliefs.

The Admiralty Islands are the gateway to Melanesia from eastern Indonesia. Hence the art of this area, like that of northern New Guinea, exhibits a mixture of Neolithic-Austronesian and Metal Age traditions in which the latter clearly predominate. Everywhere we find male and female carved figures which commemorate the dead, but are not supposed to serve as the dwelling place of their spirits: the profane aspect is stronger than the sacred. Figures on door posts, ladders, bed legs, lime spatulas, spears, and daggers are carved in the same form, and are primarily ornamental in character, just as was the case in the Lake Sentani area and elsewhere. The male figure (plate 157) is a characteristic example of the local style. The arms hang down perpendicularly, the hands rest upon the thighs, the legs are bent forward slightly, and the sexual parts are clearly shown. The shoulders are shaped in two shieldlike planes. The head sits almost neckless on the trunk. The straight-edge chin protrudes far forward, the face recedes. The mouth runs straight across the lower part of the face. The ears with lengthened pierced lobes are distinctly shown. A tendency to realism which we have repeatedly observed is also apparent in the Admiralty Islands. The incised ornamentation, filled in with white lime, is supposed to represent tattoo patterns and woven leg and arm bracelets. The cone on the head must be interpreted as stylization of the hairdress. In many such figures the usual shell penis-cover is clearly shown, as well as the necklace (colorplate 30). Figures from this area are usually painted red, and the white ornamental bands stand out clearly against this brilliant ground.

A rare example of this art is the female figure with a child (colorplate 29). Its face clearly shows the most important features of the Metal Age tradition. There is no firm link between edge of forehead, nose, and eyes: the marked setting off of the forehead is entirely absent, the area of the eyes forms an independent narrow oval next to the nose. The same analysis applies to the ladder (plate 158), which shows an iconographic motif very frequent in this area: a man standing on a crocodile's snout.

The inhabitants of the Admiralty Islands have a large number of receptacles—baskets, bottles, and bowls. The bird-shaped bowl with four legs in the Linden Museum, Stuttgart (plate 159) is no doubt the finest specimen of this type. The combination of bird and bowl is as admirable as the artist's highly developed capacity for abstraction: he has executed his motif with the greatest possible economy of means. Here again, we must point to a problem which will have to be solved by future investigation: within the region extending from southern Micronesia through the Admiralty Islands into eastern Melanesia, there are numerous occurrences of works of art which, significantly, take the form of abstract sculpture. We are bound to presume some interconnections between the areas.

The large food bowl (plate 160) is very different. Here, too, the bowl stands on four legs. The outside is divided into regular ornamental fields, in which the same motif appears repeated in relief-band technique. But a peculiarity of this type is the pair of curved handles in openwork, terminating in large, very regular, almost freefloating, spirals.

The last example from this area (plate 161) is a carved crocodile. It is known that such animal sculptures (as well as figures of pigs, lizards, and opossums) were used in various rituals of the early culture of the Admiralty Islands, but we do not know what their religious significance was. Once again we must admire the realism of these artists. This carving shows particularly clearly why we have to speak of "realism" rather than of "naturalism": the artist's purpose is not to give a lifelike reproduction of a crocodile; he confines himself to the most obvious, unmistakable characteristics of the beast and combines them with ornamental motifs that were never derived from the naturalistic model.

NEW BRITAIN The inhabitants of this rainy island are still largely a mystery. Only on those of the Gazelle Peninsula, to the east, do we have a certain amount of data; mainly these are excellent accounts, primarily by Catholic missionaries, of the coastal Gunantuna and the inland tribes—the Baining, the Mengen, and the Sulka. Concerning the coastal population of the main part of the island we have only fragmentary reports. The southwest coast is inhabited by the Arawe, whose domain extends more or less from the lovely islands off

the western coast to Cape Dampier in the east. They practice artificial elongation of the head, observed elsewhere in Oceania only in the southern part of Malekula Island in the New Hebrides. Our information concerning the population of the western end of New Britain is equally scanty. As for the population of the northern coast, we have a few descriptions, mainly of the Nakanai. But the peoples of the greater part of New Britain are, at present, unknown.

By and large the culture of these people belongs to the Melanesian tropical cultivator type, which is divided into coastal and rain-forest subtypes. On the coasts, Austronesian dialects are spoken; we have insufficient data about the language of the inland peoples to assign it to any group, though it is certain that the language of the Baining is not Austronesian. The coastal population exhibits a feature of its social order which is also encountered on other Melanesian islands. The basis is still the kinship system, but parallel to it the male population is organized in so-called secret societies or clubs. (Apparently similar societies existed for women, but nothing certain is known about them.) The best known are the Duk-duk and the Iniet of the Gunantuna. The activity of such societies includes a secret phase in which only members participate, and a public phase in which the whole population joins. The most important function of the secret societies is to cultivate ritual relations between its members and certain manifestations of supernatural powers, which are recognized only by the given society. Cure of the sick, transfer of magical powers for the furthering of various economic activities, and control of the dead in the interest of the members are the most important aims of these rituals. The members of the societies appear in public as masked dancers who perform at fixed dates during the course of the year. Moreover the societies have the right to steal, or even to kill, under certain circumstances; often they function as agents of social control, punishing offenses against accepted conduct.

The best known examples of New Britain art are the spectacular Baining secret society masks. Since these are always made of painted bark cloth, we do not present them here. Less well known, but no less interesting, are certain wood sculptures, including figurines in soft wood which were worn on the head or held in the hands during dance performances (plates 162–166; colorplate 31). These works of art have so far largely been overlooked.

A glance at this group will result in the perhaps surprising discovery that the artists mastered the whole gamut of expressive possibilities from realism (colorplate 31) to the most extreme abstraction (plate 165). At first glance, the first four figures seem to be examples of the same style. The attitude of the body is essentially the same; however the faces exhibit important differences. In the two figurines (colorplate 31) from the Sulka area (the coast of Jacquinot Bay and the adjacent interior), the drop-shaped eyes are noteworthy: were these round, the facial type would correspond to that of the famous *korwar* figures from northwest New Guinea. In contrast to these are the faces of the two Gunantuna figurines (plates 162, 163). Here the face recedes under the straight lower edge of the forehead; the straight nose widens uniformly and the mouth forms a smiling semicircle. But particularly characteristic is the form of the facial contour. It is neither square nor triangular, but carefully rounded, and might be described as the lower half of an oval. This type of face occurs not only among the Gunantuna but also in the south of New Ireland (colorplate 38).

The two conical dancers' hats shown here (plates 167, 168) also come from the Sulka area; these basically consist of bamboo frames, covered with bark cloth on which black, white, and red designs are painted. The second shows how such hats were combined with soft wood carvings: on the diminutive conical hat is fixed a sculpture which has been interpreted as a dog. However, the Reverend C. Laufer, leading expert on the Sulka culture, has shown that the figure is that of a praying mantis, which the Sulka regard as an important totemic symbol. The painted ornament on the vertical shield at the back of the sculpture also represents the praying mantis. This time the motif is seen frontally projected on the two-dimensional surface. As in the case of the art of the American Pacific Northwest Coast, we must imagine that the image of the praying mantis was divided into two profiles, and these were brought together in a single plane. The forms of the head and eyes in this painting show clearly enough that the intended figure was not human. The treatment of the legs is no less interesting: they were elongated to fill the lower half of the ornamented surface. This gives rise to a very characteristic ornamental form which occurs singly or in continuous repetition in many paintings from this culture. In this connection we may also refer to the three painted war shields (plates 172, 173; colorplate 32).

Until a few years ago it was generally believed that figure carving hardly existed on the south coast of New Britain, but in 1962, H. Damm, director of the Ethnological Museum in Leipzig, published a series of sculptures from the Arawe area (plate 170). These figures are called *burbur* and are regarded as female. They stand in the ceremonial house or, as shown by a single photograph taken by E. W. P. Chinnery, underneath it. Sacrifices are made to them, and they obviously fall in the category of large carved fetishes. Only the head is shown, and the round post is worked as little as possible. There also exist small figurines of this type, which were carried by dancers.

The carved wooden masks of the Gunantuna are rather unimpressive (plate 169); these people modeled masks from real skulls, and as a result attached little value to wooden masks. Much more importance was attached to wooden masks in the French Islands, north of New Britain. These took the form of casques which covered the dancer's head and rested on his shoulders (plate 171).

NEW IRELAND The long (282 miles), narrow island of New Ireland and the islets lying off its eastern coast (Tabar, Lihir, Tanga, Anir-Feni) are the home of a people whose works of art have reached Europe and America in large quantities. The colorful, almost baroque carvings exhibit an incredible abundance of iconographic motifs. But other aspects of this people's culture also exhibit an extraordinary wealth of forms within their small land area. For instance, New Ireland, of all the islands of Melanesia, has the greatest number of house types. Economically, however, the people belong to the typical Melanesian coastal and rain-forest types of cultivators. Austronesian dialects are spoken by all but a few small groups.

In contrast to those from all the areas of Oceania discussed above, New Ireland sculptures do not consist of a single piece of material, but are composites of several parts. Arms, ears, noses, and other additions are carved separately and fitted into sockets, a technique which permitted great elaboration of ornament. However, such complicated sculptures require soft wood and the majority of the famous *malanggan* carvings are made of the wood of *Alstonia villosa*. Hard wood (*Borragniee Cordia subcordata*) is used only for the images made to stand in the grove devoted to the sorcerers specializing as

rainmakers, which must be resistant to wind and weather. The word *malang-gan* itself means "carving"; the individual types bear further identifying designations.

The series of reproductions from this area begins with a unique work, acquired in 1903 on the northeast coast by the German ex-governor, Bolu-minsky (plate 174). This is a soul boat almost twenty feet long which was made to commemorate an important chieftain. The bow and stern are shaped as large fish heads with boarlike tusks and, in addition, the particularly striking feature of a tremendous tongue curling upward. The exterior of the boat is ornamented with a series of fish and snakes. Inside, nine statues have been fitted into sockets: four oarsmen, four passengers, and near the bow, a statue with outstretched arms and a hornbill perched on its head. These statues are supposed to represent the dead chieftain with his relatives and some of the enemies he has slain. The work comes from an area in which it was customary to put the corpses of notable men in a canoe and send them out to sea.

A leading role in the culture of the east coast is played by the so-called rainmakers. Their most important fetishes were the skulls of their successful predecessors. They are kept in the *marandan* groves in a bowl made from the shell of a giant clam (*tridacna*). In addition, headless idols are carved, on top of which the skulls are placed. There are also rainmaker figures carved entirely in wood; two particularly impressive examples are reproduced here (plates 175, 176).

The inland villages of northern New Ireland are the home of the famous *Uli* figures (plate 177). This type is called *selambungin lorong*, the second word meaning "rich." The figure is dominated by a powerful head with elaborate coiffure, including a comb. There are two horizontal strips of wood around the body, one directly under the breasts and the other above the genitals. The penis is fully sculptured; the legs bend forward sharply at the knees. The arms point vertically upward, but each is itself shaped as a small *Uli*, a repetition of the main figure. The whole figure is enclosed in a lattice work of ornamental strips. Such sculptures are associated with a series of thirteen festivals which are held over a three-year period. Only when the last of these is held are the *Uli* figures assembled and painted, and great dances performed in front of them.

In considering the classical *malanggan* sculptures, we must distinguish between vertical statues and horizontal friezes. The latter are invariably prepared in connection with the funerary rites for prominent men, and are thrown away after the ceremony. They always refer to specific persons— kinsmen or other individuals who played a role in the lives of the deceased. The horizontal *malanggan* shown here (colorplate 34) terminates at each end in the head of a fish. The circle in the middle, called a "big fire," probably represents the hearth of the dead man's family; the interpretation of this circle as standing for the sun has been contested. The "big fire" is surrounded by a snake. The two men, to right and left, hold on with one hand to the snake around the "big fire" and with the other hand to another snake.

One of the finest specimens from this area is a horizontal frieze (color-plate 35, center) which represents an eagle. The bird is seen frontally at the moment when it spreads its wings and carries off a snake in its beak. The unique combination of realism, elegance, and well-balanced proportions raises this work to the level of a masterpiece. The means by which the artist has combined so many divergent forms into a self-contained whole deserve attention. The feathers executed in openwork technique convey the impression of a powerfully down-swooping bird of prey; but this dynamic movement is arrested by a surrounding ornamental frame which imprisons the movement of the wings within the rectangular form of the horizontal frieze, which is emphasized by the shells of marine snails (*turbo*) inlaid at the four corners. The frame is in its turn framed within a radially protruding wreath of feathers. Here the carver once again displays the sureness of his taste: how easily the feathers could have destroyed the unity of the work! But the artist solved this difficult problem by carving them at an angle instead of vertically. This work of art would have satisfied even Lessing, who said: "That alone is fruitful which leaves free room for the imagination." (*Laokoon*, III)

The vertical *malanggan* carvings reflect the same spirit. To appreciate the artist's accomplishment one must identify oneself for a moment with the baroque complexity of the columnar carving (plate 179), which is more than eight feet tall. At the center of the column is the symbol of the "big fire"; above and below it the same figures are repeated. A man stands on a pig's head while on his head is perched a bird. Everything is subordinated to the vertical lines, and ornamental ribs stress this effect. Of especial interest is a

carving (colorplate 33) showing a man standing on a fish; a snake is wound around his body, its head under his chin. The man holds a mask with pointed ears in front of his face, of which we see only the mouth and chin. Such masks represent monsters believed to be encountered in the forest by hunters. In the mask (colorplate 41) the most striking feature is the square frame around the area of the eyes; the oval eye lies diagonally inside it, so that no room is left for the cheeks. Around the neck is carved a chain of betel nuts, and the tail of a half-swallowed fish protrudes from the mouth. The attached nose is an elaborate image in itself: the lower part combines a hornbill and a snake, while the upper represents a cockatoo with lowered head and a large crest. The long, pointed ears represent flying foxes. Finally, over the nape of the neck rises an ornament of chicken feathers.

Of the numerous types of masks from this area, three more are shown. The *tatanua* mask (plate 182) is one of the finest examples of this type; the caterpillar-like helmet of sea grass and chalk covering represents a coiffure with comb, much like that shown on *Uli* figures. The *kepong* mask (plate 183) again shows clearly how skillfully the technique of assembled figures can be applied. The mask's beard consists of root fibers, the hair on the head of coconut fiber. Inside the attached ears stand two fully executed male figures, and at the lower edge of each ear is carved the "flying fox" ornament.

Young girls are often kept confined to a special house for years before marriage, in order to bleach their skins and fatten them. This custom is not observed throughout Melanesia though it exists among the nobility of many Polynesian islands. The special girls' houses are decorated outside with beautifully painted and carved boards. One specimen of these (plate 181; collected before 1880) shows faces with ornamental designs above and below them; these designs are supposed to represent the leaves of the caryota palm.

At the beginning of this century, limestone figures were discovered in central New Ireland, but the significance of these peculiar sculptures remained obscure. Before the First World War, O. Schlaginhaufen ascertained that they had something to do with a so-called *papaua* cult, but was unable to learn anything more about them. In 1962 a voluminous manuscript, written about 1925 by K. Neuhaus, a former missionary, revealed a surprising amount of information concerning the Pala culture in the Namatanai district, which is situated at the narrowest part of the island. It appears that such

figures are employed in two cults, *papaua* and *langan*, both of which were developed in the interior of southern New Ireland, and spread slowly northward. Their purpose is to secure the health and welfare of the cults' members.

The art of the limestone figures extended as far as the Gazelle Peninsula, where similar carvings are used in the ritual of the Iniet secret society. In the *papaua* cult, wood figures were also employed but proved less durable. The stone figures represent characters from the creation myths of the cult and dead or even living members of the cult society. They are displayed on altars as tableaux; the cult congregation crouches in solemn silence before them, and thus performs the act of communion. The two figures (plates 186–188) are characteristic examples of this kind.

Considering the art of New Ireland as a whole, we must make a fundamental distinction between the baroque *malanggan* style in the north and the simpler style prevalent in the south (plate 185). The culture of southern New Ireland is closely related to that of the coast of the Gazelle Peninsula of New Britain. But characteristic of New Ireland is a special alteration of the Neolithic-Austronesian tradition in the representation of faces: straight-edge line of forehead, perpendicular nose, strong recession of the facial surface, and a broad mouth extending across the face. The facial contour is often quadrangular, but as a rule is a half-oval. Also, in many figures the verticals are stressed and the legs bent. But the way in which the New Ireland artists received and developed the stimulus of the Metal Age stylistic tradition is unique in Oceania. The combination gave rise to an unmistakable local style, works which are today justly regarded as some of the most valued possessions of museums and private collections.

SOLOMON ISLANDS By the middle of the sixteenth century, when the Spaniards realized that the Inca empire of Peru was not, as they had thought, King Solomon's Ophir, they sent daring expeditions into the Pacific in search of that mythical land of gold. In 1567, after a long, wearisome voyage, Alvaro de Mendaña discovered a Melanesian archipelago which he named the Solomon Islands. Though he found no gold there, the Biblical name has been preserved to this day.

The inhabitants are, again, tropical cultivators with the usual coastal and

highland subdivisions. The people in the northern islands are markedly dark-skinned. The culture of the Solomon Islands as a whole belongs to the Austro-Melanid type; the influence of the Metal Age stimulus is evident, particularly in the southeastern islands.

The type of canoe which has washboards and an outrigger on one side is characteristic of the whole of Melanesia; but the Solomon Islanders have a special boatbuilding technique. They sew planks together, making the seams watertight by filling them with oakum and resin. The canoes have no outrigger and are not fit for long voyages; but, slim and capable of being propelled with great speed by seated paddlers, they are excellently suited for bonito fishing, when it is necessary to pursue a rapid quarry. The islanders used the same canoes for their dreaded head-hunting expeditions within the calm waters of their own archipelago.

A survey of the art of these people shows that three areas are distinguishable: the northwest, with the islands of Nissan, Buka, and Bougainville; the central islands; and the southeast. In the northwest, two-dimensional works painted in color predominate. In the other two areas, three-dimensional sculptures are the most frequently found. Characteristic of the central Solomons are black-polished wood sculptures with ornamental bands of tiny and brilliant inlaid pieces of mother-of-pearl. In the southeast Solomons the wood carvings are left in natural color. Stone sculptures, many found on Choiseul Island, are somewhat exceptional. But apart from these variations, the entire area exhibits the same basic stylistic features.

From the island of Nissan comes a mask (colorplate 42) which, strictly speaking, is not a sculpture. A frame of bamboo strips was coated with a resinous substance into which the facial features were incised. Only the radially protruding ears are carved in wood. The ears are round in this example, but there are also examples with rectangular ears, and even some in open-work technique. Such masks supposedly represent a spirit called *kokorra*, invoked by secret societies in northern Bougainville.

The three-dimensional figure sculptures of northern Bougainville (plates 189–191) appear in the so-called *watawut* ceremony described by B. Blackwood. This ceremony is public and held in the village, not secretly in the bush like others. It is one of the three great initiation rituals. Early in the morning a solemn procession sets out from the ceremonial house; some of the partic-

ipants carry these figures. As a work of art, the male standing figure is fairly simple. The oval face is a characteristic form which occurs everywhere between southern New Ireland and the central Solomons. The facial plane is convex, and the ears protrude radially. The parallel white lines which run around the face are especially characteristic. The bird carvings, too, are simple, but their economical contours disclose excellent observation and a very sure hand.

The dance plaque (plate 192) from the Telei tribe in northern Bougainville is representative of the style of the northwest Solomons. The implement is held by the lower bar and moved in time to the beat of the dance. The relief designs on a white-painted field are particularly charming. The row of crouching people with linked hands and feet is a recurrent motif throughout Oceania.

The figure (plate 193), typical of the style of the central Solomons, is supposed to represent a protective spirit. The head sits easily on the distinct neck. The chin juts far forward, and the receding facial plane terminates in a conical head covering. But particularly typical is the convex line of the nose, which is emphasized by sharp curvature and almost vertical nostrils. The oversized, almost brutal mouth opposes with this line. The figure holds a small human skull in its hands. It is not known whether the skull symbolizes the head-hunt or refers to the custom of a second burial in which the bones are exhumed, and the skull removed to be preserved separately.

There is an unmistakable affinity between the styles of the central Solomons and the Admiralty Islands (cf. plate 157). This is also true of the food bowls (plates 200, 201) which exhibit an incredible variety of forms. The combinations of animal and man and bird and fish here achieve an artistic high point. But what is decisive in every case is that the motifs are shown in profile. All these bowls must be viewed from one side if we are to enjoy them fully as artistic creations.

From Choiseul Island come two sculptures which are among the most important works in stone produced in Oceania. The urnlike sarcophagus (plate 194) was collected in 1933 by H. Bernatzik. In form it is very similar to many stone urns found in eastern Indonesia. The body of the sarcophagus is decorated with a standing male figure in relief. On the foot the same face reappears. Each has the radially protruding ears found in the paintings and

the other sculptures of the Solomon Islands. The removable lid is decorated at all four corners with smaller human figures, also in relief. They are closely related to the figure from New Caledonia (plate 220). No less extraordinary as a work of art is the squatting stone figure (plate 195). Stylistically, however, these figures do not differ from the usual wood carvings of the archipelago; they cannot be regarded as the works of another population with a style of its own, but are a variation on the basic Solomon Islands style.

The shark plays an important role in the religion of these islanders. It is therefore not surprising that wooden figures of this predatory fish are common (plate 196). On some islands the body is hollow, and the exhumed skulls of prominent chieftains are kept inside such "tombs" as sacred relics. The sparse but realistic outline of the figure is a fine example of an expressionist technique which often achieves a classic quality in profile.

On the southeastern islands of the archipelago the posts of ceremonial houses are decorated with carved figures. In an example from Ugi (plate 197) all the basic features of the Solomon Islands style are recognizable. But here the face is flat instead of convex, possibly since the post was carved in a harder wood than usual. Under the chin there is the suggestion of a small beard. The massive hat gives the impression that it must go back to a Spanish model, but it is necessary to be on guard against such analogies, as the figure is part of a long house post, the top and bottom of which have been cut off. This becomes particularly clear when we look at the figure (plate 198) of a man standing inside a shark's mouth. He wears a similar hat, but here it is topped by a crescent-shaped form which served to support a crossbeam. Finally, the realistic tendency of these carvings is especially noticeable in the figure (plate 199) of a man holding in his hand a fully carved gourd for the lime used in chewing betel.

NEW HEBRIDES Like the cultures of other Melanesian archipelagoes, that of the New Hebrides is of the Austro-Melanid type and was perceptibly influenced by the tradition of the Metal Age. Here too, the population is divided into a coastal and an inland type. Thanks to a few outstanding modern monographs we are particularly well informed about the central New Hebrides, where secret societies proliferate. Some of these differ from the societies of New Britain in

an important respect; their membership is divided into grades or ranks. The highest-ranking members enjoy the highest social status. Promotion from one grade to the next must be earned by a lavish feast: for several days the candidate must supply the members of his own grade, and the one to which he is to be promoted, with large quantities of food, above all pork. At the same time specific rituals must be observed, and to commemorate the occasion the candidate must hire artists to carve prescribed types of figures in tree fern or other kinds of wood. Stone figures are executed only for the highest grade.

A typical example of the tree-fern statues (plate 203) is from the island of Ambrym. The face dominates the composition: below it the body, down to the legs, has entirely disappeared. The crucial aspect of the face is its completely convex surface with huge saucer-like or oval eyes. The nose is straight with flaring nostrils, and the mouth cuts all the way across the lower edge of the facial oval.

This type of face is common in the art of the New Hebrides; it is, indeed, the distinctive characteristic of this area. This is particularly apparent in the large standing slit gong (plate 205), also from Ambrym. Whole orchestras of such gongs were carved, at the candidates' expense, for the feasts of promotion. But the same type of face is also used in smaller works of art, for instance in the stone carving employed in love magic (plate 212). It occurs in the remarkable carved figure on the handle of a dancing adze from southern Malekula (plate 206), and yet again on the underside of a food bowl (plate 208). In Melanesia, this convex facial surface is an important trait throughout the central Solomons, the New Hebrides, and New Caledonia.

The archaic-looking wooden mask from Ambrym (plate 209) also exhibits this feature, but here a new element is added. The nose forms a wide round arc, and the resulting disc is pierced. The mouth, too, differs from those of the other carvings: the upper and lower lips, occupying the whole width of the mouth, protrude sharply and look as though split open. These two features are especially characteristic of southern Melanesia—they occur from the south of the central New Hebrides to New Caledonia. However, they also appear in northwest Melanesia, in many *malanggan* carvings from New Ireland.

Off the northeast end of Malekula lies a chain of small islands which show interesting individual traits of culture and art. The carved post of a platform

on which offerings were set comes from one of these islands, Vao (colorplate 43). Such platforms are made of stone; they are real dolmens with a stone menhir at the back. The wooden post stands at the front, and over the menhir and the post is placed a horizontal beam which serves as a kind of ridge pole for a roof of leaves sheltering the actual dolmen platform. Here are sacrificed large boars whose tusks were made to curl back upon themselves to describe a circle—a process which takes a number of years. The officiating priest carries the boar, its legs trussed, onto the platform and there kills it with a heavy ceremonial club (plate 207). The face carved on this post is a pure example of the Neolithic-Austronesian stylistic tradition. The rectangular connection between forehead and nose, the receding facial surface, and the circular eyes demonstrate this incontestably. Arms and shoulders are indicated in relief. The shoulders reach as high as the cheeks, just below the level of the eyes—this too is characteristic of the same tradition.

The adjoining small island of Atchin has yielded another figure, this time in a style clearly influenced by the Metal Age tradition (plate 204). Once again we are reminded that the mingling of the two traditions was a highly complex process which did not result in a uniform new style. The individual societies on the different islands adopted different features of the existing traditions and transformed them into basic elements of their local styles.

The Nalawan is an important secret society of Malekula, and for the members of the rank called *numbou timbarap* a stone menhir must be set up. Toward the end of the ritual, a high-ranking member of the society must ceremonially kill with bow and arrow the statues set up for this purpose. This man has his entire body painted, and wears several caps made of cobweb (the so-called spiderweb caps). At the end of the ceremony the four-faced mask called *napal* (colorplate 45) is placed over his head. The faces of the mask are molded on a frame of bamboo strips, and the conical top made of tree fern represents a particular style of hairdress. Another mask (colorplate 46), belonging to a member of the same secret society but of a different grade, was modeled on a hollow piece of tree-fern wood. The dancer put this tubular mask over his head, so that it rested upon his shoulders.

The stone carving (plate 210) collected on the island of Aoba in 1934 is unique: it is a bowl in the shape of a boar with its tusks grown into a circle. Nothing is known about the use of such bowls. This one was found in the

rubble near an abandoned settlement far from the coast. This work and the animal-shaped wooden bowls must surely be similar in function and form.

NEW CALEDONIA

New Caledonia (248 miles long; 25–30 miles wide) was discovered by James Cook in 1774. It lies to the south of the Melanesian area and, after New Guinea, is the largest island in the southwest Pacific: hence its French name, *La Grande Terre*. About six miles offshore it is encircled by a coral reef; ships can reach the island only through a few gaps in this barrier which are mostly opposite the mouths of rivers. Inland, the mountains rise to a height of more than five thousand feet.

Racially, linguistically, and in other cultural aspects, the New Caledonians are pure Melanesians. But it seems that in the decades before Europeans took over the islands, New Caledonia maintained close relations with the Fiji Islands and other parts of western Polynesia. Many anthropologists have pointed out this link but only recently has it been proved by the French anthropologist J. Guiart that many chief families in New Caledonia came originally from western Polynesia.

The New Caledonians are outstanding agriculturists. For the cultivation of taro, which needs a great deal of water, they built a large-scale system of terracing with artificial irrigation. This technological feat is the more amazing because it was performed with very simple tools. When the Europeans came, the inhabitants had only one domestic animal—the chicken. The dog and the pig, which are found everywhere else in Oceania, were absent. Archaeological excavations have proved that these animals existed formerly but had become extinct. The same excavations proved that New Caledonia was settled as early as 800 B.C.

The old type of house in New Caledonia was a round structure with a conical roof. The houses were generally small, only the dwellings of the chieftains being imposing structures. The roofs of the latter are sometimes thirty-three feet high, and as a rule they stand on earth terraces sustained by stone walls. The doors of such houses are provided with rich wood carvings. Particularly famous are the massive door jambs (averaging five feet in height and between thirty and forty inches in width). The example shown (plate 213) is over six feet high; it is from the northwest of the island and the face on it is not easily comparable with the other Melanesian styles because it was

adapted to the size of the board. The skill with which this is done shows the great sense of form possessed by these artists. Eyes, nose, and mouth are widely separated, the nose with its flaring nostrils being the dominant feature. Indicative of the specific local style is the fact that the outer corners of the eyes, the nostrils, and the mouth are of corresponding shape: a maneuver by which the artist has achieved extraordinary unity without enclosing the features within a facial contour.

Inside the house the conical roof is supported by a central pole which terminates high above the roof in an elaborate carving. Such carvings show local variations, for instance in the east central area (plate 214) and the west central area (plate 215). In the latter the facial contour is modified: below the eyes the face spreads laterally so that the cheeks seem puffed out. The semicircle on which the face rests has been interpreted as a jaw, and the down-pointing hooks directly underneath are supposed to be the legs of the figure. Thus, as in many carvings from the New Hebrides, we have here an abridged human figure consisting only of head and legs. Above the face are three horizontal bands; the middle one is decorated with a chevron pattern which is interpreted as a wreath of leaves. The one above, with the hook-point upward, is supposed to represent the arms; the heart-shaped disc above that is supposed to indicate the spherical hairdress affected by New Caledonian men. Thus all the important parts of the human body are represented, not arranged in the natural order but subordinated to the formal principle of this vertical ornament.

In other parts of the island, roof ornaments feature figures fully carved in the round, including representations of masked dancers (plate 219) wearing a mask and a costume of feathers such as occur in actuality (plate 217). This is a small example of the type—other examples are up to five feet high.

The most famous New Caledonian masks are those with enormous hooked noses and softly rustling feather costumes. The carved wooden mask covers the face, and has a broad woven band in the back. It is supported on a stick the dancer carries in his mouth. On top of the mask is fixed hair formed into the characteristic spherical coiffure. The heavy costume, which covers the dancer completely, is attached to the lower edge of the mask. The mouth opening of the mask serves as a slit through which the dancer can peer out (plate 217). Another example (plate 218) shows again the puffed-out cheeks which, unlike

the first, suggest joviality to a European viewer—an impression not shared by the New Caledonians. For these masks are supposed to represent a water spirit called Pouémoin, who dwells in the mangrove forests along the coast. He is normally invisible, but when summoned forth he appears in the form imitated by these mask-costumes, brandishing a lance and a club, and attacking fishermen.

In a somewhat older type of mask (plate 216), the face is a bisected piece of tree trunk. The work strikes one as more archaic than the others. The large bulbous nose dominates the face with its puffed-out cheeks. The up-curved mouth is open, showing two rows of sharp teeth. The frightening appearance of this face is further stressed by the two bulging eyebrows.

The New Caledonian rain sorcerers, like their counterparts in New Ireland, employ wooden figures. The female figure shown here (plate 220) is an unmistakable example of the local style. The head rests upon a distinctly carved neck. Though the arms hang down vertically, the hands are turned inward and touch the sexual parts. The joint-marks at the knees are clearly visible. The feet point inward and are incised in relief on the supporting block. The figure is another good example of the basic Melanesian style, derived from a mixture of Neolithic-Austronesian and Metal Age traditions.

EASTERN MELANESIA

This chapter deals with works from several areas: Saint Matthias (north of New Ireland), and the Tasman (Nukumanu), Mortlock, Banks, and Santa Cruz island groups. This is not to imply that they constitute an ethnic, linguistic, or cultural unit. However, the majority of these islands, in contrast to those previously discussed, do not belong unmistakably to the Melanesian cultural area. On these islands, as well as a few others not mentioned here, several cultural traditions are observable, though unfortunately they have not yet been sufficiently elucidated. In some of these groups, while the familiar Austro-Melanid substratum is unmistakable, at least two other influences have left their traces. The first of these is a kind of echo of the culture of western Polynesia. The second, a more recent though still pre-European influence probably originating in eastern Micronesia, has been emerging ever more clearly in the course of recent research.

Interesting, though certainly not among the masterpieces of Oceanic art,

are ancestor figures from Saint Matthias (plate 221). Face and hair style with comb are clearly related to those in the *malanggan* carvings of north New Ireland. The attitude of the body with its emphasis on the vertical is in the Neolithic-Austronesian tradition. The execution is poor; in particular, the shoulders, which are elsewhere so meticulously carved, are here merely suggested by incised lines. The head is supported by a neck—a detail which points to the Metal Age tradition.

More impressive, though simple in technique, is the figure of the ancestral god Popua from the Tasman Islands (plate 222), which is nine feet high. It is recognizable at once as an example of Neolithic-Austronesian stylistic features. It was collected by E. Sarfert during the extensive Hamburg South Seas expedition (1908–10), and is known to have been in existence as early as 1902. It is also known that its predecessor was sixteen feet high, but this colossal image unfortunately could not be collected and has since disintegrated; it can today be seen only in a photograph. The Tasman Islanders believe that the coconut and the taro grow thanks to Popua. But the god must also have something to do with the sea: it is reported that the priest carried the statue down to the beach when the island was threatened by angry seas, as Popua was supposed to calm the waters.

The ancestor figure from the island of Taku in the Mortlock group (plate 223) exhibits the same stylistic features, but this time the comblike ornament on the head is parallel to the plane of the face rather than set at right angles to it as in the figure of Popua. Similar figures also appear on the islands of the Ontong Java group at the eastern extremity of Melanesia, where they represent, among others, the important goddess Keluahine and her son by her first marriage, Pulmakua. This goddess, also called Ohine, is believed to have given mankind the taro and a certain pattern of tattooing. The name "ancestor figures" as applied to such carvings may thus be interpreted in two ways. Either they represent actual ancestors who are venerated as such, or they refer to mythical ancestors who are made visible by being so depicted.

A second ancestor figure from Taku (plate 224) is intended to show the range of variations of which these stylistic traditions are capable. It is easy to recognize the same features as in the other figure. But the face hangs less far down over the chest, the head is more rounded, the comblike ornament is absent, and the ears are distinctly carved.

Two unusual tree-fern sculptures were collected by F. Speiser on Gaua in the Banks Islands (plates 225, 226). The two figures commemorate promotions in secret societies of the same type as exist in the New Hebrides. Stylistically the figure in plate 225 belongs to the Neolithic-Austronesian tradition. The triangular face hangs down very low over the chest. Here the arms rest with the elbows on the block of the thighs and the forearms are bent so that the hands can be folded. The legs are bent slightly forward, the feet turned inward. The broad ornamental band rising above the head is particularly interesting: superficially it resembles human figures with bent arms standing side by side. Actually it represents the silhouettes of pig's jaws with curved tusks. The number of jaws, corresponding to the pigs killed at the promotion ceremony, indicates the rank of the man who commissioned this work and for whom the sacrifice was carried out. Another figure (plate 226) seems stylistically out of key because of its circular faces, but nose, eyes, and mouth belong emphatically to the same stylistic tradition as does the other figure. The two ornaments, above and below the faces, have been interpreted as crosses. This is an error: they actually represent birds standing vertically with spread wings.

The influence of eastern Melanesia is strongly marked in the Santa Cruz Islands, which lie off the eastern end of the Solomons. The two figures from this area (plates 227, 228) are quite simple as carvings. Attitude and face disclose the older Neolithic-Austronesian style, whereas the position of the head directly on the body and the free-standing pointed hairdress on the back of the head must surely be assigned to the Metal Age tradition. Decisive elements include not only the edge of the forehead, the nose, and the eyes, but above all the mouth, which is entirely shifted to the lower edge of the face. However, among the most charming works of art from this archipelago are the elegant fish sculptures (plate 229), which can certainly be related to the shark sculptures from the Solomons (plate 196). But unlike those black carvings with their mother-of-pearl insets, the Santa Cruz examples are painted with red and white ornamentation. The whole surface is divided into ornamental fields, within which the patterns are repeated.

ADMIRALTY ISLANDS

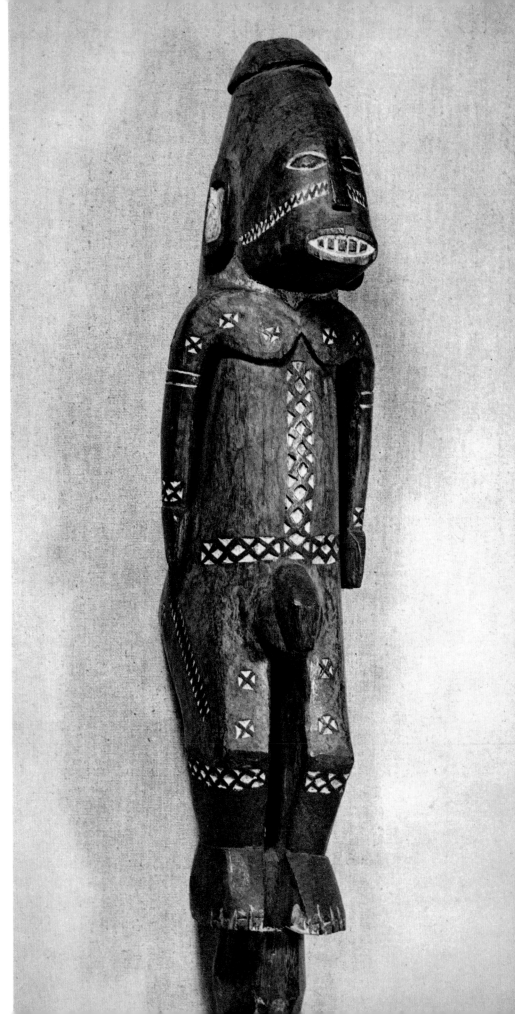

PLATE 157. MALE FIGURE
Admiralty Islands (Thiel, 1908)
Height 30 3/4″
Linden Museum, Stuttgart

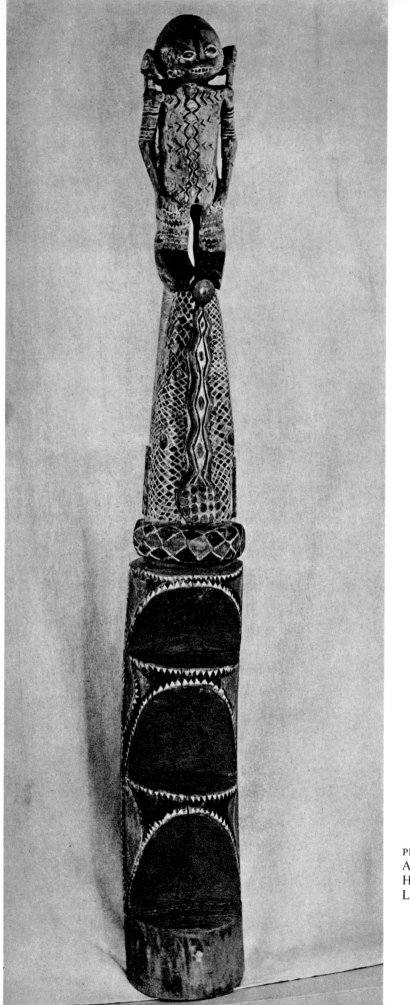

PLATE 158. LADDER
Admiralty Islands (Thiel, 1908)
Height 64 5/8″
Linden Museum, Stuttgart

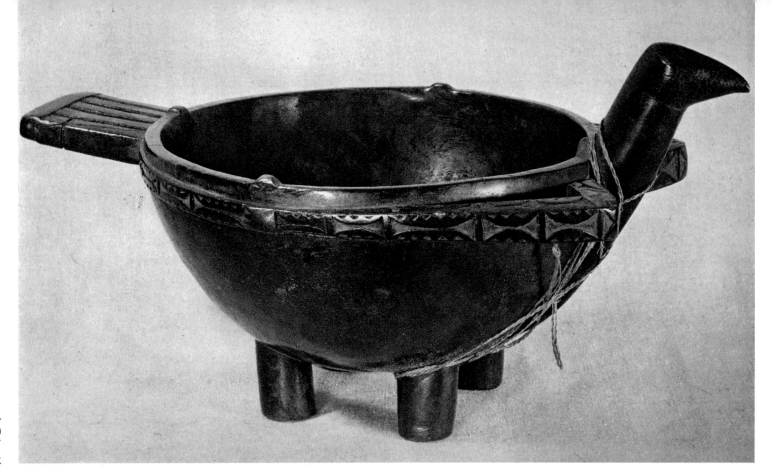

PLATE 159. BOWL
Admiralty Islands (Zembsch, 1902)
Length 16 7/8″
Linden Museum, Stuttgart

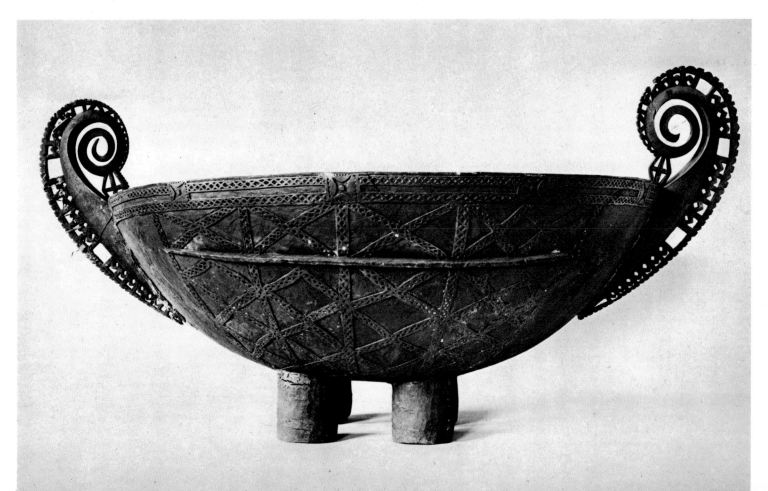

PLATE 160. FOOD BOWL
Admiralty Islands (Bühler, 1932)
Height 20 1/8″; diameter 44 7/8″
Museum für Völkerkunde, Basel

COLORPLATE 29. FEMALE FIGURE WITH CHILD
Admiralty Islands (collected before 1912)
Height 29 1/8″
Museum für Völkerkunde, Basel

PLATE 161. CROCODILE
Admiralty Islands
Length 30 3/4″
Staatliches Museum für Völkerkunde, Munich

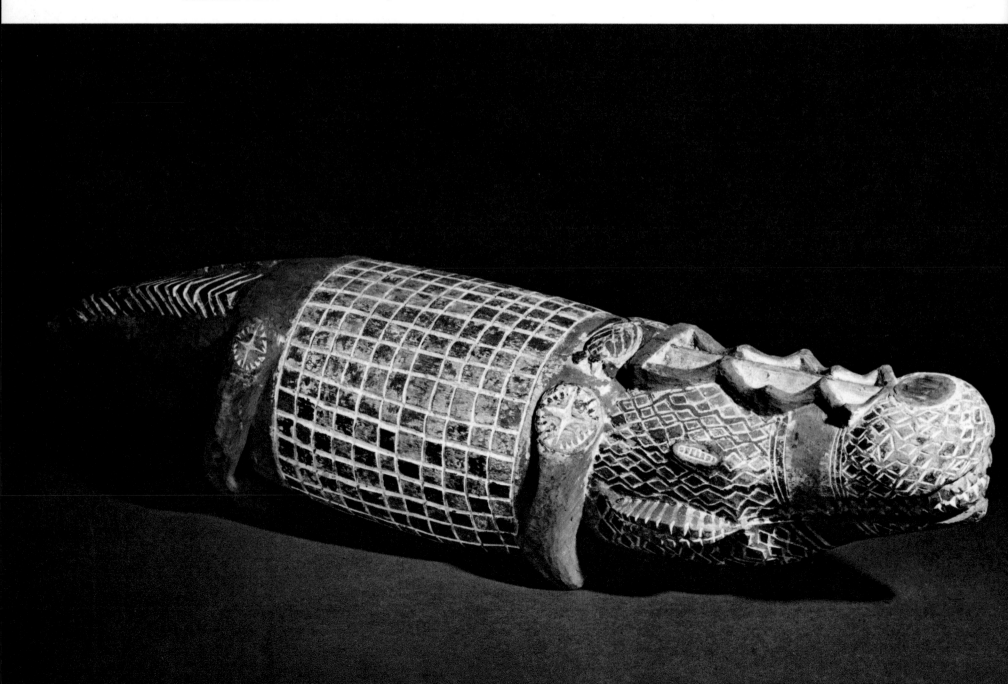

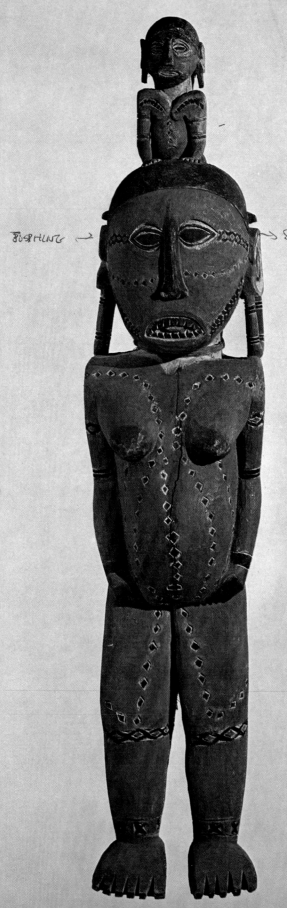

BÜSCHING → → Susanna

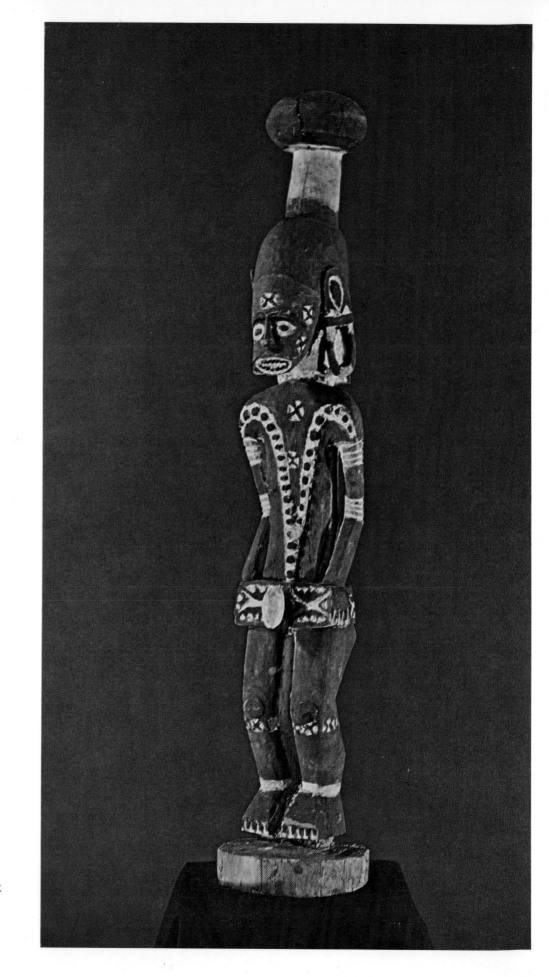

COLORPLATE 30. FIGURE
Admiralty Islands
Height 32 1/4″
American Museum of Natural History, New York

NEW BRITAIN

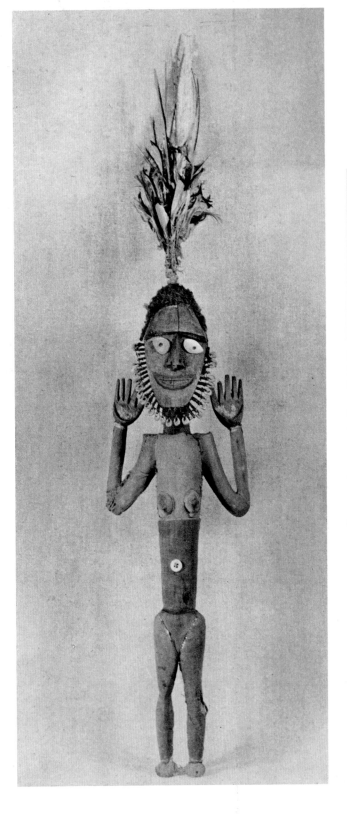

PLATE 162. FIGURINE FROM DANCE COSTUME
New Britain, Gunantuna
Height 34 1/4″
Linden Museum, Stuttgart

PLATE 163. FIGURINE FROM DANCE COSTUME
New Britain, Gunantuna (Fellmann)
Height 18 1/8″
Linden Museum, Stuttgart

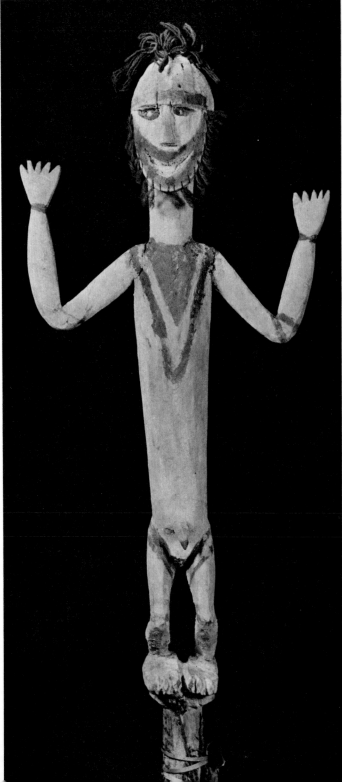

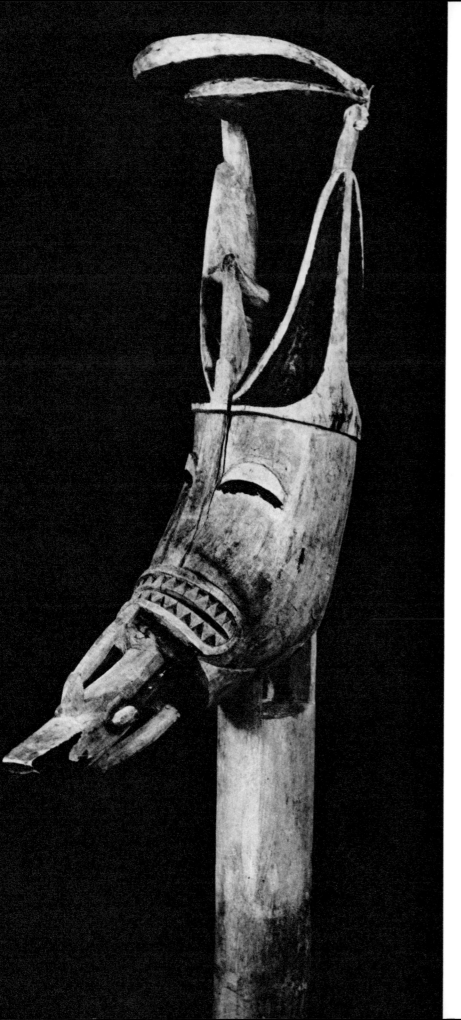

PLATE 164. FIGURE FROM DANCE COSTUME (detail)
New Britain, Matupit
Height of entire figurine 21 5/8″
Linden Museum, Stuttgart

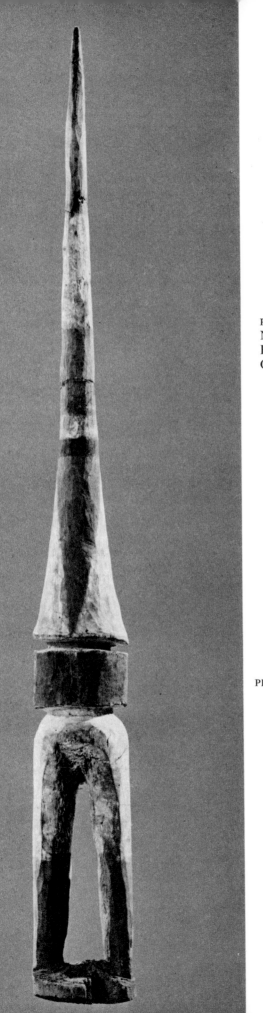

PLATE 165. FIGURINE FROM DANCE COSTUME
New Britain, Gunantuna (Wandres, 1906)
Height 36 5/8″
Collection N. Heinrich, Stuttgart

PLATE 166. FIGURINE FROM DANCE COSTUME
New Britain, Matupit (Burger, 1911)
Height 38 5/8″
Linden Museum, Stuttgart

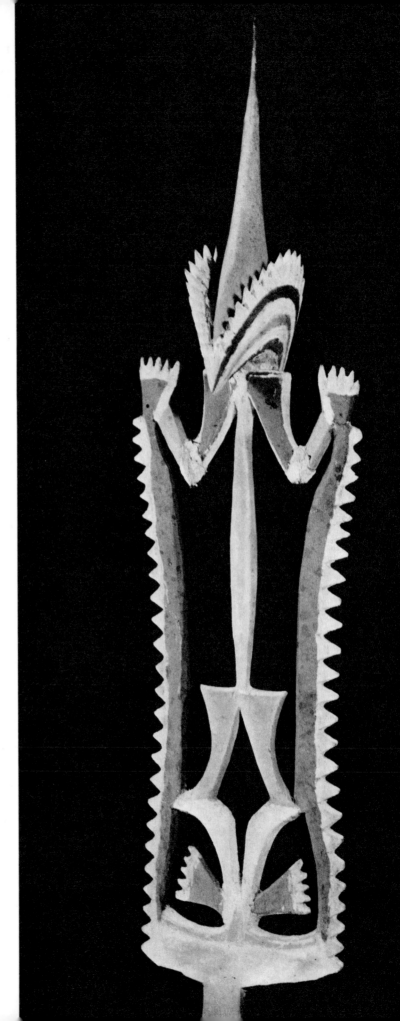

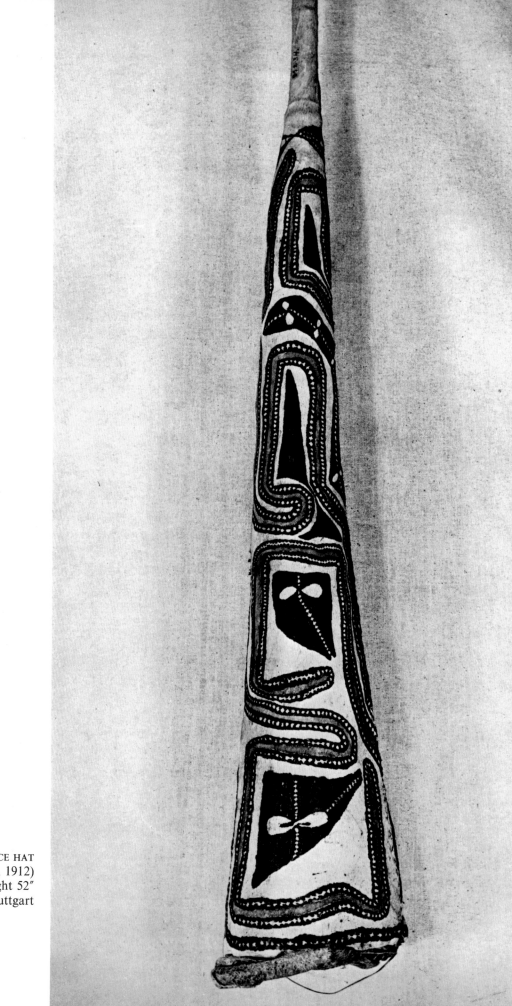

PLATE 167. DANCE HAT
New Britain, Sulka (Scharf, 1912)
Height 52″
Linden Museum, Stuttgart

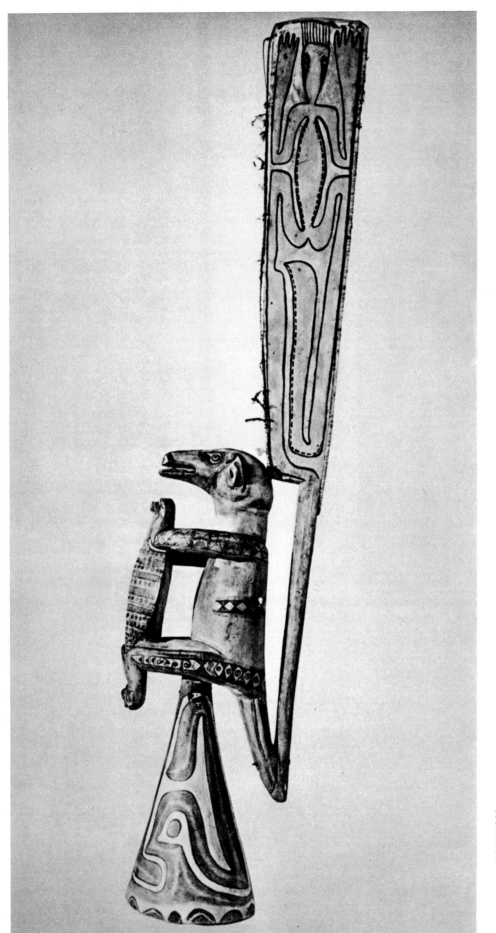

PLATE 168. DANCE HAT: PRAYING MANTIS
New Britain, Sulka
Height 60 1/4″
Ethnographical Museum, Budapest

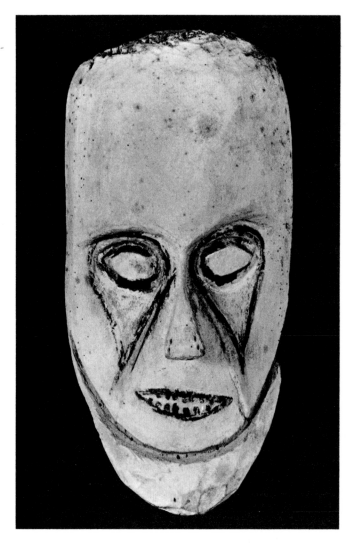

PLATE 169. MASK
New Britain, Gunantuna (Parkinson, 1903)
Height 12 1/4″
Museum of Primitive Art, New York

PLATE 170. CEREMONIAL POST (*burbur*)
New Britain, Sulka (Scharf, 1912)
Height 59 7/8″
Linden Museum, Stuttgart

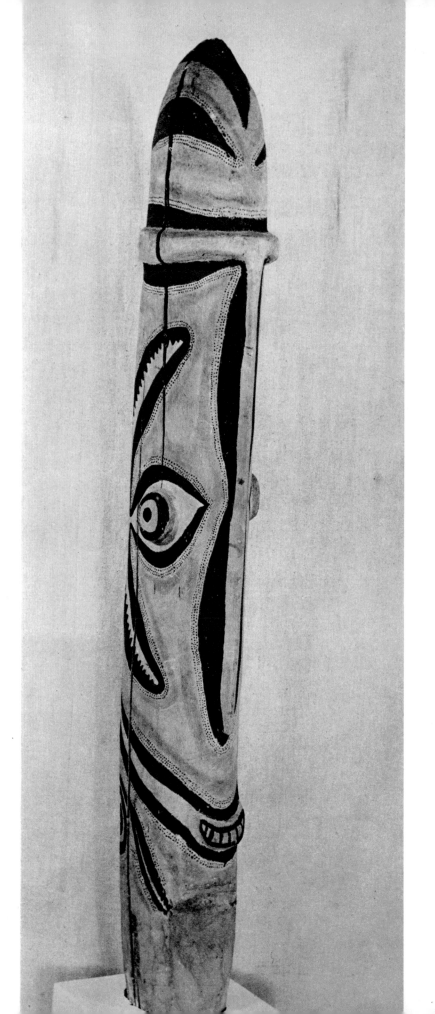

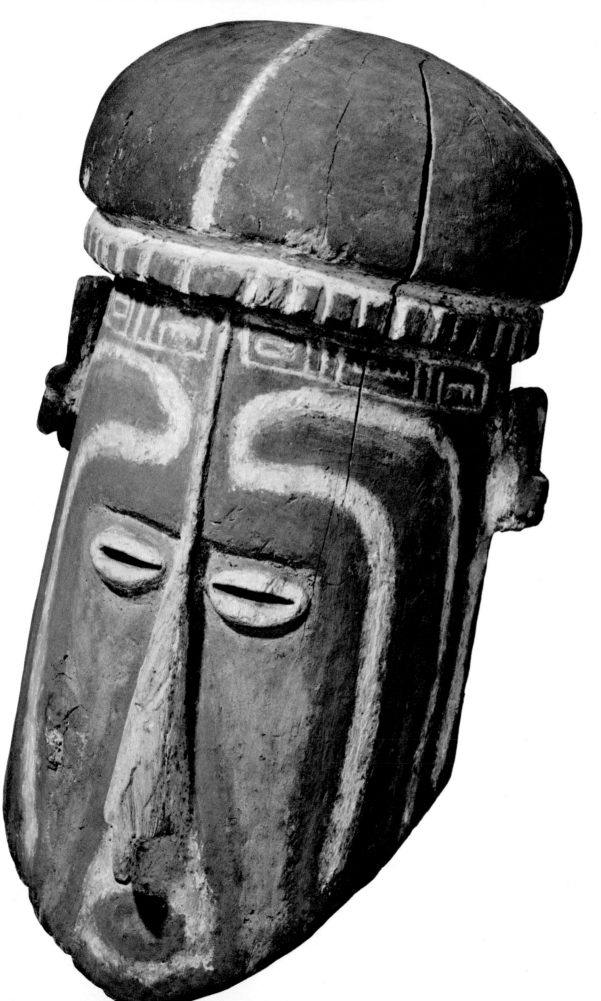

PLATE 171. MASK
New Britain, French Islands (Hering, 1906)
Height 18 7/8″
Collection N. Heinrich, Stuttgart

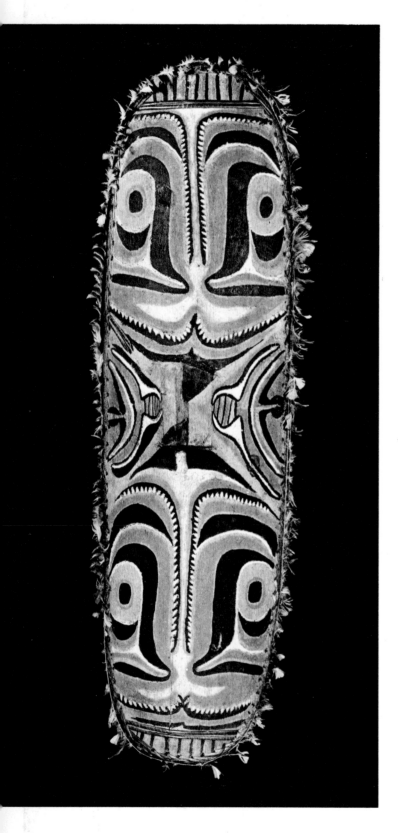

PLATE 172. SHIELD
New Britain, Sulka Group (Mencke, 1901)
Height 62 1/4″
Linden Museum, Stuttgart

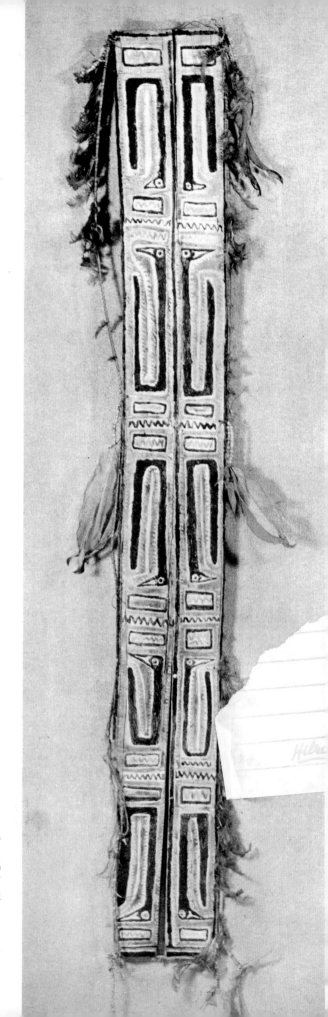

PLATE 173. SHIELD
New Britain, French Islands,
Unéa (Besenbruch, 1912)
Height 42 1/8″
Linden Museum, Stuttgart

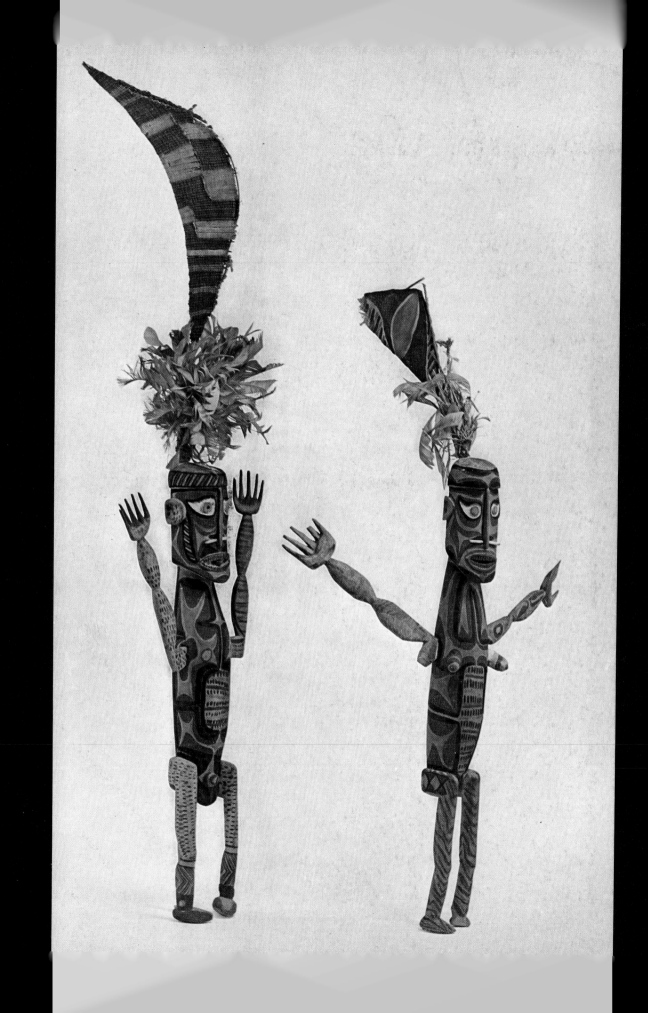

COLORPLATE 31. TWO FIGURINES
FROM DANCE COSTUME
New Britain, Sulka
Left: height 57 1/8″; right: height 42 1/8″
Staatliches Museum für Völkerkunde, Munich

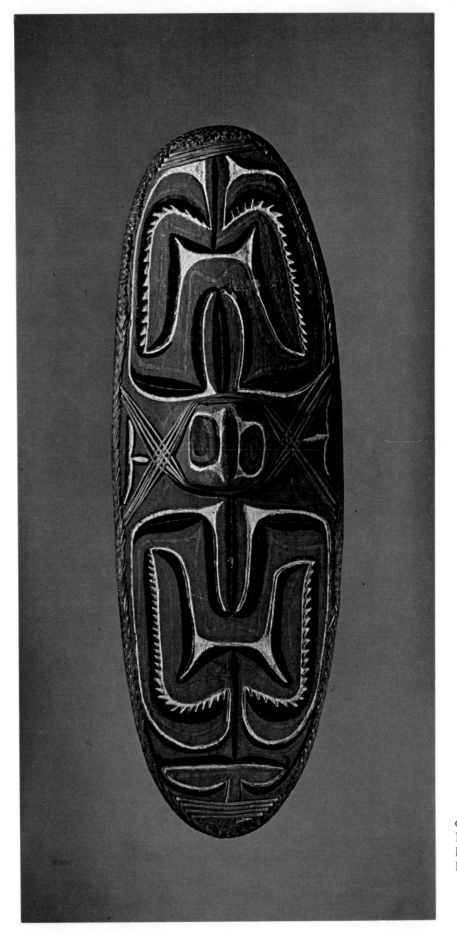

COLORPLATE 32. SHIELD
New Britain, Western
Height 50 1/4″
Museum of Primitive Art, New York

NEW IRELAND

PLATE 174. SOUL BOAT
New Ireland, Northeast Coast, Paruai (Boluminsky, 1903)
Length 19′
Linden Museum, Stuttgart

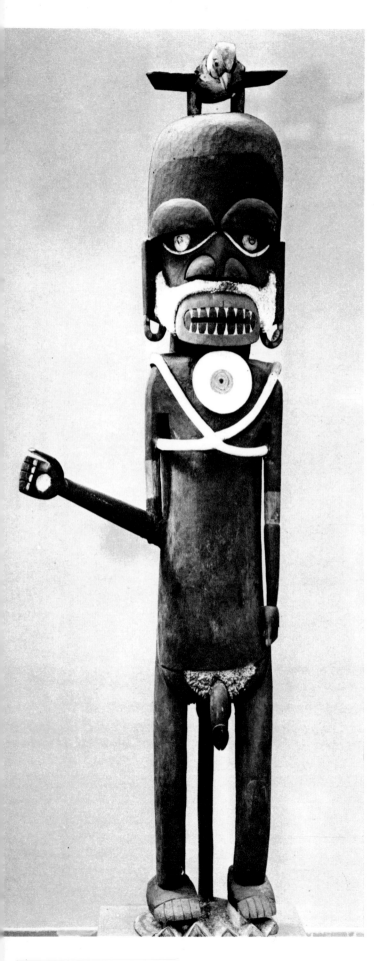

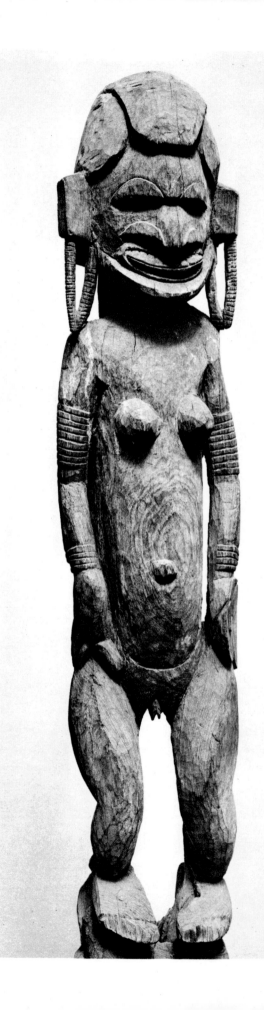

PLATE 175. RAINMAKER FIGURE
New Ireland, Namatanai (Hahl, 1907)
Height 96 7/8″
Linden Museum, Stuttgart

PLATE 176. FEMALE RAINMAKER FIGURE
New Ireland, Namatanai (Burger, 1912)
Height 61 3/4″
Linden Museum, Stuttgart

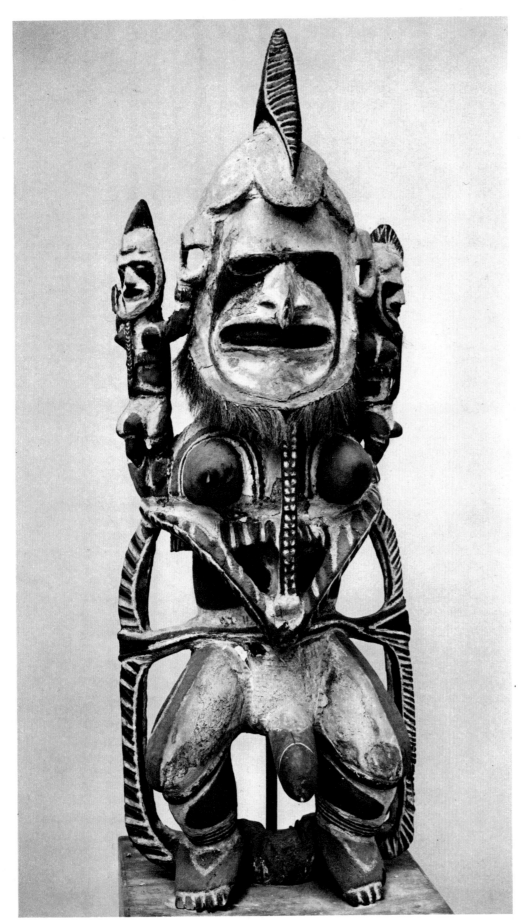

PLATE 177. *Uli* FIGURE
New Ireland, North, Luasigi (Hahl, 1906)
Height 63″
Linden Museum, Stuttgart

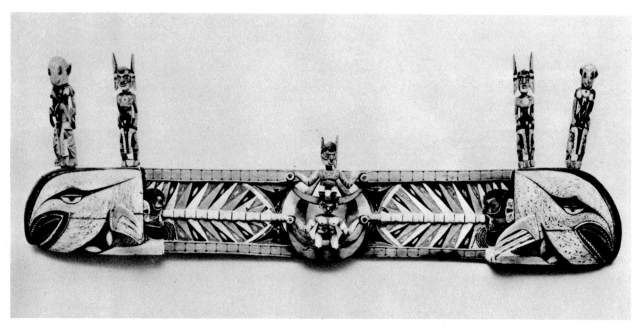

PLATE 178. HORIZONTAL *Malanggan*
New Ireland, Southwest Coast, Lamusmus (Bühler, 1932)
Length 8′8″
Museum für Völkerkunde, Basel

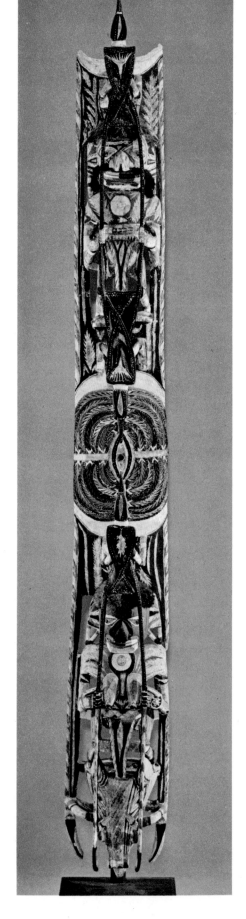

PLATE 179. VERTICAL *Malanggan*
New Ireland, Northern (S.M.S. Seeadler, 1912)
Height 8′5″
Collection J. J. Klejman, New York

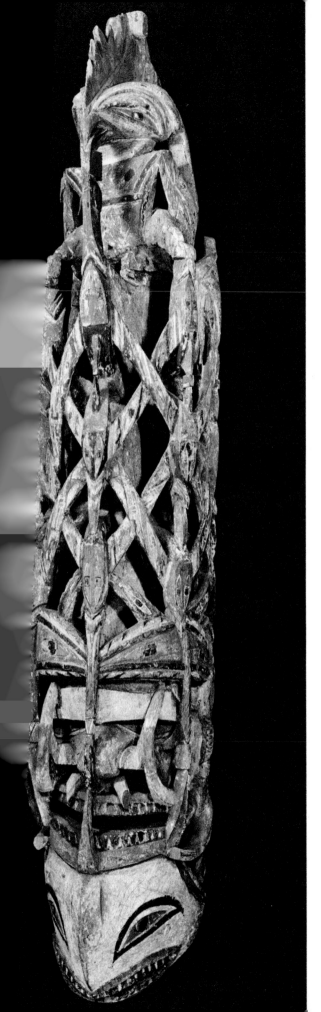

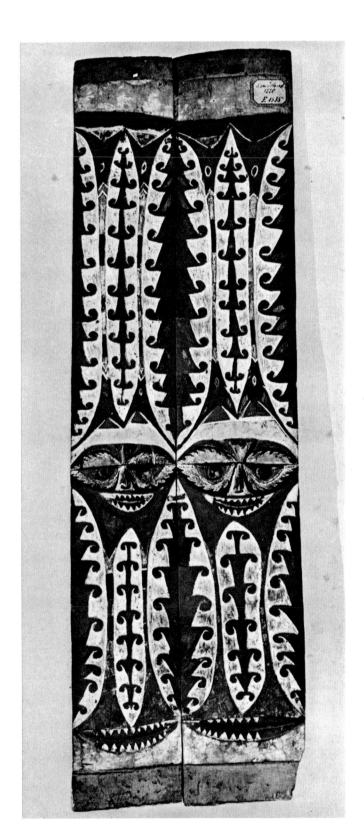

PLATE 180. OWL *Malanggan*
New Ireland, Northern (Scharf, 1912)
Height 44 1/8″
Linden Museum, Stuttgart

PLATE 181. DOUBLE BOARD
FROM GIRLS' HOUSE
New Ireland, Northern,
Pakail (collected before 1880)
Height 48″
Städtisches Museum für
Völkerkunde, Frankfort

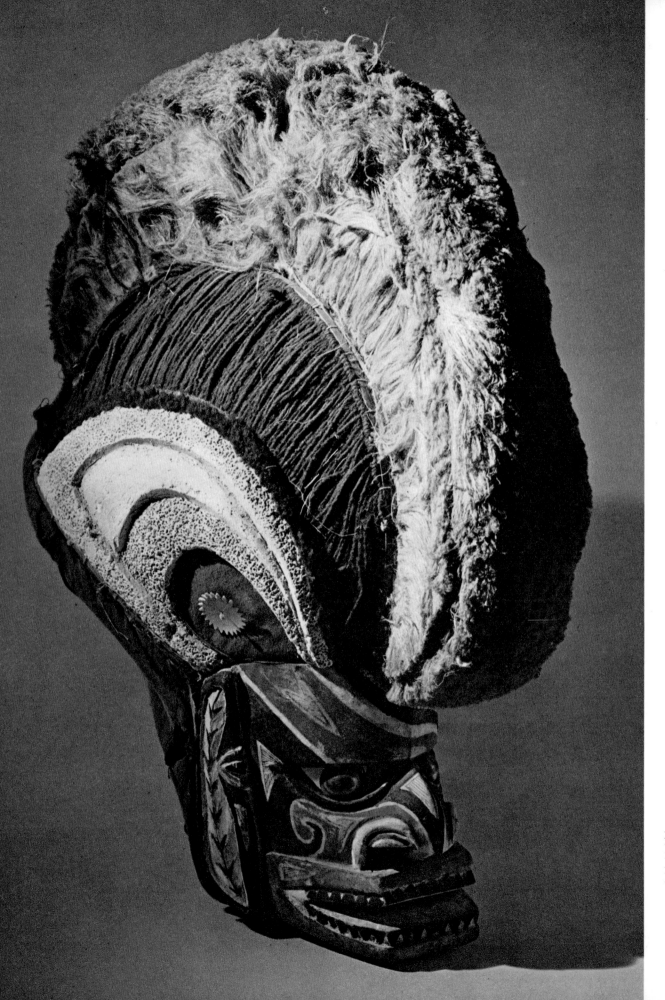

PLATE 182. *Tatanua* MASK
New Ireland, Northern (v. d. Heydt)
Height 15 3/4″
Museum Rietberg, Zurich

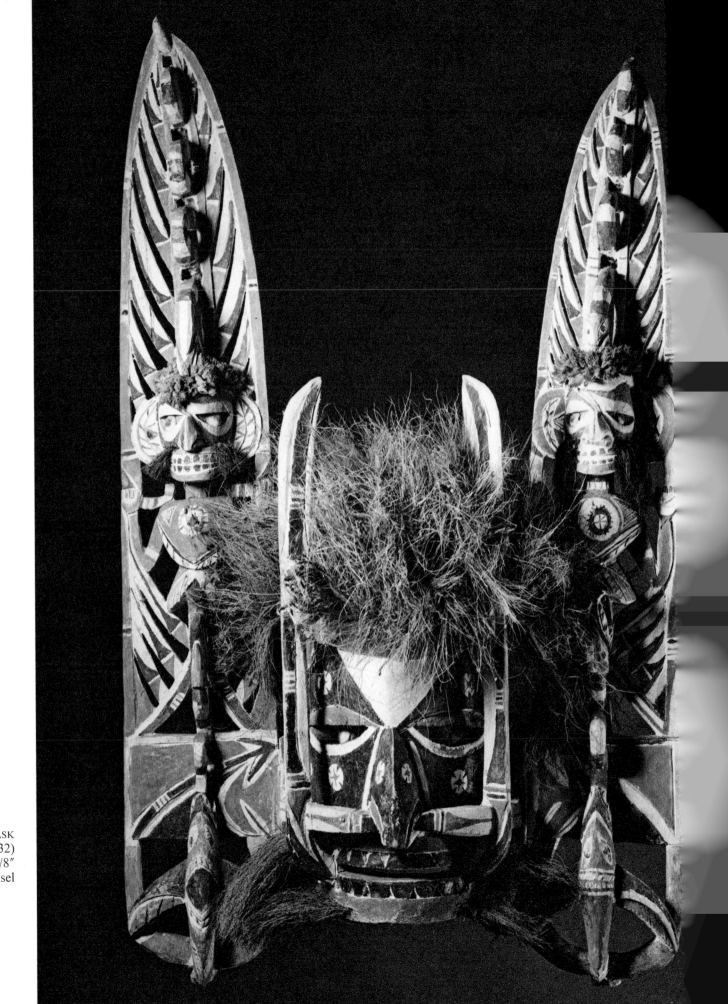

PLATE 183. *Kepong* MASK
New Ireland, Northern, Medina (Bühler, 1932)
Height 33 1/8″
Museum für Völkerkunde, Basel

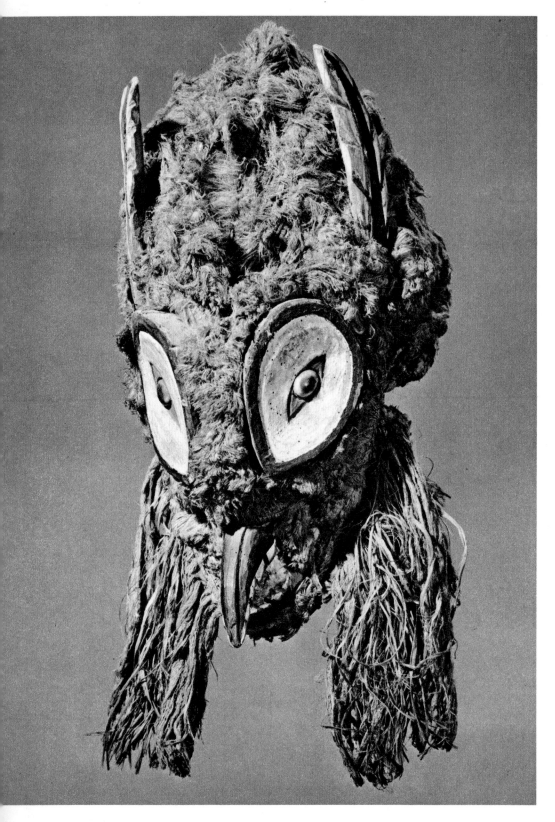

PLATE 184. OWL MASK
New Ireland, Northern (Besenbruch, 1906)
Height 16 1/8″
Collection N. Heinrich, Stuttgart

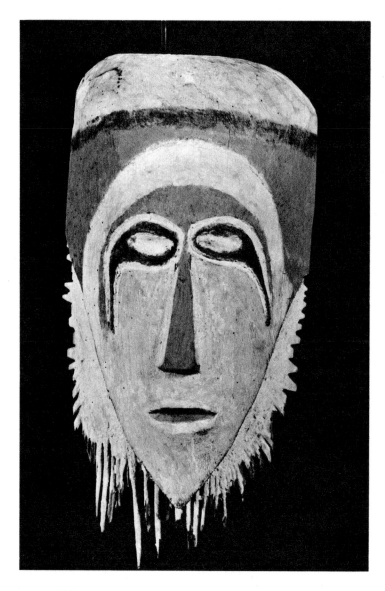

PLATE 185. MASK
New Ireland, So˙ thern, Mioko (Krämer, 1913)
Height 15″
Linden Museum, Stuttgart

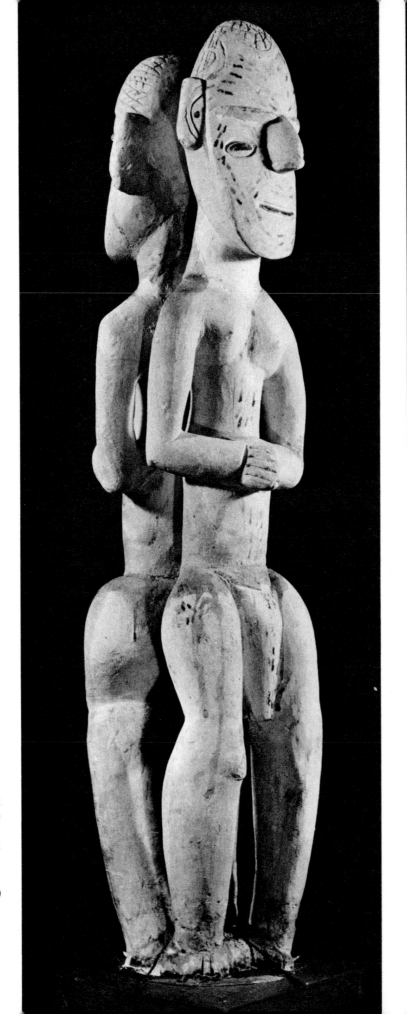
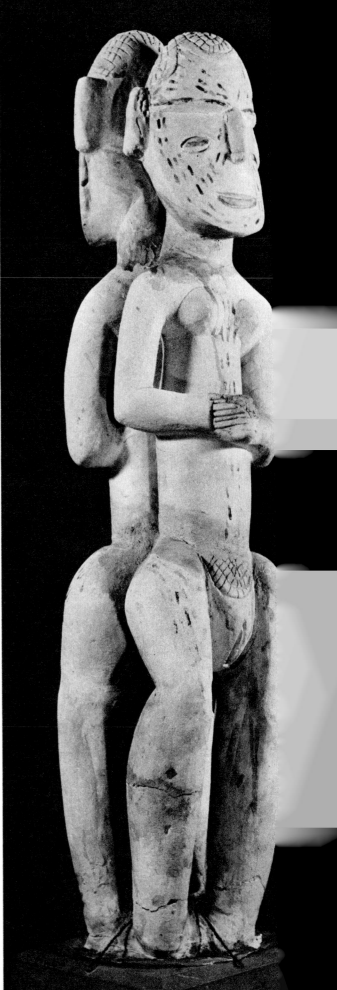

PLATE 186. DOUBLE FIGURE
New Ireland, Northern (Wostrock, 1908)
Limestone, height 30 1/4″
Linden Museum, Stuttgart

PLATE 187. DOUBLE FIGURE (second view)

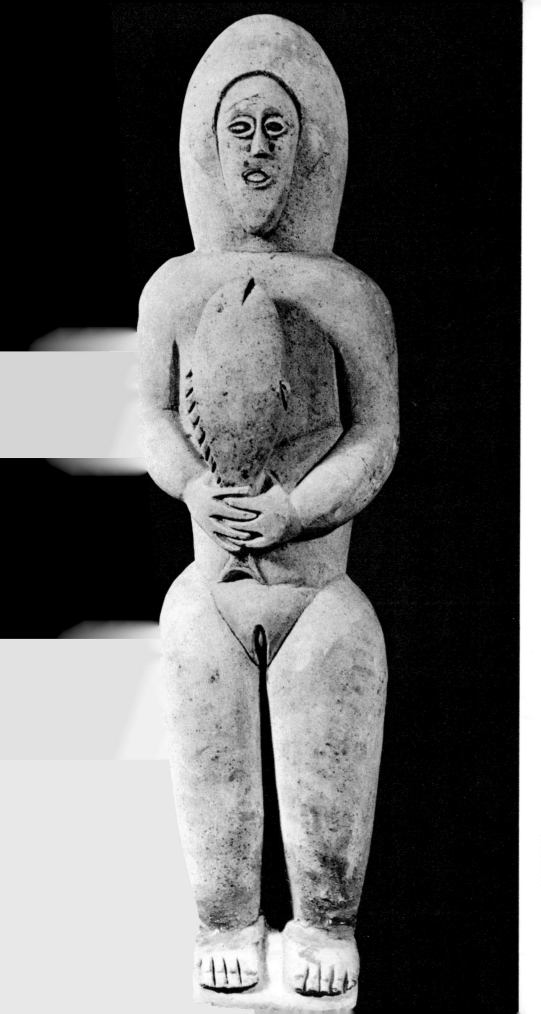

PLATE 188. FIGURE
New Ireland, Southwest Coast, Kures (v. Bennigsen, 1901)
Limestone, height 17 3/4″
Linden Museum, Stuttgart

COLORPLATE 33. MALE FIGURE
STANDING ON A FISH
New Ireland, Northern (S. M. S. Seeadler, 1912)
Height 60 1/4″
Collection N. Heinrich, Stuttgart

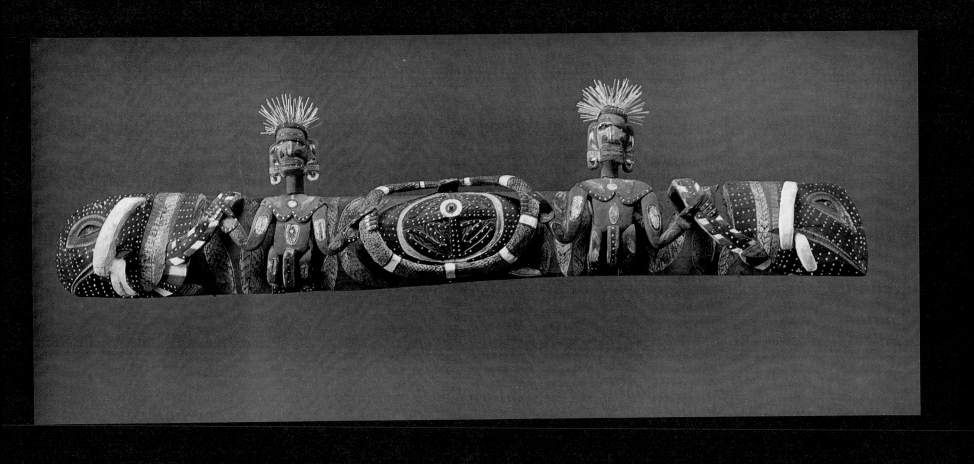

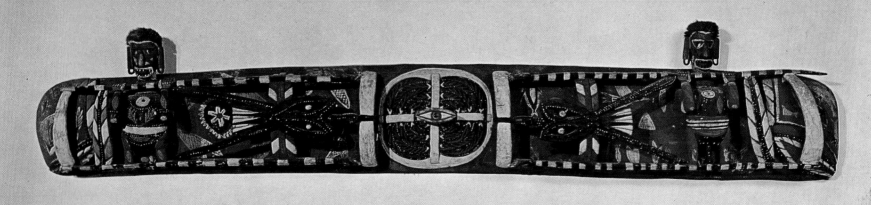

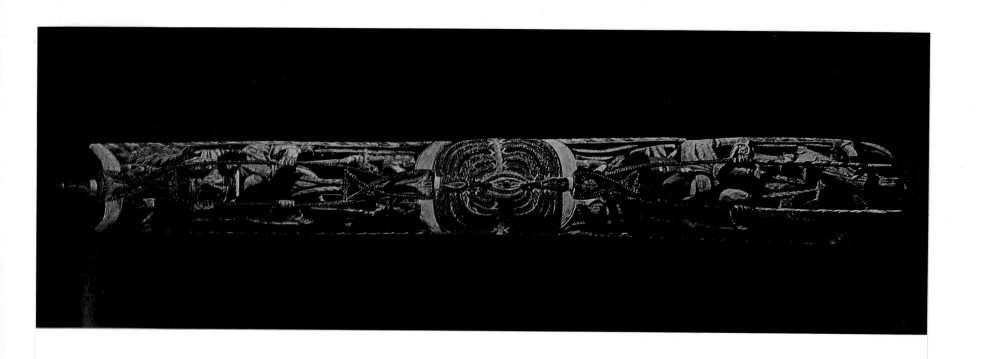

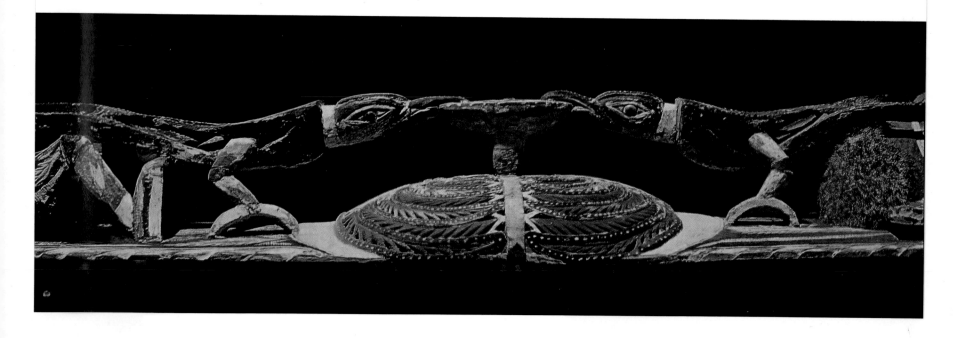

COLORPLATE 36. HORIZONTAL *Malanggan*
(top view and detail)
New Ireland, Lessu (A. Krämer)
Length 83 1/2″
Collection N. Heinrich, Stuttgart

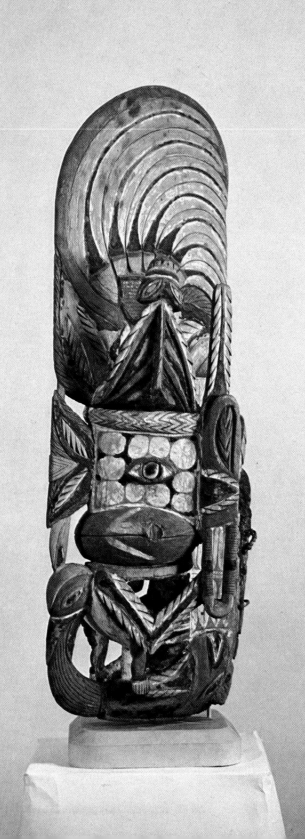

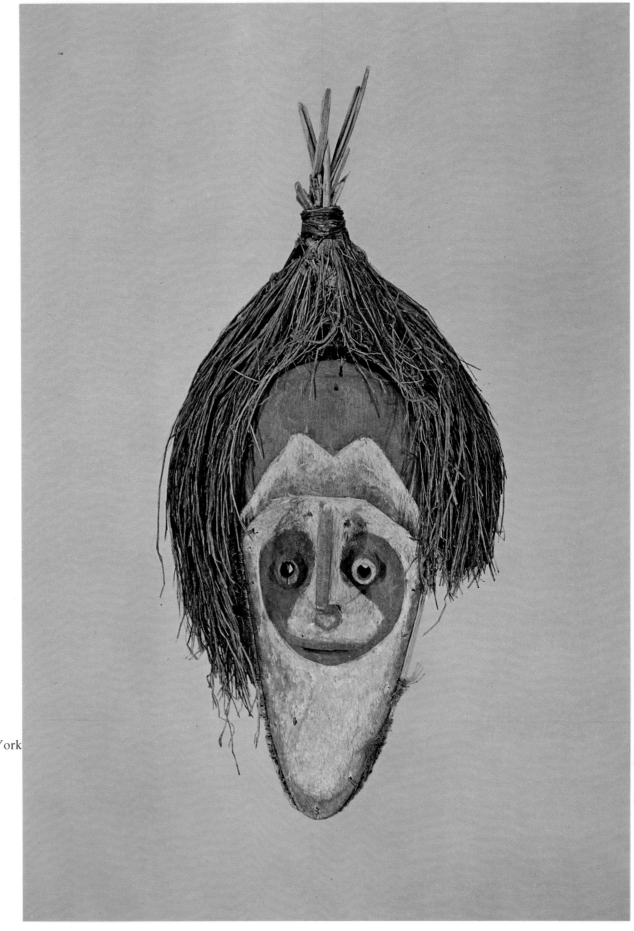

COLORPLATE 37. CANOE PROW ORNAMENT
New Ireland
Height 25 1/2""
American Museum of Natural History, New York

COLORPLATE 38. MASK
New Ireland, Duke of York Islands
Height 26"
Museum of Primitive Art, New York

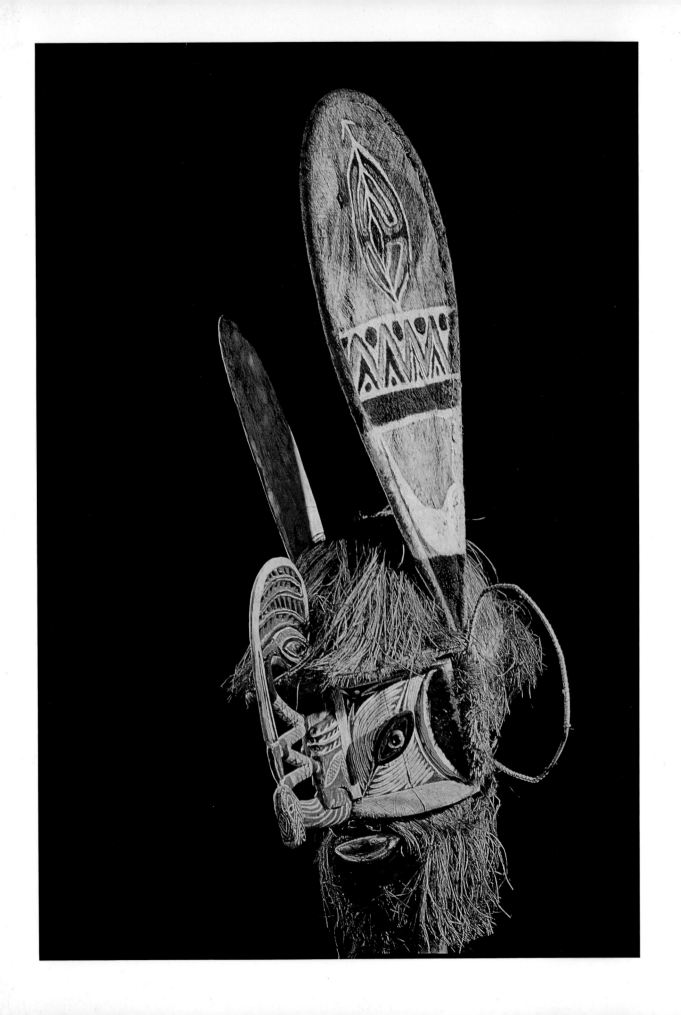

COLORPLATE 40. MASK
New Ireland, Lihir Island (Parkinson)
Height 39″
Collection N. Heinrich, Stuttgart

COLORPLATE 41. *Bobonóe* MASK
New Ireland, Northeast Coast,
Logagon (Bühler, 1932)
Height 33 1/2″
Museum für Völkerkunde, Basel

SOLOMON ISLANDS

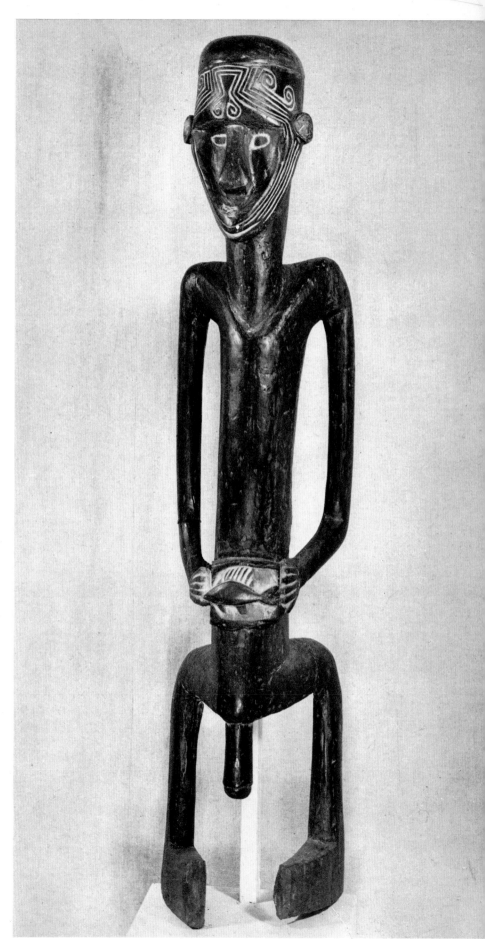

PLATE 189. MALE FIGURE
Solomon Islands, Bougainville (Kibler, 1918)
Height 41″
Linden Museum, Stuttgart

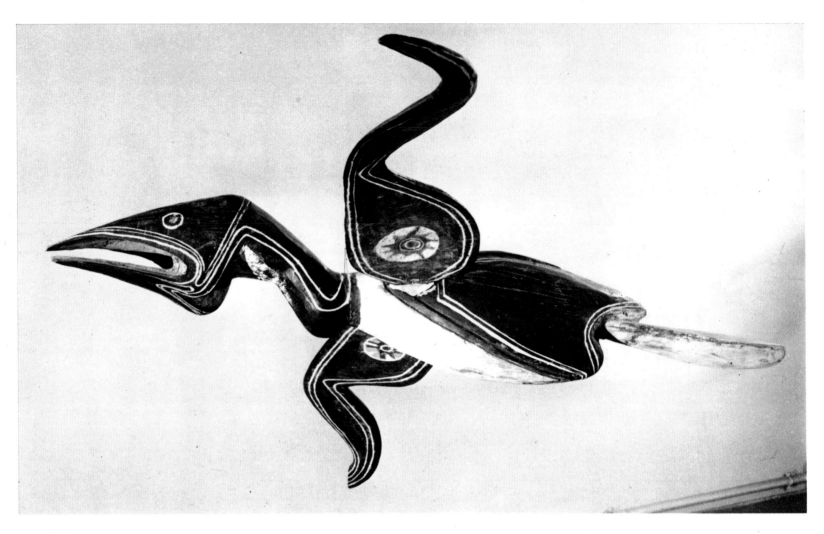

PLATE 190. RITUAL BIRD CARVING
Solomon Islands, Bougainville, Izipatavei
Length 46 1/2″
Musée de l'Homme, Paris

PLATE 191. RITUAL BIRD CARVING
Solomon Islands, Bougainville, Pokapa
Length 21 1/4″
Musée de l'Homme, Paris

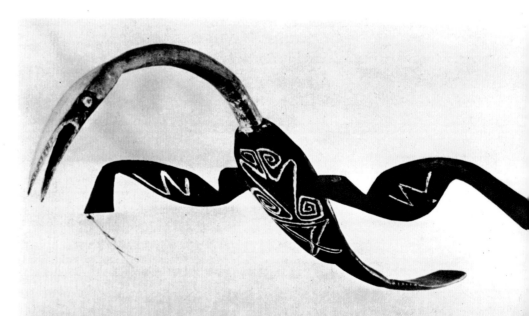

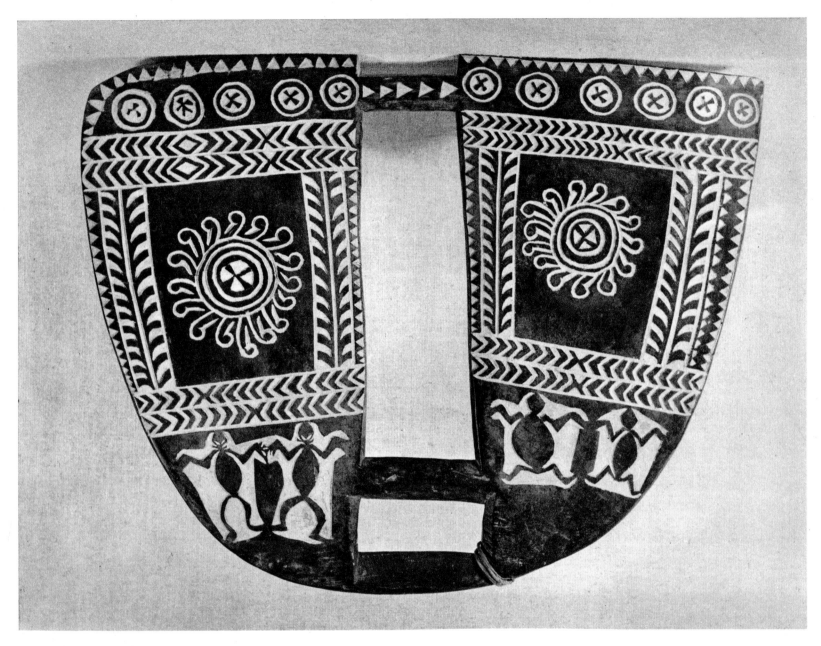

PLATE 192. DANCE PLAQUE
Solomon Islands, Bougainville, Telei Tribe (Kibler, 1918)
Height 11 3/8″
Linden Museum, Stuttgart

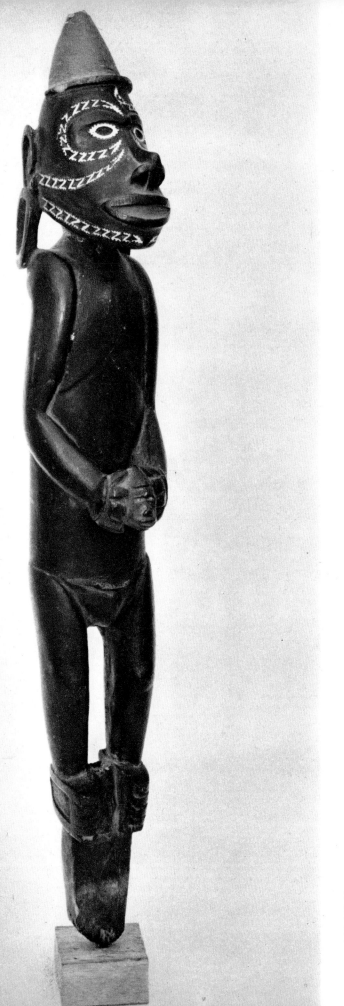

PLATE 193. PROTECTIVE SPIRIT FIGURE
Solomon Islands, New Georgia, Rubiana Lagoon
Height 19 1/4″
Rautenstrauch-Joest Museum für Völkerkunde, Cologne

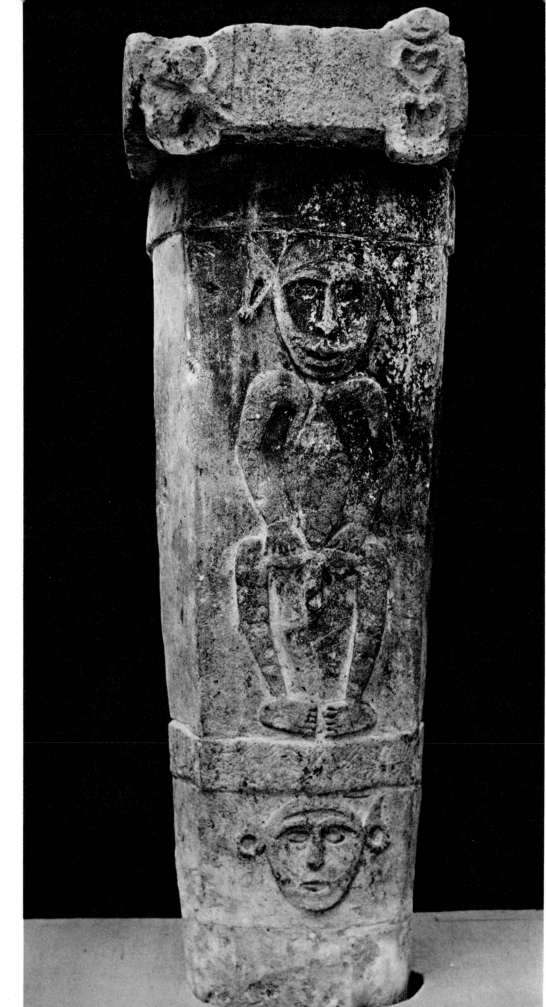

PLATE 194.　SARCOPHAGUS
Solomon Islands, Choiseul (Bernatzik, 1933)
Stone, height above ground 31 1/8″
Museum für Völkerkunde, Basel

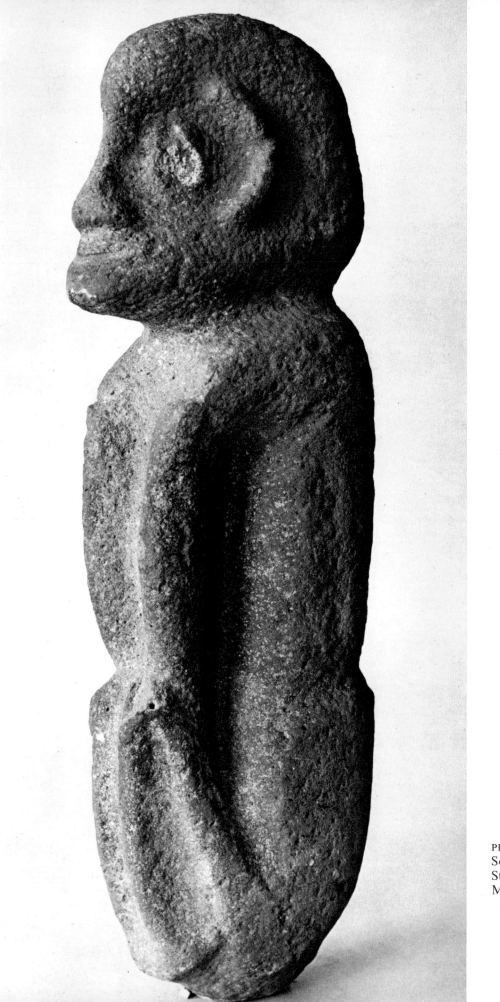

PLATE 195. SQUATTING FIGURE
Solomon Islands, Choiseul (Paravicini, 1929)
Stone, height 18 7/8″
Museum für Völkerkunde, Basel

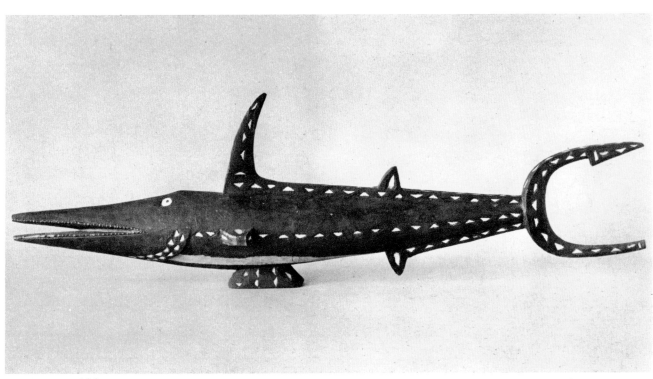

PLATE 196. SHARK
Solomon Islands, Ysabel (Paravicini, 1929)
Length 39 3/8″
Museum für Völkerkunde, Basel

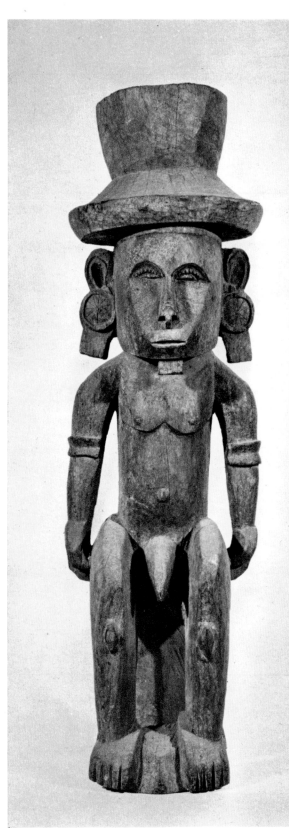

PLATE 197. PART OF HOUSE POST: SITTING MALE FIGURE
Solomon Islands, Ugi
Height 39″
Rautenstrauch-Joest Museum für Völkerkunde, Cologne

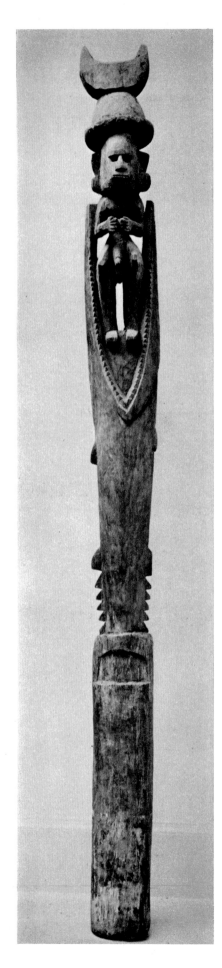

PLATE 198. HOUSE POST:
MAN INSIDE A SHARK'S MOUTH
Solomon Islands, San Cristobal,
Manugia (Paravicini, 1929)
Height 9′2″
Museum für Völkerkunde, Basel

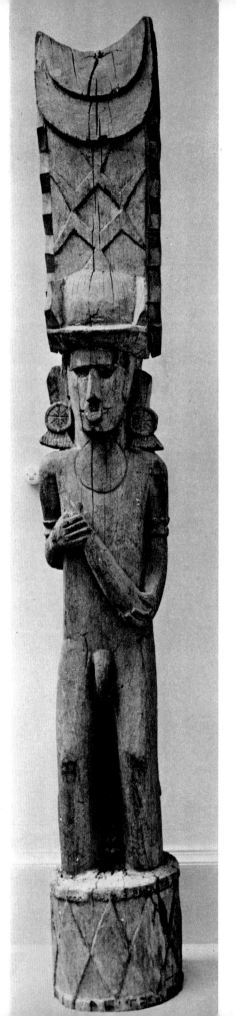

PLATE 199. HOUSE POST:
MAN HOLDING A GOURD
Solomon Islands, Santa Anna
(Paravicini, 1929)
Height 96 1/2″
Museum für Völkerkunde, Basel

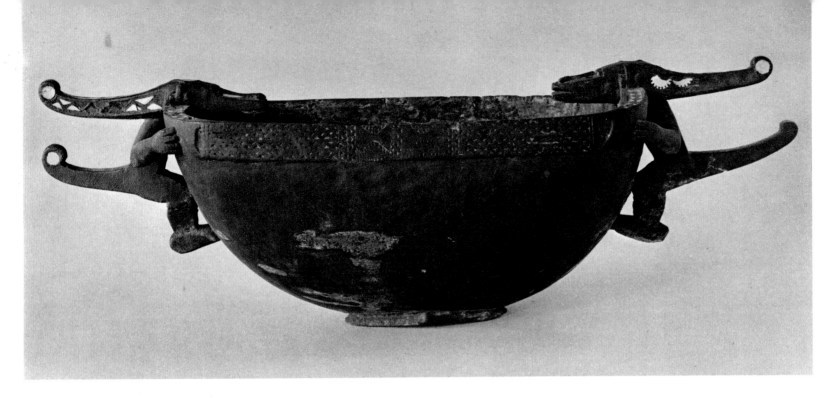

PLATE 200. BOWL
Solomon Islands, San Cristobal, Manugia (Paravicini, 1929)
Length 22″
Museum für Völkerkunde, Basel

PLATE 201. BOWL
Solomon Islands, San Cristobal (Paravicini, 1929)
Length 20 7/8″
Museum für Völkerkunde, Basel

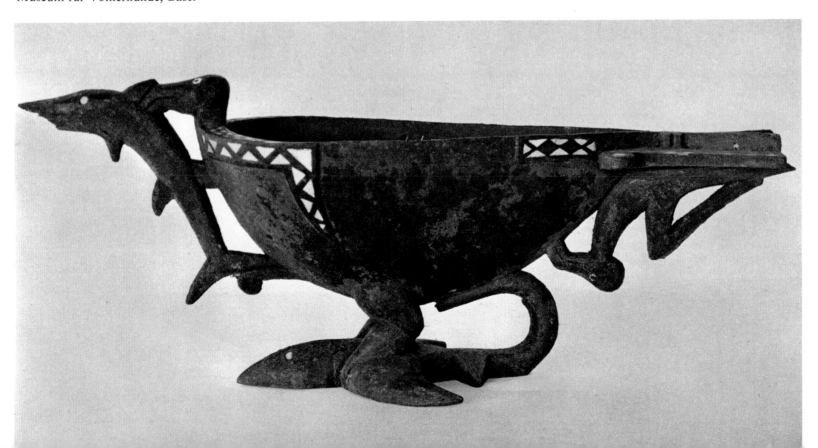

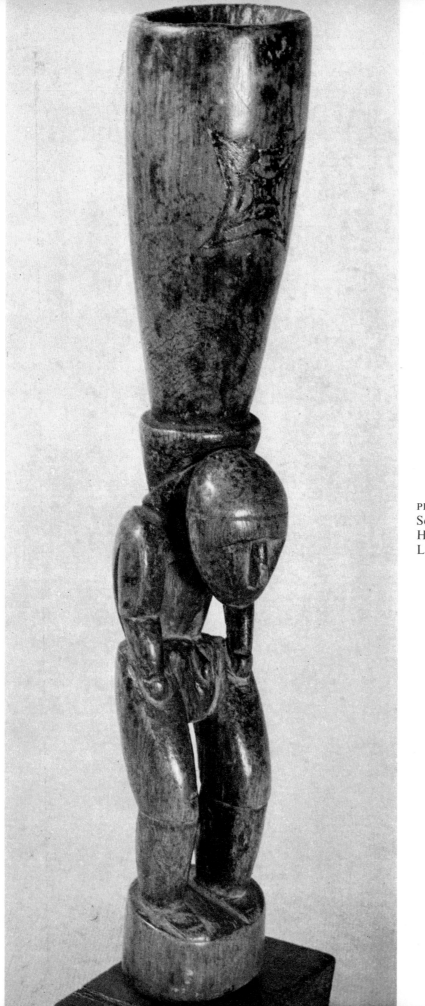

PLATE 202. BETEL MORTAR
Solomon Islands, Choiseul (Speyer)
Height 9″
Linden Museum, Stuttgart

COLORPLATE 42. MASK
Solomon Islands, Nissan (collected before 1922)
Height 20 1/8″
Museum für Völkerkunde, Basel

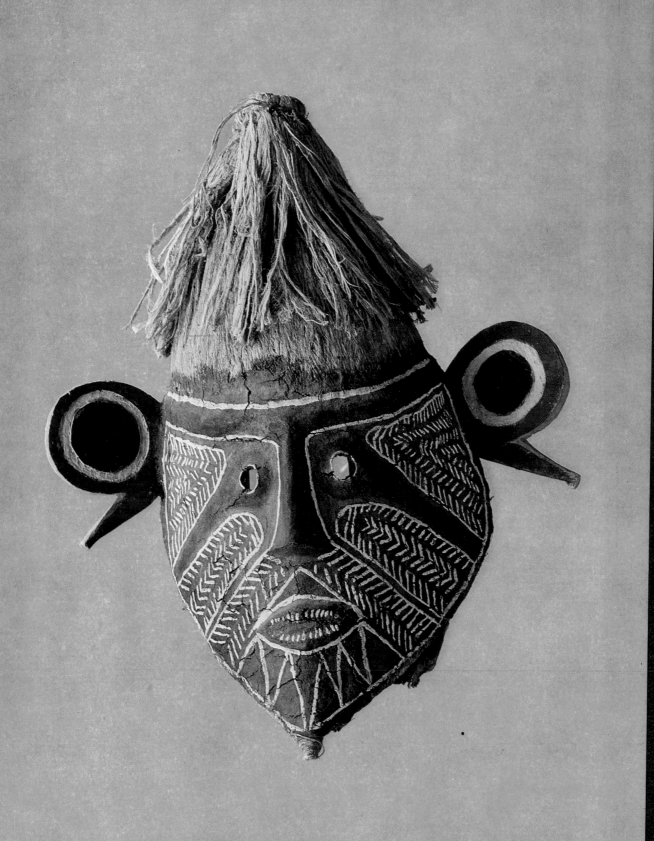

NEW HEBRIDES

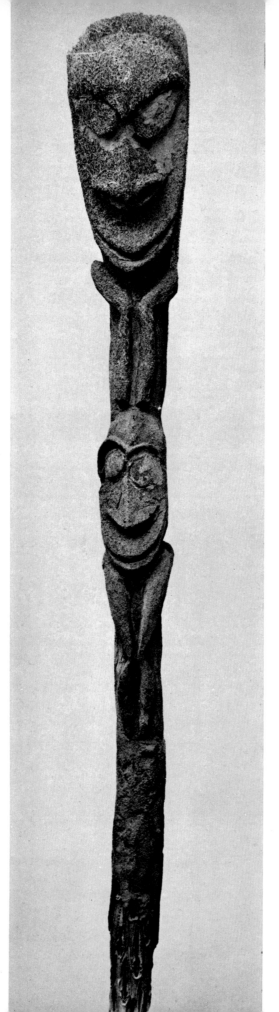

PLATE 203. ANCESTOR AND GRADE STATUE
New Hebrides, Ambrym (Speiser, 1912)
Height 8′10″
Museum für Völkerkunde, Basel

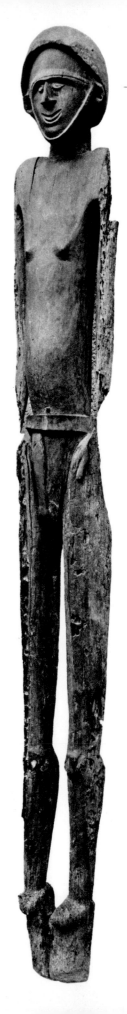

PLATE 204. ANCESTOR FIGURE
New Hebrides, East Malekula,
Atchin (Speiser, 1912)
Height 8′6″
Museum für Völkerkunde, Basel

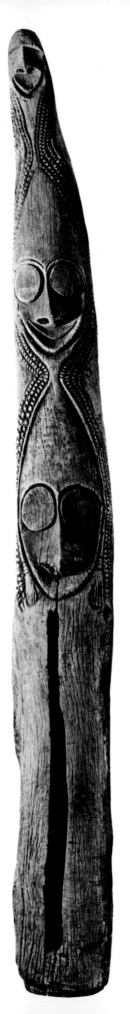

PLATE 205. STANDING SLIT GONG
New Hebrides, Ambrym (Speiser, 1912)
Height 13 3/4″
Museum für Völkerkunde, Basel

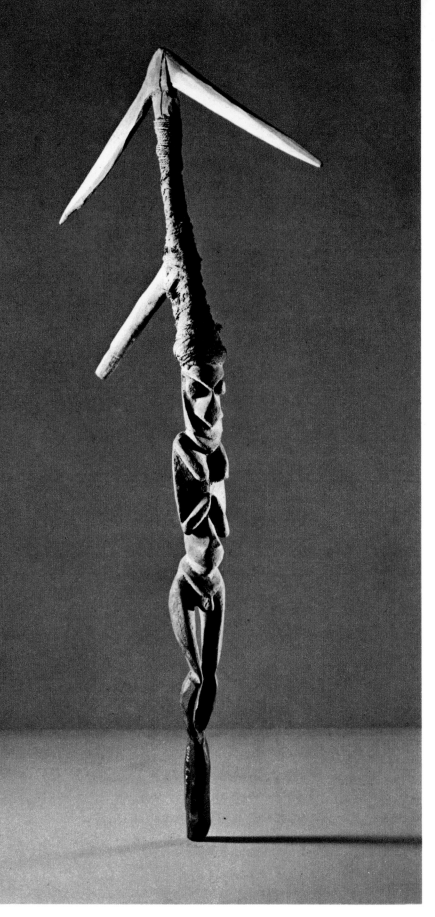

PLATE 206. CEREMONIAL ADZE
New Hebrides, South Malekula (Speiser, 1912)
Length 31 1/2"
Museum für Völkerkunde, Basel

PLATE 207. CEREMONIAL CLUB
New Hebrides (v.d. Heydt)
Height 37"
Museum Rietberg, Zurich

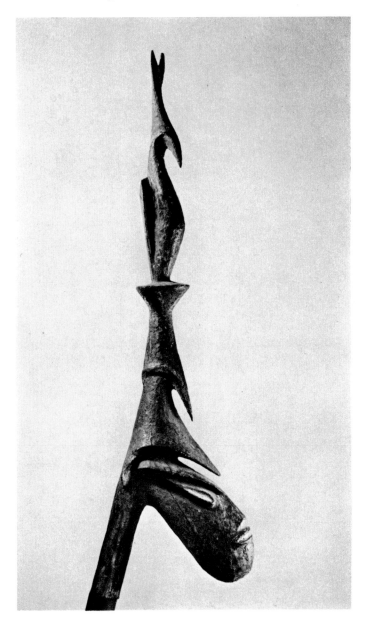

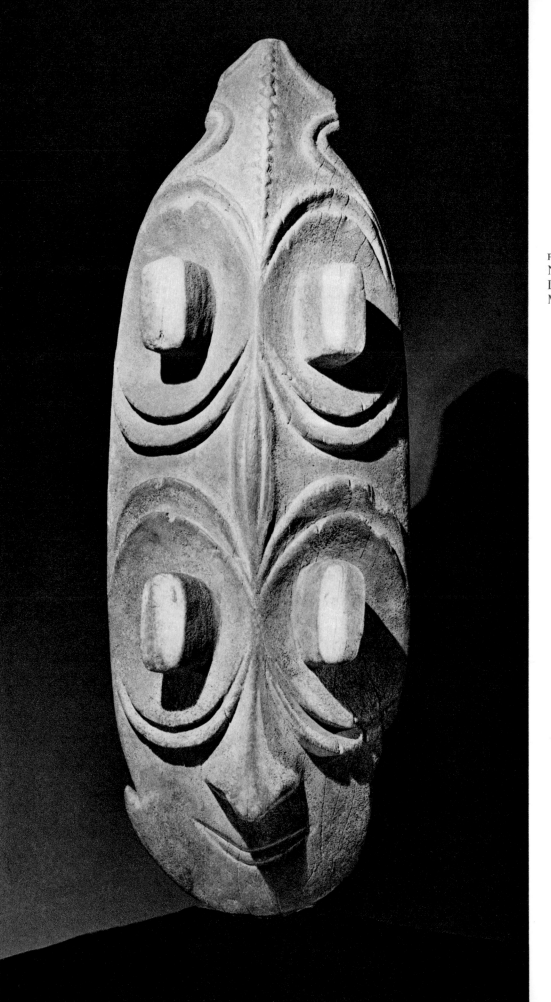

PLATE 208. FOOD BOWL (underside)
New Hebrides, West Ambrym
Length 33 1/8″
Museum of Primitive Art, New York

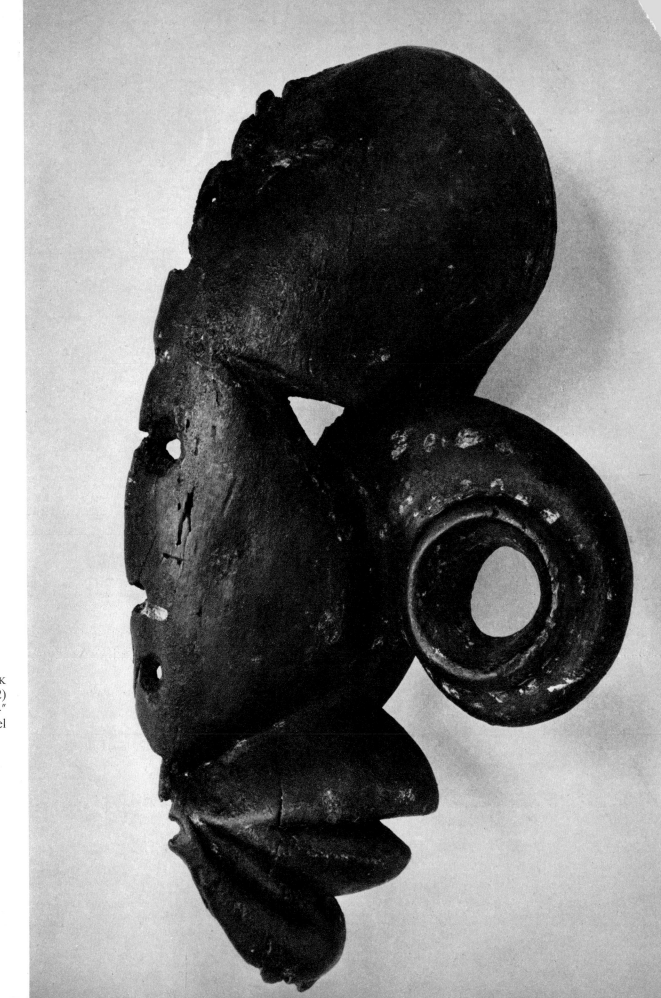

PLATE 209. MASK
New Hebrides, Ambrym (Speiser, 1912)
Height 10 1/4″
Museum für Völkerkunde, Basel

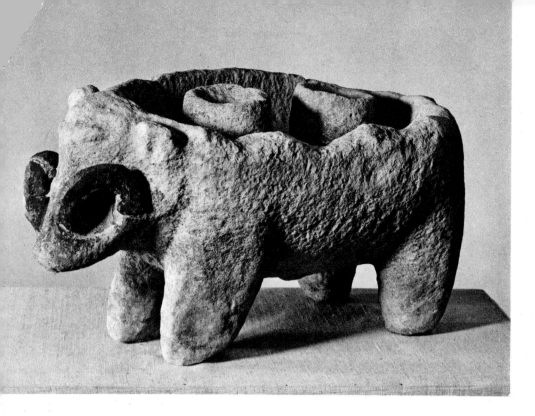

PLATE 210. CARVING
New Hebrides, Aoba (Stähelin, 1934)
Stone, length 25 1/4″
Museum für Völkerkunde, Basel

PLATE 211. CARVING FOR PIG TRADE MAGIC
New Hebrides, North Malo (Speiser, 1912)
Stone, length 3 1/8″
Museum für Völkerkunde, Basel

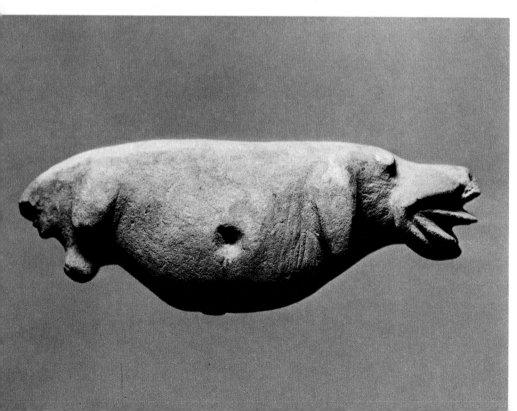

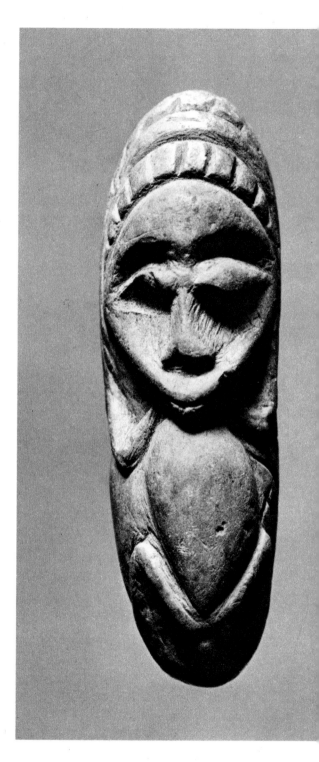

PLATE 212. CARVING FOR LOVE MAGIC
New Hebrides, North Malo (Speiser, 1912)
Stone, length 5 7/8″
Museum für Völkerkunde, Basel

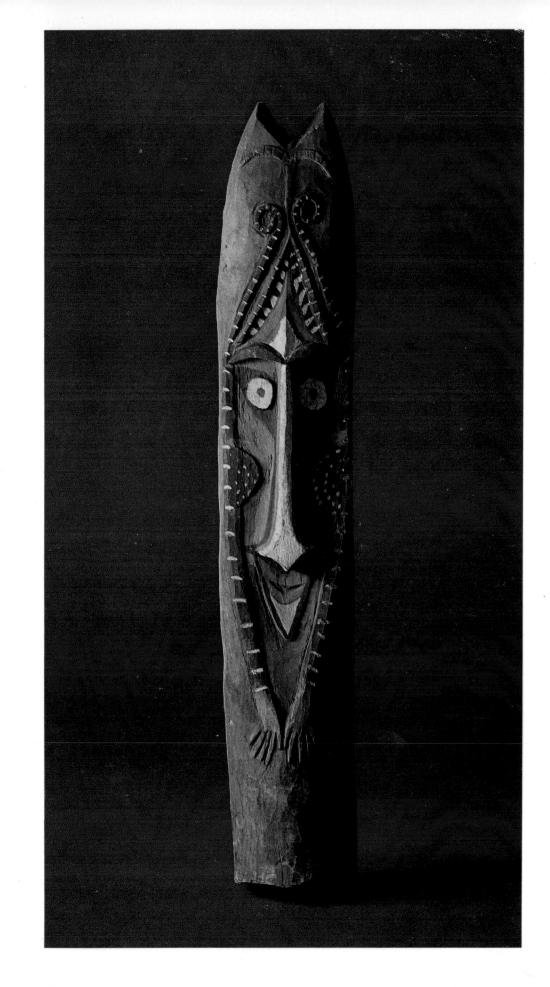

COLORPLATE 43. POST OF OFFERING PLATFORM
New Hebrides, Vao (Speiser, 1912)
Height 66 7/8″
Museum für Völkerkunde, Basel

COLORPLATE 44. MASK
New Hebrides
Height 14 3/8″
Museum of Primitive Art, New York

COLORPLATE 45. FOUR-FACED MASK (*napal*)
New Hebrides, South Malekula (Speiser, 1912)
Height 17 3/8″
Museum für Völkerkunde, Basel

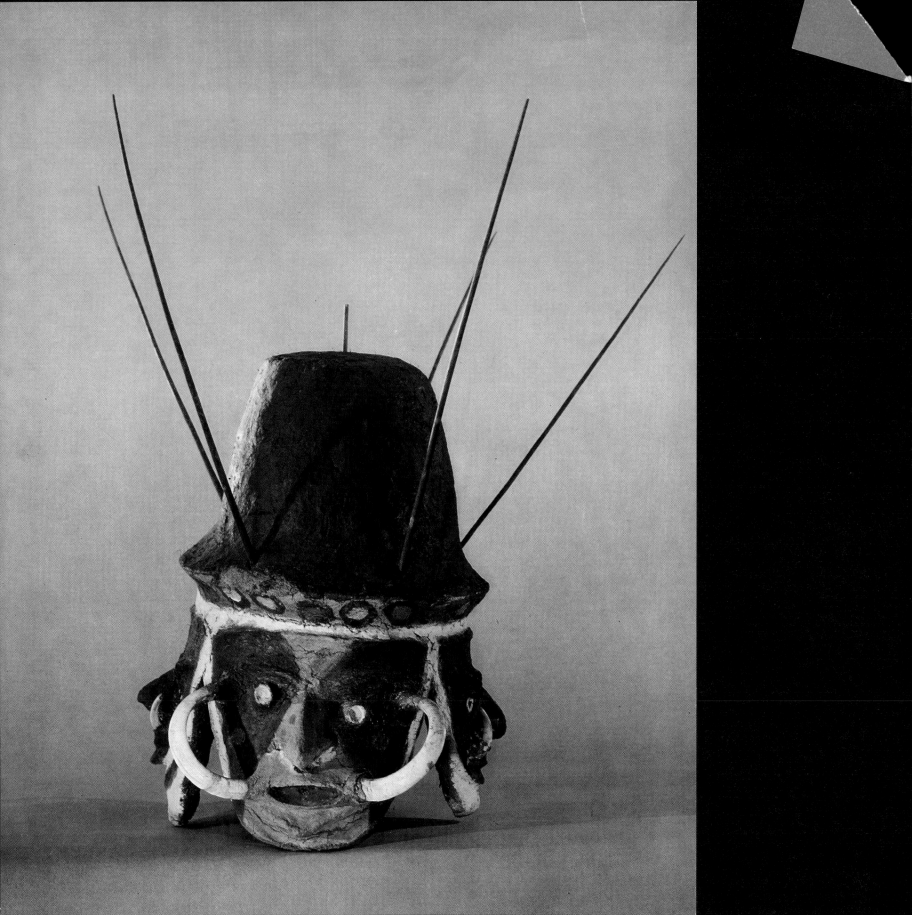

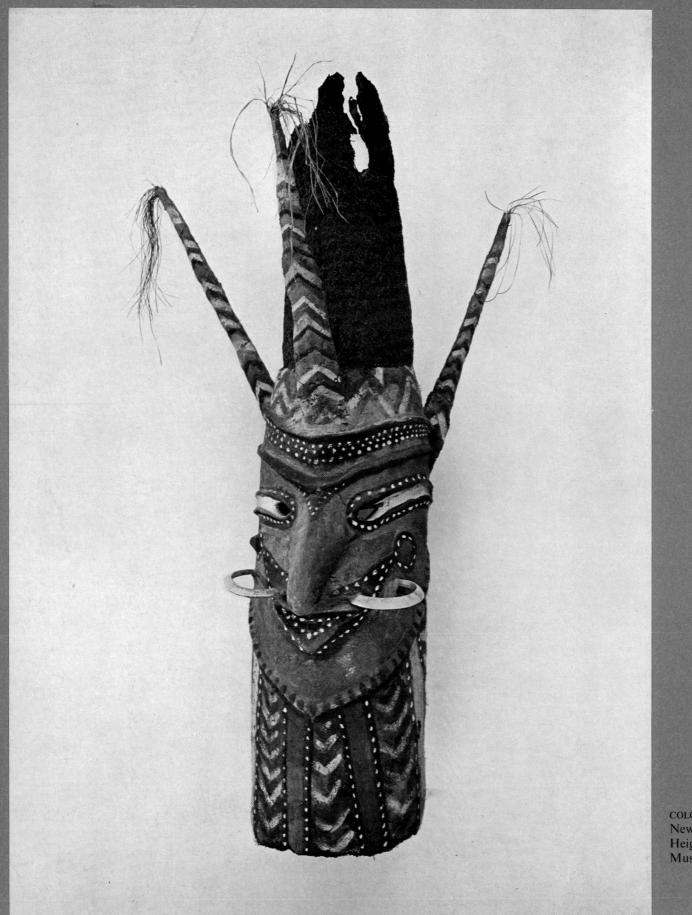

COLORPLATE 46. MASK
New Hebrides, South Malekula (Speiser, 1912)
Height 47 1/4″
Museum für Völkerkunde, Basel

NEW CALEDONIA

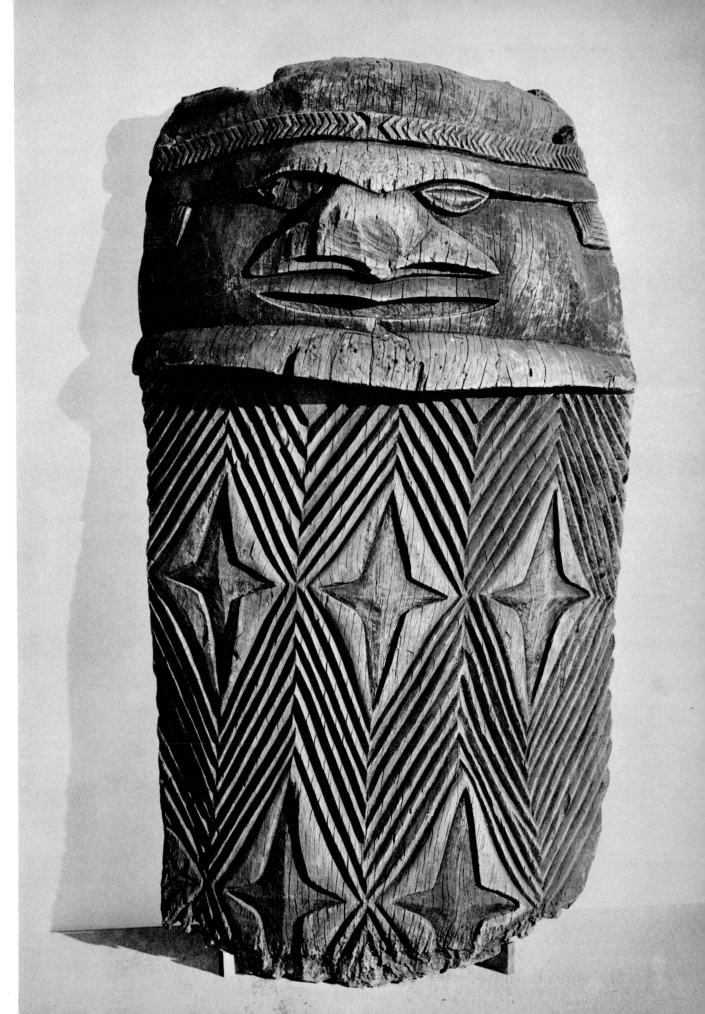

PLATE 213. DOOR JAMB
New Caledonia, Jambé (Sarasin, 1913)
Height 73 1/4″
Museum für Völkerkunde, Basel

PLATE 214. ROOF FINIAL
New Caledonia, Coindé (Sarasin, 1913)
Height 82 5/8″
Museum für Völkerkunde, Basel

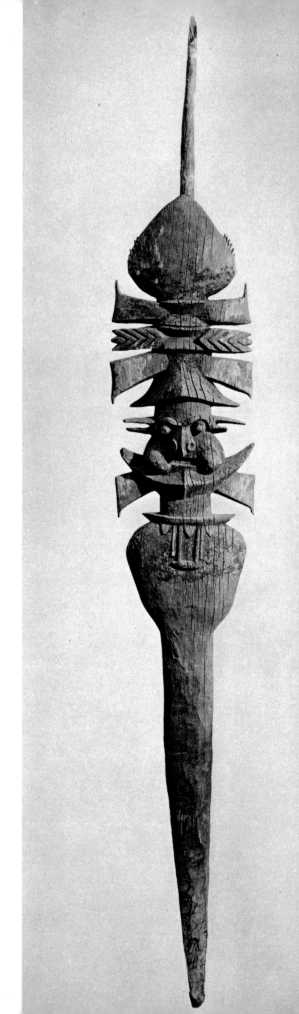

PLATE 215. ROOF FINIAL
New Caledonia, Poté, Bonrail (Sarasin, 1913)
Height 86 5/8″
Museum für Völkerkunde, Basel

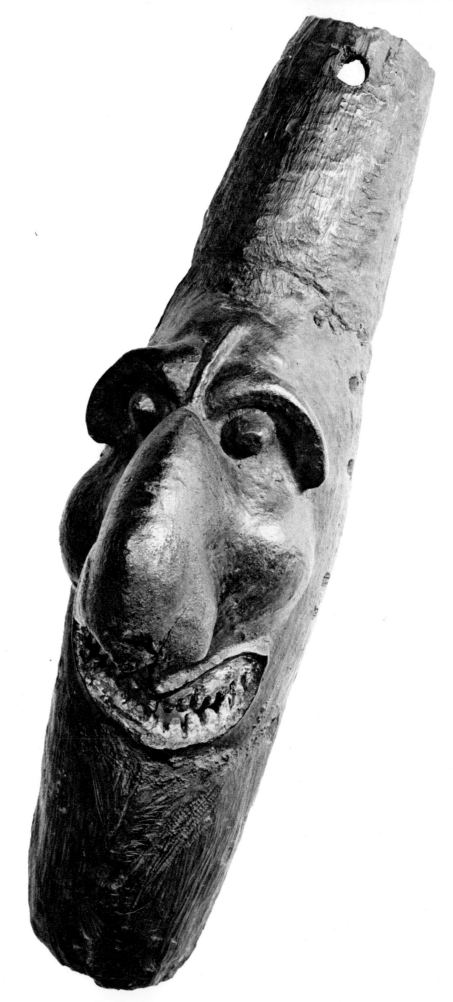

PLATE 216. MASK
New Caledonia (collected before 1908)
Height 21 5/8″
Museum für Völkerkunde, Basel

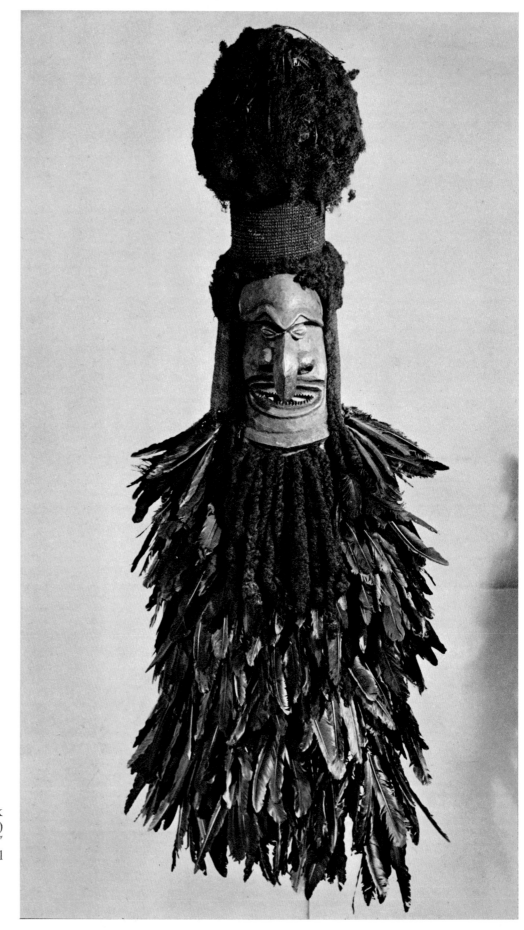

PLATE 217. MASK
New Caledonia, Hienghene (Sarasin, 1913)
Height 59″
Museum für Völkerkunde, Basel

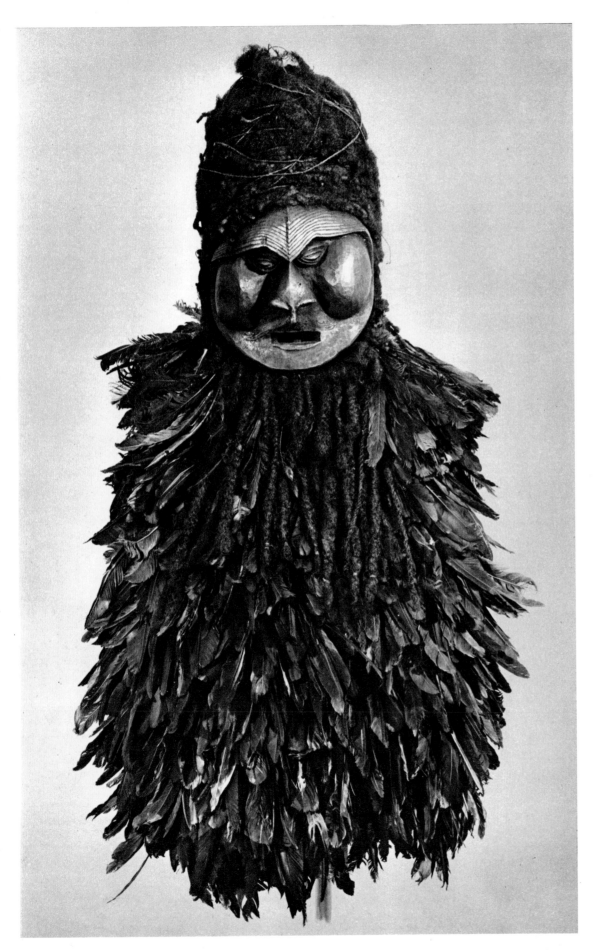

PLATE 218. MASK
New Caledonia, Bopopé (Sarasin, 1913)
Height without feathers 9″
Museum für Völkerkunde, Basel

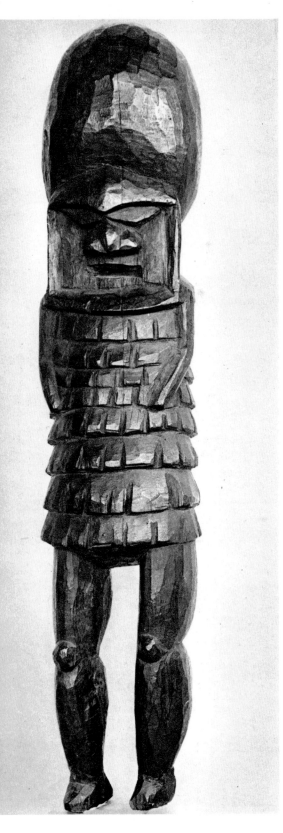

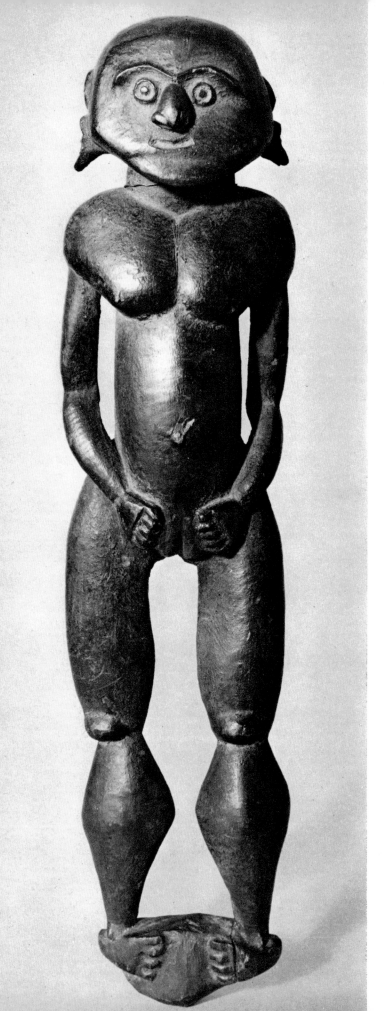

PLATE 219. STANDING MALE FIGURE OF A
MASKED DANCER WITH FEATHER COSTUME
New Caledonia (collected before 1908)
Height 28″
Museum für Völkerkunde, Basel

PLATE 220. STANDING FEMALE FIGURE
New Caledonia
Height 15″
Museum für Völkerkunde, Basel

EASTERN MELANESIA

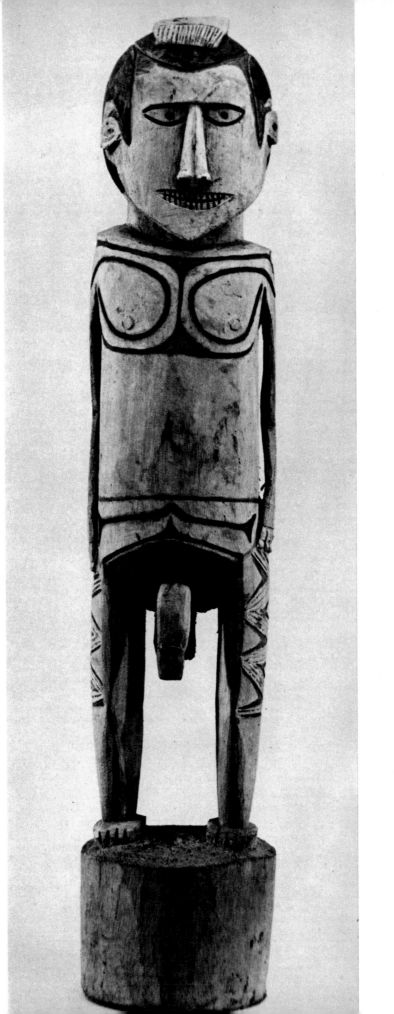

PLATE 221. ANCESTOR FIGURE
Eastern Melanesia, Saint Matthias Islands (Nauer)
Museum für Völkerkunde, Leipzig

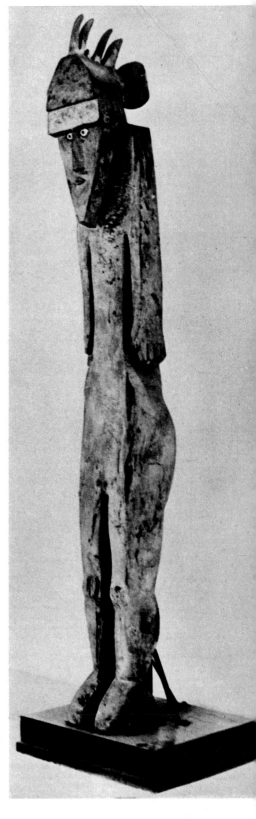

PLATE 222. FIGURE OF THE GOD POPUA
Eastern Melanesia,
Tasman Islands (Nukumanu)
(Hamburger Südsee Expedition 1908–10)
Height 9′
Museum für Völkerkunde, Leipzig

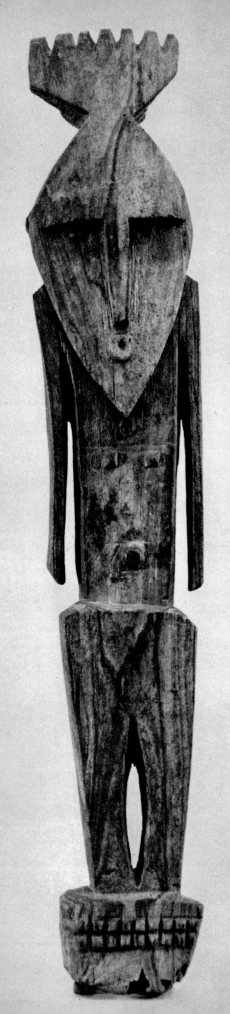

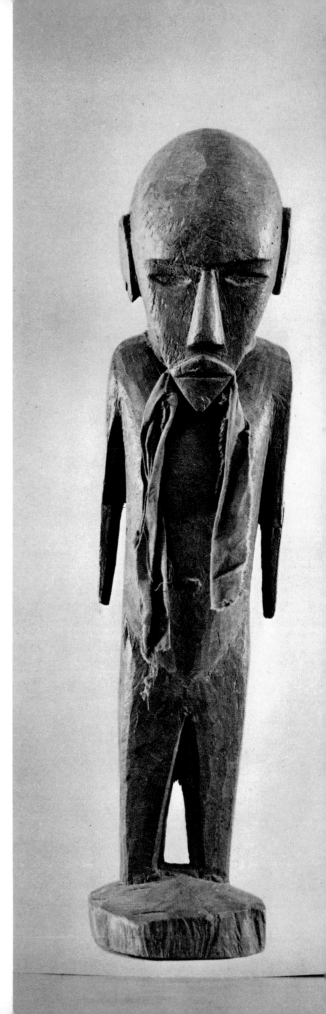

PLATE 223. ANCESTOR FIGURE
Eastern Melanesia, Mortlock Islands, Taku (Nauer)
Height 38 5/8″
Museum für Völkerkunde, Leipzig

PLATE 224. ANCESTOR FIGURE
Eastern Melanesia, Mortlock Islands, Taku (Nauer)
Height 20 7/8″
Museum für Völkerkunde, Leipzig

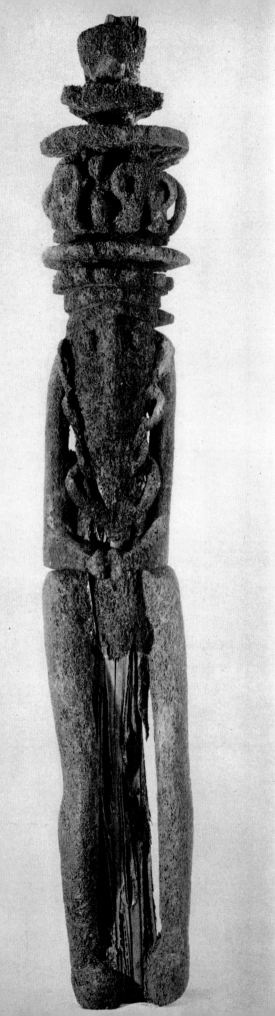

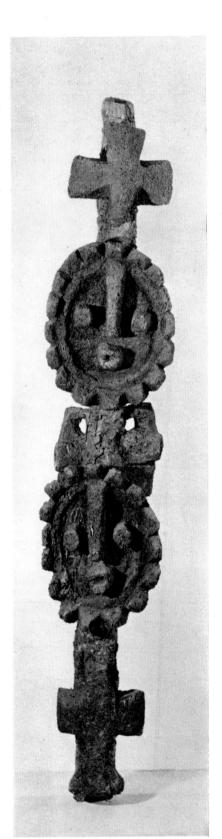

PLATE 225. GRADE STATUE
Eastern Melanesia, Banks Islands,
Gaua (Speiser, 1912)
Height 9'2"
Museum für Völkerkunde, Basel

PLATE 226. GRADE STATUE
Eastern Melanesia, Banks Islands,
Gaua (Speiser, 1912)
Height 72 7/8"
Museum für Völkerkunde, Basel

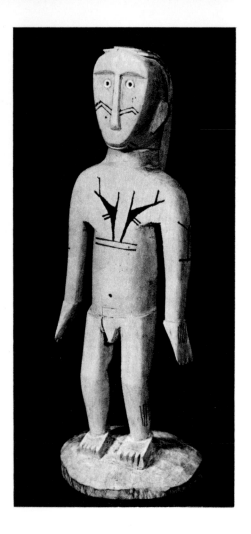

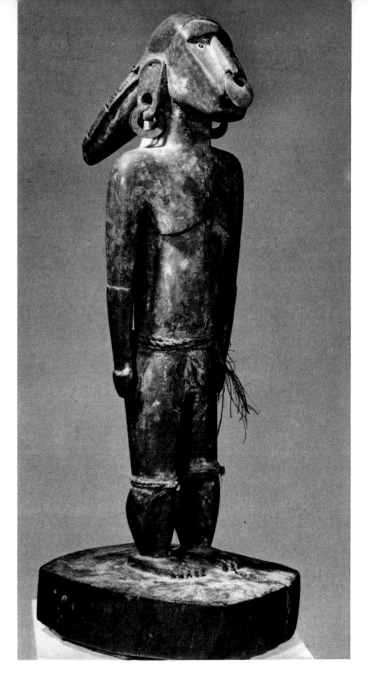

PLATE 227. MALE FIGURE
Eastern Melanesia,
Santa Cruz Islands (Rautenstrauch)
Height 14 1/8″
Linden Museum, Stuttgart

PLATE 228. STANDING MALE FIGURE
Eastern Melanesia, Santa Cruz Islands
Height 13 3/4″
Collection Mr. and Mrs. R. Wielgus, Chicago

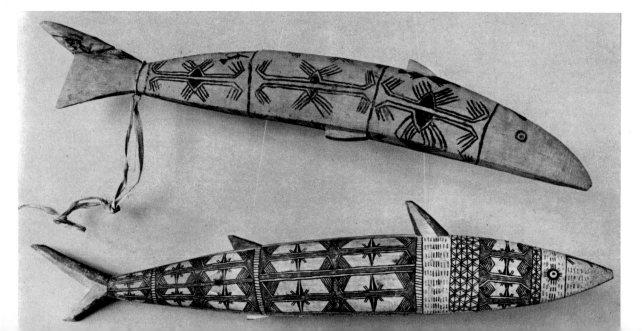

PLATE 229. FISH CARVINGS
Eastern Melanesia, Santa Cruz Islands (Speiser, 1912)
Above: length 21 1/4″; below: length 25 1/4″
Museum für Völkerkunde, Basel

POLYNESIA

O C E A N

EQUATOR

MARQUESAS IS.

Nuku Hival.

UAMOTU ARCH.

ISLANDS

Mangareva I.

Easter

POLYNESIA

0 500 1000

STATUTE MILES AT EQUATOR

WESTERN POLYNESIA

THE culture of the inhabitants of Polynesia and Micronesia differs considerably from that of Melanesia and New Guinea; its essential features have been described briefly in the Introduction. The crucial elements in it, in contrast to those of Melanesian culture in general, include greater differentiation in the social structure, with a nobility and a priesthood, and a distinct tendency to genuine polytheism. In the Polynesian and Micronesian culture area two variations in the basic cultural equipment asserted themselves, through adaptation to the environment. The differing conditions of life on volcanic islands with rain-forest vegetation, and those of coral atolls, crucially influenced Micronesian and Polynesian culture respectively.

Whereas in New Guinea and the smaller islands of Melanesia sacrifices and other acts of worship were performed by all the men of a kinship group, in Polynesia and Micronesia these duties are assumed by priests. The priests make contact with the divinity either by undergoing possession by it or through material symbols. These symbols can be divided into natural and man-made objects. The former include whales' teeth, sharks' teeth, conch shells, cowries, and stones. The latter include fine mats, coconut-leaf baskets, white tapa cloth, boomerangs, coconut-wood spears, and so on. In central and marginal Polynesia the spiritual essence of the divine is symbolized mainly by red feathers, though the individual gods are also represented by wood, stone, and bone sculptures.

In central, northern, and eastern Polynesia the priests officiated on stone terraces and platforms usually built at a narrow end of a rectangular area in which the congregation assembled. The place of assembly is called *marae*, the platform, *ahu*. In western Polynesia, however, the term *malae* designates the large village square which serves as a communal meeting place. The symbols of the gods were kept in an ordinary house built on a stone platform which was merely part of the house, not a cult sanctuary in itself. The house was, as a rule, inhabited by the priest, and his paraphernalia were kept there. The symbols of deity were solemnly taken outside for the services, and spread on a mat in front of the house.

Two rare wood sculptures from the Fiji Islands were brought to the United States by Captain Wilkes in the first half of the nineteenth century. They are standing human figures: the first (plate 230) was obviously part of a house post, the second (plate 231), a freestanding sculpture, must be regarded as a

335

female divinity. Some stylistic differences are recognizable. The large male figure clearly exhibits features of the Neolithic-Austronesian tradition; for instance, the torso and the arms are very long. The shoulder area is stressed by a small incision across the chest. The same feature is especially distinct in an idol figure from the island of Nukuoro in southern Micronesia (plate 283). Even though the face of the figure from the Fiji Islands does not extend far down over the chest, it is flat as a board and almost triangular in shape. As a whole this figure is very like one from the Massim area (plate 133). The goddess figure (plate 231) is another case entirely. The attitude of the body, the position of the hands, the realistic treatment of the breasts, and the absence of any clearly marked facial outline point definitely to the Metal Age tradition. An affinity with the figure in plate 220 is unmistakable.

Even though Fijian art shows some influence of the Metal Age tradition, it is linked to the Neolithic-Austronesian tradition more closely than is the art of the other western Polynesian islands. This is particularly apparent in the two following works. The oil dish (plate 234) is a remarkable accomplishment. In the typical Neolithic tradition, the human figure is given a completely flat treatment. The position of the arms and the shape of the face are further confirmatory evidence; while the shoulders are at the level of the ears, the facial contour is triangular, and the face recedes directly under the forehead. Similarly, the male figure on the suspension hook from the Fiji Islands (plate 235) belongs to this tradition; here the ears are carved and the face is fitted tightly into the triangular outline. The large round disc above the figure served as a guard against rats.

However, the most important work from the Fiji area is the ivory suspension hook with two figures (plate 236) under five inches high. A note by the collector tells us that the two female figures standing back to back represented *Na Lila vatu*, the two wives of the chief god worshiped in the Nadi district. It was believed that long ago the god himself gave this sculpture to an old priest, and it was kept in a miniature temple made of woven sennit cord, which was kept in a larger temple. The miniature temple had two doors, and the object was placed so that the two female figures could "see" out.

Although it comes from the Fiji, this hook seems to belong to the same group as the ivory carvings from the Tonga Islands, of which two examples are shown here (plates 237, 238). Judging by what we know about them, they

were used in the same way as the piece from the Fijis. John Williams, a missionary who visited the Tonga archipelago in 1830, has left an interesting account. At the time the island of Haapai, where the ivory carvings were found, was ruled by the chieftain Taufaahau, who later became ruler of the whole archipelago under the name of Tupou I. He wanted to abolish the traditional cult, but his efforts met with vehement opposition.

"Taufaahau resolving to anticipate and neutralize this movement, drove a large herd of pigs into the sacred enclosure, converted the most beautiful little temple, which stood in the middle of it, into a sleeping apartment for his female servants, and suspended the gods by the neck to the rafters of the house in which they had been adored. The idolators, ignorant of the proceedings, came, with great ceremony, attended by their priests, to present their offerings, and found, to their astonishment, a number of voracious pigs, ready to devour anything they had to offer, and the gods, disrobed of their apparel, hanging in degradation, like so many condemned criminals."* On this occasion the missionary, who was the first European to visit the island, was given one of the divine images, but one carved in wood.

These ivory carvings are surely among the finest creations by the artists of Oceania. The position of the head and the striking realism of the whole figure show clearly that the Metal Age stylistic tradition was in ascendancy here. In general the sculpture of western Polynesia is closely related to that of the eastern fringe of Melanesia and of Micronesia. They differ essentially from the other Polynesian works. We must assume that in comparatively recent times a Micronesian influence penetrated western Polynesia, and came to overshadow the older links between Melanesian and Polynesian art.

CENTRAL POLYNESIA:
Cook, Tubuai, and Society Islands

At first sight one might suppose that with the art of the Cook Islands, the Tubuai (Austral) Islands, and the Society Islands (Tahiti), we are confronted with an entirely new stylistic tradition. But a closer examination discloses the persistence of some fundamental guiding ideas operative in both Melanesian art and that of western Polynesia.

One justly famous work, now in the British Museum, is the sculpture of

* *A Narrative of Missionary Enterprises in the South Sea Islands* (London, 1839), p. 273.

the god Te Rongo from the island of Rarotonga (plate 239). It is generally known as "Te Rongo with His Three Sons," but Sir P. Buck, one of the leading experts on Polynesian culture, has pointed out that this title probably involves a confusion between Te Rongo and the god Rongo from the island of Mangaia, father of the three ancestors of the Ngariki tribe. It seems there is no mythological authority for the supposition that Te Rongo had three sons. Incidentally, there are four additional human figures incised on the god's arms and forearms, shown in the same style as the three figures on his chest. The figure is carved from a single block: hence the peculiar shape of the torso, with its receding chest and protruding round belly. The chest had to be displaced backward so that the piece of wood might accomodate the three smaller figures. The depiction of the shoulder area with its sharp horizontal incision (most clearly recognizable from the back) and the protruding thighs are familiar enough. What is peculiar to this figure, however, is that the knees are pulled up close to the body, and that the block of the thighs surrounds the body. The almost horizontal jutting chin is set on a clearly visible neck which, in cross section, is oval in shape: one of the vertices of the oval is extended vertically to form the exact center of the face. The face itself is dominated by the symmetry of the three ovals of eyes and mouth. These three ovals are a distinctive feature of Central Polynesian faces, even more than the prominent nose and carved ears.

This becomes particularly clear in the figure of a fisherman's god from the Cook Islands (plate 240). Except for a shallow incision, parallel to the lips, the nose is not represented at all; the other stylistic features are the same as above. The second work is about a third smaller than the figure of Te Rongo, and is much more compact, owing to the placement of the head. There is no neck, and the chin does not protrude but hangs down slightly over the chest, so that the shoulders are at a higher level than the chin.

The same stylistic features are found in the large "staff–gods" from Rarotonga (plate 241). Here, too, the nose is not represented. The long staff extending down from the head supports groups of crouching human figures alternately in frontal and profile view with prominent phalli. Those carved in frontal view are double, that is, they show two figures standing back to back. These strange symbols of divinity were originally completely wrapped in tapa cloth except for their heads. Underneath the cloth, red feathers and

pieces of polished sea shells were concealed; these were called "the soul" of the god. The missionary, J. Williams, who was the first European to see these staff–gods, sent an example to London. "It is not, however," he wrote, "so respectable in appearance as when in its own country; for the Britannic Majesty's officers, fearing lest the god should be made a vehicle for defrauding the king, very unceremoniously took it to pieces; not being so skilled in making gods as in protecting the revenue, they have not made it so handsome as when it was an object of veneration to the deluded Rarotongans."*

Of somewhat different appearance are the idols from the Tubuai (Austral) Islands, of which we show here a female figure carved in wood (plate 242) and one in stone (plate 243). The head is set on a clearly marked shoulder area. The hands of the wood figure are placed over the belly, those of the stone figure are raised. The legs of the two figures are bent, and the knee caps are accentuated. The face, shoulders, and arms of the wood figure are ornamented with incised rows of small triangles. The rectangular block under the feet of the stone figure obviously served to set it firmly in the ground or in the masonry of the platform. These elegant, elaborately decorated works contrast somewhat with the simple, clear forms of the idol figures from other islands, but demonstrate better than anything we have so far seen what outstanding artists lived in central Polynesia.

CENTRAL POLYNESIA:

Marquesas Islands

The culture of the Marquesas Islands occupies, in some ways, a central place in eastern Polynesia, because its influence extended as far as Tahiti, the Hawaiian Islands, and even Easter Island. Excavations by R. C. Suggs have shown that the island group was settled as early as the second century B.C., that the settlers came from western Polynesia, and that their culture was of the Austro-Melanid type. A particularly interesting discovery was that of numerous potsherds: As far as we know the art of pottery was completely forgotten in Polynesia in the course of the following centuries; certainly the Polynesian culture which the Europeans discovered early in the nineteenth century possessed no ceramics.

* *Ibid.,* p. 99.

It seems that until about A.D. 1000 the culture of the early settlers developed peacefully and steadily. But in the three centuries between A.D. 1100 and 1400, a very dynamic expansion of the population took place. It is still a matter of debate whether this sudden development was a result of fresh immigration or not. In any event, fortified villages were now built in the mountains, and during the ensuing violent struggles many groups of people took refuge in caves. It is to the period between 1400 and the first contacts with Europeans that we refer when we speak of a "classical" Marquesas Islands culture, and it is this which is represented in European and American museums.

The god symbols of Tahiti (*to'o*) are ordinary staffs with plaited coverings of sennit, on which red feathers have been pasted. The carved human figures (*tu'u*) represent the familiars of sorcerers. Stylistically, the figure shown here (plate 244) belongs very definitely to the same class as the god symbols from the Cook and Tubuai groups, but is incontestably poorer in execution. It should not, however, be inferred that the artists of the Society Islands were incapable of producing excellent wood carvings. The idols needed no further ornamentation than the sacred vehicles of magical power—bird feathers, pieces of sea shell, and the tapa cloth in which they were wrapped. But the artists' imagination was given free rein in the treatment of objects of daily use. The fan handle (plate 245) is proof of their mastery. It is in the typical central Polynesian style. The triangular face has an accentuated lower edge of the forehead, and the perpendicular nose extends down over the chest. The arms rest on the belly. The legs are pulled up, and the pelvic girdle surrounds the body. The protruding ears suggest that the artist was not thinking of a human figure. The basic features are rendered in a highly abstract form and adapted to the requirements of a double figure.

The art of carving, however, was not limited to the human figure. Many objects of daily use were painstakingly ornamented. A particularly impressive example is the drum (plate 246) from the Tubuai Islands. Technically this is a tubular drum covered with a shark skin held by strings. The lower part is lavishly carved in openwork.

The term *tiki* (or derivations therefrom) designates human figures sculptured or painted in central and marginal Polynesia. The basic meaning of the root in Austronesian languages is "small." In connection with sculptures,

however, the term does not refer to size but is a metaphoric usage signifying "image of man." In the Marquesas, *tiki*'s did not represent gods, as they did in the islands of central Polynesia, but ancestors elevated to the rank of gods. They were set up on large stone platforms or kept by the priests in special little houses. They supplied the visible focus for sacrificial offerings, and it was believed that, at least during the act of worship, the spiritual essence of the deceased was dwelling in them.

Our reproductions begin with a large *tiki* post (plate 247). The face clearly exhibits the classical Marquesas style: there is no indication of facial contour, and the symmetrical oval eyes and the wide mouth with protruding tongue are dominant features. The nose is reduced to a narrow vertical strip, but the nostrils are executed symmetrically as disproportionately large, horizontal semicircles. Eyes, nostrils, and mouth are all the same width. The head rests directly on the torso (without neck), the chin protrudes horizontally. One of the forearms rests on the belly, the other is bent upward, as though the figure were about to put its hand over its mouth.

After this general description, the stone *tiki* (plate 248) will be at once recognized as in the Marquesas style. Its large circular eyes are actually more typical than oval eyes. At the same time we discover here a feature to which we have already called attention in discussing the art of central Polynesia. The knees are pulled up toward the trunk which the pelvic block surrounds.

The small bone or ivory *tiki*'s, which served as hair or ear ornaments, are real masterpieces. The little hollow cylinders (plate 250) were worn in the hair, especially by warriors, as protective amulets; a man was supposed to use them until he had avenged the death of a kinsman. This pair shows male and female variations on the type. The wide mouth, the horizontal semicircular nostrils, and the large round eyes are in the best Marquesas style. The nose is markedly reduced. The eyebrow line comes down between the eyes, so that the whole area has the shape of an extended figure eight. Finally, the ears are prominently depicted.

No less impressive are the carved ear plugs (plate 251), stuck through the ear lobes so that the carved end protruded horizontally, and the *tiki*'s could be clearly seen.

In the very rich range of works from these islands, the bowls are outstanding; two examples are illustrated. The large round bowls were covered with relief

ornamentation on the outside (plate 252). The division of the surface into regular ornamental fields is characteristic; in my belief, this stylistic feature goes back to the Metal Age tradition. The individual designs are carved as relief bands on a smoothly polished surface. At the center of each field is the oval contour of a human figure; its head is stylized in the shape of a V or U. Legs and arms point laterally and are elongated to form angular spirals. Wherever it is necessary to fill the field entirely, arm and leg spirals are repeated. This technique shows once again that the artists consciously aimed at symmetry with the ornamental fields.

A particularly interesting example is the bowl with a cover, decorated with carved *tiki*'s (plate 253); such lids certainly belong to the Metal Age tradition. They were called *kotué* or *otué*. (The term designates a black seabird about the size of a pigeon.) The bowls served mainly for storing precious red paint. At each end of the bowl, a head with a conical hat directs its gaze outward. On the long side of the bowl the upper parts of the bodies of four *tiki*'s are carved. The center of the lid has a small cylindrical knob, and is ornamented with eight carved *tiki*'s.

<div style="display:flex">
<div>

MARGINAL
POLYNESIA:

Hawaiian
Islands,
Mangareva,
and Easter
Island

</div>
<div>

The Hawaiian group is the northernmost archipelago populated by the Polynesians; excavations sponsored by the Bernice P. Bishop Museum in Honolulu show that there must have been a settlement as early as A.D. 400.

The stone foundations of temples (called *heiau*) have been discovered in great numbers, and vary considerably in plan. It seems that such temples were built so often that a professional class of temple architects may well have developed. These artists would have been hired by chieftains who wanted to found a temple. Naturally every architect would have tried to create something new and clearly different from the work of his predecessors or colleagues.

Functionally, two basic types are distinguishable—the war temple (*heiau waikaua* or *Luakini*) and the *Lono* or *napele* temple. In war temples, priests of the *Ku* order officiated; they belonged to the highest rank of priesthood. At *napele* temples the services were presided over by a priest of the *Lono* order. Their intercession was supposed to exert a beneficial influence on growing things and on the peaceful aspects of life generally. Any chieftain could build

</div>
</div>

342

a *napele* temple, but only the king was entitled to a *Luakini* temple. In the latter, human as well as other sacrifices were made, whereas in the former only pigs were offered.

Our reproductions begin with a large wood sculpture of the war god Kukailimoku of the royal Kamehameha family (plate 254). The body, with slightly bent legs and vertically hanging arms, lacks the prominent pelvic girdle found so often in other Polynesian sculptures of the human figure. The thigh area is set off by a distinct incision where the thighs join the trunk. But the figure as a whole is dominated by the huge, awe-inspiring head. And here it is the open mouth, shaped like a figure-eight, that most notably expresses the warlike nature of the god. The nose is reduced to a lump, and this impression is stressed by the laterally pointing nostrils. The oval eyes are almost invisible under the impressive plaited hair, which terminates in two pigtails at the back. The bases of such figures were carved into peg-form under the feet, so that they could be set firmly in the ground. It was customary to have several of them side by side in the middle of the *heiau*.

On the carved slab from a temple on the island of Kauai (plate 255), the face is essentially more peaceful. This base was extended to be buried in the ground so that the chin was nearly resting on the earth. The circular eyes, the slender vertical nose, and the horizontal oval mouth with the protruding tip of the tongue add up to a classic example of the Metal Age tradition's style.

The kneeling goddess, probably Kihe Wahine (plate 256) is carved in wood, and the mouth is studded with real human teeth; there were originally shell plaques set into the oval eye spaces, but these have since been lost. The head is hollowed out so that it could be used as a container. The breasts are very realistic. This is the only kneeling idol figure so far discovered in Hawaii. The iconographic motif of kneeling female figures in Oceania has not yet been elucidated. We may refer to two similar examples from the northern coast of New Guinea (plates 21, 26). This undoubtedly old sculpture was found by Hawaiians in 1885; we do not know exactly where it stood nor what purpose it served.

The wood sculpture (plate 257) in the Musée de l'Homme, Paris, represents the goddess Pele. The classical Hawaiian torso was here very boldly hacked out by the sculptor. Although the planes of the body meet at acute angles, the bent legs, the incision of the thighs, the vertical hanging arms,

343

and the female breasts are clearly recognizable. The neck is thin and somewhat overlong; the chin protrudes horizontally; the facial surface is convex; and the mouth has the figure-eight shape characteristic of Hawaiian art. A large arc rises between the shoulder blades to curve over the head, and carries a comblike crest.

Human figures in stone were called *kili pohaku*. It seems that they were not regarded as divine during religious ceremonies, but that this quality was ascribed to them later. Then they were called *akua pohaku* or "stone god." Of especial interest are certain of these found on Necker Island far to the north (plate 258). The features of the Hawaiian style are recognizable at once: the bent legs, the vertical hanging arms, the incisions around the thighs. The face hangs down over the chest, so that the shoulders come directly below the ears. All these figures are male, but the genitals in the example shown here are fashioned as a face. The figure's face is almost round in outline; the circular eyes are unconnected; the vertical nose has no nostrils. The mouth is semicircular, and the tongue protrudes slightly. It is generally believed that these works belong to an older school of the local Hawaiian style.

The Mangareva or Gambier Islands lie at the eastern extremity of the Tuamotu archipelago. Standing figures of gods were discovered on this island by explorers in the early nineteenth century. The one shown here (plate 259) most probably represents the god Rogo, who was responsible for garden fruits and rain. Stylistically, this sculpture must be regarded as a local variant of the eastern Polynesian style. The tendency to represent the body in realistic proportions is striking. The slightly parted legs are bent at the knees, and the arms hang vertically. The genitals are distinctly executed. The neck is somewhat elongated, and the chin protrudes horizontally. The facial plane recedes slightly below the clearly marked lower edge of the forehead, and the flat semicircular eyes are dependent from this edge. The vertical nose is very realistically shaped. Only the small oval mouth is completely out of key with the rest. This work, composed to be seen from the front, has the kind of heraldic rigidity that comes into full numinous effectiveness in the sacred atmosphere of a temple.

Easter Island, or Rapa-nui, is a lone island far off in the eastern Pacific. It has become widely known for its mysterious, huge stone figures. Almost equally famous are the small wooden tablets with incised characters, recently

deciphered by the German anthropologist, T. S. Bartel, after many unsuccessful previous attempts. The individual characters do not stand for letters or syllables, but are mnemonic signs of more or less complex meaning which can rarely be rendered in a single word. The order in which they are set down makes further interpretation necessary, even where the meanings of all the signs are known. Even now only a limited number has been deciphered with any very great degree of certainty.

The small wood statuettes, *moai kavakava*, obviously represent a half-decayed human body (plate 260). The trunk is so nearly fleshless that we can make out the spinal column, protruding ribs, and a protruding, birdlike, breast bone. The face is carved very realistically, each of the long ear lobes has an ornament hanging from it, and the small goatee is always present. A bird or a monster in human shape is occasionally carved in relief on the crown of the head. In addition to these *moai kavakava*, which are always male figures, flat female figures, *moai paepae* (*paepae:* "flat"), were carved at a later date. The example shown here (plate 261) was collected by sailors out of New Bedford in 1845.

Little is known of the use and religious significance of these figures. They were set up during feasts, especially at celebrations of the harvest, and "first fruits" were brought them as offerings; otherwise, they were wrapped in tapa cloth and kept inside a house. Owners of such figures were sometimes observed to pick them up like dolls and execute slight dancing motions.

Surely no one can fail to be impressed by the cruel realism of the male figures, among the very finest works of Oceanic art. We can hardly be surprised that European travelers have always tried to obtain such figures, and as a result, in Christian times, production of them has become a real industry. H. Lavachery visited a workshop which turned them out, and has described how the artists adapted the traditional forms to catch the eye of the visiting Chilean sailors who were their best customers. Thus we find typically skeletal figures wearing the cap of a naval officer.

The most famous and best described cult of the Easter Islanders is that of the Bird-man, which was closely connected with the cult of the god Make-make, and involved a race. The participants' goal was to be the first to bring back an egg of the *manu-tara* bird which nested annually on the little island of Motu-nui. The egg was thought to be an incarnation of Makemake, and

possession of it conferred tremendous magical powers for the space of one year. When the birds' nesting season approached, large numbers of people gathered in the village of Orongo, on a steep slope of the volcano Rano-kao. Competitors for the title of "Bird-man," who as a rule had to be war chieftains, entrusted the task of "Bringing" back an egg to their servants. These made the perilous trip to the little island of Moto-nui, the first to present an egg to his master being the winner. Drained of its contents and stuffed with tapa cloth, the egg was hung in the Bird-man's house.

The wood sculpture (plate 262) is of a type which the Bird-men probably carried on their backs. The combination of human figure and bird's head is peculiar to Oceania; it constitutes an important document of that order of religious ideas in which the boundary between man and animal means little.

Another characteristic object from this area shows a crescent breast ornament (*rei-miro*) with two faces carved on it (plate 263). Only members of the nobility were entitled to wear these ornaments. Simple in itself, the ornament charms by the balanced symmetry of its lines, to which the two narrow faces at the ends have been subordinated. Here we must admire not only great technical skill, but also sureness of taste.

MARGINAL POLYNESIA:

The Maori of New Zealand

New Zealand is the southernmost point reached by Polynesian culture. There is no longer any doubt that the original settlers came from central Polynesia in several waves, the first some time between A.D. 500 and 1000. Traces of these early settlers have been discovered mainly in the southern island and along the northeastern coast of the northern island. After their long, perilous voyage, they found here an entirely new and, above all, cooler world. Archaeological finds have established that their economy was based primarily on food gathering and hunting; in this the moa bird (now extinct) played an important role, hence the name "Moa-Hunter Period" given to this phase.

The greatest immigration to New Zealand took place in what is traditionally described as the "Great Fleet" around A.D. 1250, and several important Maori kinship groups trace their ancestry to individual canoe-loads of that time. Between the two immigrations a number of smaller ones took place; the Chatham Islands to the east were probably settled around A.D. 1200.

The basic art-historical problem of the Maori has been formulated by T. T. Barrow as follows: "The curvilinear style of developed Maori art would appear opposed to the basically rectilinear style of the parent Central Polynesian art. This fundamental problem is closely tied with the problem of origins, and remains largely unexplained. At first glance it would appear that the curvilinear style was introduced into New Zealand from Melanesia where the curvilinear style is typical. . . . As there is what at present appears to be quite satisfactory evidence that the first New Zealand inhabitants came from Tahiti and nearby groups, we can be confident that the first art created by man in this country was Central Polynesian in character. This would suggest that later Maori art would follow basically similar styles and patterns. However, an examination of Maori wood carving quickly convinces us that the problem is not quite so simple. In the comparatively short time-interval, say about five hundred years after the arrival of the great canoes . . . Maori art as the first Europeans found it, was curvilinear in style and of great vigor, while the contemporary style of Central Polynesia was basically rectilinear. . . . Probably the seeds of the curvilinear style which later flourished in New Zealand were present in the art of the first migrants. Early scholars believed that the first New Zealand settlers were of Melanesian origin. This would, if true, have greatly simplified the problem of curvilinear elements in New Zealand art, but no archaeological or other evidence supports this theory."*

More recent archaeological work in central and eastern Polynesia has shown that the area was probably settled as early as 200 B.C. The culture of the early central Polynesians belonged to the Austro-Melanid type; its links with Melanesian culture are thus established, though a direct emigration from Melanesia to New Zealand surely never took place. But, as Barrow says justly, "the seeds of the curvilinear style were present in the art of the first migrants."

The art of the Maori carvers is at its best in the ornamentation of objects and figures; in short, its function is mainly decorative. The observation that Maori art is curvilinear and central Polynesian art rectilinear refers exclusive-

* "Maori Decorative Carving–An Outline," *Journal of the Polynesian Society,*
 LXV (1956), pp. 305–6.

ly to relief ornamentation. Closer scrutiny of the basic features in the representation of human figures shows that the basic differences between New Zealand and Central Polynesian art styles are not very great: the common heritage is easily recognizable. The admiration justly bestowed on the decorative mastery of the Maori artists has shifted the art-historical problem in a direction that excludes any satisfactory solution. The curvilinear Maori ornamentation possibly dates back to the common Austro-Melanid heritage, but it is largely an indigenous achievement of the Maori culture.

Our reproductions begin with an impressive canoe prow ornament (plate 265). The forward-leaning figure, with protruding tongue and backward-reaching arms which seem to be holding onto the spiral, is called *tau-ihu*. The central plank with the two spirals carved in openwork is called *manaia* or *tauroa*, and the figure looking into the boat, *huaki*. The attitudes of the two human figures are essentially determined by the architecture of the ornament as a whole. They frame the central plank whose expressive ornamentation is the dominant feature of the work; its elegance and symmetry provide a classical example of the skill of the Maori artists.

Maori war canoes carried a second tall ornament, the sternpost—*taurapa*. The sternpost of the *toki-a-tapiri* canoe of the Kahungunu tribe (plate 266) is in the Auckland Museum. The vertical board is entirely carved in openwork, in the middle of which rise two parallel solid beams which served to give the sternpost stability. The human figure at the foot of the sternpost, looking into the boat, is called *Puhi-kai-Ariki*. The elegant and technically accomplished adaptation of ornament is admirable. The Maori artists rarely used the simple spiral; in most cases we have double spirals, sometimes plain but often provided with incised ornamentation of their own. The spaces between the lines are often ornamented, too, giving an impression of baroque excess. Few areas of Oceania so clearly disclose a *horror vacui*, which leads the artists to fill the individual surfaces with ornaments down to the tiniest available space.

Freestanding figures are rare, and all the known examples date from the period before European influence asserted itself. The little data we possess concerning their function suggest that they represented gods. The example shown here (plate 267) justifies recalling a few features they have in common with central Polynesian works. The bent legs with clearly marked knee caps;

the positions of the thighs, penis, and arms, have all been defined earlier as symptomatic of the style. The position of the head and the execution of the face also exhibit features of central Polynesian type. The facial plane recedes below the horizontal edge of the forehead; the straight nose is fairly realistic. The figure-eight mouth is, as we have seen, the most distinctive feature of Hawaiian figures. By contrast, the hand with three fingers and the incised decoration covering the entire face are characteristic of the local Maori style.

The link with central Polynesia is even clearer in the wood carving of the Moriori from the Chatham Islands (plate 269) in which the familiar traits of the horizontal edge of the forehead, the perpendicular nose, the receding face, the circular upward-pointing mouth, and the half-oval face all appear yet again.

The next two works shown here, however, are impressive examples of the local Maori style itself. At Te Ngae on Lake Rotorua stood a gigantic sculpture, the lower part of which has been lost. Originally it represented the chieftain Pukaki, his wife, and his two children (plate 270). All articulations, such as shoulders and thighs, are ornamented with large incised spirals. But the shape of the face and the position of the head and arms are by no means unusual in Polynesian sculpture. More typical of the Maori style is the house post (plate 268). Although the figure had to be fitted into the rectangular frame of the post, all features permitting of comparison are present. Legs, and the position of arms and of the head are unmistakably Polynesian. The face, on the other hand, exhibits features which occur also in the war god figures of Hawaii. The wide open mouth, shaped in a figure-eight, shows the tongue. The area of the eyes diagonally above it is oval, though in this plane the eyes themselves look like concentric circles. The nose is a small compact lump between the mouth and the edge of the forehead. One must not be misled, in comparing the last two works, by the incised ornamentation which partly conceals the forms.

The next two works can be similarly compared. The roof ornament from Kaitaia (plate 271) marks a complete departure from the classical Maori style. It was originally supposed that the object was a door board or *pare*. However, it seems rather to be a roof ornament, such as are found on certain burial houses in Borneo. But the human figure in the middle of this board is nothing new stylistically: on the contrary, the body attitude and

head exhibit the influence of the Neolithic-Austronesian tradition with rare purity.

By contrast, the beautiful door board from Hauraki Plain (plate 272) is again in the classical Maori style. Against a background of interlocking loops, carved in openwork, five figures shown in frontal view are seated, and at each end there is a figure in profile view (*manaia*). The five frontal figures have essentially identical bodies and faces. The distortions in the attitudes of the four outer figures suggest a tendency in Maori art which is scarcely found elsewhere in Oceania: not only are several figures combined to form a unified work of art, but the composition, through distortion of the basic motifs, is endowed with a liveliness which departs considerably from the heraldic rigidity of all other Oceanic art.

Along with the double spiral, the interlocking loops, the three-fingered hand, and the figure-eight mouth, the *manaia* motif is an important component of the Maori repertory of forms. Its origin has long been the object of discussion, but so far no convincing explanation has been found for it. Some consider the motif derives from a bird's beak; others, that it relates to the human face—namely, one-half of the face with the figure-eight mouth, here entirely in profile.

The following three reproductions show god-sticks (plates 273–275), which were thrust into the ground on the occasion of lesser offerings. The figure from the Wickliffe Bay area is somewhat different stylistically from the others; its simplicity strongly suggests the Neolithic-Austronesian tradition. It appears to have been associated with human remains from cannibal victims, and pig bones; it probably dates from about 1820. The other three figures come from the Wanganui district; it is suggested that one (plate 274 right) represented the god Hukere. Confrontation of these four works shows once again the great range of formal variety in Maori art, even when the objects served the same purpose.

Any survey of Maori art would be incomplete without one of the beautiful nephrite carvings which have become a national symbol of New Zealand (colorplate 49). These *hei-tiki's* (*hei:* "to hang"), worn on a string around the neck, are unsurpassed masterpieces. The tucked-in legs and the inclined head are characteristic, while the face with figure-eight mouth and round inset eyes is unmistakably Maori in style.

WESTERN POLYNESIA

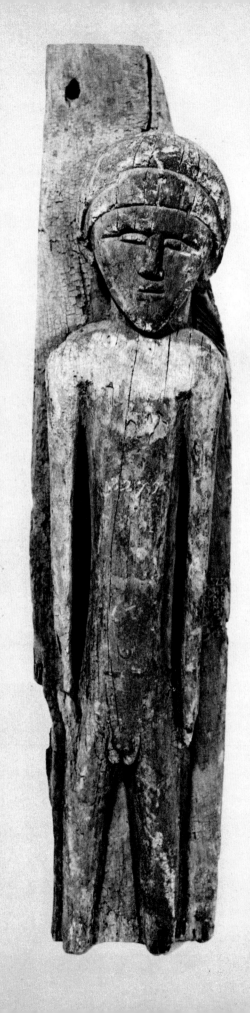

PLATE 230. PART OF HOUSE POST: STANDING MALE FIGURE
Western Polynesia, Fiji Islands (Wilkes)
Height 50 3/8″
Smithsonian Institution, Washington, D. C.

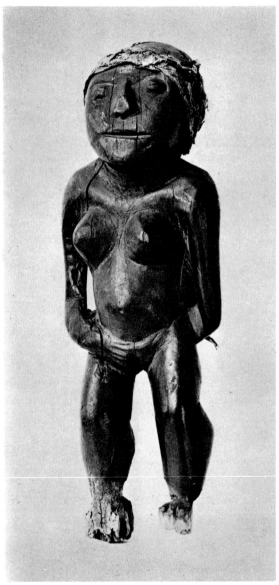

PLATE 231. STANDING FEMALE FIGURE
Western Polynesia, Fiji Islands (Wilkes)
Height 15″
Smithsonian Institution, Washington, D. C.

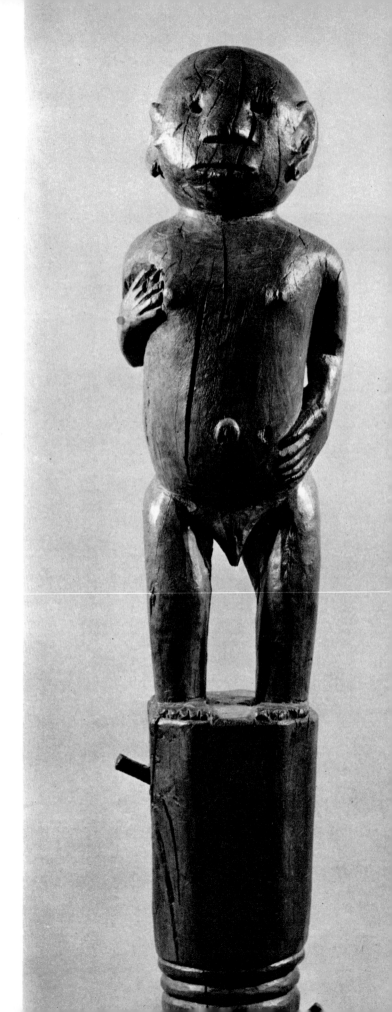

PLATE 232. STANDING MALE FIGURE
Western Polynesia, Fiji Islands
Height with post 46 1/2″; figure alone, height 16 3/4″
Collection Robert and Lisa Sainsbury, New York

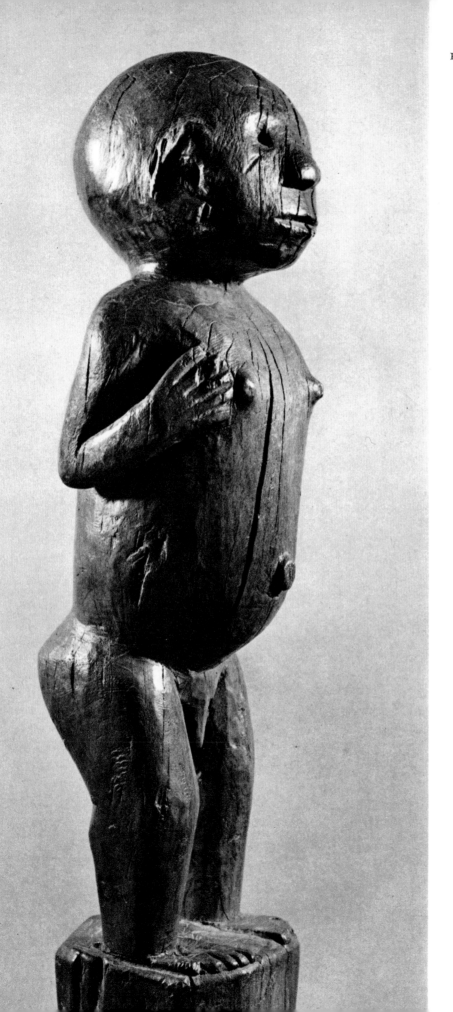

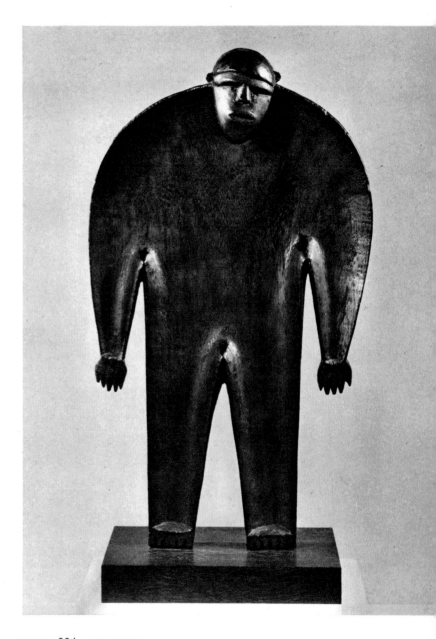

PLATE 233. STANDING MALE FIGURE (profile view of figure in Plate 232)

PLATE 234. OIL DISH
Western Polynesia, Fiji Islands
Height 17 3/8"
Collection Mr. and Mrs. R. Wielgus, Chicago

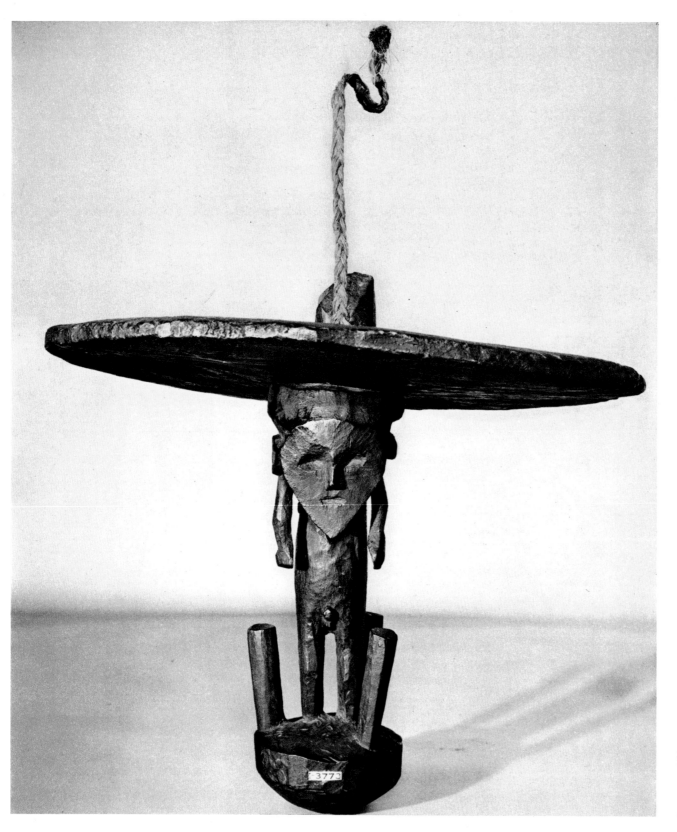

PLATE 235. SUSPENSION HOOK
Western Polynesia, Fiji Islands
Height 12 7/8″
University Museum of Archaeology
and Ethnology, Cambridge, England

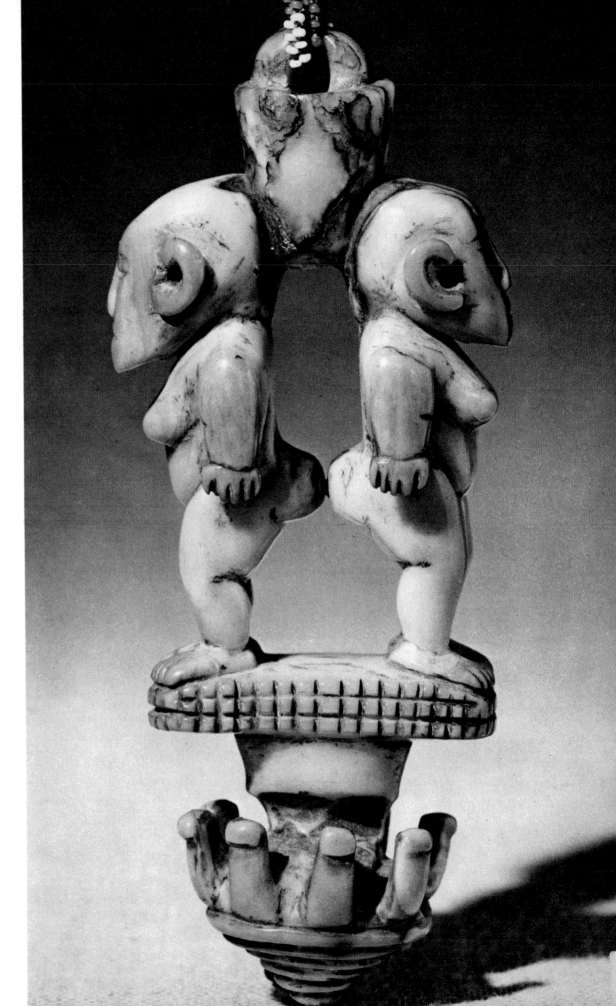

PLATE 236. SUSPENSION HOOK
Western Polynesia, Fiji Islands (Sir A. Gordon, c. 1875)
Ivory, height 4 3/4″
University Museum of
Archaeology and Ethnology, Cambridge, England

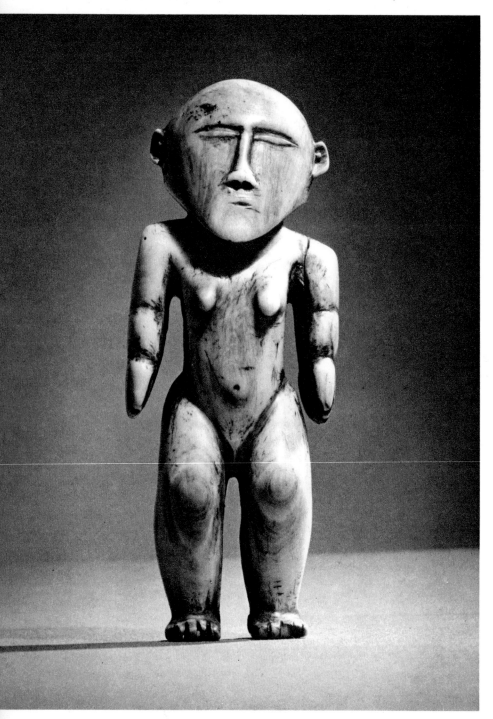

PLATE 237. FIGURE
Western Polynesia, Tonga Islands, Haapai Group
Ivory, height 5 1/8″
Museum of Primitive Art, New York

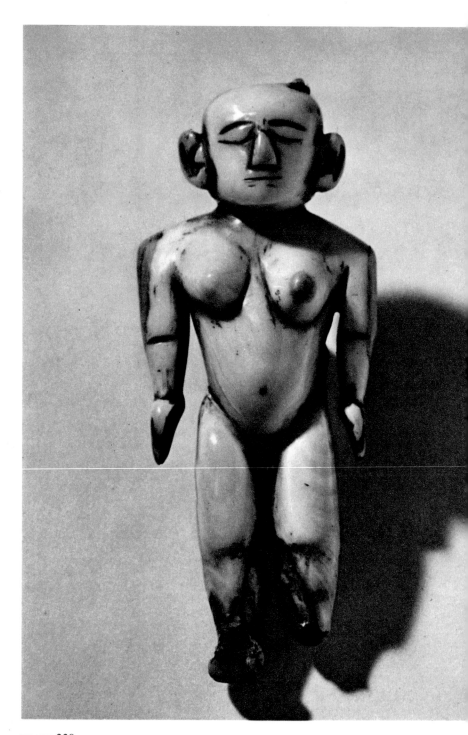

PLATE 238. FIGURE
Western Polynesia, Tonga Islands,
Haapai Group (collected before 1900 in Fiji)
Ivory, height 4 3/8″
University Museum of Archaeology and Ethnology, Cambridge, England

COLORPLATE 47. PENDANT
Western Polynesia, Tonga Islands, Haapai Group
Ivory, height 5″
Collection Mr. and Mrs. R. Wielgus, Chicago

CENTRAL POLYNESIA:

Cook, Tubuai, and Society Islands

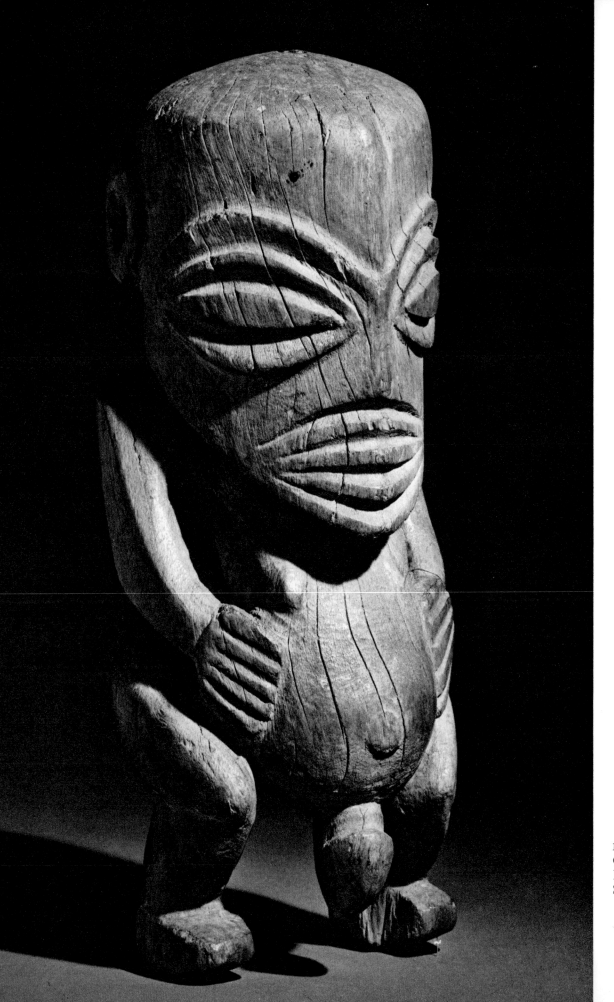

PLATE 240. FIGURE OF FISHERMAN'S GOD
Central Polynesia, Cook Islands
Height 16 1/2″
Staatliches Museum für Völkerkunde, Munich

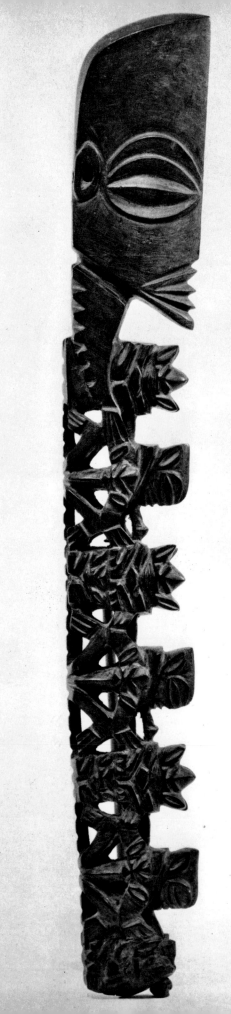

PLATE 241. STAFF-GOD
Central Polynesia, Cook Islands, Rarotonga
Height 28 3/8″
Staatliches Museum für Völkerkunde, Munich

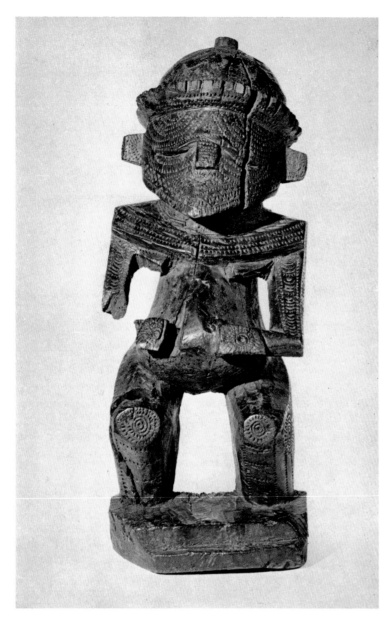

PLATE 242. FEMALE FIGURE
Central Polynesia, Tubuai
(Austral) Islands (Oldman Collection No. 413)
Height 26″
Auckland Institute and Museum

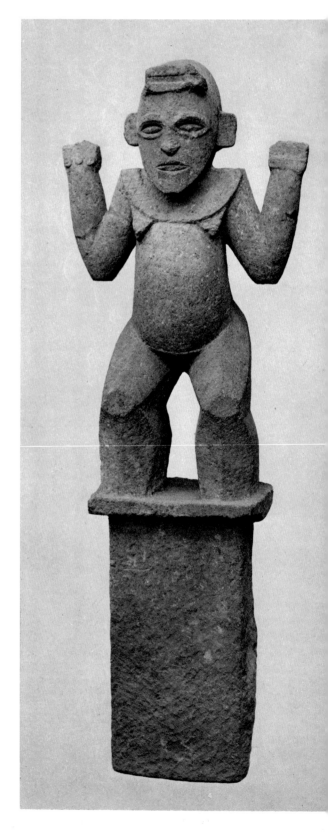

PLATE 243. FEMALE FIGURE
Central Polynesia, Tubuai (Austral) Islands, Raivavae
Stone, height 37 1/8″
Pitt Rivers Museum, Oxford

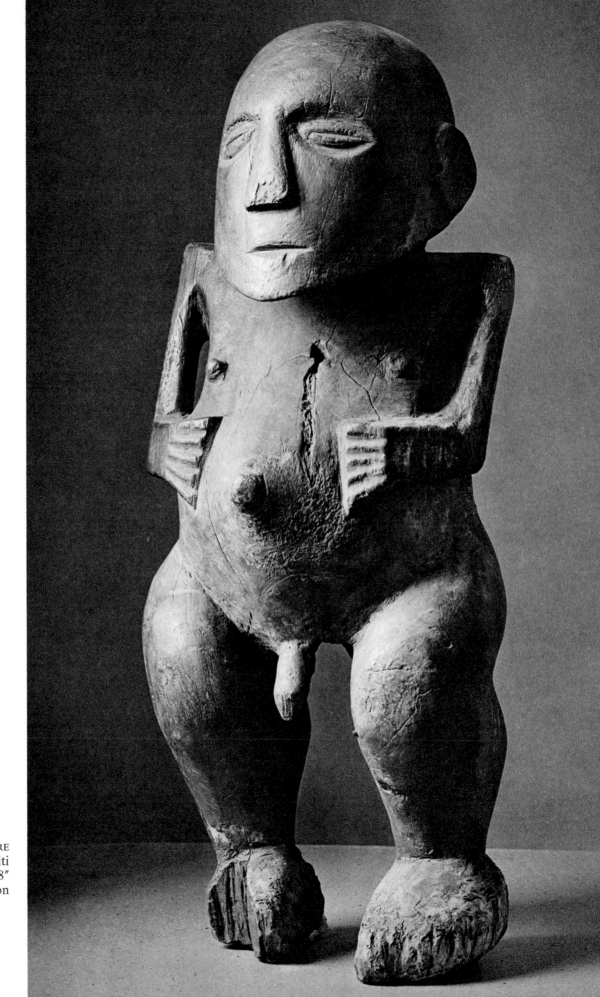

PLATE 244. MALE FIGURE
Central Polynesia, Society Islands, Tahiti
Height 16 7/8″
British Museum, London

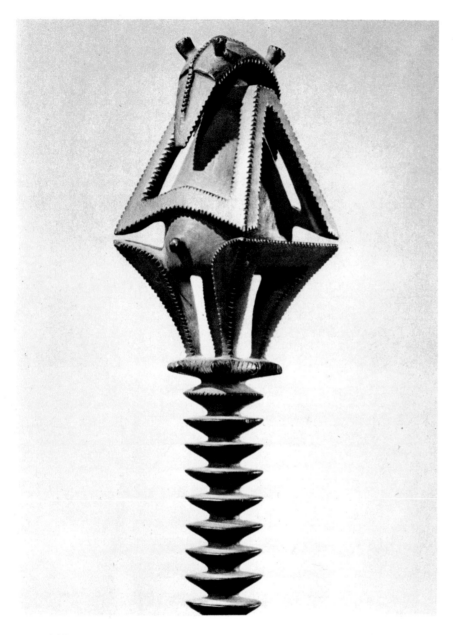

PLATE 245. FAN HANDLE
Central Polynesia, Society Islands, Tahiti
Height 22 7/8″
Museum of Primitive Art, New York

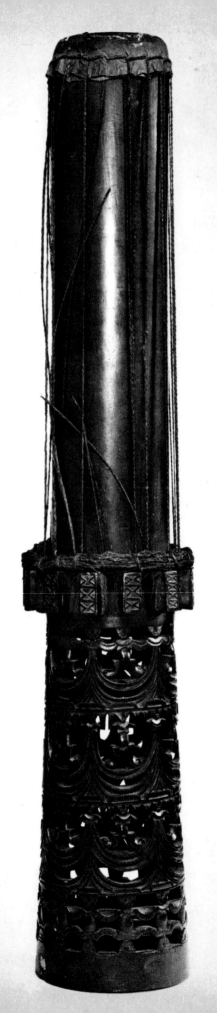

PLATE 246. DRUM
Central Polynesia, Tubuai (Austral) Islands
Height 57 1/2″
Museum of Primitive Art, New York

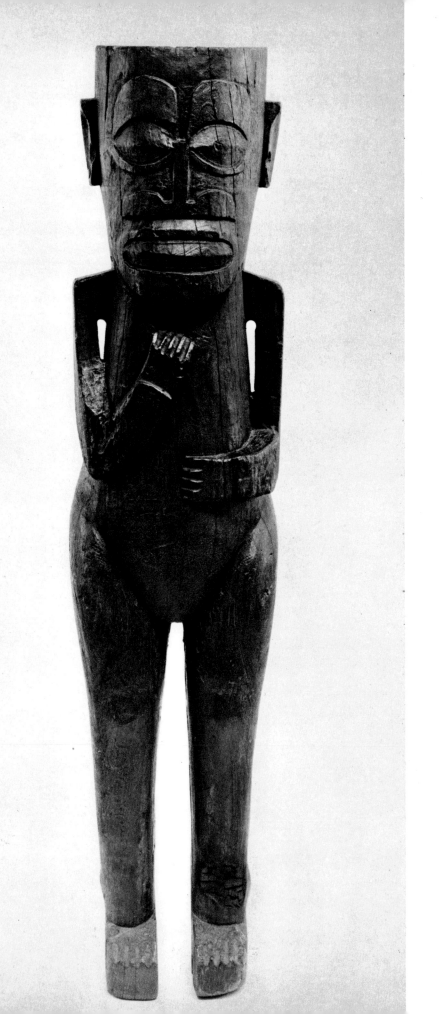

CENTRAL POLYNESIA:

Marquesas Islands

PLATE 247. *Tiki* POST
Central Polynesia, Marquesas Islands (v. d. Steinen)
Height 56 1/4″
Staatliches Museum für Völkerkunde, Munich

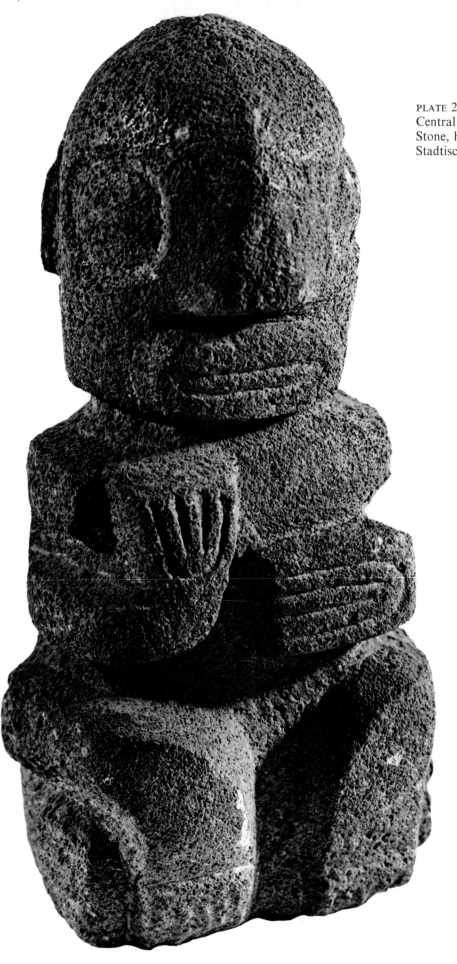

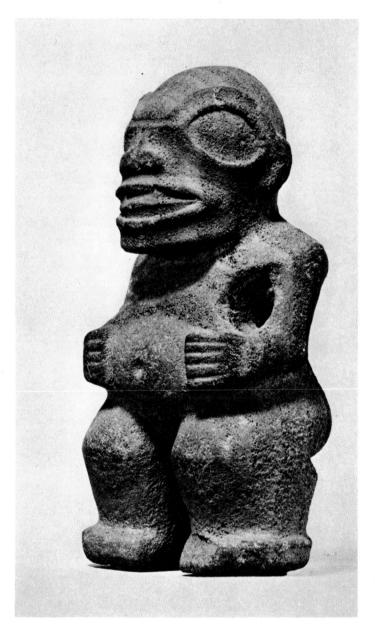

PLATE 248. *Tiki*
Central Polynesia, Marquesas Islands
Stone, height 8 1/4″
Stadtisches Museum für Völkerkunde, Frankfort

PLATE 249. PENDANT
Central Polynesia, Marquesas Islands
Basalt, height 6 1/4″
Collection Mr. and Mrs. R. Wielgus, Chicago

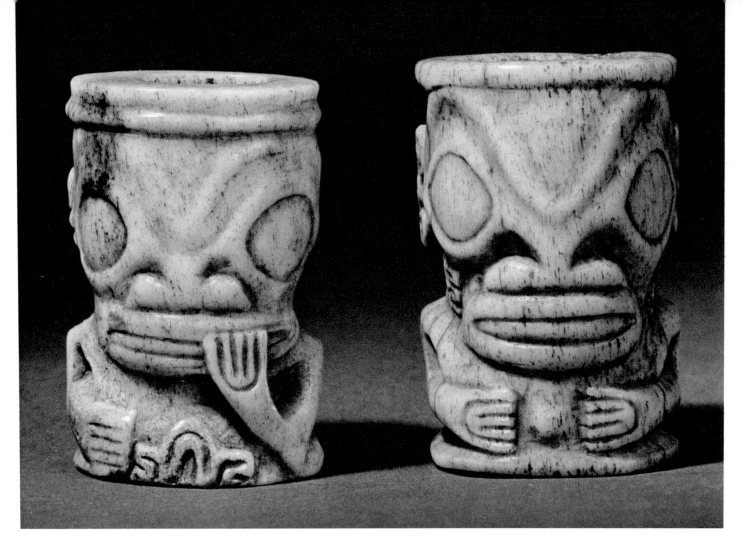

PLATE 250. *Tiki* FOR HAIR ORNAMENT
Central Polynesia, Marquesas Islands
Bone, height 2 3/4″
Collection G. Markert, Munich

PLATE 251. EAR PLUGS
Central Polynesia, Marquesas Islands
Whale's tooth, height 2 3/4″
Museum of Primitive Art, New York

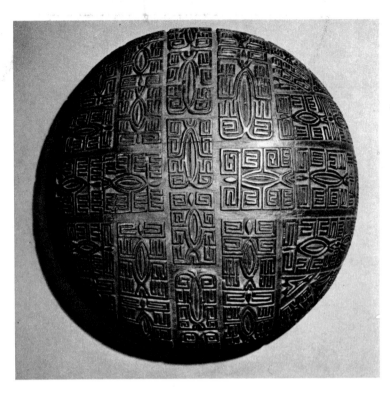

COLORPLATE 48. FAN (*tahi*)
Central Polynesia, Marquesas Islands
Pandanus and whale ivory, height 18 1/4″
Collection Mr. and Mrs. R. Wielgus, Chicago

PLATE 252. FOOD BOWL (underside)
Central Polynesia, Marquesas Islands
Diameter 9 1/2″
Staatliches Museum für Völkerkunde, Munich

PLATE 253. BOWL WITH LID
Central Polynesia, Marquesas Islands (Scharf, 1912)
Diameter 12 5/8″
Linden Museum, Stuttgart

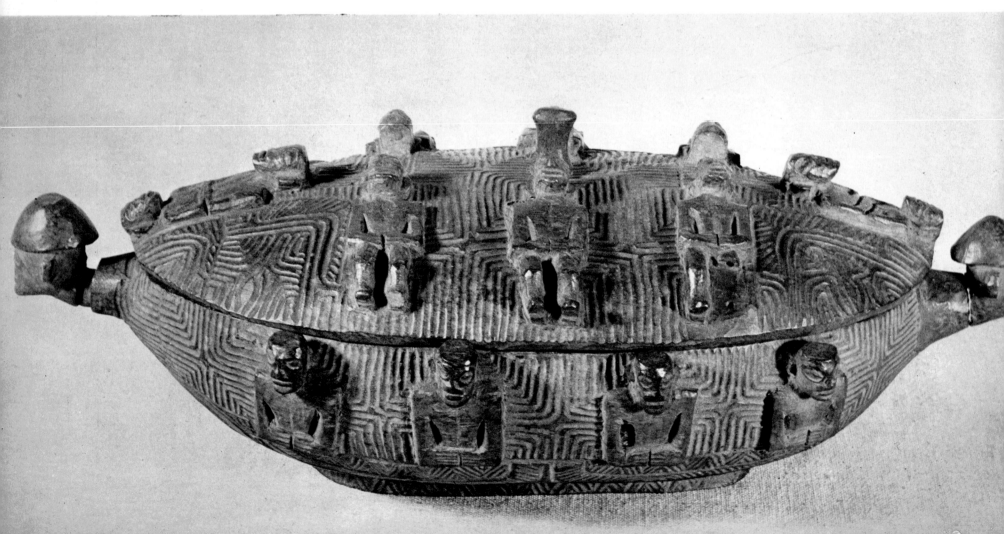

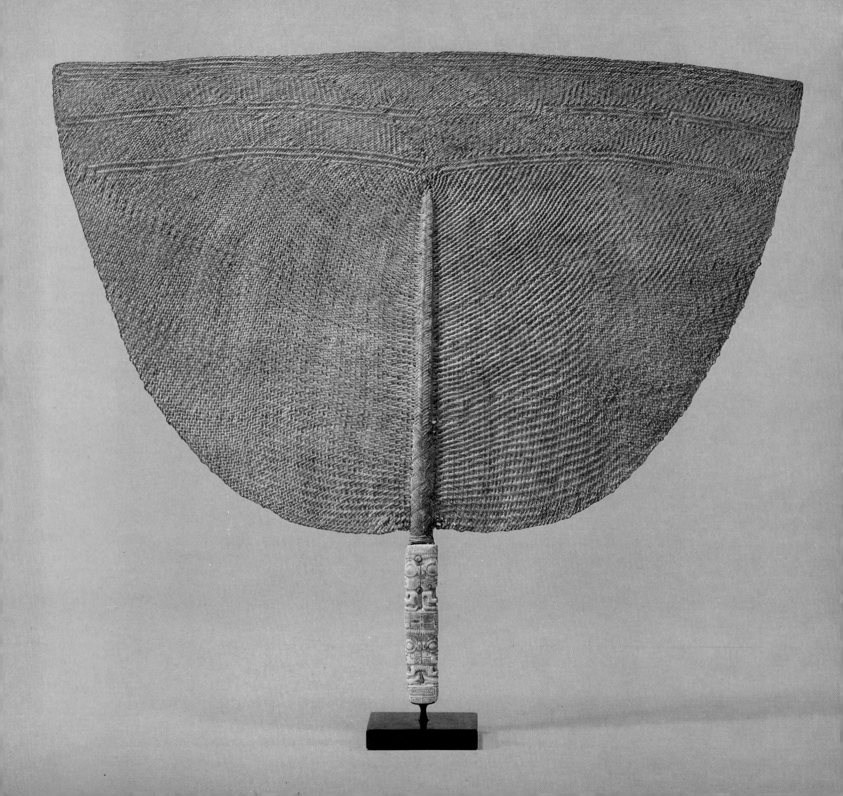

MARGINAL POLYNESIA:

Hawaiian Islands, Mangareva, and Easter Island

PLATE 254. WAR GOD KUKAILIMOKU
(front and profile)
Marginal Polynesia,
Hawaiian Islands (John T. Prince, 1846)
Height 90 1/8″
Peabody Museum, Salem, Mass.

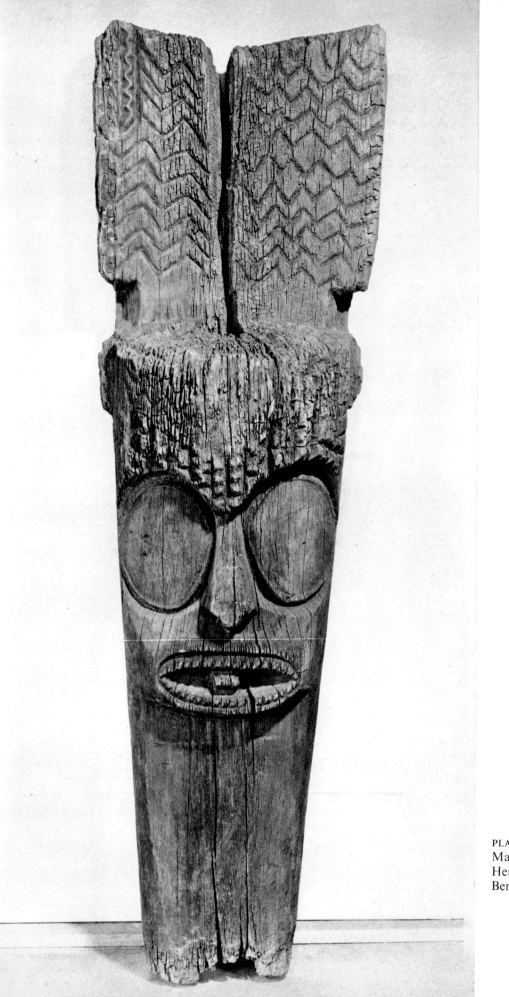

PLATE 255. CARVED SLAB FROM TEMPLE
Marginal Polynesia, Hawaiian Islands, Kauai
Height 73 1/4″
Bernice P. Bishop Museum, Honolulu

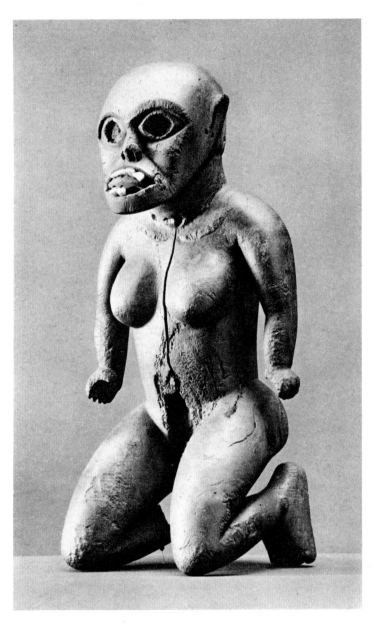

PLATE 256. KNEELING FIGURE,
PROBABLY OF THE GODDESS KIHE WAHINE
Marginal Polynesia, Hawaiian Islands
Height 16 7/8″
Staatliches Museum für Völkerkunde, Berlin

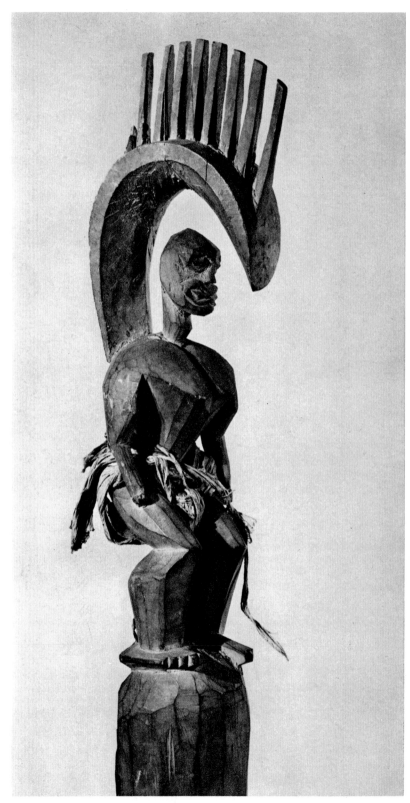

PLATE 257. FIGURE OF THE GODDESS PELE
Marginal Polynesia, Hawaiian Islands (José Oster)
Height 33 7/8″
Musée de l'Homme, Paris

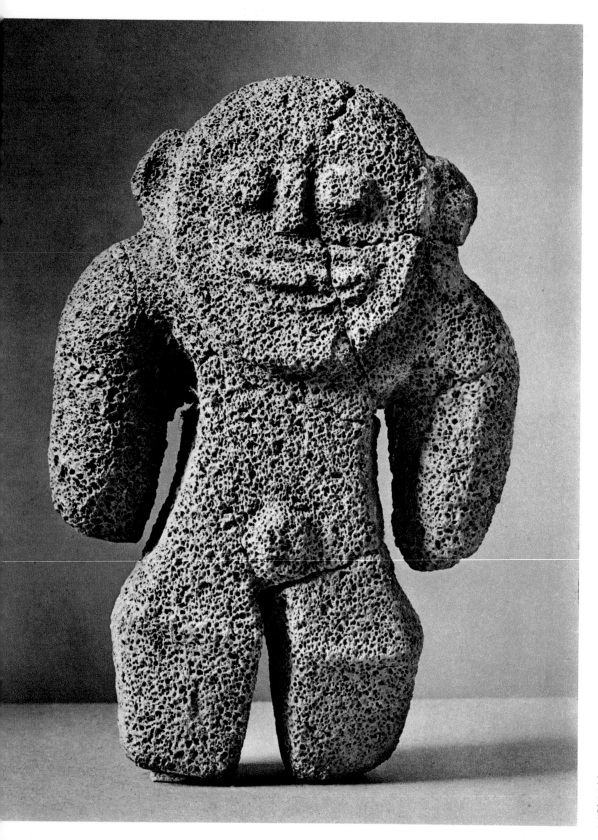

PLATE 258. FIGURE
Marginal Polynesia, Hawaiian Islands, Necker Island
Stone, height 11 3/8″
British Museum, London

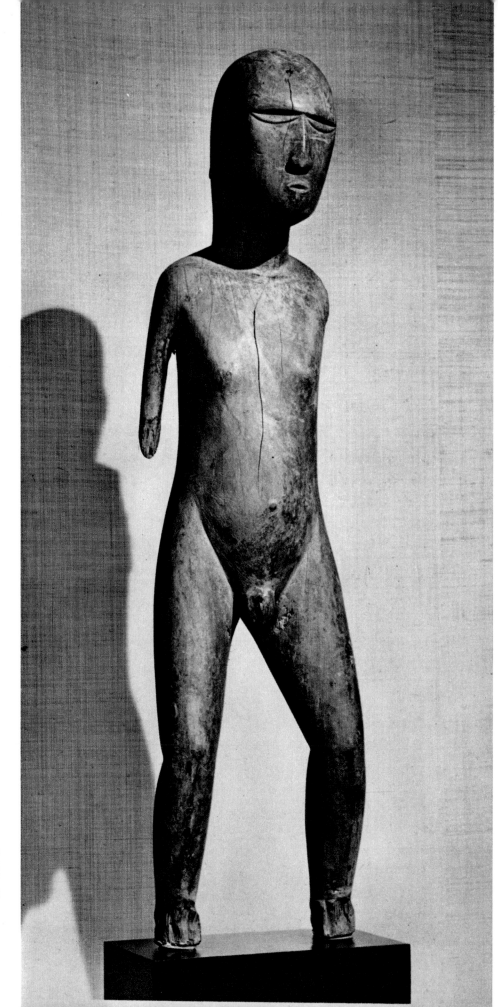

PLATE 259. FIGURE, PROBABLY OF THE GOD ROGO
Marginal Polynesia, Mangareva
Height 42 1/2″
Museum of Primitive Art, New York

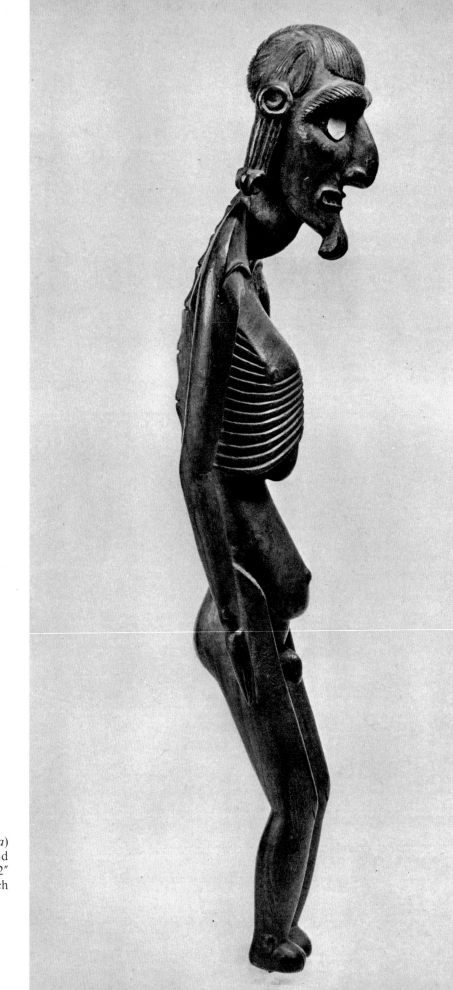

PLATE 260. MALE FIGURE (*moai kavakava*)
Marginal Polynesia, Easter Island
Height 20 1/2″
Staatliches Museum für Völkerkunde, Munich

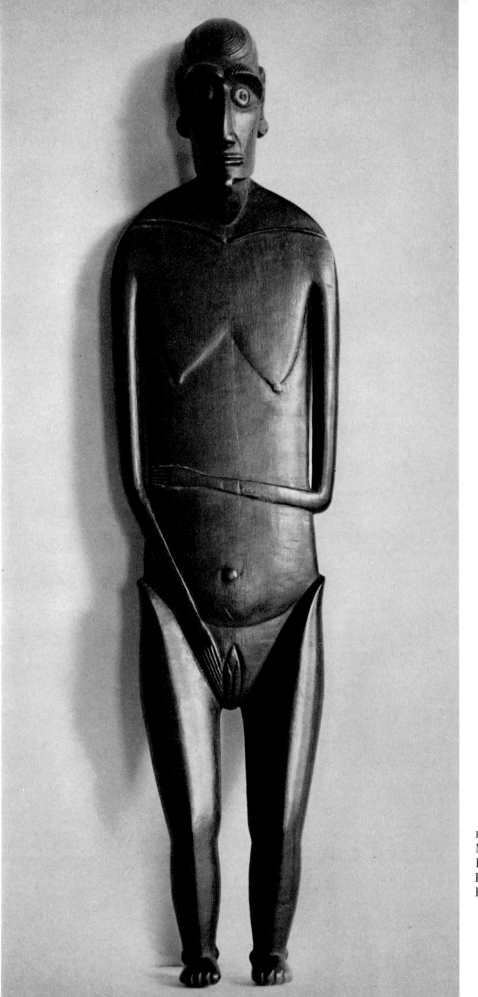

PLATE 261. FEMALE FIGURE (*moai paepae*)
Marginal Polynesia, Easter Island (collected in 1845)
Height 25 1/4″
Peabody Museum of Archaeology and Ethnology,
Harvard University, Cambridge, Mass.

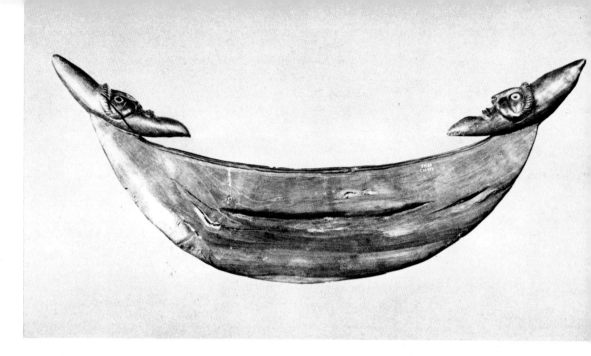

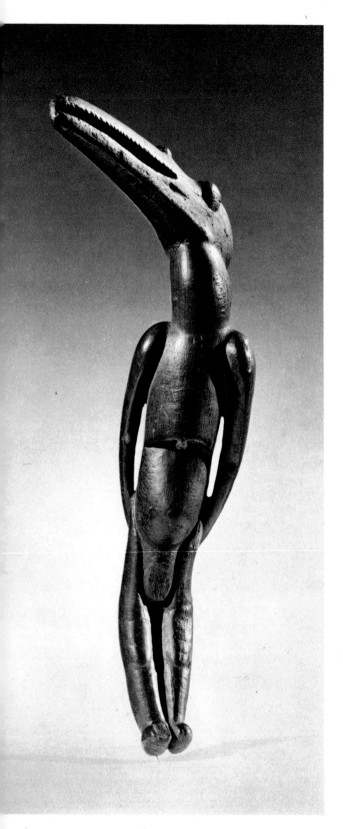

PLATE 263. BREAST ORNAMENT (*rei-miro*)
Marginal Polynesia, Easter Island
Length 22 1/2″
Buffalo Museum of Science

PLATE 262. BIRD-MAN FIGURE
Marginal Polynesia, Easter Island
Length 18 7/8″
American Museum of Natural History, New York

PLATE 264. BREAST ORNAMENT (*rei-miro*)
Marginal Polynesia, Easter Island
Length 15″
Field Museum, Chicago

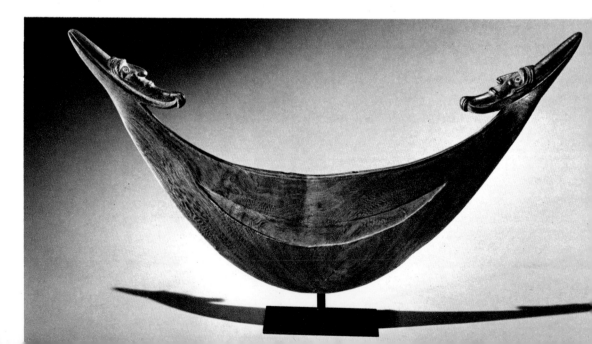

MARGINAL POLYNESIA:

The Maori of New Zealand

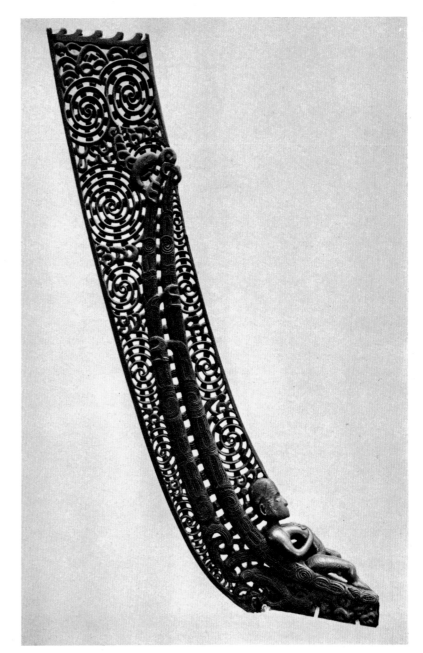

PLATE 265. CANOE PROW ORNAMENT
Marginal Polynesia, New Zealand, Kapiti
Length 48″
Canterbury Museum, Christchurch, New Zealand

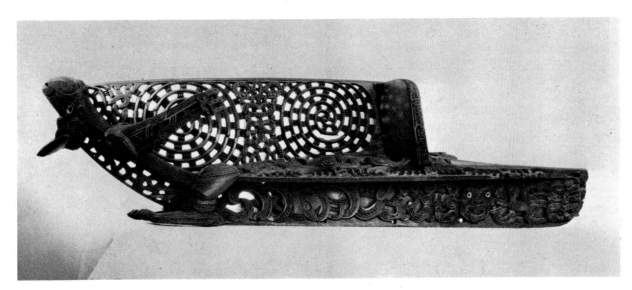

PLATE 266. STERNPOST
Marginal Polynesia, New Zealand,
Poverty Bay, Kahungunu Tribe
Height 88″
Auckland Institute and Museum

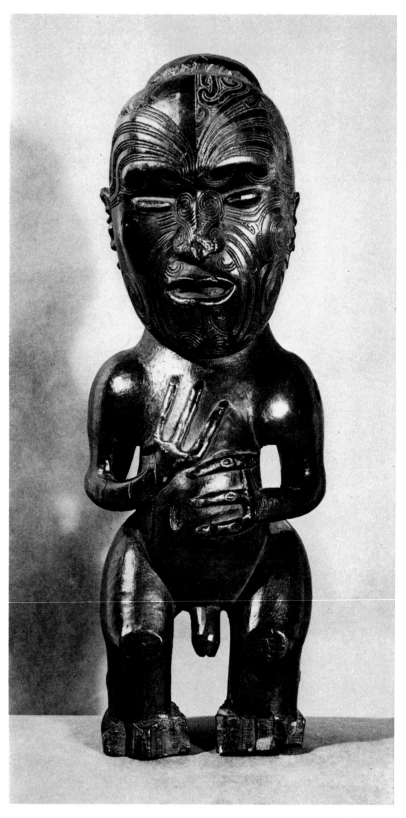

PLATE 267. STANDING MALE FIGURE
Marginal Polynesia, New Zealand (Oldman Collection No. 148)
Height 17 3/4″
Dominion Museum, Wellington

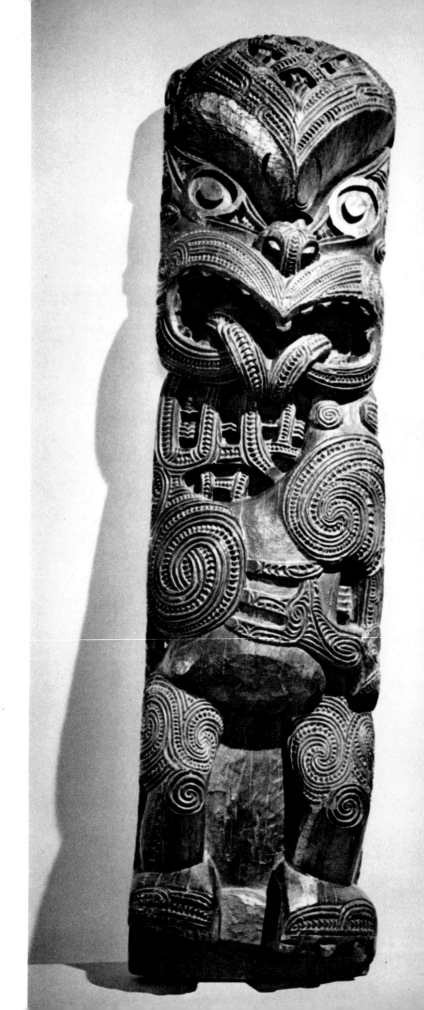

PLATE 268. HOUSE POST
Marginal Polynesia, New Zealand
Height 48 7/8″
Museum of Primitive Art, New York

PLATE 269. CARVED FIGURE
Marginal Polynesia, New Zealand, Chatham Islands
Height 41 3/8″
Auckland Institute and Museum

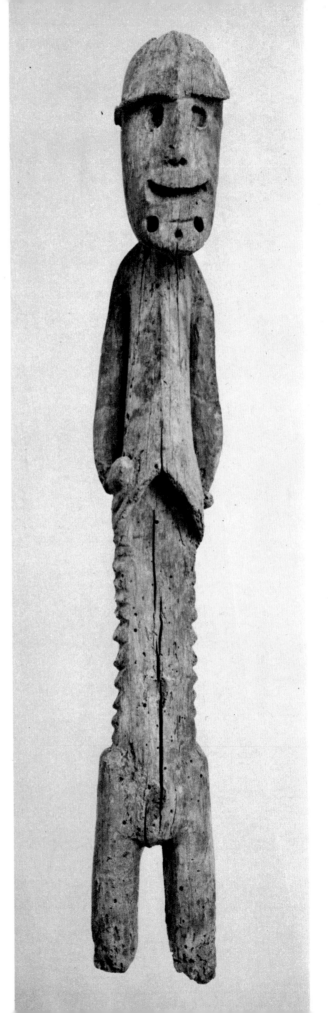

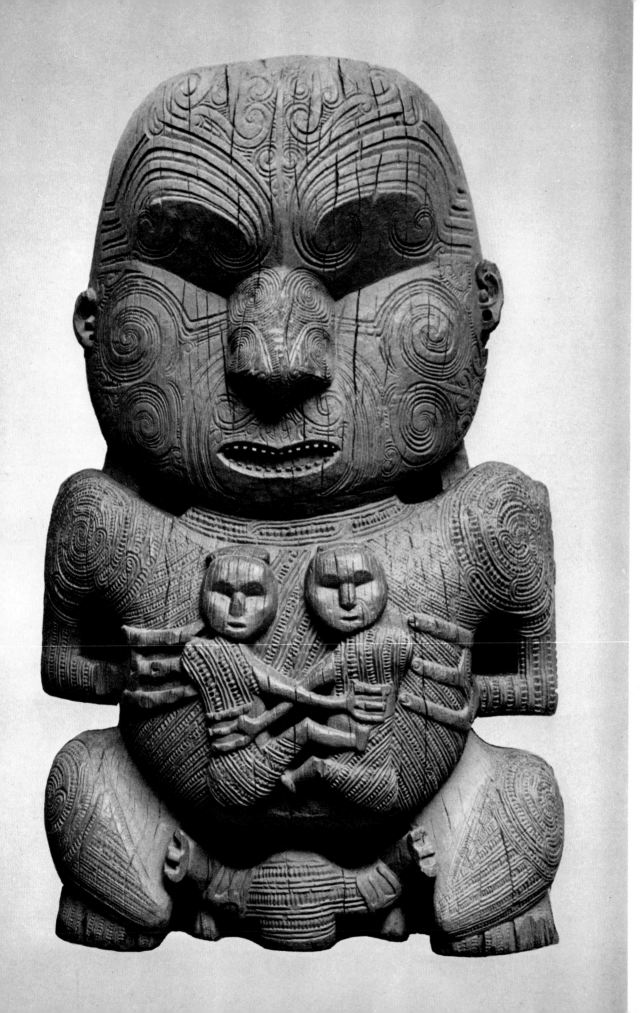

PLATE 270. FIGURE OF THE CHIEFTAIN PUKAKI
Marginal Polynesia, New Zealand,
Lake Rotorua, Te Ngae
Height 78″
Auckland Institute and Museum

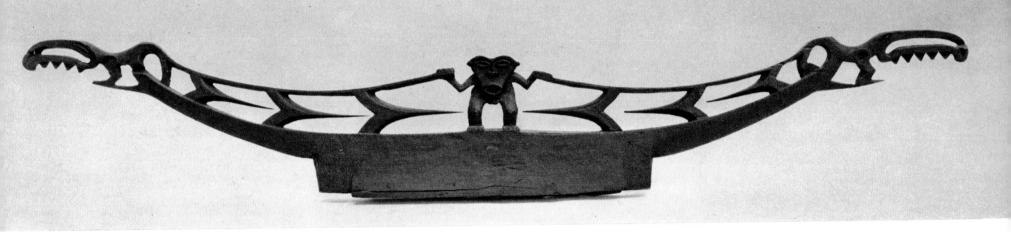

PLATE 271. ROOF ORNAMENT
Marginal Polynesia, New Zealand, Kaitaia
Length approximately 72″
Auckland Institute and Museum

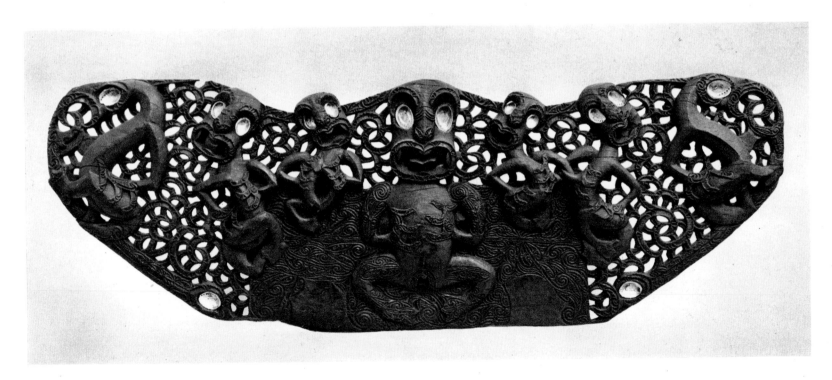

PLATE 272. DOOR BOARD (*pare*)
Marginal Polynesia, New Zealand, Hauraki Plains
Length approximately 60″
Auckland Institute and Museum

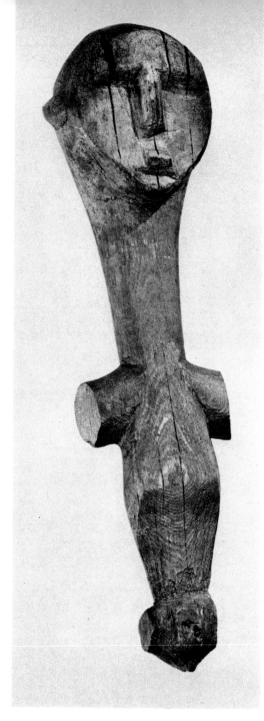

PLATE 273. GOD-STICK (*tiki wananga*)
Marginal Polynesia, New Zealand, Wickliffe Bay
Height 8 1/4″
Otago Museum, Dunedin, New Zealand

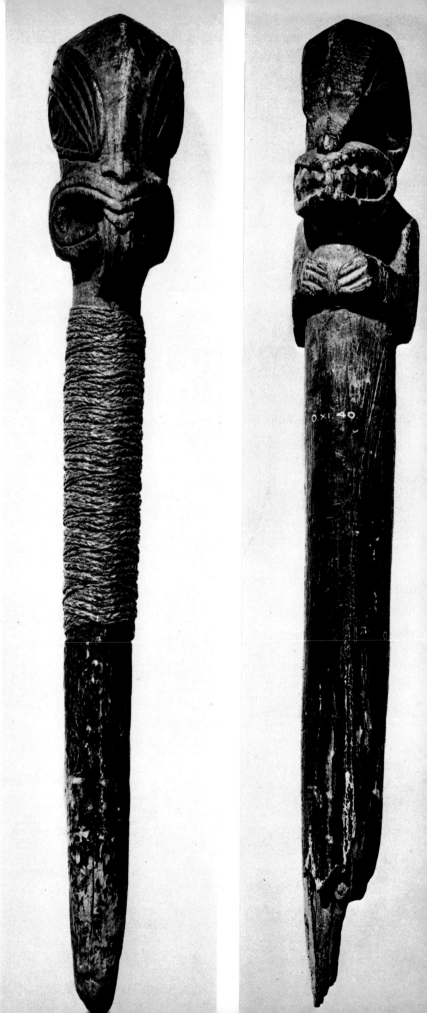

PLATE 274. GOD-STICKS
Marginal Polynesia, New Zealand, Wanganui District
Left: height 14 5/8″; right: height 5 1/8″
University Museum of
Archaeology and Ethnology, Cambridge, England

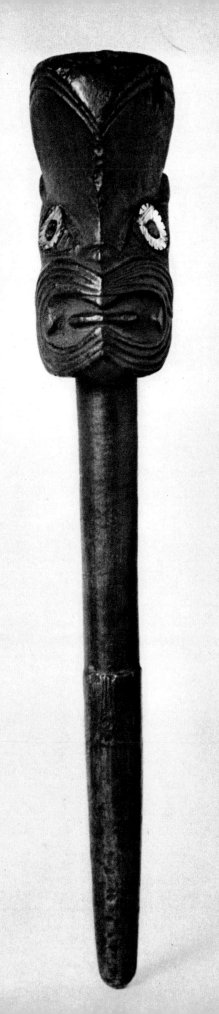

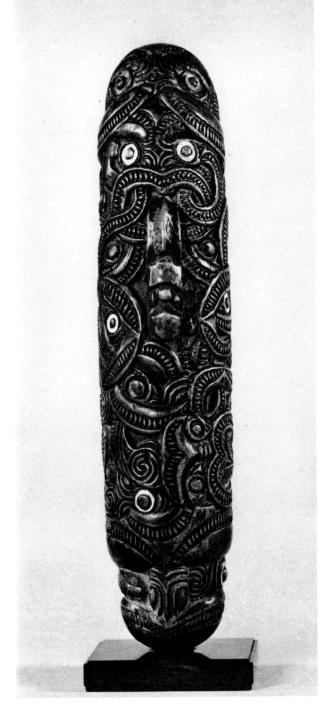

PLATE 276. FLUTE
Marginal Polynesia, New Zealand, Maori
Height 7 1/2″
Collection Mr. and Mrs. R. Wielgus, Chicago

PLATE 275. GOD-STICK
Marginal Polynesia, New Zealand, Wanganui District (Oldman Collection No. 155)
Height 12 5/8″
Dominion Museum, Wellington

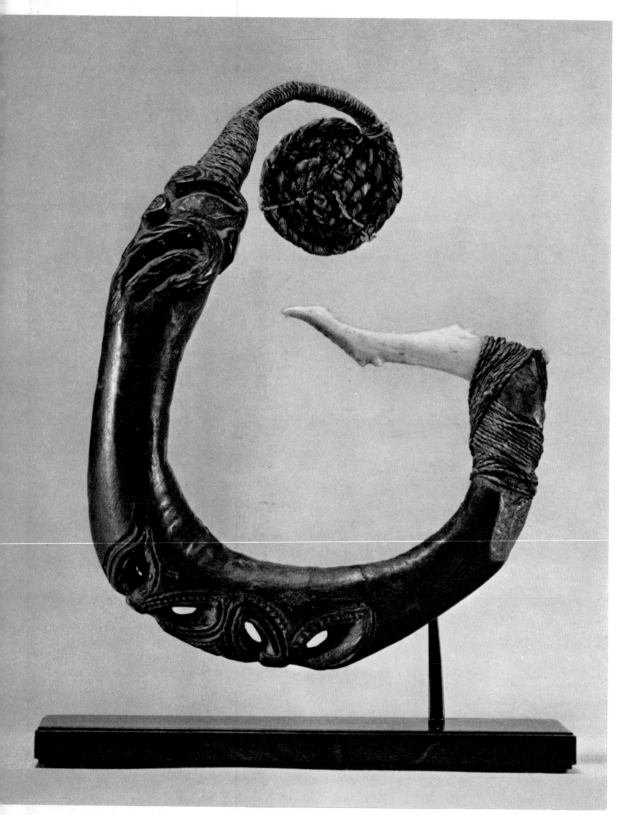

PLATE 277. FISH HOOK
Marginal Polynesia, New Zealand, Maori
Height 6″
Collection Mr. and Mrs. R. Wielgus, Chicago

COLORPLATE 49. PENDANT (*hei-tiki*)
Marginal Polynesia, New Zealand
Nephrite, height 9″
Collection Mr. and Mrs. R. Wielgus, Chicago

COLORPLATE 50. FEATHER BOX (*waka*)
Marginal Polynesia, New Zealand, Maori
Wood and abalone shell, length 17 5/8″
Museum of Primitive Art, New York

MICRONESIA

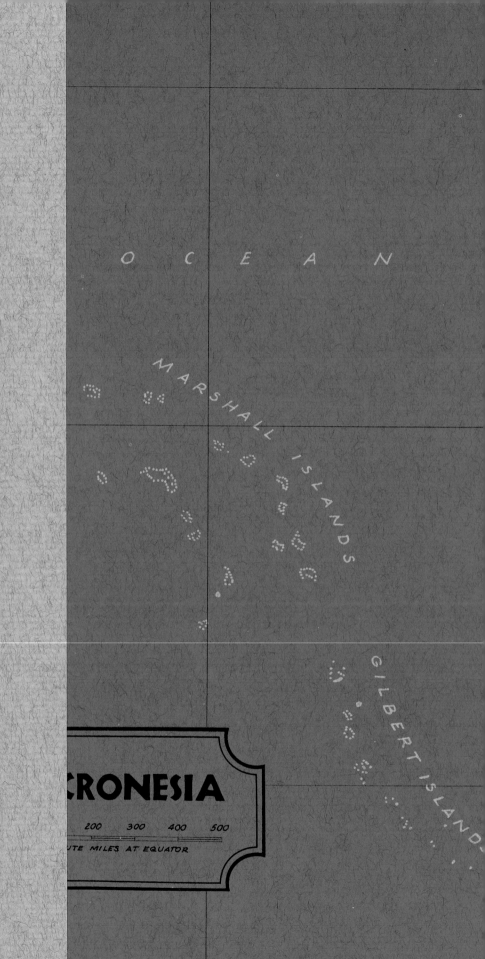

O C E A N

MARSHALL ISLANDS

GILBERT ISLAND

CRONESIA

200 300 400 500

UTE MILES AT EQUATOR

IN a book devoted primarily to the sculpture of Oceania, Micronesian art must inevitably be treated briefly: wood and stone sculptures of any interest come only from the islands of the Palau group and a few others to the south of them. It would be wrong to infer that the Micronesian culture was artistically poor; but its emphasis was rather on two-dimensional techniques, such as the ornamentation of surfaces and figurative painting.

For the comparative study of Oceania, the culture of these small islands is of great importance. There can be no doubt that a considerable impulse of Metal Age influence reached Polynesia by way of the Micronesian Islands. For this reason Micronesia was the first area in which the Metal Age culture had to adjust itself to maritime conditions. Thus the few existing wood sculptures are of particular interest; in the history of Oceanic art, as has often been pointed out, Micronesia forms a unit with eastern Melanesia and western Polynesia.

In the great ceremonial houses, wood figures of gods were set up or hung. The very simple example shown (plate 278) exhibits several features which play an important part in central Polynesia. Here, too, the legs are bent, though this feature is not very marked. The pelvic block forms a ring around the body, and the trunk is set like a wedge between the legs. The shoulder area is clearly marked, and the arms hang vertically. The hands rest laterally on the thighs. There is no neck; in contour, the face is an oval flattened at the top. The eyes appear as two small horizontally positioned ovals; the nose between them is straight and realistically shaped. The mouth is set very low at the edge of the contour. Here the facial surface advances slightly, and as a result, the area of the mouth is slightly convex. Generally speaking, the traits of the Neolithic-Austronesian tradition predominate.

The face of the local god Ngaraus, which used to be kept in a special shrine, exhibits the same features (plate 279). The figure's main attribute is an oversized phallus, probably symbolic of the belief that mankind came into being as a result of a sexual act performed by the gods.

This is not the case with the exhibitionistic female figure (plate 280), which belongs to a type found on the front gable of every clubhouse. The Russian anthropologist N. Miklukho-Maclay recorded a myth concerning the origin of such figures. "A long time ago," he writes, "in the village of Guarar, a woman named Dilukai lived with her mother and her wicked brother

Atmatuyuk. He had a skin disease, and was forbidden to bathe with other men. Fined for his failure to comply, he refused to pay, and since no one was willing to lay hands on him, the people waited for a suitable opportunity for revenge. One day when he was staying in another village, his house was stoned, and his mother and sister took refuge in the nearest clubhouse (*bai*). Then their own house was set afire. When Atmatuyuk came back he did not know where to house his mother and sister, so he advised them to remain in the clubhouse until he found other quarters for them. But he made no great effort to do so, merely coming to the clubhouse now and then to visit his women and to annoy the men living there. The men made the two women into *mongol* (prostitutes). When this too proved of no avail, they resorted to an ultimate means in order to discourage Atmatuyuk's visits. They stripped the two women naked and tied them in an exhibitionistic attitude over the entrance of the clubhouse. This proved effective: Atmatuyuk never came back. But to make sure that he would not return in the future, wood sculptures of women in the same attitude were set up outside all the clubhouses." These figures are designated by the name of the young woman, Dilukai.

Next to such figures, the ability of the Palau wood carvers is best seen in bowls both with and without lids. The bowls with lids are called *dangab*, and one of these is shown here (plate 281). Two monkeys are seated right and left of the handle, carved with a realism which proves the artist's talent.

A particularly interesting ritual object found all over Micronesia is the so-called boat altar. This is in every case a simplified model of a double or outrigger boat carved in wood. The example shown here (plate 282) is a double boat, with small half-moons carved at its four corners. In Palau such ritual objects are hung outdoors, whereas on other islands they are suspended from the rafters of boathouses or chieftains' houses. Some boat altars were dedicated to specific gods; others were associated with actual ancestors.

In southern Micronesia, the small island of Nukuoro is known for figures which are justly regarded as among the world's finest abstract sculptures in wood. These *tino* figures (plate 283) were kept in cult houses and decorated with flowers and colorful mats during the sacrificial feast. Their economy and elegance of line—which nevertheless does not conceal their fidelity to the stylistic tradition of Oceania—are unsurpassed.

The same is true of the wood *Tapuanu* mask from Satawan, one of the

Mortlock Islands (plate 284). The face is flat; the nose is straight and slender; the two bent eyebrows are rendered as narrow incisions; the eyes are set horizontally, and close together. The small mouth is enlarged by a line painted around it. But the crucial factor is that the individual features are not related to the facial contour; this reminds us, for example, of many masks from northern New Guinea, so that the Mortlock masks come closest to resembling those from the Huon Gulf.

The last three works shown here come from Kaniet and Hermit Islands west of the Admiralty group. These islands were referred to as the para-Micronesian area, as Micronesian influence no doubt extended southward and is detectable in the culture of the Admiralty Islanders. The figure (plate 285), a rare work, exhibits features with which we are familiar. The shoulder area is broad and sharply accentuated; the thigh area is narrow. The face hangs down over the chest, but this latter feature is primarily accounted for by the prolonged rectangular chin, which was perhaps meant as a beard. Once again the facial features are contained within the facial contour, and the areas of eyes and nose are related to those in Central Polynesian figures.

From the Hermit Islands comes a prow ornament which, by exceptional good fortune, could be reproduced in this well-preserved condition (plate 286). On the inner side of the elegant arc is a board partly carved in open-work. It shows animal motifs and geometric patterns. The main part of the prow ornament is entirely carved with incised patterns in small, regular fields.

The last picture shows a ceremonial adze (plate 287) from Kaniet, which may be compared with a ceremonial adze from the coastal area of New Guinea opposite Kaniet (plate 40). The whole surface is divided into regular fields, within which zigzag lines are incised. On the forward edge of the knee area are four faces, one above the other, in the typical style of the Kaniet figure (plate 285).

MICRONESIA

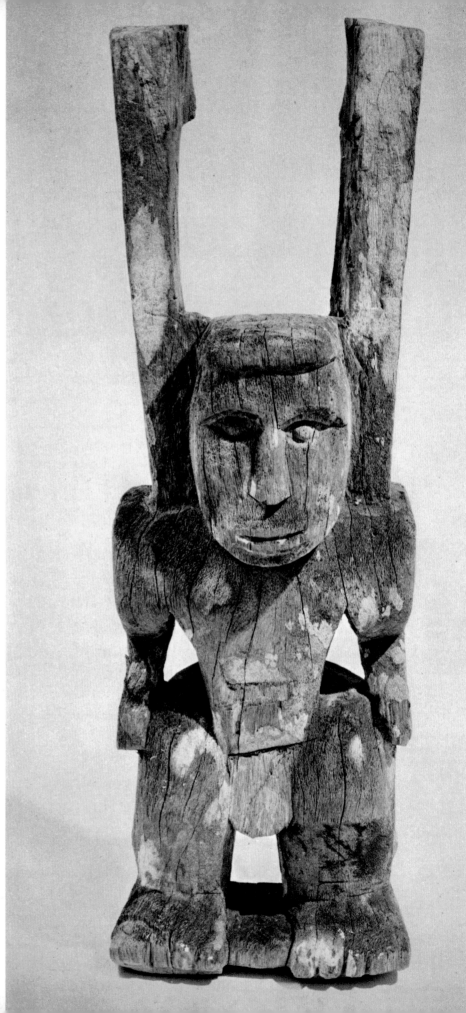

PLATE 278. GOD FIGURE
Micronesia, Palau
Height 18 7/8″
Museum für Völkerkunde und Vorgeschichte, Hamburg

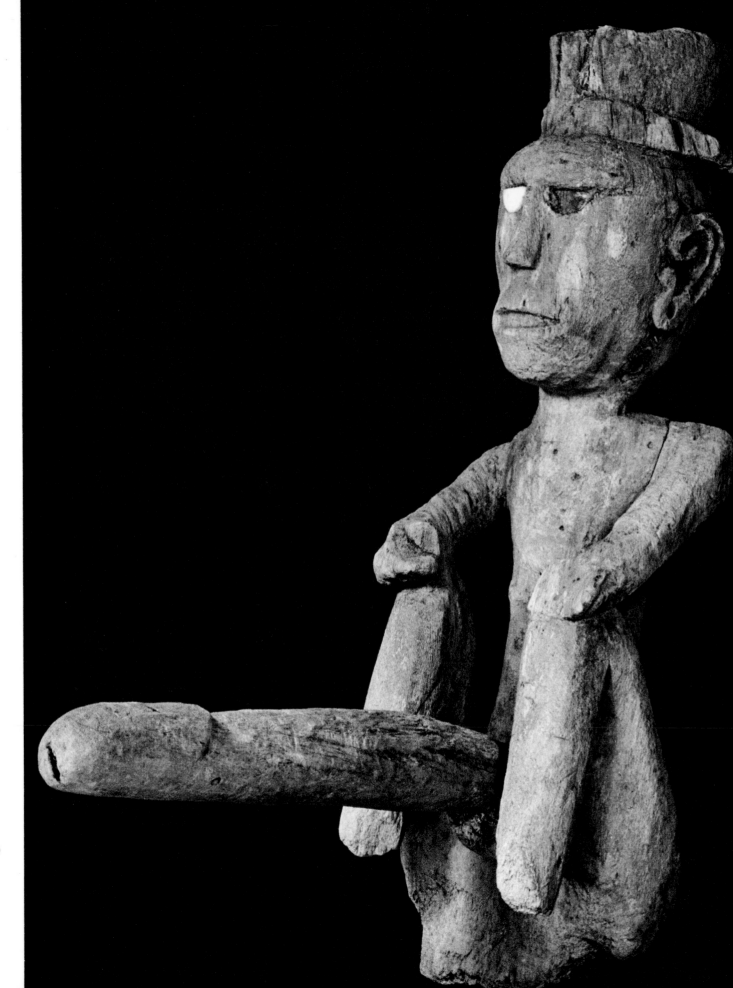

PLATE 279. MALE FIGURE
Micronesia, Palau (Krämer, 1912)
Height 19 1/4″
Linden Museum, Stuttgart

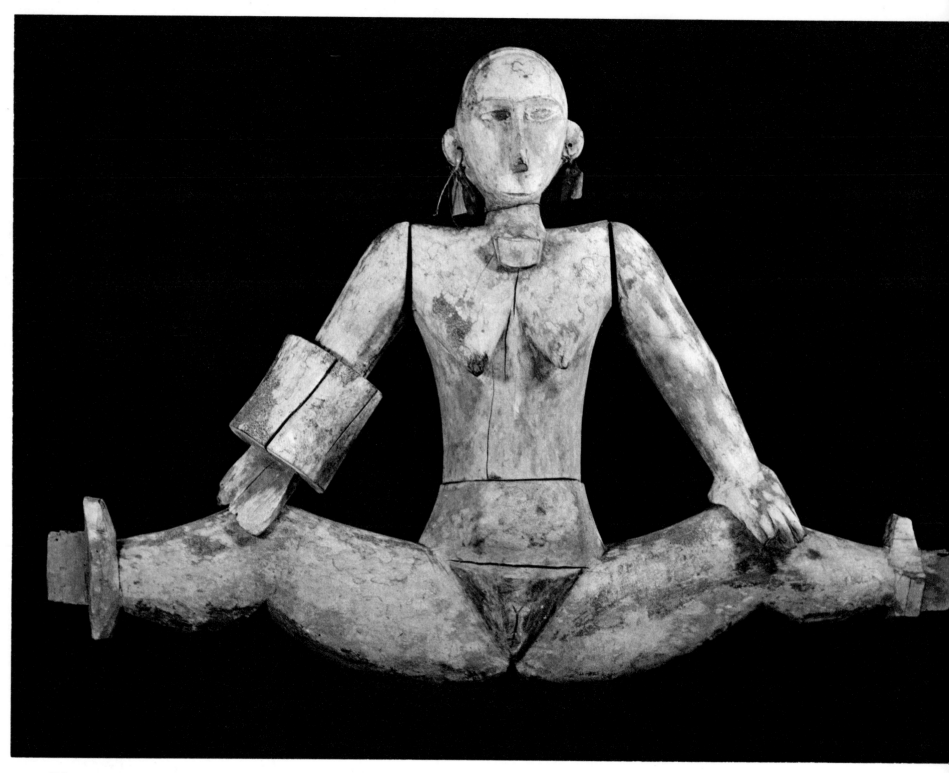

PLATE 280. FEMALE FIGURE
Micronesia, Palau (Krämer, 1912)
Height 23 5/8″
Linden Museum, Stuttgart

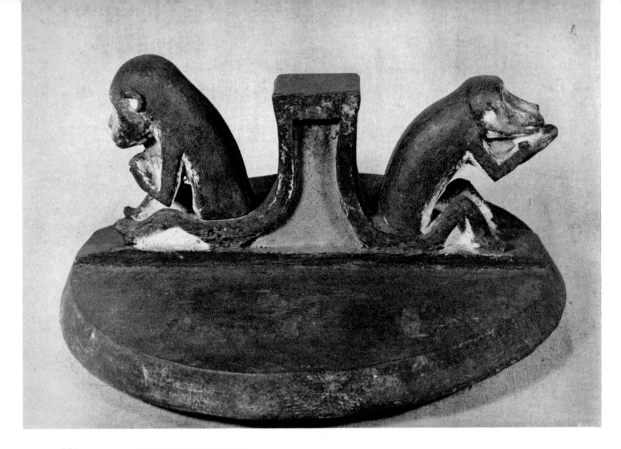

PLATE 281. LID OF BOWL WITH MONKEYS
Micronesia, Palau (Krämer, 1912)
Height 15 3/8"; diameter 11"
Linden Museum, Stuttgart

PLATE 282. BOAT ALTAR
Micronesia, Palau (Missner)
Length 26 3/8"
Linden Museum, Stuttgart

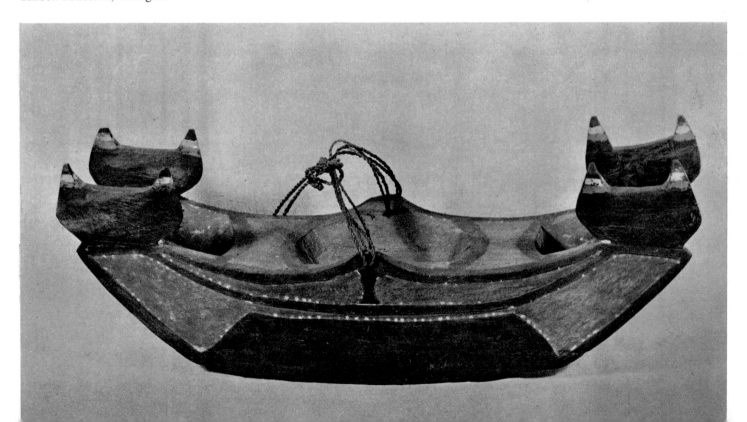

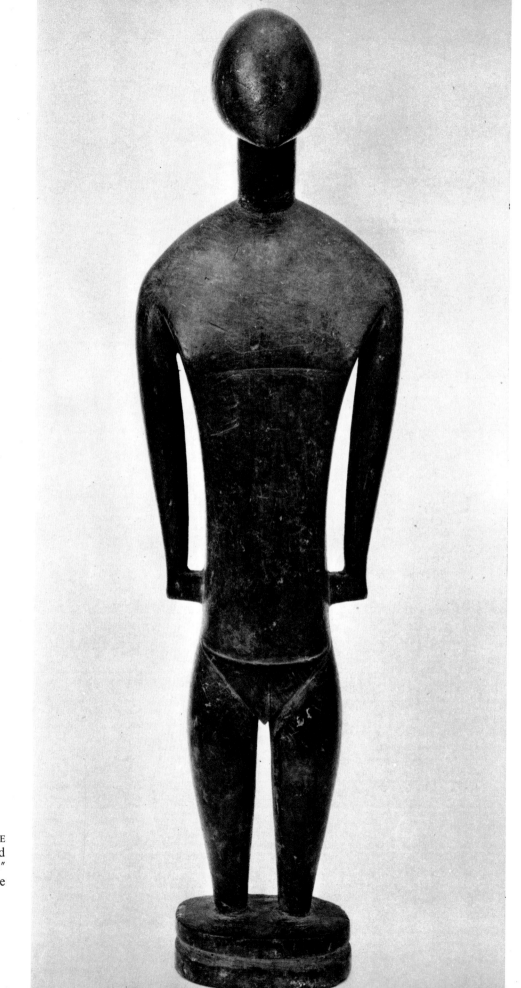

PLATE 283. *Tino* FIGURE
Micronesia, Nukuoro Island
Height 20 1/8″
Rautenstrauch-Joest Museum für Völkerkunde, Cologne

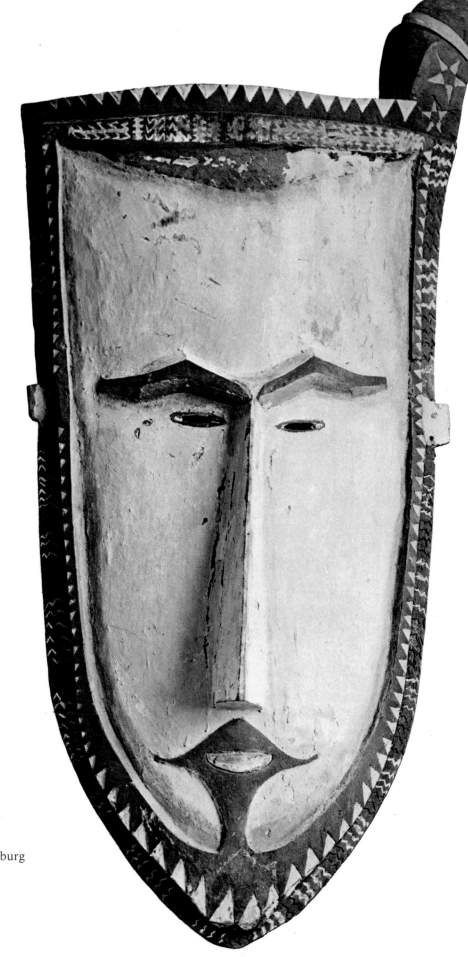

PLATE 284. *Tapuanu* MASK
Micronesia, Mortlock Islands, Satawan
(Hamburger Südsee Expedition, 1908–10)
Height 44 1/8″
Museum für Völkerkunde und Vorgeschichte, Hamburg

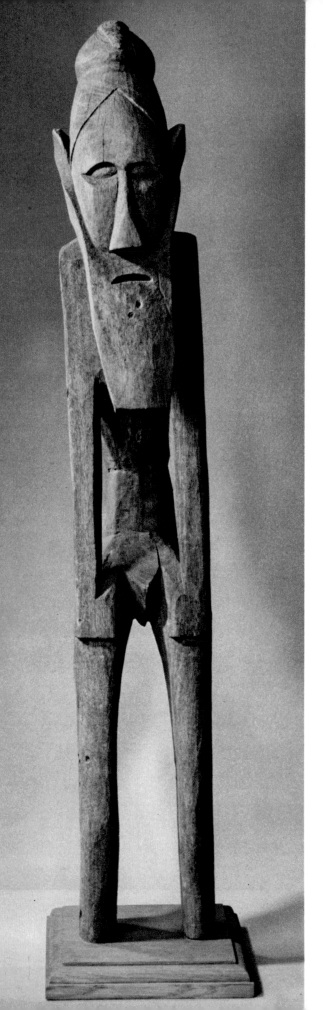

PLATE 285. HUMAN FIGURE
Micronesia, Kaniet Islands
Height 31 7/8″
Übersee-Museum, Bremen

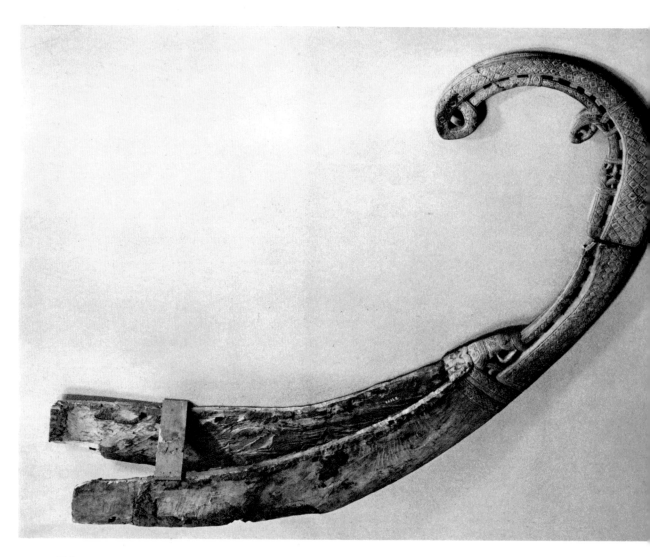

PLATE 286. PROW ORNAMENT
Micronesia, Hermit Islands (Umlauff, 1894)
Length 50 3/8″
Übersee-Museum, Bremen

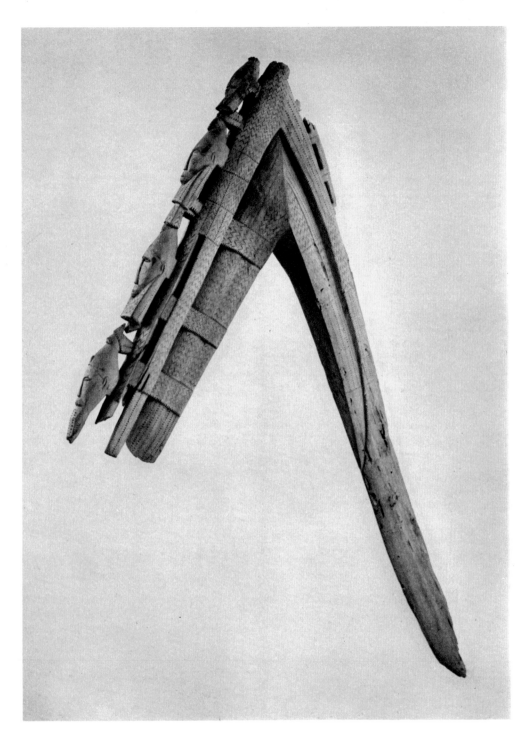

PLATE 287. CEREMONIAL ADZE
Micronesia, Kaniet Islands
Length 39 3/8″
Museum für Völkerkunde und Vorgeschichte, Hamburg

BIBLIOGRAPHY

GENERAL

GUIART, JEAN. *The Arts of the South Pacific.* New York: Golden Press. 1963.

TAYLOR, C. R. H. *A Pacific Bibliography.* 2nd ed. Oxford: Clarendon Press. 1965.

NEW GUINEA, GENERAL

FIRTH, RAYMOND. *Art and Life in New Guinea.* London and New York: Studio Publications. 1936.

NEWTON, DOUGLAS. *New Guinea Art in the Collection of the Museum of Primitive Art.* New York: The Museum of Primitive Art. 1967.

NORTHWEST COAST

BAAREN, T. P. VAN. *Korwars and Korwar Style.* The Hague and Paris: Mouton. 1968.

GERBRANDS, A. A. "Kunststijlen in West Nieuw-Guinea," *Indonesië,* The Hague, IV, 251, 1950–51.

LAROCHE, M. "Notes sur quelques ornaments de pirogue de la Nouvelle Guinée Hollandaise, Baie de Walkener," *Journal de la Société des Océanistes,* Paris, V, 105, 1949.

NUOFFER, OSKAR. *Ahnenfiguren von der Geelvinkbai, Holländisch Neuguinea,* Abhandlungen und Berichte des Königlichen Zoologischen und Anthropologisch-Ethnographischen Museum zu Dresden, Leipzig, XII, no. 2, 1908.

SERRURIER, LINDOR. "Die Korware oder Ahnenbilder von Neu Guinea," *Tijdschrift voor Indische Taal-, Land- en Volkenkunde,* Batavia, XL, 287, 1898.

LAKE SENTANI AND HUMBOLDT BAY

HOOGEBRUGGE, JAC. "Sentani-meer, Mythe en Ornament," *Kultuurpatronen,* Delft, IX, 5, 1967.

KOOIJMAN, S. *The Art of Lake Sentani.* New York: The Museum of Primitive Art. 1959.

NORTH COAST, FROM HUMBOLDT BAY TO ASTROLABE BAY

BIRO, LUDWIG. *Beschreibender Katalog der ethnographischen Sammlung Ludwig Biró's aus Deutsch-Neu-Guinea (Astrolabe-Bai und Berlinhafen).* 2 vols. Budapest: Kaiserl. und Königliche Hofbuchdruckerei Victor Hornyánszky. 1899–1901.

MAPRIK AREA

BUHLER, ALFRED. *Heilige Bildwerke aus Neu-Guinea.* Basel, 1958. (Guide to exhibition at Museum für Völkerkunde, Basel, November 9, 1957—March 31, 1958).

FORGE, J. ANTHONY W. "Art and Environment in the Sepik," *Proceedings of the Royal Anthropological Institute for 1965,* London, 1966.

KOCH, GERD. *Kultur der Abelam.* Berlin: Museum für Völkerkunde. 1968.

SEPIK AREA

BATESON, GREGORY. *Naven.* 2nd ed. Stanford, Calif.: Stanford University Press. 1958.

BUHLER, ALFRED. *Kunststile am Sepik.* Basel, 1960. (Guide to exhibition at Museum für Völkerkunde, Basel, June 11, 1960—November 30, 1960).

FORGE, J. ANTHONY W. "Three Kamanggabi Figures from the Arambake People of the Sepik District," in *Three Regions of Melanesian Art, New Guinea and the New Hebrides.* New York: The Museum of Primitive Art. 1960.

HABERLAND, EIKE. "Schilde vom oberen Sepik aus dem Völkerkunde-Museen Frankfurt am Main und Stuttgart," *Tribus,* Stuttgart, no. 12, December, 105, 1963.

————. "Zum problem der 'Haken-Figuren' der südlichen Sepik-Region in Neuguinea," *Paideuma,* Frankfort, X, 52, 1964.

KAUFFMAN, CHRISTIAN. "Uber Kunst und Kult bei den Kwoma und Nukuma (Nord-Neuguinea)," *Museum für Völkerkunde, Bericht,* Basel, LXXIX, 56, 1967.

KELM, HEINZ. *Kunst vom Sepik.* 3 vols. Berlin: Museum für Völkerkunde. 1966–68.

LAUMANN, KARL. "Geisterfiguren am mittleren Yuat River in Neuguinea," *Anthropos,* Fribourg, XLIX, 27, 1954.

————. "Vlísso, der Kriegs- und Jagdgott am unteren Yuat River, Neuguinea," *Anthropos,* Fribourg, XLVII, 897, 1952.

NEWTON, DOUGLAS. *Bibliography of Sepik District Art, Annotated for Illustrations, Part I,* The Museum of Primitive Art, Primitive Art Bibliographies, New York, no. 4, 1965.

RECHE, OTTO. *Der Kaiserin-Augusta-Fluss,* Ergebnisse der Hamburgischer Südsee-Expedition, 1908–10, Hamburg, I, 1913.

SCHLAGINHAUFEN, OTTO. *Eine ethnographische Sammlung vom Kaiserin-Augusta-Fluss in Neu-Guinea,* Abhandlungen und Berichte des Königlichen Zoologischen und Anthropologisch-Ethnographischen Museum zu Dresden, Leipzig, XIII, no. 2, 1910.

SCHMIDT, E. W. "Die Schildtypen vom Kaiserin-Augusta-Fluss und eine Kritik der Deutung ihrer Gesichtsornamente," *Baessler-Archiv,* Leipzig, XIII, 136, 1929.

SODERSTROM, JAN AND HOLTKER, GEORGE. *Die Figurstühle vom Sepik-Fluss auf Neu-Guinea,* Statens Etnografiska Museum, Smärre Meddelanden, Stockholm, no. 18, 1941.

NORTHEAST COAST, ASTROLABE BAY TO SIASSI ISLANDS

BODROGI, TIBOR. "New-Guinea Style Provinces: The Style Province 'Astrolabe Bay'," *Opuscula Ethnologica Memoriae Ludovici Biró Sacra,* Budapest, 39, 1959.

EAST COAST, HUON GULF TO MASSIM AREA

BODROGI, TIBOR. *Art in North-east New Guinea.* Budapest: Pub. House of the Hungarian Academy of Sciences. 1961.

HADDON, ALFRED C. *The Decorative Art of British New Guinea,* Royal Irish Academy, Cunningham Memoirs, Dublin, no. 10, 1894.

SOUTH COAST, GULF OF PAPUA TO TORRES STRAITS

NEWTON, DOUGLAS. *Art Styles of the Papuan Gulf.* New York: The Museum of Primitive Art. 1961.

SOUTHWEST COAST, ASMAT AREA

GERBRANDS, A. A. *Wow-Ipits.* The Hague and Paris: Mouton. 1967.

KOOIJMAN, S. "Art of Southwestern New Guinea," *Antiquity and Survival,* The Hague, I, 343, 1956.

RENSELAAR, H. V. VAN. *Asmat, Zuidwest-Nieuw-Guinea,* Mededeeling Koninklijk Instituut voor de Tropen, Amsterdam, CXXI, 1956.

ROCKEFELLER, MICHAEL C. *The Asmat of New Guinea.* New York: The Museum of Primitive Art. 1967.

ADMIRALTY ISLANDS, MANUS DISTRICT

NEVERMANN, HANS. *Admiralitäts-Inseln,* Ergebnisse der Hamburgischer Südsee-Expedition, 1908–10, Hamburg, III, 1934.

NEW BRITAIN

DAMM, HANS. "Ethnographische Materialien aus dem Küstengebiet der Gazelle-Halbinsel (Neubrittanien)," *Jahrbuch des städtischen Museums für Völkerkunde zu Leipzig,* Leipzig, XVI, 110, 1957.

———. "Sacrale Statuen aus dem Gebeit der Arawe (Arue) in Süd-Neubritannien (Südsee)," *Annals of the Náprstek Museum,* Prague, I, 29, 1962.
LAUFER, CARL. "Rigenmucha, das Höchste Wesen der Baining (Neu-brittanien)," *Anthropos,* Fribourg, XLI–XLIV, 497, 1946–49.
LUSCHAN, F. V. "Schilde aus Neu-Britannien," *Zeitschrift für Ethnologie,* Berlin, XXXII, 496, 1900.

NEW IRELAND

ANTZE, GUSTAV. "Ahnenfiguren aus Kreide von Neu-Mecklenburg," *Jahrbuch des städtischen Museums für Völkerkunde zu Leipzig,* Leipzig, IV, 37, 1910.
KRÄMER, AUGUSTIN. *Die Malanggane von Tombára.* Munich: Georg Müller. 1925.
LEWIS, PHILLIP H. "The Social Context of Art in Northern New Ireland," *Fieldiana: Anthropology,* Chicago, LVIII, 1969.
STEPHAN, EMIL. *Südseekunst.* Berlin: D. Reimer. 1907.

SOLOMON ISLANDS

BERNATZIK, HUGO. *Owa Raha.* Vienna: Bernina-Verlag. 1936.
BLACKWOOD, BEATRICE. *Both Sides of Buka Passage.* Oxford: Clarendon Press. 1935.
DAMM, HANS. "Unbekannte Zeremonialgeräte von Rubiana (Salamo-Inseln)," *Zeitschrift für Ethnologie,* Berlin, LXXIII, 29, 1941.
FOX, CHARLES ELLIOTT. *The Threshold of the Pacific.* London: K. Paul, Trench, Trubner & Co., Ltd. 1924.
IVENS, WALTER GEORGE. *Melanesians of the South-east Solomon Islands.* London: K. Paul, Trench, Trubner & Co., Ltd. 1927.
SARFERT, ERNST. "Masken aus dem Bismarck-Archipel, I, Nissan," *Jahrbuch des städtischen Museums für Völkerkunde zu Leipzig,* Leipzig, V, 38, 1911–12.

NEW HEBRIDES

GUIART, JEAN. "Les Effigies religieuses des Nouvelles-Hébrides, Etudes des collections du Musée de l'Homme," *Journal de la Société des Océanistes,* Paris, V, 51, 1949.
SPEISER, FELIX. *Ethnographische Materialien aus den Neuen Hebriden und den Banks-Inseln.* Berlin: C. W. Kreidel. 1923.

NEW CALEDONIA

GUIART, JEAN. *L'Art autochtone de Nouvelle-Calédonie.* Nouméa: Editions des études mélanésiennes. 1953.

———. *Mythologie du Masque en Nouvelle-Calédonie.* Paris: Musée de l'Homme. 1966.
LUQUET, GEORGES HENRI. *L'Art néo-calédonien,* Université de Paris, Travaux et Mémoires de l'Institut d'Ethnologie, Paris, II, 1926.
SARASIN, FRITZ. *Ethnologie der Neu-Caledonier und Loyalty-Insulaner.* 2 vols. Munich: C. W. Kreidel. 1929.

EAST MELANESIA

DAMM, HANS. "Sakrale Holzfiguren von den nordwest-polynesischen Randinseln," *Jahrbuch des städtischen Museums für Völkerkunde zu Leipzig,* Leipzig, X, 74, 1926–51.
NEVERMANN, HANS. *St. Matthias-Gruppe,* Ergebnisse der Hamburgischer Südsee-Expedition, 1908–10, Hamburg, II, 1933.
SARFERT, ERNST AND DAMM, HANS. *Luangiua und Nukumanu,* Ergebnisse der Hamburgischer Südsee-Expedition, 1908–10, Hamburg, XII, 1931.
SPEISER, FELIX. "Die Ornamentik von Santa Cruz," *Archiv für Anthropologie,* Braunschweig, XIII, 323, 1915.

WEST POLYNESIA

BARROW, T. T. "Human Figures in Wood and Ivory from Western Polynesia," *Man,* London, LVI, 165, 1956.
BUCK, PETER H. "Material Representatives of Tongan and Samoan Gods," *Journal of the Polynesian Society,* Wellington, New Zealand, XLIV, 48, 1935.

CENTRAL POLYNESIA

ARCHEY, GILBERT. "Art Forms of Polynesia," *Auckland Institute and Museum Bulletin No. 4,* Auckland, 1965.
BROWN, J. MACMILLAN. "Raivavai and its Statues," *Journal of the Polynesian Society,* Wellington, New Zealand, XXVII, 72, 1918.
HANDY, EDWARD SMITH CRAIGHILL. *History and Culture in the Society Islands,* Bernice P. Bishop Museum Bulletin, Honolulu, no. 79, 1930.
———. *Houses, Boats, and Fishing in the Society Islands,* Bernice P. Bishop Museum Bulletin, Honolulu, no. 90, 1932.
HANDY, WILLOWDEAN CHATTERSON. *Handicrafts of the Society Islands,* Bernice P. Bishop Museum Bulletin, Honolulu, no. 42, 1927.
HENRY, T. *Ancient Tahiti,* Bernice P. Bishop Museum Bulletin, Honolulu, no. 48, 1928.
TE RANGI HIROA (PETER H. BUCK). *Arts and Crafts of the Cook Islands,* Bernice P. Bishop Museum Bulletin, Honolulu, no. 179, 1944.

MARQUESAS ISLANDS

HANDY, MRS. WILLOWDEAN CHATTERSON. *L'art des îles Marqueses.* Paris: Les Editions d'art et d'histoire. 1938.

LINTON, RALPH. *The Material Culture of the Marquesas Islands,* Bernice P. Bishop Museum Memoirs, Honolulu, vol. 8, no. 5, 1923.

STEINEN, KARL VON DEN. *Die Marquesaner und ihre Kunst. Studien über die Entwicklung primitiver Südseeornamentik.* 3 vols. Berlin: D. Reimer. 1925–28.

HAWAII, MANGAREVA, AND EASTER ISLAND

BRIGHAM, WILLIAM T. *Old Hawaiian Carvings,* Bernice P. Bishop Museum Memoirs, Honolulu, vol. 2, no. 2, 1906.

HORNELL, JAMES. "The Artistic Degradation of Easter Island Wood-Carving," *Journal of the Polynesian Society,* Wellington, New Zealand, XLIX, 282, 1940.

LAVACHERY, H. *Ile de Pâques.* Paris: B. Grasset. 1935.

LUQUIENS, H. M. *Hawaiian Art,* Bernice P. Bishop Museum, Special Publication, Honolulu, no. 18, 1931.

METRAUX, ALFRED. *Ethnology of Easter Islands,* Bernice P. Bishop Museum Bulletin, Honolulu, no. 160, 1940.

TE RANGI HIROA (PETER H. BUCK). *Arts and Crafts of Hawaii,* Bernice P. Bishop Museum, Special Publication, Honolulu, no. 45, 1957.

——. *Ethnology of Mangareva,* Bernice P. Bishop Museum Bulletin, Honolulu, no. 157, 1938.

NEW ZEALAND

ARCHEY, GILBERT. "Evolution of Certain Maori Carving Patterns," *Journal of the Polynesian Society,* Wellington, New Zealand, XLII, 171, 1933.

——. "Maori Carving Patterns," *Journal of the Polynesian Society,* Wellington, New Zealand, XLV, 49, 1936.

——. *South Sea Folk, Handbook of Maori and Oceanic Ethnology.* Auckland: Auckland War Memorial Museum. 1949.

BARROW, T. T. "Maori Decorative Art:—An Outline," *Journal of the Polynesian Society,* Wellington, New Zealand, LXV, 305, 1956.

——. *Maori Wood Sculpture of New Zealand.* Wellington, Auckland, Sydney, and Melbourne: A. H. & A. W. Reed. 1969.

HAMILTON, AUGUSTUS. *The Art Workmanship of the Maori Race in New Zealand.* Dunedin, New Zealand: Fergusson & Mitchell. 1896.

PHILLIPS, WALTER J. *Carved Maori Houses of Western and Northern Areas of New Zealand,* Dominion Museum Monograph, Wellington, New Zealand, no. 9, 1955.

——. "Maori Spirals," *Journal of the Polynesian Society,* Wellington, New Zealand, LVII, 30, 1948.

SKINNER, H. D. "Evolution of Maori Art," *Journal of the Royal Anthropological Institute of Great Britain and Ireland,* London, XLVI, 184, 1916.

——. "The Origin and Relationship of Maori Material Culture and Decorative Art," *Journal of the Polynesian Society,* Wellington, New Zealand, XXXIII, 229, 1924.

MICRONESIA

DAMM, HANS. "Mikronesische Kultboote, Schwebealtäre und Weihegabenhänger," *Jahrbuch des städtischen Museums für Völkerkunde zu Leipzig,* Leipzig, XIII, 45, 1954.

EILERS, ANNELIESE. *Inseln um Ponape,* Ergebnisse der Hamburgischer Südsee-Expedition, 1908–10, Hamburg, VIII, 1934.

KRÄMER, AUGUSTIN, *Palau,* Ergebnisse der Hamburgischer Südsee-Expedition, 1908–10, Hamburg, III, 1917–29.

PHOTOGRAPHIC
SOURCES

The publisher wishes to thank the museums and private collectors for permitting the reproduction in black and white of works of art in their possession. Photographs have been supplied by the owners except for the following, whose courtesy is gratefully acknowledged:

Art Institute of Chicago (249, 276, 277); Breiting, M., Leipzig (32, 221–24); Elisofon, E., New York (153–55); Franz, Dunedin, New Zealand (146, 273); Harvey, R., Auckland, New Zealand (266, 269, 270–72); Hawaiian Culture Committee, University of Hawaii, Honolulu (255); Heinrich, N., Stuttgart (85, 115, 116, 165, 171, 179, 184); Hewicker, F., Kaltenkirchen, Germany (284); Hildyard, London (142); Hinz, H., Basel (46, 67, 102, 178, 215, 225, 226); Howard, J., New Haven, Conn. (88); McGregor, F., Christchurch, New Zealand (265); Moeschlin and Baur, Basel (4, 9, 10, 12, 13, 16, 21, 23, 25, 31, 33, 38, 39, 41, 44, 45, 59, 60, 62–65, 68, 70, 71, 73, 76, 87, 90, 92, 94, 95, 101, 118, 120, 124–26, 132, 133, 147, 149, 183, 205, 206, 210–14); Moosbrugger, B., Zurich (182); Reuhle, R., Adelaide, Australia (139); Schmidt, Cologne (193, 197, 283); Sparrow, Auckland, New Zealand (242); Uht, C., New York (150, 151, 156, 237); Weber, H., Basel (7, 19, 26, 27, 34, 35, 37, 40, 42, 43, 47, 48, 57, 58, 66, 69, 72, 75, 78, 89, 91, 97, 100, 103–14, 117, 122, 123, 128, 130, 138, 142, 143, 160, 194–96, 198–201, 203, 204, 209, 216–20, 229); Wettstein and Kauf, Zurich (207); Wiesner, H., Bremen (285, 286).